MW01042888

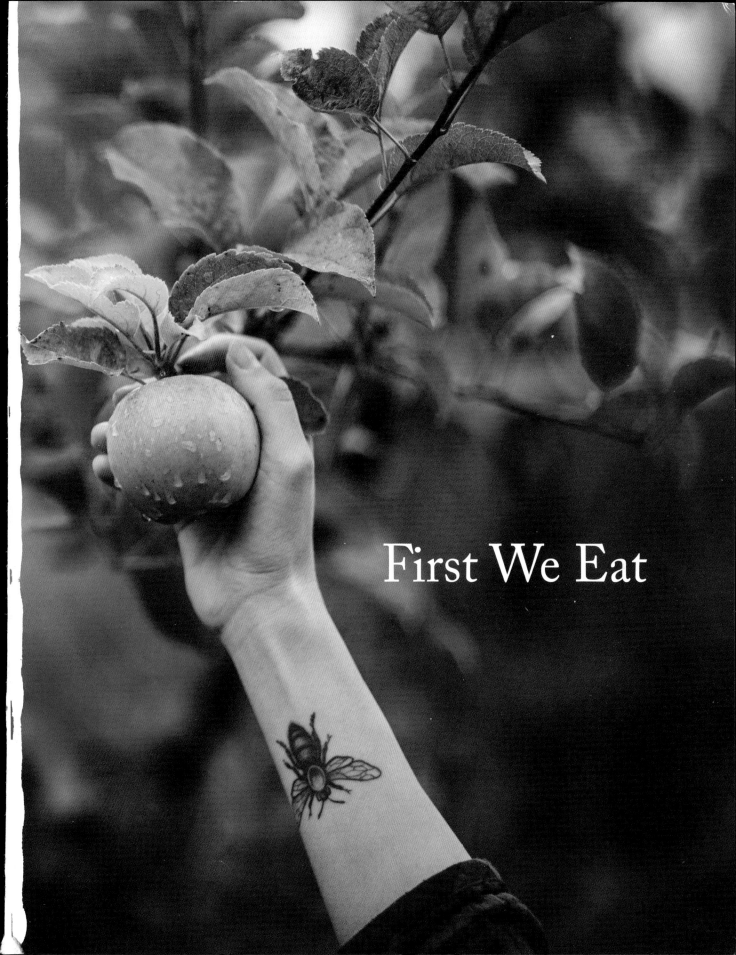

First We Eat

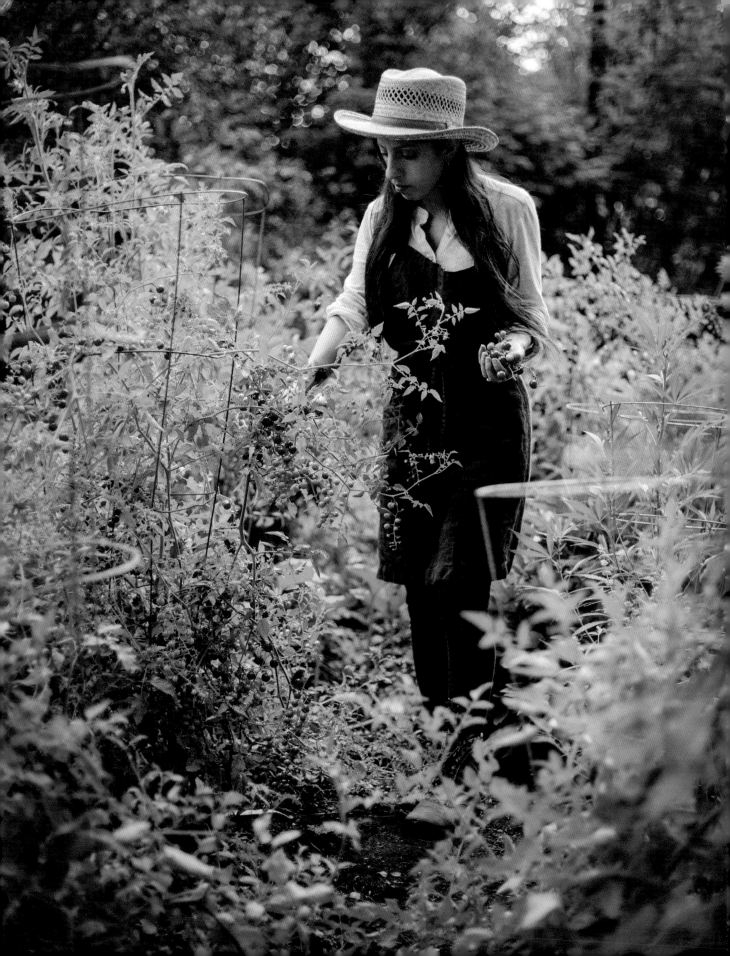

First We Eat

Good Food for Simple Gatherings
from My Pacific Northwest Kitchen

EVA KOSMAS FLORES

Abrams, New York

Editor: Laura Dozier
Designer: Danielle Young
Production Manager: Kathleen Gaffney

Library of Congress Control Number: 2017944947

ISBN: 978-1-4197-2896-9

ABRAMS The Art of Books
195 Broadway, New York, NY 10007
abramsbooks.com

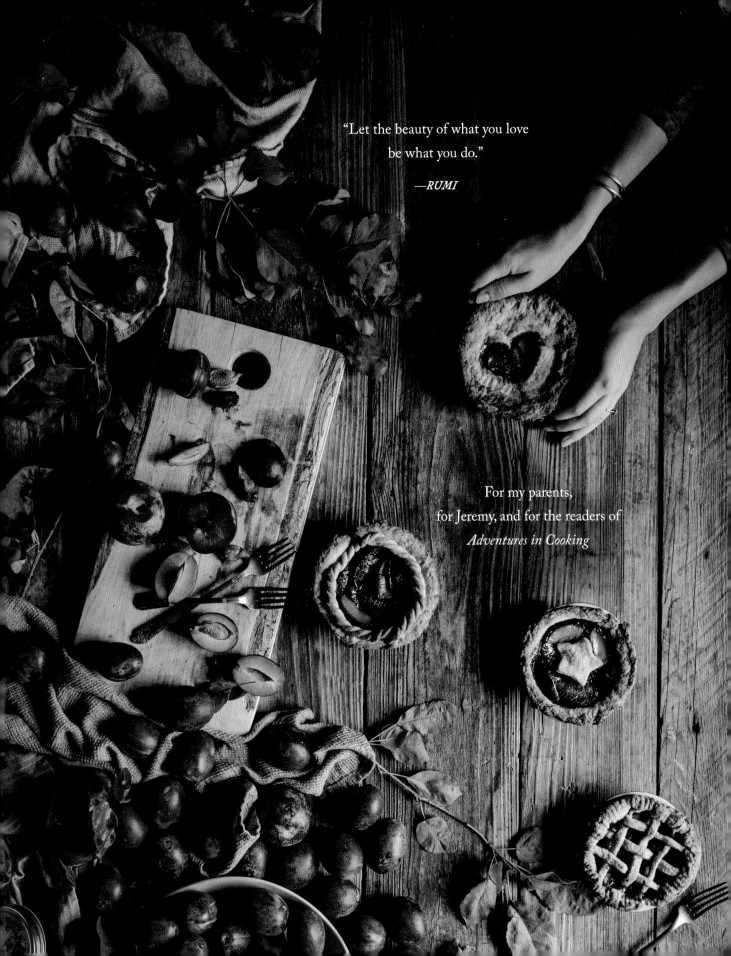

"Let the beauty of what you love
be what you do."

—*RUMI*

For my parents,
for Jeremy, and for the readers of
Adventures in Cooking

SPRING 36

SUMMER 96

AUTUMN 164

WINTER 234

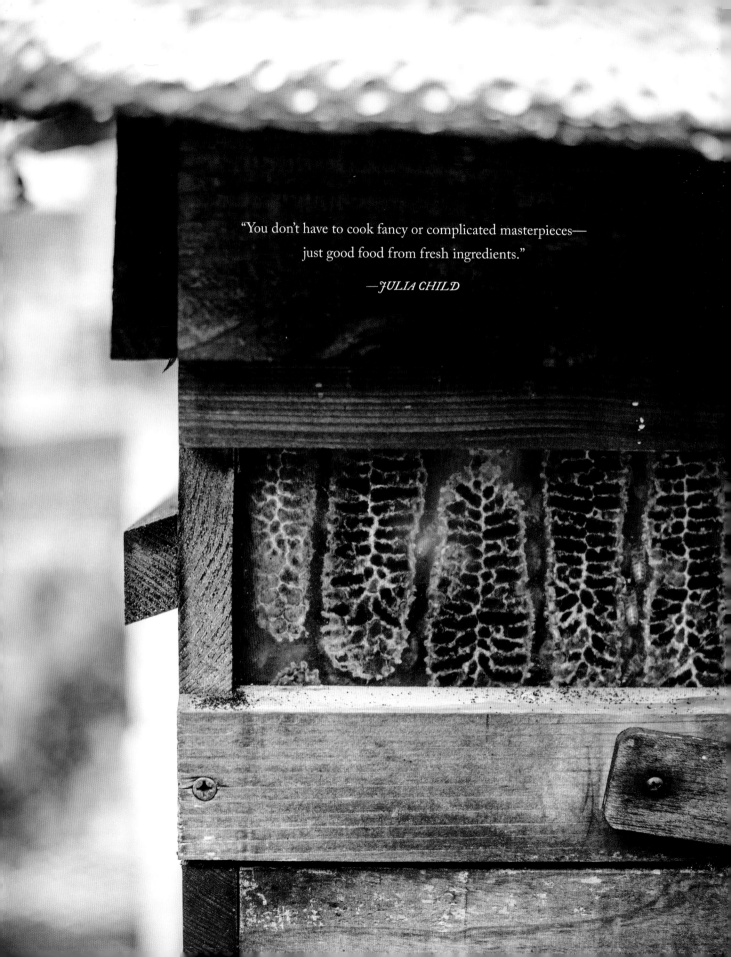

"You don't have to cook fancy or complicated masterpieces—
just good food from fresh ingredients."

—*JULIA CHILD*

Introduction:
A Warm Welcome

—

IN THIS BOOK, I AM GOING TO TELL YOU A STORY. It's the story of one year in my kitchen, as well as all the years leading up to it. At its heart, this is a story about eating. I know you are here because you love to eat, but that love goes deeper than just the act of eating. You want to do more than eat; you want to cook, too—transforming ingredients from individual shapes and tastes into deeply flavorful, cohesive dishes. The metamorphosis of ingredients through cooking is the closest thing we have to real, live magic. But good food doesn't require page-long ingredient lists, complex cooking techniques, or fancy far-away components—the best food comes from the simplest recipes with the freshest ingredients. I'm so excited to share my story with you and to show you how using seasonal, fresh ingredients can transform not just the way you cook and eat but also the way you live.

In this tale of food, I am also telling you the story of my family—one rich with baklava, *kopanisti*, perfectionism, and octopus tendrils wrapped around my *yiayia's* tomato sauce. I was raised in a household where home-cooked food was the norm. This was, in part, because my parents owned and operated a Greek deli in Portland, Oregon, for more than thirty years. My father is from a small island called Aegina, where his father, my *papou*, started as a shoemaker and eventually became a landowner and pistachio farmer. My *yiayia* helped tend the farm and raised eight children in a two-room house with no running water. Grit, determination, and an overall sense of sassiness are important traits in Greek people, and that's very evident in my family. While my mother is not Greek, she completely embraced the Greek culture upon marrying my father. And, with her being one hell of a cook, the Greek culture embraced her back. My mother is the warmest person you will ever meet, and her cooking reflects that. She worked full-time at the deli while we were growing up but still made dinner from scratch every single day. Some of my earliest memories are of her pulling up a chair to let me stand in front of the stove so I could reach the pot. I loved helping her stir, and when she started to let me sprinkle in seasonings, I was over the moon. The way a pinch of something could completely transform the flavor of a dish seemed magical to me. I was hooked.

Both my parents are avid gardeners, and I was lucky to be able to eat fresh produce from our yard year-round. They used the tomatoes and cucumbers from our garden for the Greek salads at the deli, before "farm to table" was a blip on the trend radar. They also had a giant compost heap in the backyard that consisted of rotting old bits of vegetables and plants, which our neighbors didn't really understand. When my father wasn't working at the deli, he would usually be out in the garden, and I'd teeter my tiny self out to spend time with him. The more time I spent

with him out there, the more I learned about gardening, and the more fascinated I became. I was amazed that a little seed smaller than a ladybug could give you dozens of pounds of tomatoes in a matter of months, and all you had to do was place it in soil and give it water. This was the beginning of another addiction that would see me through ripping out the entire front lawn of my first home and filling it with tomato plants. Again, the neighbors didn't really understand.

Along with being in the kitchen with my mother and in the garden with my father, I also spent a lot of time with both of them at the deli. My parents didn't really trust day care, so I spent my time outside of school playing and lending a hand at the business. I started helping out with small things at the restaurant, like cleaning tables, and eventually began lending a hand with prep work.

My father was, and still is, a perfectionist with food. He borders on OCD when it comes to the correct way to cut a cucumber. He had to make the same dishes again and again for the restaurant, so being consistent and exact was very important. From him, I learned the art of precision. My mother, though, had a style that was much more relaxed, and she would make up our dinners based on what we had from the garden and what she felt like preparing. Her cooking style was much more adventurous, which inspired me to try preparing new foods as I grew older and started cooking on my own.

It stayed that way for a long time, with me helping at the deli on weekends and during school breaks, watching my mom whip up delicious meals in our kitchen at home, and lending a hand in the garden. And then, at the age of fifteen, I picked up my first film camera, and another addiction began. I loved to chronicle everything through my photos, and that led me to pursue filmmaking at university.

I graduated from college in 2009 at the height of the recession and had no idea if I'd ever find a job. This was the period of my life I like to refer to as the unemployment tango. Going from working three jobs and being a full-time student to struggling to find gainful employment of any kind was a bit of a shock to my work-loving ethos. So, with a lot of extra time on my hands, I poured myself into what I loved most—cooking. I started cooking all the time, making whatever I could with the meager grocery budget I had. And that's when I started my blog. I didn't do it because I wanted to showcase my photography. (You can look at old photos as proof. I shot shrimp at nighttime using flash! It was terrible.) I didn't do it because I wanted to find a way to make money. (Sponsored posts weren't a thing back then.) I did it because I loved food and wanted to share that love with as many people as possible. And I still do.

Six months into my unemployment, I was hired as a page at NBCUniversal. Yes, like Kenneth from *30 Rock*, but the West Coast version. I gave tours of the Burbank studio lot, worked on *The Tonight Show*, and began climbing the corporate ladder. I threw myself into my "dream job" full-time on weekdays and worked all weekend long on the blog—cooking, shooting, and writing. This nonstop cycle went on for several years. And then, my dream job wasn't my dream job anymore. I realized I didn't really care about shooting schedules and viewership and budgets and producers' egos. Those weekends of cooking and writing became a life raft keeping me afloat in a seemingly endless flow of monotonous, pointless days. Eventually, I realized that all I looked forward to were those two glimmering days a week spent in the kitchen and on my computer nerding out with other foodies, but I didn't know what to do about it. I wasn't happy with my job, but I couldn't afford to quit and didn't have the time to apply elsewhere. And then, the universe dropped me the least subtle hint ever when the sitcom I was working on was canceled. I found a transitional tech support job within the entertainment industry that had a *much* healthier work environment and paid well enough to allow me to save up and take the leap into full-time freelancing after several months.

A lot has happened since then. My blog, *Adventures in Cooking*, grew a large and dedicated following and was nominated for a Saveur Food Blog Award. I met my best friend, Carey, through my blog, and we started

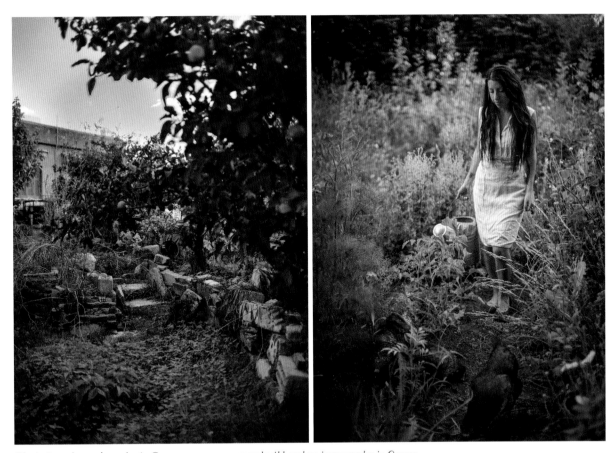

My yiayia *and* papou's *garden in Greece, now overgrown and wild, and me in my garden in Oregon.*

travel-based photography workshops called First We Eat (www.firstweeat.co), where we teach food photography and styling over a period of five days in locations all over the world. We plan out the menus for each one based on the local food culture and prepare seasonal, fresh dishes for the duration of the workshop. We also have excursions into the food community of each location, like truffle foraging in Croatia's centuries-old forests, wine tasting in Bordeaux, or maple sapping in Vermont. We started a podcast of the same name where we geek out 1,000 percent about food. I wrote my first cookbook, *Adventures in Chicken*, and I got married to my longtime partner, Jeremy. It was a whole, whole lot.

Wanting something more than city life, but not knowing precisely what, we bought a house outside of Portland and moved back to Oregon. Then, I cofounded a pop-up dinner series called Secret Supper with my

friends Danielle, Mona, and Jaret, where we created one-night-only, long-table suppers in beautiful natural surroundings, like the Columbia River Gorge and Mount Hood. Jeremy and I adopted two dogs . . . and then I convinced him to add seven chickens to our brood. We started composting and turned every square inch of our lot into a functioning garden. And then I went to Greece for the first time in seventeen years.

I hadn't seen my cousins since I was a child, and I was ready to make up for lost time. I wanted to hear all the family stories, especially the ones about my *yiayia*. She passed away when I was very young, and I only met her once when I was one year old, so it was really meaningful to be able to hear firsthand about how deep her laugh was, the way the chickens and turkeys used to follow her around the garden for scraps, and how she made her own sheets of filo by rolling out the

dough paper thin with a long wooden rod. Every story painted a clearer picture, and I was able to really know her for the first time, just as she used to be, content in the farmhouse's kitchen and garden in Kypseli, always cooking, sharing, giving, feeding, and loving. The more I heard about her, the more she resonated with me. And I realized that the "something more" I'd been pursuing was the life she led—an honest and simple one that revolved around good seasonal food, a love of sharing it, and a passion for working the earth. It was an epiphany of both who I wanted to be and what I'd already become. And when I got back, I wrote this book. My dream book, *First We Eat*.

This book is meant to help you eat seasonally, locally, ethically, and flavorfully. It starts with Homemade Pantry Basics (page 22), which is chock-full of simple and delicious recipes for spicing up your daily meals. This includes tasty things like Garlic and Bay Leaf Salt, Chipotle Honey, Quick-Pickled Onions, Flavorful Preserved Lemons, and Roasted Mushroom Butter. It also helps you replace frequently store-bought ingredients with simple homemade versions—like good ol' tomato sauce and homemade soup stocks. The rest of the book is broken up by season, and the recipes within each one will serve as a road map for the types of ingredients that are fresh that time of year. At the beginning of each season, I have a little gardening how-to for those of you who are interested in getting a little deeper into growing your own. This is by no means an all-encompassing grow-your-own instruction (I'd need to write an entire separate book for that!), but it will help guide you in your first forays into gardening, whether outdoors in the earth or in a container on an apartment balcony.

As a whole, *First We Eat* will provide you with the groundwork for cooking seasonally in the months to come. It will give you the building blocks and tools to make this year of eating the best one yet, and I am so excited for you join me on this journey!

I will say, though, that I am very lucky to be able to lead this life. No matter how much hard work you put into your accomplishments, some amount of luck is always involved. But I think that when you do what you're passionate about, you have luck on your side. When you care about your work—the sort of work that gives you purpose and joy and warmth—it seeps into you, leaks out into the world, and starts to attract all the good things. Good people, good opportunities, good choices. I know that most people aren't able to pursue their passions full-time, and that's okay. But try to make your passion some part of your life. Even if it's just for a few minutes a week; little by little, it will make each week brighter than the last. It might take you somewhere, and it might not, but at least you'll be happy. And, in the end, that's all that matters. Writing this book has been one of the most demanding experiences of my life in the best possible way, and I think that's because I've really put every ounce of my happiness, my heart, and my soul into it. It's easy to throw yourself into your work when you love it so much. I hope that my passion and love for food comes through on each page and inspires you to eat fresher, eat local, and eat well. In the words of Julia Child, "Learn how to cook—try new recipes, learn from your mistakes, be fearless, and above all have fun!"

Eating Seasonally

—

I CURRENTLY LIVE ON A HALF-ACRE PLOT on the outskirts of Portland, Oregon. I have seven chickens that provide me with a rainbow of eggs and a giant garden that produces hundreds of pounds of produce every year. This has been a source of inspiration for me in developing recipes, but this is not how you need to live to eat seasonally. Eating seasonally doesn't have to be a grand leap where you immediately begin growing all your own food and give up your life in the city. It starts with baby steps. Something as simple as buying one piece of produce from the farmers' market every week, or even strolling through one just to take it all in.

At first, you might wander around the open-air market nervously, feeling as though you don't belong and you're not quite sure what you're doing there. There are so many stands, and some of them have the same things but also different things, and why is that? It's not like that at the grocery store, where there's one square of normal-looking eggplants and that's it. It can be a little overwhelming. Then, a beautiful apple catches your eye. One that's matte yet shimmers in the sunlight because of the gold freckles across its rough and swollen skin. It's perfectly imperfect, and it's unlike any apple you've seen before. This little apple lures you up to its stand, and you buy a couple of them. The stand owner is friendly, not at all pretentious or gruff. It is pleasant, and now you have these curious little apples.

You go home, you take a bite, and it's the best apple you've ever had. You come back next week, but you can't find that variety on the table anymore. You talk to the stand owner and learn that this year's harvest from that particular ninety-year-old heirloom apple tree is finished for the season. You find yourself in a discussion about the orchard, and you end up buying several other apple varieties the owner recommends, take them home, and fall in love all over again. You come back the next week, and this time, you linger at some other stalls, too, going home with a wonky little winter squash in addition to your now-regular bag of apples. As the weeks progress, you see the market transform.

There are fewer people there in the winter, and the food that is on the tables has changed. You notice that the days are getting shorter, and shorter, and then longer again. You can't find plums for the life of you, but there are persimmons, these little pale-orange orbs that have the most beautiful sage-green leaves. The stand owner is giving you their favorite recipe for persimmon jam, and you realize that you don't need to buy plums in the middle of January, anyway. Every fruit or vegetable that you get there is fleeting and special and tastes better than any supermarket counterpart that you've had. You get to know the people behind the fold-out tables, how passionate they are about what they grow, and how they do it. You feel good about supporting community agriculture, and even better when you're pulling a hot pan brimming with a local roasting chicken and heirloom potatoes from the market out of the oven. All you can think is that this must be what heaven smells like. Life is good, and eating like this is even better.

And then, one day, you're walking the market as a part of your Saturday morning ritual, picking up eggs from your egg lady and mushrooms from the mushroom man—because you heard he has chanterelles, and you've decided that this year you're finally going to try them—when something catches your eye. It's a beautiful little apple, with gold freckles and a funny shape. It's perfectly imperfect, and it reminds you of an apple you had once before a long time ago. You buy it. You take a bite, and it transports you back to that moment. That moment when all you cared about in the world was this apple that tasted unlike anything else you'd had before, this apple that opened your eyes and your mouth and your kitchen to a world of good food. This apple that started the first of many friendships. This apple that has taken ninety years of roots mixing with earth just to come into this world to feed you. This apple that's dripping juice all down your chin in the middle of the market but you don't even care because it is *that* good.

This is what eating seasonally is all about. It is about creating community. It is about respecting nature and letting *it* choose what time of year is best for eating a strawberry or a turnip. It is about building moments with food year after year, ones that you can look forward to and think back on when the calendar goes round again. It is about feeling the change of the seasons within you, and enjoying how your body begins to crave exactly what the earth is offering up to you at that precise moment. Most of all, though, it is about food. A love of food. Of sharing food, of good food, and, most of all, of eating food. The best food doesn't come from the best cooks. The best food comes from the best people. People who love to eat.

I have listed some of the many reasons for eating seasonally below, and I hope that they, along with the rest of this book, encourage you to enjoy the awe-inspiring variety of foods that nature's calendar provides us with each year.

It Tastes Better. When food is harvested out of season, it is picked when it is unripe and then is either gassed to ripen it artificially or expected to ripen during the shipping process. These fruits and vegetables lack the complex natural sugars and flavors that develop when food is allowed to ripen on the vine and continues to receive nutrients from the soil and sun through the plant's circulation system, ensuring a delicious, nutritious, and flavor-packed food source. The contrast in flavor between an in-season, completely ripe tomato versus an out-of-season, rock-hard one is like eating two totally different types of food.

It Reduces Carbon Emissions. When food is shipped from faraway places, it needs to be transported on some kind of a vessel. Whether that be a ship, truck, or train, the transportation vehicle ends up emitting carbon dioxide into the air, and the longer the distance the food needs to travel, the greater the amount of polluting emissions. When you buy locally grown and sourced ingredients, though, you cut down on these transportation emissions considerably.

It Reduces Pollutants in the Water Supply. When you try to grow a plant outside of its normal growing season, you're going against the plant's naturally evolved defenses. All the defenses a pea has built up become useless if you try to grow it in a greenhouse in the winter. Growing a plant outside of its season makes it more vulnerable to diseases and pests, which means more pesticides and fungicides are needed to get it to produce . . . which means more chemicals leach into the soil . . . which then leaches into groundwater . . . which can then leach into local water supplies for humans, wild animals, and fish. Then, there are the adverse health effects that plague the farm workers due to daily exposure to these chemicals. You get the point.

It Supports Your Local Economy. When you buy directly from local farms, you're supporting small businesses and families in your town. These local businesses pay taxes, which then go back into improving your local community and infrastructure.

It Looks Pretty. If none of the above are enough of a motivating factor to eat seasonally, just look at the rainbow of shapes, colors, and textures of apples at a farmers' market in autumn. It's insanely beautiful.

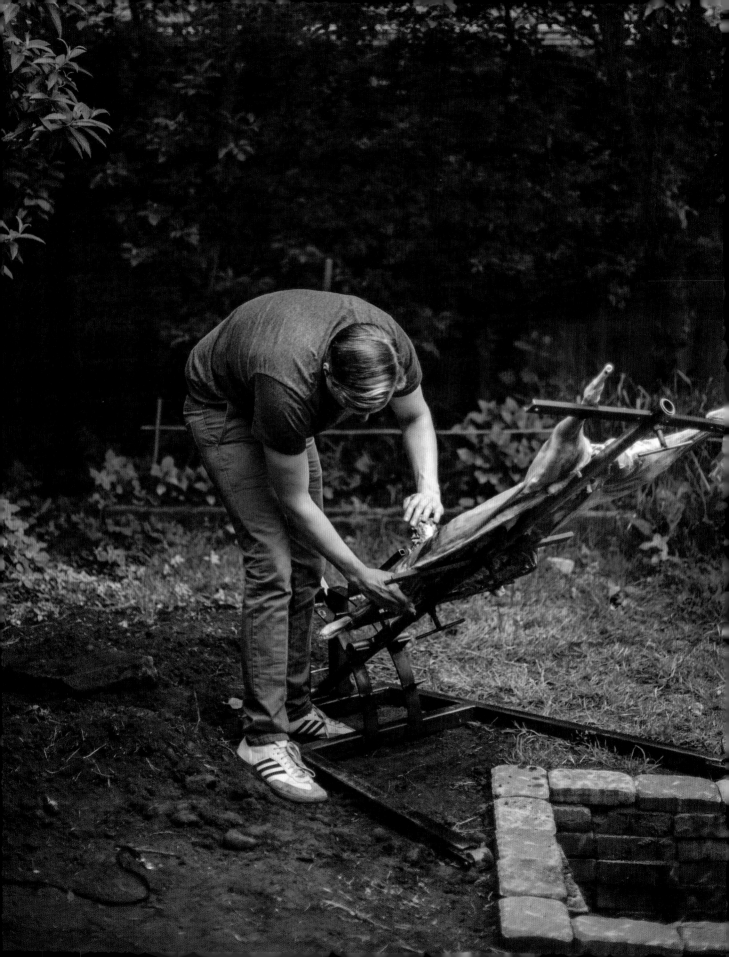

Ethically Sourcing Your Meats

—

I LOVE ANIMALS AND THE ENVIRONMENT, but I still like eating meat, so this section explores how I try to support the folks who are raising happy animals in an environmentally conscious way and slaughtering them humanely, instead of supporting the mass-market meat industry.

To preface, I am going to talk about the fact that meat comes from animals. If this bothers you, go ahead and skip to the next part. It may sound silly that I am saying this, given that your interest in ethically sourcing meat clearly means you're an omnivore. But the truth is that people can get really weird about the fact that meat comes from animals. For example, I roasted a whole lamb on an iron cross for Greek Easter and posted a picture of it cooking on Instagram. I picked up the lamb from the local farmer who raised it, slaughtered it, and sold it. I grew up seeing whole lambs roasted on Easter, so it wasn't at all unusual to me. But the Internet disagreed. I received a lot of comments about how "disgusting" and "disturbing" it was, but what I found most disturbing was that some of these folks were meat-eaters themselves, with photos of burgers and pork chops in their own feeds. How did that disconnect happen? Why is it okay to eat meat, but not see the whole animal the meat comes from?

When you go to the grocery store, you see cuts of meat lined up in neat little packages all ready to go. It's easy to distance yourself from its origins, and the fact that it was once part of a living thing. But to be a responsible meat-eater, you must come to terms with the fact that anytime you eat meat, an animal has to die. That's just how it works, folks. If you can't handle that fact when faced with it on a visual level, then perhaps you should reevaluate your stance as a carnivore. But just because an animal is destined for slaughter, that doesn't mean it should live a miserable life confined to a dirty pen with hundreds of other animals. Aside from the obvious animal welfare concerns of the current commercial meat market, there is also a lot of environmental damage caused by animals raised in these mass "meat farms." Then, there's the preservatives, hormones, antibiotics, and additives that many of the mass-produced meats contain, and that's another rabbit hole entirely. (There are many thick books out there on each of these subjects alone, so I won't attempt to chip a cube off the iceberg here. If you're interested, though, see Recommended Reading on page 297.) So if you want to have good, clean, wholesome meat that's raised ethically, these are my two tried-and-true methods.

1. *PURCHASE A WHOLE ANIMAL DIRECTLY FROM THE FARM.* This means that you buy either a whole or a part of a large animal direct from a farmer that has it slaughtered for you, and then you pick up all the cuts of meat at once and store them in a large freezer, where they will remain until you eat them all. Most farms allow you to buy a quarter, half, or whole cow and a half or whole hog. I source my beef and pork from Champoeg Creamery here in Oregon, and I love it because Charlotte (my meat lady) has me call the butcher who will be working on my order, and I get to decide what cuts I want, any organs I want to keep, or bones I might want for stock. I also love

2. JOIN A MEAT-BUYING CLUB OR CSA.

I am currently a member of a poultry-buying club through Marion Acres—a poultry and hog farm in my hometown of Hillsboro, Oregon. I filled out a form on their site telling them the number of chickens I'd like to pick up, selected a few pickup dates off their calendar, and that was it! I simply show up to the pickup point, and they have the number of chickens I requested ready for me. I know that the chickens I get from them are pasture-raised and enjoy having the sun on their backs and eating all the little bugs and green grass they can find. I also know Geoff and John by name and that I'm supporting their families by purchasing from them.

I also highly recommend visiting the farm that you're going to be buying from. Pretty much every farm that is raising animals in an ethical way will be fine with it, if not excited about the fact that you want to see the animals in person. Ask them about it first, of course (farmers are very busy, and they need a heads-up!), but most of them will be happy to meet you in person.

AND ONE MORE NOTE: Some of the recipes in this book, namely the ones for stock, call for animal ingredients that you may not be familiar with using, like pork feet or chicken heads. I know it seems scary at first, if you're not used to handling these things, but know that you are helping put good, quality ingredients to use that are often otherwise discarded. Yes, at first, it is kind of weird seeing a little chicken head look up at you from a pot of boiling water. But once you taste the stock, and see all the flavor it can impart into a dish, you'll be pleased that you took the dive. As far as sourcing these odds bits of animals, many farms that raise animals for slaughter have lots of these kind of less-popular pieces on hand, and many smaller, more artisanal butcher shops will be able to source them for you, too. I recommend finding a source that has several pounds of whatever it is that you're looking for, buying a big batch of bits once or twice a year, and keeping them in your freezer, where you can pull them to replenish your stock, as needed.

it because I can ask Charlotte all sorts of questions about how the animals are raised, and she actually knows the answers. I know that she moves her cows to fresh pasture every twelve hours, that they're grass-fed, and that they supplement with hay in the wintertime, when the grasses aren't as prolific as they are in the summer. There is no way I'd be able to get this information buying a pack of meat at the grocery store. As far as the freezer goes, I have a 32 by 37 by 21-inch (82 by 94 by 53-cm) chest freezer that fits a quarter of a cow with extra room to spare. If you don't have the space for a chest freezer, you can definitely fit it in a normal refrigerator freezer if you go in on an order with friends and split the quarter cow or half hog between you. Cost-wise, buying an animal this way ends up being about the same cost per pound as purchasing organic ground meat (the cheapest cut) at the supermarket. But this way, you have delicious tenderloins and ribs and roasts in addition to the ground stuff, and it ends up being a much better deal to cut out the middleman and buy in bulk directly from the farm itself.

Staple Ingredients

—

FLOUR

I use King Arthur Flour bread flour for every recipe in this book that calls for flour, unless otherwise noted. It has a higher protein content than their all-purpose flour, and I find that it gives baked goods a richer golden hue and a wonderful crumb.

SUGAR

My go-to for granulated sugar is Wholesome organic sugar. It is not as stark white as the bleached granulated sugars out there, but that's okay. The soft beige of this sugar is actually the natural color of processed cane sugar; the other stuff is just bleached to be that stark white color we think of as normal for sugar. I like the organic one because it has a stronger sugarcane flavor, and I know that it was grown using organic farming methods.

SALT

I use Jacobsen Salt Company pure kosher sea salt anytime my recipes call for flake kosher salt in the book. I love the consistency of this salt, because it does have a wonderful flake to it that crunches when you bite down on it, but it isn't so big that it makes it tricky to measure it correctly. I buy it in a big, cost-effective 2-pound (950 g) box and keep it in the pantry, refilling the salt cellar on my kitchen countertop, as needed. If you're unfamiliar with a salt cellar, it's basically a small bowl or jar that you store your salt in and leave on the countertop at all times for easy access. I highly recommend getting one.

OLIVE OIL

I use California Olive Ranch's Everyday blend for every recipe in this book that calls for extra-virgin olive oil. First, I love that I'm supporting a U.S. business that works directly with small farmers who are passionate about what they do. And second, the quality is unreal. They have a variety of different olive oil blends based on the flavor profiles of the different olives they use, and they're all delicious. You can even deep-fry with their olive oil, because it isn't adulterated with other oils like many imported olive oils are nowadays, and the quality of California Olive Ranch's flavor, texture, and processing methods is very high. You know you have a great olive oil when there's a little dusting of deliciously cloudy olive sediment at the bottom of the bottle.

BUTTER

Hands down, my favorite butter in the world is Vermont Creamery cultured unsalted butter. It has a higher butterfat content than any other butter in the commercial marketplace, making for extra-flaky crusts and even richer meals. It can be hard to find at grocery stores on the West Coast, though, so if you're looking for a different butter option, my second choice is Tillamook's unsalted butter. The cows from this creamery are raised here in Oregon in the town of Tillamook and make some of the tastiest butter this side of the Mississippi.

CRÈME FRAÎCHE

I'm going to mention Vermont Creamery again here, but that's just because I love them so darn much. If you've never had crème fraîche before, it's basically heavy cream that has been cultured with bacteria in the same way that you culture milk to make yogurt, but in this instance, the cream turns into a crazy thick, silky smooth, and incredibly rich substance that is unrivaled by any other in the food world. Flavor-wise, it tastes kind of similar to sour cream, but the texture is *much* smoother.

GARLIC POWDER

This is my savory recipe secret weapon; it just adds a little bit of umami and richness that no other seasoning I've come across can supply, and you can learn how to make it yourself on page 27.

Homemade Pantry Basics

—

THESE INFUSED INGREDIENTS ARE meant to add extra flavor to your everyday cooking adventures and help you jazz up the recipes that you're already comfortable making. They consist of pantry staples like salt, sugar, and butter, as well as some not-so-typical condiments that are staples in my kitchen and that I recommend making a part of your pantry, too! Some of the recipes in this book specifically call for these items, and with those that don't, you can feel free to sub in a flavored ingredient for a little extra kick—for example, using the Garlic and Bay Leaf Salt in a savory recipe that just calls for plain ol' flake kosher sea salt. The following are flavor-building tools that can help you experiment with the way different tastes play off each other, and to generally heighten the flavor of your everyday dishes. Now, go and experiment!

The icons below indicate the season when you should consider making the recipes in this chapter, highlighting when the ingredients are at their peak or when the recipes might be best enjoyed. But feel free to make these items any time of year if the mood strikes.

 Spring Autumn

 Summer Winter

FLAVORED SALTS

I love salt. It gives food depth and that extra-tasty oomph. I like using homemade flavored salts because 1) they are a fun way to add some new tastes into the mix, 2) they're an awesome way to preserve seasonal flavors, and 3) they can stretch out the flavors of expensive ingredients and make them go further.

Chive Blossom Salt
Makes about 1 cup (268 g)
This salt preserves the wonderfully mild green onion flavor that chive blossoms have while creating a gorgeous salt with little purple flowers mixed in that's awesome for adorning dishes like salads or steaks.

> 10 chive blossoms
> 1 cup (268 g) flake kosher sea salt

—Separate the individual chive blossoms and place them in a bowl with the sea salt. Stir to evenly distribute the blossoms throughout the salt and pour into an 8-ounce (240-ml) jar. Seal and store in a dark place for 2 weeks before using. The salt will keep in the jar in a cool, dark place for up to 2 years.

Garlic and Bay Leaf Salt
Makes about ½ cup (134 g)
This is the most versatile of my homemade salts. I put it on roasted vegetables, hamburger patties, salads, soups, and so on. It just takes anything savory up a notch.

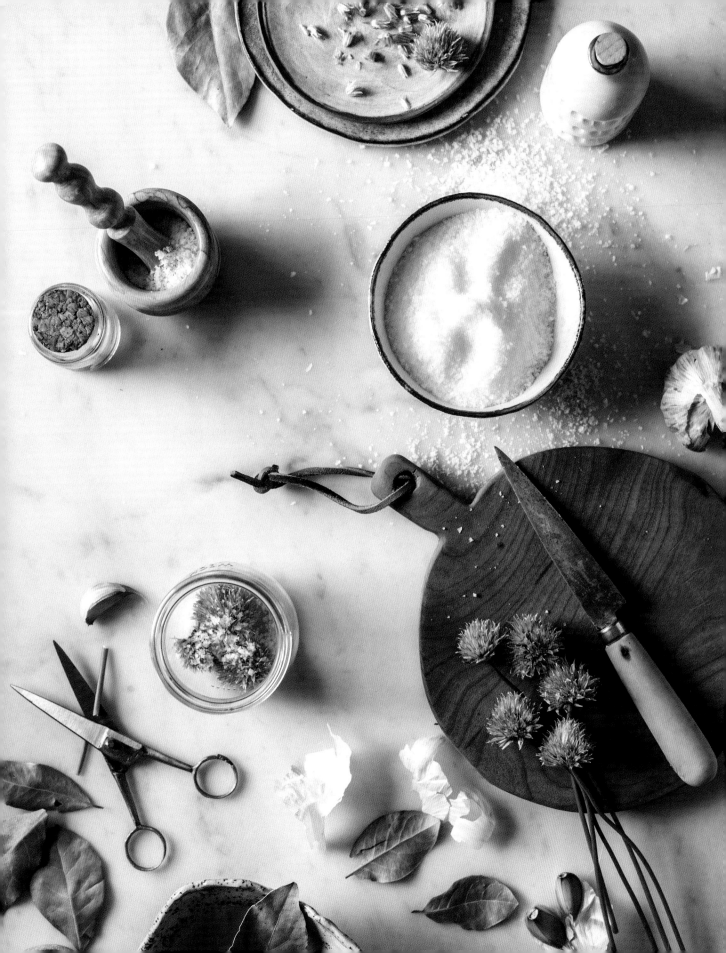

5 garlic cloves, minced

½ cup (134 g) flake kosher sea salt

3 dried bay leaves, pulsed in a blender until finely crumbled

—Preheat the oven to 200°F (90°C). Line a baking sheet with parchment paper. Using a mortar and pestle, blend the garlic, salt, and bay leaves together until the garlic is crushed and evenly distributed throughout the salt mixture. Spread on the prepared baking sheet and bake for 50 minutes.

—Allow to cool before breaking the salt blocks off the baking sheet. You can crumble them by hand for a coarse-textured salt, or pulse them in a blender or food processor for a fine-textured salt. Store in an airtight container. Best if used within 1 year.

Saffron Salt ⓨ ⊙ ⊙ ❀

Makes about ½ cup (134 g)

I love using this salt to impart the exotic, warm, and slightly floral flavor that is entirely unique to saffron. The saffron also turns the salt an amazing shade of

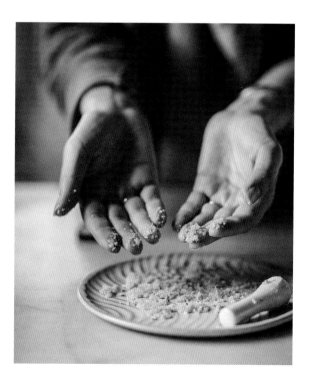

yellow when it's fresh, and since saffron is expensive, it helps make a little of this pricey ingredient go much further.

½ cup (134 g) flake kosher sea salt

½ teaspoon loose saffron threads

¾ teaspoon filtered water

—Using a mortar and pestle, blend together the salt, saffron, and water until the saffron threads are broken into small pieces and the entire mixture is yellow, 2 to 3 minutes. Spread the mixture out onto a large, flat plate and allow to dry at room temperature for 6 hours before storing in an airtight container. Best if used within 1 year.

INFUSED SWEETENERS

There's so much more to the world of sweeteners than just sugar (although straight-up sugar is admittedly tasty stuff), and I love experimenting with infusing my favorite flavors into the wide variety of sweet-tooth fuels out there. I have recipes for infused granulated sugar, honey, and maple syrup below, but other sweeteners I'd recommend experimenting with are agave, coconut/palm sugar, blackstrap molasses, date sugar, maguey sweet sap, and brown rice syrup. If you want to dive into experimenting with infusions, I recommend using dried ingredients rather than fresh ones so you don't have to worry about the moisture in fresh ingredients causing food spoilage.

Chipotle Honey ⓨ ⊙ ⊙ ❀

Makes about 2¼ cups (540 ml)

This is based on my favorite condiment from my go-to taco stand in Los Angeles, Hugo's Tacos. This stuff drizzled on carnitas is like riding a rocket to heaven.

5 whole dried chipotle peppers, halved lengthwise, stemmed, and seeded

2 cups (480 ml) honey

—Put the peppers in a 16-ounce (480-ml) mason jar. Pour the honey into the jar until the peppers are completely submerged. Seal the jar and store at room temperature out of direct sunlight for 3 weeks, shaking the jar once every week.

—Pour the mixture into a blender or food processor and pulse until the peppers are broken into small pieces but not completely pureed. Pour the mixture back into the jar and seal. Store at room temperature out of direct sunlight. Best if used within 1 year.

Rosemary and Vanilla Bean Maple Syrup

Makes about 3 cups (720 ml)

This is what to use if you want your pancakes to be as addicting as heck. The combination of warm maple, herbal rosemary, and floral vanilla creates the ultimate complement to any pastry, breakfast-related or otherwise.

> 1 vanilla bean pod, split lengthwise
> 2 tablespoons dried rosemary
> 3 cups (720 ml) grade-A dark or amber pure maple syrup

—Use a blunt butter knife to scrape the vanilla bean seeds into a 24-ounce (540-ml) jar; toss the scraped vanilla bean pod in there as well. Add the rosemary and maple syrup and seal the jar. Refrigerate for 3 weeks, shaking the jar twice a week. After 3 weeks, you can strain out the vanilla and rosemary and reserve the maple syrup, or just leave them in the syrup to allow the flavors to intensify over time, straining it as you use it. Keep refrigerated. Best if used within 1 year.

DRIED HERBS AND SPICES

Drying your own herbs is one of the easiest ways to enjoy the herbs from your garden all year long, regardless of the weather. It will also save you a ton of money over time, too, since one flourishing rosemary shrub can make buckets of dried rosemary in a season, if properly maintained. You can dry them three different ways: air-drying (this takes the longest but keeps the freshest flavor), dehydrating them in a dehydrator (this takes a shorter amount of time and preserves the flavor fairly well), or drying them in the oven at a low temperature (this is the shortest method but reduces the flavor intensity, and there is a greater risk of accidentally burning the edges of the herbs). Each method has its own advantages and drawbacks—my personal favorite is air-drying, but feel free to try what works best for you.

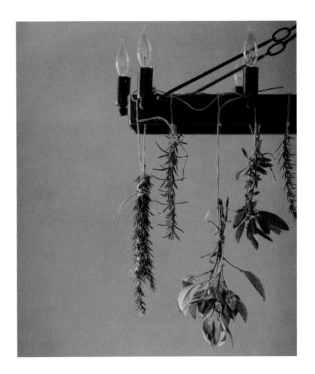

Dried Rosemary

Makes about ¼ cup (9 g)

This method works for other herbs, but the cooking time will vary. The thinner the herb leaf, the shorter the cooking time.

> 6 (6-inch/15-cm) sprigs fresh rosemary

—Rinse the rosemary, then shake it gently to rid it of excess water, and pat it completely dry with a clean, absorbent dish towel or paper towels.

—To **air-dry,** bundle the rosemary in groups of three sprigs and use twine to hang the bundles upside down

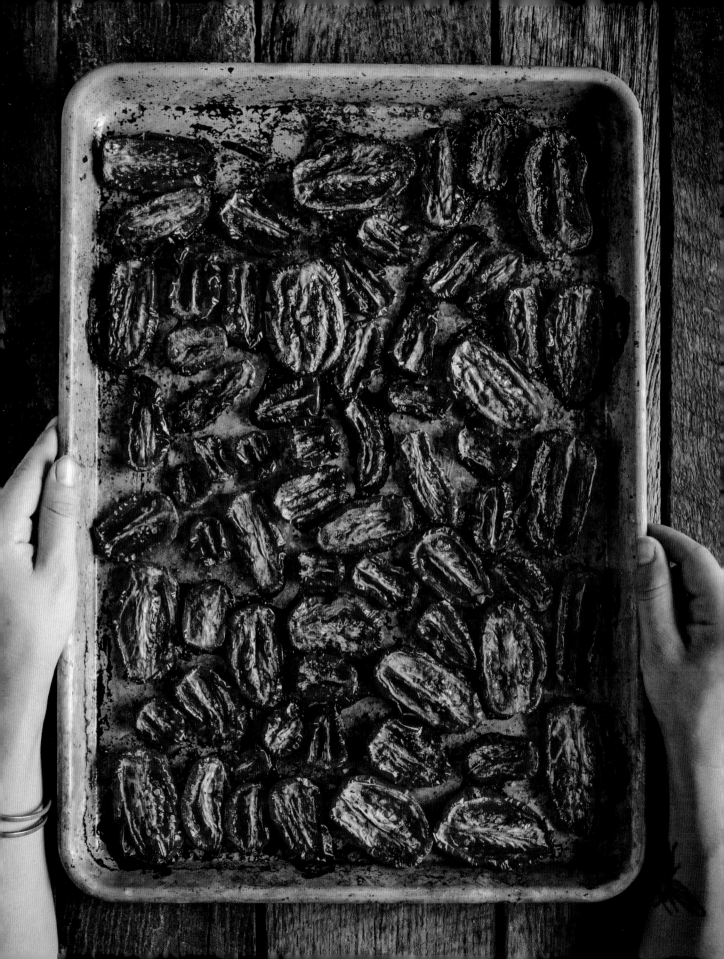

by their base in an area of your home without direct sunlight and with good air circulation until they are completely dry and some of the needles have begun falling off. The number of days will depend on the temperature and humidity of your home, but give them at least a week of drying before checking them.

—To dry them in the **oven**, preheat the oven to 175°F (80°C). Line a baking sheet with parchment paper. Remove the rosemary leaves from the sprigs and spread them in an even layer on the baking sheet. Bake until dry but still somewhat green, about 1 hour 30 minutes, stirring every 30 minutes to ensure even drying.

—To dry them in a **dehydrator**, preheat the dehydrator to 95°F (35°C). Place the rosemary sprigs on the dehydrator tray in an even layer with each sprig barely touching the one next to it. Dehydrate until dried but still somewhat green, 6 to 8 hours.

—Once the sprigs are dried, hold each sprig over a bowl and clamp the sprig at the top between your thumb and forefingers and pull down to the bottom of the sprig, knocking off all the rosemary needles as you do so. Repeat with all the sprigs, discarding the stripped sprigs.

—You can either leave the rosemary needles whole, or pulse them in a food processor or blender to your desired fineness. Store the dried rosemary in an airtight jar out of direct sunlight. Best if used within 1 year.

Garlic Powder

Makes about 3 tablespoons

Garlic powder is my secret weapon when it comes to savory foods. It boosts the overall umami-ness of the meal without giving it a spicy garlicky flavor the way raw garlic does. It's also great as a salt substitute for those on low-sodium diets since it gives that savory element to dishes without the negative health effects.

1 garlic bulb, cloves separated and peeled

—Preheat the oven to 175°F (80°C). Line a baking sheet with parchment paper.

—Very thinly slice the garlic and place the slices on the baking sheet, making sure the slices don't touch one another. Bake until the garlic slices are completely dry and snap in half rather than bend when you fold them, 2½ to 3½ hours, depending on the thickness of the slices.

—Remove from the oven, allow to cool to room temperature, and transfer to a blender or food processor; pulse until finely ground. Store in an airtight container out of direct sunlight. Best if used within 1 year.

Roasted Tomatoes

Makes about 1¼ cups (240 ml)

I like to roast tomatoes for a few reasons. First, evaporating the water inside them reduces their size and makes it easier to fit more of them in a container before I freeze them for later use. Second, roasting caramelizes the sugars within ripe tomatoes, creating a delicious sweet and tangy flavor. And third, it helps break down the structure of the tomatoes, which helps them disintegrate faster when tossed into soups, sauces, or stews, reducing the overall cooking time of whatever I happen to be making with them. This and the Tomato Sauce below are how I process the vast majority of the tomatoes from my garden that aren't eaten fresh.

1 pound (455 g) Roma (plum) tomatoes, halved lengthwise

2 teaspoons extra-virgin olive oil

½ teaspoon flake kosher sea salt

¼ teaspoon freshly cracked black pepper

—Preheat the oven to 375°F (190°C).

—Set the tomatoes on a baking sheet, cut side up. Rub the cut sides with the oil and sprinkle with the salt and pepper. Roast until the tomatoes have reduced in size by half, are a bit wrinkly, and have turned a deep, dark red, 40 minutes to 1 hour, depending on the size of the tomatoes—smaller tomatoes will have a shorter cooking time.

—Remove and allow to cool to room temperature.

Leave the tomatoes whole to add to soups and stews for a bit of tomato flavor, as needed, or transfer them to a food processor or blender and puree to make a roasted tomato concentrate that is excellent when added to soups, stews, and spreads and can be subbed in for tomato paste.

—The puree can be frozen in an airtight freezer-safe container to use later on. I recommend lining a baking sheet with parchment paper and using a ¼-cup (60-ml) scoop to measure out the pureed mixture onto the baking sheet, leaving about 1 inch (2.5 cm) between each mound. Freeze for at least 4 hours or overnight. Once the puree portions are frozen solid, transfer them to an airtight freezer-safe container and store in the freezer for up to 1 year.

—The whole roasted tomato halves can also be frozen for later use. Transfer them to a baking sheet lined with parchment paper and freeze. Once the individual roasted tomatoes are frozen, transfer them to an airtight freezer-safe container and store in the freezer for up to 1 year. This will make it easier to grab just a couple of them rather than needing to thaw out dozens at once if you only want to add a couple.

Tomato Sauce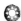

Makes about 1 quart (960 ml)

I keep my tomato sauce pretty simple, because the flavors of the ripe tomatoes are all that really matter here. There's a bit of garlic, basil, and oregano for some herbal and umami elements, but they're just a complement to the sweet, tangy, and robust garden-fresh tomatoes. I highly recommend getting yours from a farmers' market if you don't grow your own. If you get them from the supermarket, try to get the heirloom ones, since they're usually riper and softer than the plain red hothouse ones. If you have ripe seasonal tomatoes, you won't need to add sugar to this sauce, but if they aren't super-juicy or saturated inside when you cut them open and the sauce tastes slightly too acidic, you'll need to add a teaspoon or two of sugar to balance it out.

¼ cup (60 ml) extra-virgin olive oil

4 garlic cloves, minced

3¼ pounds (1.5 kg) fresh slicing or Roma (plum) tomatoes, cored and halved or quartered

3 tablespoons chopped fresh basil leaves

¾ teaspoon dried oregano

¼ teaspoon freshly cracked black pepper

Flake kosher sea salt

2 teaspoons sugar (optional)

—Heat the oil in a medium Dutch oven over medium-low heat. Add the garlic and cook, stirring, until the garlic is very fragrant and lightly browned around the edges, 4 to 5 minutes, stirring every minute.

—Add the tomatoes and ¼ cup (60 ml) water and raise the heat to medium. Once it reaches a boil, reduce the heat to low and cook, uncovered, until the sauce has reduced by half and the tomatoes have completely disintegrated, 50 to 60 minutes, stirring every 5 minutes at first to help the tomatoes disintegrate and every 10 to 15 minutes after that, breaking the tomatoes apart with the end of the spoon as they cook.

—Remove from the heat and stir in the basil, oregano, and pepper. Season with salt and add the sugar, if needed.

—Store in an airtight container in the refrigerator for up to 10 days. You can also transfer the sauce to an airtight freezer-safe container and freeze it for later use. Will keep in the freezer for up to 1 year.

QUICK PICKLES

These recipes aren't meant for long-term storage of produce, but rather for easy and low-stress homemade pickled veggies. They give you the awesome tangy flavor and crunch of freshly pickled foods without the anxiety of properly pickling something in a sterile-enough environment to last several years in the basement. Each of these recipes takes less than fifteen minutes to make, keeps for about two months in the refrigerator, and

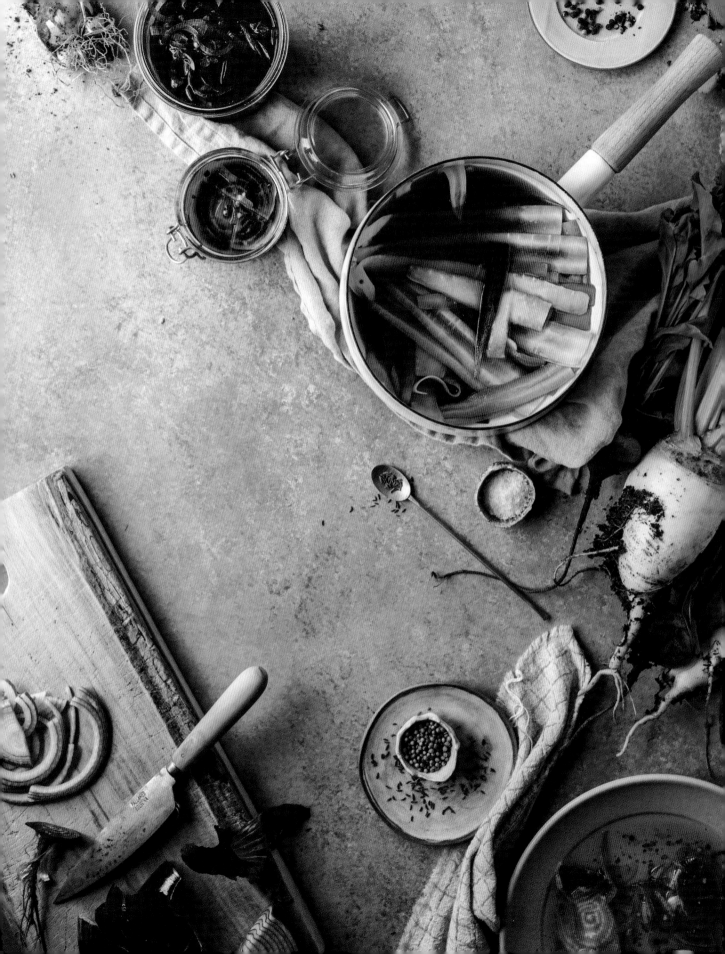

packs a delicious and tart flavor that adds a wonderful tanginess to a wide variety of dishes. If you like, you can substitute other vegetables for those listed in the recipes below to try out various types of quick pickles; just make sure to stick to the same weight as the recommended vegetable so the proportion of brine to veggies stays consistent.

Quick-Pickled Onions

Makes about 1½ pints (720 ml)

These are a must-have for summer grilling season. I love putting them on hamburgers, tacos, and grilled corn salads for a little extra tang and color. The texture of the onions softens considerably when they're pickled, though, so just be aware that the texture won't be as firm and crunchy as a raw onion, but rather flexible and floppy like a cooked onion would be.

> 1½ cups (360 ml) red wine vinegar
>
> 1¼ teaspoons sugar
>
> 1¼ teaspoons flake kosher sea salt
>
> ½ teaspoon caraway seeds
>
> ½ teaspoon whole black peppercorns
>
> 1 large red onion (about 11 ounces/310 g), thinly sliced

—In a medium saucepan, combine the vinegar, sugar, salt, caraway seeds, and peppercorns and bring to a boil over medium heat. Add the onion and simmer until the onion softens slightly, about 5 minutes. Pour the mixture into a quart-size (945-ml) glass container and allow to cool to room temperature before covering and refrigerating. Will keep in the refrigerator for up to 2 months.

Quick-Pickled Beets

Makes about 1½ cups (360 ml)

I have a recipe on my blog for barbecue pulled pork buns with pickled beets, and that's still my number-one favorite way to enjoy these guys. But they're also great in salads, deli sandwiches, and ceviche.

> 1 cup (240 ml) white vinegar
>
> 1 medium shallot, thinly sliced
>
> 1 teaspoon flake kosher sea salt
>
> 1 teaspoon whole black peppercorns
>
> ½ teaspoon sugar
>
> ¼ teaspoon red pepper flakes
>
> 1 small beet (about 4 ounces/115 g), peeled and thinly sliced

—In a medium saucepan, combine the vinegar, shallot, salt, peppercorns, sugar, and red pepper flakes and bring to a boil over medium heat. Add the beet and cook for 4 minutes. Pour the mixture into a pint-size (480-ml) glass container and allow to cool to room temperature before covering and refrigerating. Will keep in the refrigerator for up to 2 months.

Quick-Pickled Carrots

Makes about 1½ cups (360 ml)

Pickled carrots are awesome condiments for any sort of Southeast Asian recipe like *bánh mì* sandwiches, pho, or pad thai. You can leave them in long shavings or dice them into smaller bite-size pieces prior to serving.

> 1 cup (240 ml) distilled white vinegar
>
> 1 teaspoon sugar
>
> 1 teaspoon flake kosher sea salt
>
> 1 teaspoon coriander seeds
>
> ½ teaspoon whole black peppercorns
>
> 1 garlic clove, thinly sliced
>
> 5 ounces (140 g) carrots, julienned

—In a medium saucepan, combine the vinegar, sugar, salt, coriander seeds, peppercorns, and garlic and bring to a boil over medium heat. Add the carrots and cook for 5 minutes. Pour the mixture into a pint-size (480-ml) glass container and allow to cool to room temperature before covering and refrigerating. Will keep in the refrigerator for up to 2 months.

PRESERVED LEMONS

Preserved lemons are a staple in many Middle Eastern countries, and for good reason. They add a tangy, complex quality to dishes that plain old lemons just can't compete with, and the flavor in the rinds of the lemons becomes so concentrated that you only need a little bit of the minced rind to impart the same flavor that an entire fresh lemon's worth of zest would. I've always had a mild obsession with the flavor combination of lemon and vanilla. It creates a slightly sweet and still very salty concentrate of lemon and warm, floral vanilla. Another favorite is preserved lemons that have a little bit of a kick to them in the form of a hefty dose of black pepper. These are great in Mediterranean recipes, especially ones where lamb is involved. Finally, I love using the fennel and coriander version in salads and dressings, in particular. Something about the bright fennel flavor and the herbal coriander really harmonizes well with the lemon and gives even the simplest salad a huge boost of flavor.

Preserved lemons are a great addition to any dish in which you would normally use lemons, so things like salad dressings, marinades, cakes, seafood, and roasts are your best bets for these guys. I reference them in recipes throughout the book, usually calling for the rind, but sometimes for the juice. To chop the rind, remove the lemon from the jar and peel the fruit off of it (it will just slip right off), then chop the desired amount of rind. To get the juice, just stick a little spoon into the jar and snag some of that salty, tangy liquid. As the preserved lemons rest, the juice will become thick in texture, like a syrup.

Flavorful Preserved Lemons
Makes 3 or 4

> 3 or 4 organic lemons (enough to fit snugly into a pint-size/480-ml mason jar)
>
> Flake kosher sea salt
>
> *VANILLA BEAN*
> 1 vanilla bean, split lengthwise and seeds scraped out
> 4 tablespoons sugar, plus a few pinches
>
> *PEPPERCORN*
> 1 tablespoon crushed black peppercorns
>
> *FENNEL AND CORIANDER*
> 2 teaspoons coriander seeds
> 1 teaspoon finely chopped fennel fronds

—Wash the lemons well. Cut them as if you're cutting them into quarters, but stop ½ inch (12 mm) before you reach the bottom on one end so that all the quarters are still attached at the base of the lemon.

—For the vanilla bean preserved lemons: Rub the vanilla bean seeds inside the lemons. Then rub the interior generously with salt and a pinch of the sugar and reshape them into whole lemons. Pack 1 inch (2.5 cm) of salt plus 1 tablespoon of the sugar into the bottom of a pint-size (480-ml) mason jar, place one of the lemons in it, and pack salt around the lemon, filling in any gaps between the lemon and the wall of the jar with salt. Cut the vanilla bean pod in half. Place one of the pieces in the salt next to the lemon. Once the salt has nearly covered the lemon, add another tablespoon of the sugar and another lemon, pack it with salt and a piece of vanilla bean pod, and repeat until the jar is completely packed with lemons, salt, vanilla bean pods, and the remaining sugar.

—For the peppercorn preserved lemons: Rub the interior of the lemons generously with the salt and ½ teaspoon of the peppercorns and then reshape them into whole lemons. Pack 1 inch (2.5 cm) of salt and a few peppercorns into the bottom of a pint-size (480-ml) mason jar, place one of the lemons in it, and pack in salt and more peppercorns around the lemon, filling in any gaps between the lemon and the wall of the jar with salt. Once the salt has nearly covered the lemon, add another lemon, pack it with salt and peppercorns, and repeat until the jar is completely packed with lemons, salt, and peppercorns.

—For the fennel and coriander preserved lemons: Rub the interior of the lemons generously with the salt, ¼ teaspoon of the coriander, and a pinch of the fennel fronds and then reshape them into whole lemons. Pack 1 inch (2.5 cm) of salt, a few coriander seeds, and a pinch of fennel fronds into the bottom of a pint-size (480-ml) mason jar, place one of the lemons on it, and pack in salt and more coriander seeds and fennel fronds around the lemon, filling in any gaps between the lemon and the wall of the jar with salt. Once the salt has nearly covered the lemon, add another lemon, pack

it with salt, coriander, and fennel fronds, and repeat until the jar is completely packed with lemons, salt, coriander, and fennel fronds.

—You really want to pack the lemons in there so that they're crushing each other and releasing their juices. Seal the jar tightly and shake it for 10 seconds. Set it aside at room temperature out of direct sunlight for 3 to 4 weeks, shaking it for a few seconds once per day.

—To use, cut off the desired amount of preserved lemon and rinse it thoroughly. The rinds are wonderful finely chopped in dishes for a burst of lemon flavor and are also delicious in stews and sauces. The pulp is a great concentrated source of lemon flavor for sauces, stews, and soups as well, but make sure to take into account the saltiness of the pulp and adjust the salt content of the recipe accordingly.

COMPOUND BUTTERS

Compound butters are basically butter with other flavorful ingredients mixed in. As you can imagine, they're great for a wide variety of uses, but some of my favorites are simply spreading them on toast and pancakes, rubbing down a roasted whole chicken with them, and using them in buttercream icing.

Maple, Rosemary, and Sea Salt Butter 🍐 ✷ ◈

Makes about 7 ounces (200 g)
This is a great topping for any breakfast toasts or pastries in the fall and winter months. It has a very cozy vibe to it, and the salty-sweet combo that you get from the maple and sea salt is *pretty* amazing.

> 6 ounces (1½ sticks/170 g) unsalted butter, at room temperature
>
> 1 tablespoon grade-A dark or amber pure maple syrup
>
> 1 tablespoon fresh rosemary leaves, finely chopped
>
> 2 teaspoons flake kosher sea salt

—Use a mortar and pestle to combine the butter, maple syrup, rosemary, and salt until thoroughly and evenly mixed, about 2 minutes. Use the compound butter immediately or transfer it to an airtight container, seal, and refrigerate. Will keep for up to 2 weeks.

Roasted Mushroom Butter

Makes about 14 ounces (400 g)

This is a great way to put those delicious mushrooms to use year-round—I just change up the variety of the mushroom depending on the season. I like spreading it on toast and topping it with a poached egg for breakfast, incorporating it into a creamy pasta sauce, or melting it and drizzling it over roasted veggies.

- 10 ounces (280 g) mushrooms, cut in half or quartered, if large
- 2 tablespoons olive oil
- 8 ounces (2 sticks/225 g) unsalted butter, at room temperature
- 1½ teaspoons flake kosher sea salt

—Preheat the oven to 375°F (190°C). Toss the mushrooms with the oil to coat and place on a baking sheet. Roast until the mushrooms deepen in color and are slightly wrinkled, about 25 minutes, depending on the size of the mushrooms.

—Combine the mushrooms, butter, and salt in a blender or food processor and blend until smooth, stopping to scrape down the sides of the container, as needed, to ensure that everything combines thoroughly.

—Use the compound butter immediately, or transfer it to an airtight container, seal, and refrigerate. Will keep for up to 2 weeks.

Oregano, Lemon, and Black Pepper Butter

Makes about 7 ounces (200 g)

I love using this butter as a coating on chicken thighs before roasting them. It's also great melted and brushed onto pita bread to serve alongside hummus, or spread on little baguette slices and topped with crumbled feta as a quick and easy appetizer. Or, you know, just eating it with a spoon . . .

- 6 ounces (1½ sticks/170 g) unsalted butter, at room temperature
- 2 tablespoons finely grated lemon zest
- 1 tablespoon dried oregano
- 1 teaspoon freshly cracked black pepper
- 1 teaspoon flake kosher sea salt

—Use a mortar and pestle to combine the butter, lemon zest, oregano, pepper, and salt until the ingredients are thoroughly and evenly mixed, about 2 minutes. Use the compound butter immediately, or transfer it to an airtight container, seal, and refrigerate. Will keep for up to 2 weeks.

Chocolate-Orange Butter

Makes about 8 ounces (225 g)

One of my favorite childhood Christmas memories was the chocolate orange that would inevitably find its way into my stocking on Christmas morning. You know the ones I'm talking about—with all the cute little chocolates inside shaped like orange wedges and filled with the most refreshingly decadent flavor combination ever. I decided to attempt to re-create this treat in butter form, and I definitely succeeded. I recommend using this on French toast, toasted sweet breads, pancakes, and waffles. You can serve it alongside orange marmalade for a little extra citrus kick, too!

- 6 ounces (1½ sticks/170 g) unsalted butter, at room temperature
- 2 tablespoons unsweetened cocoa powder
- 2 tablespoons honey
- 1 tablespoon finely grated orange zest

—Use a mortar and pestle to combine the butter, cocoa powder, honey, and orange zest until the ingredients are thoroughly and evenly mixed, about 2 minutes. Use the compound butter immediately, or transfer it to an airtight container, seal, and refrigerate. Will keep for up to 2 weeks.

Pork Stock

Makes 6 to 8 cups (1.4 to 2 L)

This recipe is for a very dense and rich pork stock, following the style of Japanese *tonkotsu* broth, commonly used as a base for ramen. As you cook the stock, you will need to add a bit more water to ensure that it doesn't all evaporate during the long cooking time. If you want a slightly lighter stock, you can cut the overall cooking time in half. I recommend trying to make a go of the full cooking time, though, as the flavor of the stock gets deeper the longer it cooks.

> 3 pounds (1.4 kg) pork neck bones, hocks (unsmoked), and/or feet
>
> Flake kosher sea salt

—Put the pork in a large stockpot and add 16 cups (3.8 L) water. Bring to a boil over medium-high heat. Reduce the heat to low and simmer, covered with the lid slightly ajar, for 12 hours, stirring every couple of hours. Add water, as needed, to keep the bones submerged in liquid. Alternatively, you can place all the ingredients in a large slow cooker and cook, covered, on low for 12 hours, adding water as needed to keep the bones submerged in liquid. Strain and discard the solids. Season the stock with salt and allow to cool to room temperature. The stock can be stored in airtight containers in the refrigerator for up to 2 weeks or in the freezer for up to 1 year.

Poultry Stock

Makes 8 to 10 cups (2 to 2.3 L)

This is a really simple stock that you can make with whatever poultry odds and ends you have around. If you have a turkey carcass left over from Thanksgiving, great! Toss it in there. If you've saved all the necks from your roast chickens in a freezer bag, awesome! Put 'em in the pot. You can used mixed poultry for a general poultry stock, or stick to one kind for a more distinctly turkey, chicken, or duck-flavored one. From what I've found, poultry wings, heads, and feet make the most intensely

flavorful stock because of the high concentration of skin, bone, and cartilage in them, but any part of the bird will impart that delicious buttery poultry flavor to the stock; it'll just be in varying concentrations.

> 4 pounds (1.8 kg) poultry parts, ideally bone in and skin on (for flavor)
>
> 2 large carrots (about 10 ounces/280 g), cut into 1-inch (2.5-cm) slices
>
> 2 celery stalks (about 4 ounces/115 g), cut into 1-inch (2.5-cm) slices
>
> 1 large yellow onion (about 10 ounces/280 g), chopped
>
> 3 (6-inch/15-cm) sprigs fresh thyme
>
> 1 sprig fresh rosemary
>
> 2 bay leaves
>
> 1 teaspoon whole black peppercorns
>
> Flake kosher sea salt

—In a large stockpot, combine the poultry, carrots, celery, onion, thyme, rosemary, bay leaves, peppercorns, and 12 cups (2.8 L) water. Bring to a boil over medium-high heat. Reduce the heat to low and simmer, covered with the lid slightly ajar, for 6 hours, stirring every hour. Alternatively, you can place all the ingredients in a large slow cooker and cook, covered, on low for 10 hours. Strain and discard the solids. Season the stock with salt and allow to cool to room temperature. The stock can be stored in airtight containers in the refrigerator for up to 2 weeks or in the freezer for up to 1 year.

Vegetable Stock

Makes 8 to 10 cups (2 to 2.3 L)

I like vegetable stocks with some umami flavor to them, so I always include a generous dose of mushrooms. For a richer-flavored stock, I roast the vegetables beforehand to caramelize the natural sugars within them, but you can feel free to skip that step and just use raw vegetables for a brighter, lighter-tasting stock.

> 7 ounces (200 g) shiitake mushrooms, halved
>
> 4 large carrots, cut into 1-inch (2.5-cm) slices
>
> 3 celery stalks, cut into 1-inch (2.5-cm) slices

1 leek, washed well and cut into 1-inch (2.5-cm) slices

1 large yellow onion, quartered

3 tablespoons extra-virgin olive oil

1 ounce dried porcini mushrooms (optional)

4 garlic cloves, crushed

4 sprigs fresh thyme

¼ cup (60 ml) fresh parsley leaves

2 bay leaves

1 teaspoon whole black peppercorns

Flake kosher sea salt

—Preheat the oven to 400°F (205°C).

—In a large bowl, toss together the shiitake mushrooms, carrots, celery, leek, onion, and oil until the vegetables are evenly coated with the oil. Spread the vegetables out in an even layer on a baking sheet. Roast until the vegetables have wrinkled slightly and are lightly golden around the edges, 45 to 60 minutes, stirring the vegetables every 15 minutes.

—Transfer the roasted vegetables to a large stockpot and add the porcini mushrooms (if using), garlic, thyme, parsley, bay leaves, peppercorns, and 12 cups (2.8 L) water. Bring to a boil over medium-high heat. Reduce the heat to low and simmer, covered with the lid very slightly ajar, for 6 hours, stirring every hour. Alternatively, you can place all the ingredients in a large slow cooker and cook, covered, on low for 10 hours. Strain and discard the solids. Season the stock with salt. The stock can be stored in an airtight container in the refrigerator for up to 2 weeks or in the freezer for up to 1 year.

— MENU FOR A SPRING PICNIC —

Nothing is quite as welcome as the first little green leaf that unfurls itself after a long, cold winter. In Oregon, spring is typically a very wet season, but we do get a smattering of beautiful spring days where the sun peeks out from behind the clouds and lets you know that warmer weather isn't so far away. And it's on these days that I like to spread out on a picnic blanket, surrounded by lush green leaves and the first blossoms of spring, and just soak it all in. I created a little sampler menu of some of my favorite spring bites and drinks below, and I highly recommend making a little picnic of your own.

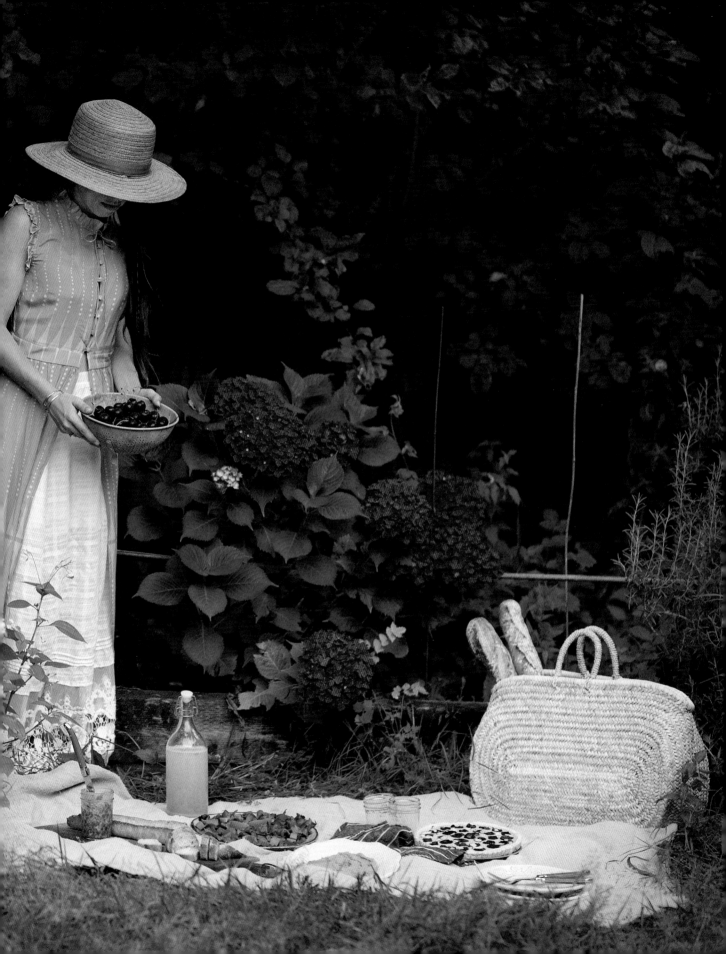

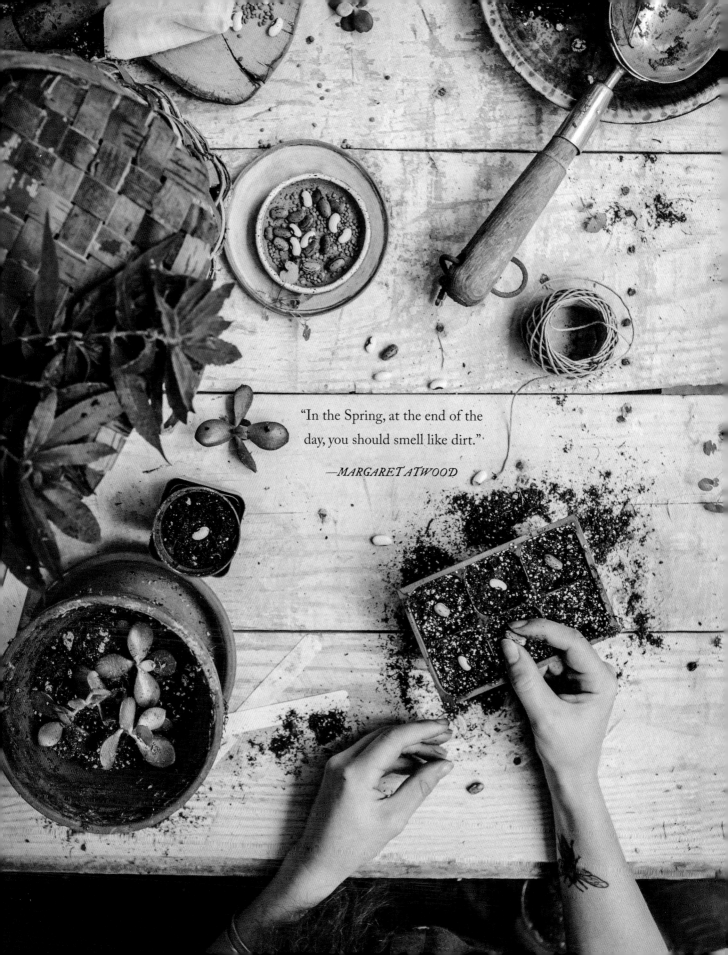

"In the Spring, at the end of the day, you should smell like dirt."

—MARGARET ATWOOD

Starting Your
Own Seeds

I'VE BEEN GARDENING FOR AS LONG as I can remember—my actual earliest memory is of being out in the yard working with my dad. When I was about three and a half, each of us three kids got to pick a seed we wanted to start in our garden. I planted a radish, my sister planted a carrot, and my little brother planted a melon of some kind. The first one to come up was my radish, and I could hardly believe that the little speck I'd dropped in the ground had actually turned into something. At first, I attributed this success to my green thumb, but after having worked with seeds and plants for many years, I know that radishes are pretty much the easiest things to grow from seed, ever. Carrots take their time to sprout, and melons need some pretty warm weather to get going. Still, this gave me confidence in the garden, and today, many years and many plants later, I always get a huge burst of excitement when I see the tip of a little green sprout start to break through the soil's surface. It's like each one is a little friend poking out to say hello! (If you weren't sure if I was a weird plant lady or not, I'm pretty sure the question has now been answered.)

Nowadays, most gardening hobbyists buy their plants from the nursery and transplant them, which is totally fine. But the varieties of plants available at most nurseries are limited, and there is a whole world of beautiful rare and heirloom fruits and vegetables out there that you can only find at various seed preservation companies and seed banks. I'm a bit of a seed hoarder and have been collecting rare heirloom seed varieties for several years now. My seed collection numbers somewhere in the thousands (it is *kinda* scary to actually type that out). With some of the heirloom varieties, you can see why they are not as popular as their more engineered counterparts (not very disease-resistant, slow-growing, or low-producing), but other heirlooms outperform the more common commercial varieties, so you never really know for sure what you're going to get in terms of production and hardiness until you give it a shot. Like all the other purchases in my life, though, I filter mine through online reviews to get a good feel about the quality of the plant before I buy my seed packets. I recommend checking out Seed Savers Exchange (www.seedsavers.org), Baker Creek Heirloom Seeds (www.rareseeds.com), and Victory Heirloom Seeds (www.victoryseeds.com), for heirloom seed purchases. They have always been high quality and reliable heirloom seed sources for me, and they have

reviews listed on their sites for each seed variety, too. Some of my favorite heirloom seed varieties are Greek Sweet Red Squash, Livingston's Golden Queen Tomato, Chris Cross Watermelon, Tongue of Fire Beans, and Casper Eggplant.

For starting seeds, I recommend using a seed-starting potting soil mix. This is a soil mix particularly blended with extra peat moss or Eco-co Coir to help the soil retain moisture and keep it light so that the small roots of the seedling can spread through it easily. Once you're ready to transplant, however, you should use a soil mix that meets the needs of the specific type of plant you're trying to grow, which you can read more about on page 101. I also recommend using a seedling heat mat, which is basically a waterproof heating pad of sorts that you plug in and set under the tray of sown seeds to keep the soil warm and increase the overall germination (sprouting) rate of the seeds. For my step-by-step planting tips, see opposite.

Getting Started

—

TOOLS
Plant stakes (Popsicle sticks work great)
Seeds
Seed-starting tray
Seed-starting potting soil mix
Watering can with a narrow spout
Gardening trowel
Seedling heat mat

—Write down the seed varieties on seed plant stakes and set them aside. Read through the sowing instructions on the seed packet to determine when is the best time of year to begin and if the seed can be started indoors. You control the conditions indoors, which is helpful, but some plants, like melons and carrots, do not transplant well. They have to be started outdoors in the place where they will grow and mature into an adult plant.

—Fill a seed-starting tray with seed-starting potting soil mix. Tap the tray down gently a couple times to help the soil settle. Water it thoroughly until liquid starts coming out the bottom of the tray, then pause and wait for a minute, and repeat three more times. The soil should now be very damp.

—Refer to the sowing instructions on the seed packet to determine how deep the seed should be sown into the soil. Strawberry seeds, for example, should just be scattered on the surface of the soil, then topped with a very thin sprinkling of soil. Beans, on the other hand, should be sown about 1 inch (2.5 cm) deep.

—Once the seeds are sown, insert the seed stakes into the side of the assigned container so you can keep track of which seeds are which. Water thoroughly once more, using a thin, gentle stream of water, because trying to water light soil like seed-starting mixes with a strong stream can actually splash and dislodge the soil and seed, disrupting the germination process. A small watering can with a very narrow spout is perfect for watering seeds.

—Place the trays on a seedling heat mat, indoors, in front of a window, with the heat mat plugged in. Water enough to keep the soil constantly moist, about once a day, increasing the frequency if it is hot and you don't have air-conditioning. The soil should never dry out while the seeds are germinating. The trays will drain water out the bottom each time you water them, so you can do it on a wire rack over a sink and allow the trays to drain for a minute before placing them back on the mat.

—Keep in mind the germination time for the seeds you are sowing before giving up on them and tossing the soil in the compost. Different types of plants germinate after different lengths of time, and some varieties, like peppers, can take several weeks to germinate.

—Once the plant has sprouted, you can take it off the germination mat, and once it has grown to the point where it has little roots poking out the bottom of the seedling tray, it is time to transplant it. If you're ready to transplant, head over to page 101 to read more.

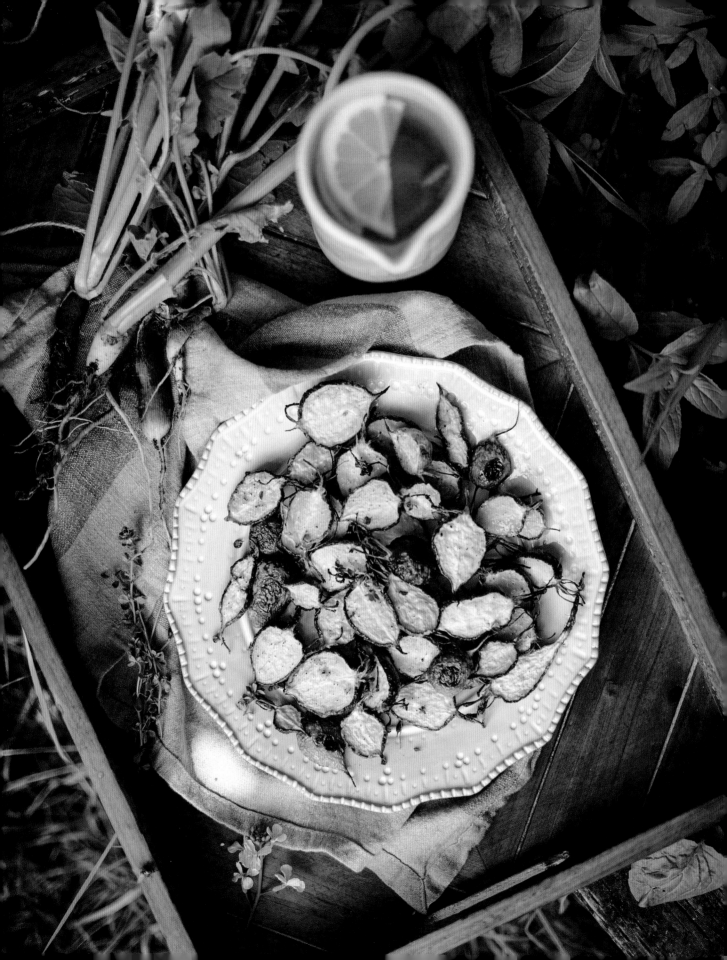

Roasted Radishes with Fresh Thyme

— Serves 2 to 4 —

This is one of my easy go-to sides for spring. It takes all of thirty minutes from start to finish, tastes great, and looks absolutely beautiful. The pink hue of the radishes deepens in the oven and the skin wrinkles slightly, giving it a lovely texture. I like to slice the radishes in half vertically, leaving a little of the green stem and root tail at each end, since those bits get extra crispy in the oven. Just make sure you've washed them well.

—Preheat the oven to 400°F (205°C).

—Cut most of the tops off the radishes, leaving 1 inch (2.5 cm) of greens. Cut the radishes in half lengthwise and toss them with the oil, salt, and pepper in a large bowl. Spread them out on a baking sheet, cut side up. Roast until the radishes begin to wrinkle and are lightly golden around some of the edges, about 25 minutes. Transfer the radishes to a serving platter, toss with the thyme, and serve.

1¼ pounds (570 g) radishes, such as Pink Beauty, Early Scarlet Globe, or Purple Plum, washed well

1 tablespoon extra-virgin olive oil

1 teaspoon flake kosher sea salt

⅛ teaspoon freshly cracked black pepper

2 tablespoons fresh thyme leaves

Green Pea Hummus with Toasted Pita

— Makes 1¾ cups (450 g) hummus —

I first made this hummus for one of my Secret Supper pop-up dinners that I co-host here in the Pacific Northwest. This particular supper was held at a beautiful guesthouse property in Hood River, and the menu was a Middle Eastern take on spring. This pea hummus, a component of an appetizer I made, was really something special. Being Greek, I like my hummus extra garlicky, so feel free to omit a clove or two if you aren't a garlic fan. If you want to go full garlic, I am giving you a mental high-five at this very moment. The spice of the garlic and the tartness of the lemon help cut through the dense, protein-rich flavor of the peas and garbanzo beans, while the cilantro provides a brightness that makes it taste insanely fresh. The best way to describe it is "concentrated spring." I know that makes it sound like a brand of bar soap but trust me: Once you try this, you'll understand what I mean.

1 cup (120 g) shelled fresh peas

1¼ cups (50 g) coarsely chopped fresh cilantro

5 ounces (140 g) garbanzo beans, drained and rinsed

3 garlic cloves, crushed

2 tablespoons tahini

2 tablespoons fresh lemon juice

2 tablespoons extra-virgin olive oil, plus more for brushing and drizzling

¾ teaspoon flake kosher sea salt

¼ teaspoon freshly cracked black pepper

8 good-quality pitas (you want to avoid dry pitas that are crumbly, or those with pockets in them)

—In a food processor or blender, combine the peas, cilantro, garbanzo beans, garlic, tahini, lemon juice, oil, salt, and pepper and puree until completely smooth. Drizzle with olive oil, for serving.

—Heat a medium skillet over medium heat. Brush the pitas with oil, then toast them in the skillet until the raised areas of the bread are lightly golden, 2 to 3 minutes per side. Serve alongside the hummus for spreading.

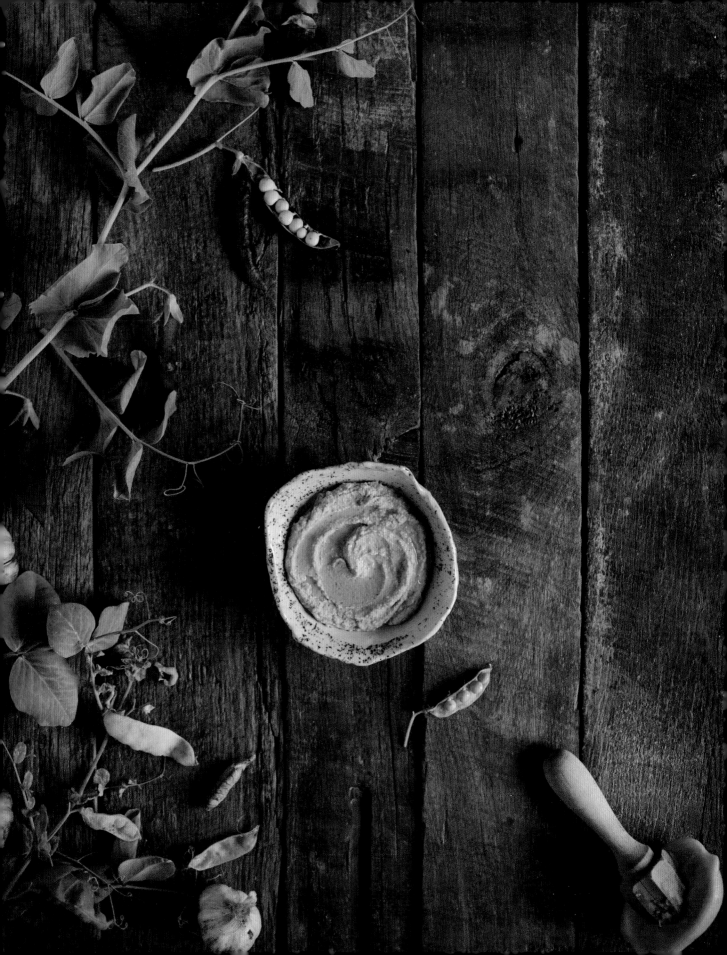

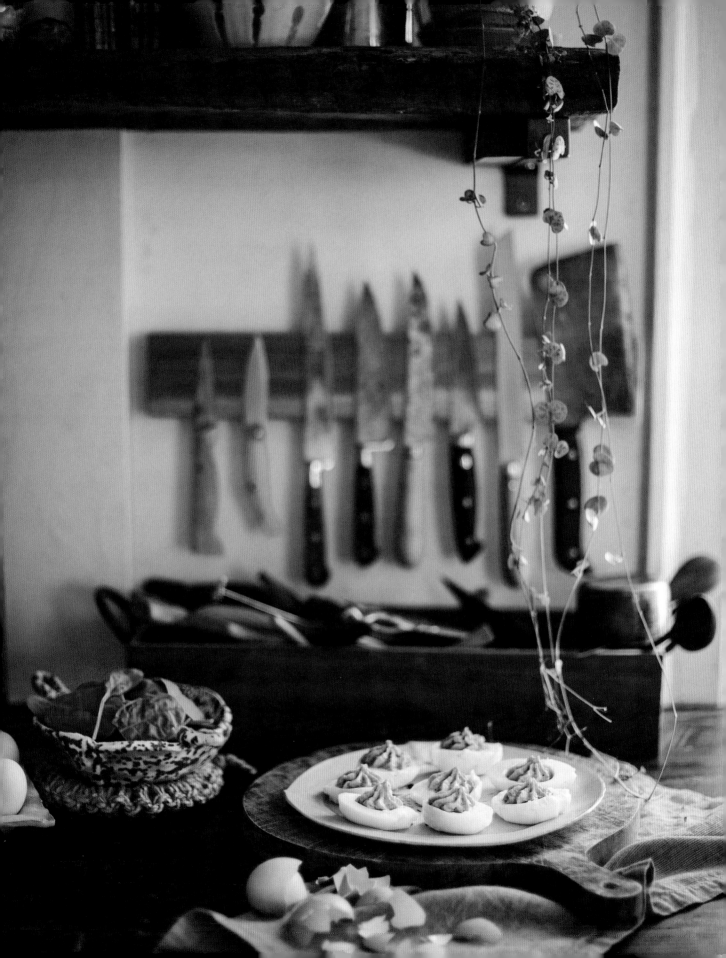

Spinach and Mustard Deviled Eggs

— Makes 12 —

Longer days mean more eggs from my feathered lady friends, and I love to make use of this bounty by making a batch of deviled eggs. I tend to like mine on the tangy side, so using vinegar-heavy mustard really kicks these guys up a notch. The tart mustard and bitter greens help make the filling a bit less rich, which means you can eat more of them, plus the green hue of the yolk mixture gives these an extra springy vibe.

—Bring a large pot of water to a rapid boil over medium-high heat. Use a slotted spoon to add the whole eggs, shell intact, to the water. Cook for 2 minutes, then turn off the heat, cover, and allow to rest for 10 minutes. While they're cooking, fill a large bowl with ice and water and set it nearby. Remove the eggs with a slotted spoon and place them in the ice bath for 5 minutes (this will make them easier to peel).

—Peel the eggs and halve them lengthwise. Use a small spoon to gently scoop out the cooked yolks; set the whites aside on a plate. Place the yolks, spinach, mayonnaise, mustard, vinegar, paprika, garlic powder, and salt in a blender or food processor and blend on high speed until completely smooth.

—Pour the mixture into a pastry bag fitted with a large star tip and pipe the filling into the center of each egg white half. Alternatively, you can transfer the yolk mixture to a plastic bag and snip off one corner through which to pipe out the filling. These can be made up to 1 day ahead and kept covered in the refrigerator.

6 large eggs
¾ cup (23 g) chopped fresh spinach
¼ cup (60 ml) mayonnaise
1 teaspoon yellow mustard
½ teaspoon distilled white vinegar
½ teaspoon paprika
¼ teaspoon garlic powder
¼ teaspoon flake kosher sea salt

Roasted Asparagus Crostini with Lemon Cream Cheese

— Serves 6 —

I love serving these at parties or just whipping them up for a snack-centric lunch. The asparagus spears get nice and crispy at the ends, and the lemon cream cheese provides a wonderfully soft contrast. They're also very easy to serve since they can be eaten out of hand and don't require the use of plates, which both my dishwasher and I consider a win.

2 baguettes, cut crosswise into slices ½-inch (12-mm) thick

4 tablespoons (60 ml) extra-virgin olive oil

1 pound (455 g) asparagus

1 teaspoon flake kosher sea salt

¼ teaspoon freshly cracked black pepper

4 ounces (114 grams) cream cheese, at room temperature

2 teaspoons finely minced fennel and coriander preserved lemon rind (page 31)

1½ teaspoons fresh lemon juice

Cayenne pepper, for sprinkling

—Preheat the oven to 400°F (205°C).

—Place the baguette slices in an even layer on a baking sheet and lightly brush them with about 3 tablespoons of the oil. Bake until they are lightly toasted and golden around the edges, about 15 minutes. Remove the baking sheet from the oven and set it aside. Increase the oven temperature to 425°F (220°C).

—Cut off and discard the lower third of the asparagus stalks. Cut remaining stalks into 2-inch (5-cm) pieces and put them in a large bowl. Add the remaining 1 tablespoon oil, ¾ teaspoon of the salt, and the pepper and toss. Spread the asparagus out on a rimmed baking sheet and roast until wrinkled and slightly crispy at the tips, 15 to 20 minutes.

—Meanwhile, in the bowl of a stand mixer fitted with the paddle attachment, combine the cream cheese, preserved lemon rind, lemon juice, and remaining ¼ teaspoon salt and beat on medium speed until smooth and fluffy.

—Spread 2 teaspoons of the cream cheese mixture onto each baguette slice and top with 1 or 2 asparagus spears. Sprinkle with the cayenne pepper and serve.

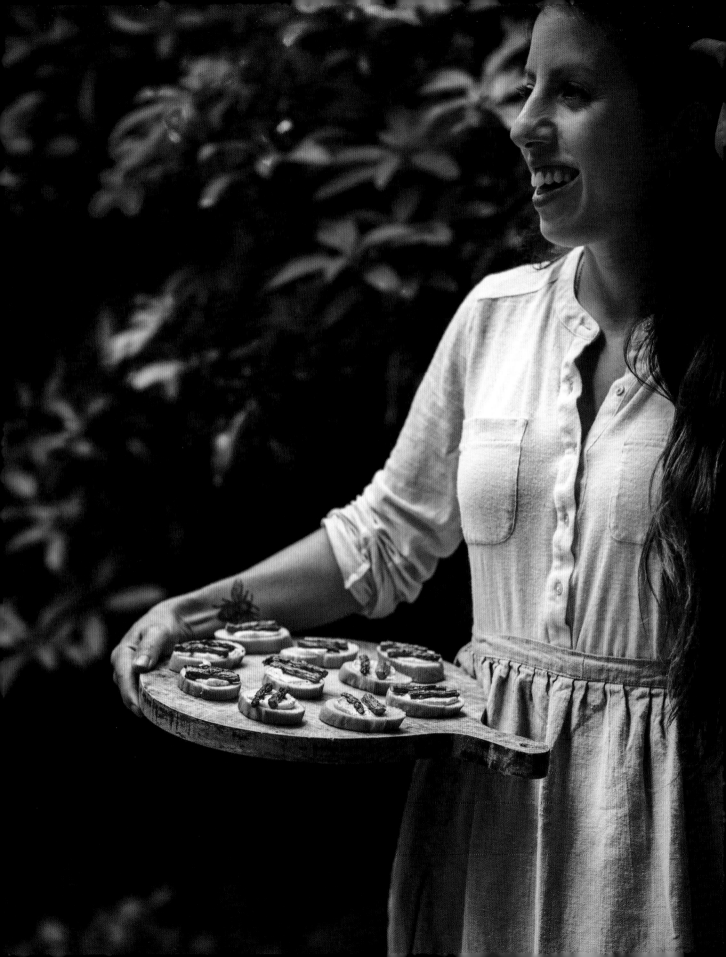

Spring Onion and Sherry Vinegar Jam

— Makes about 1 cup (240 ml) —

Sherry vinegar might not be something you keep tucked away in your pantry, but it should be. Sherry itself has a resonating, warm flavor that reminds me a lot of toasted walnuts in liquid form, and when you use it to make vinegar, you get a tart substance with delicious nutty notes that happens to pair perfectly with the sweet richness of caramelized onions. You can also whisk a bit of sherry with more sherry vinegar and some olive oil to make a tasty salad dressing, too. It's as functional as it is delicious—just like this jam, which is great on sandwiches, burgers, toast, and savory waffles or pancakes (yes, those are things that exist, and yes, you should make them immediately).

—In a large skillet, melt the butter over medium heat. Add the onions and 1 tablespoon of the oil and reduce the heat to low. Cook, uncovered, until the onions soften, about 10 minutes. Add the vinegar, sugar, salt, and remaining 2 tablespoons oil and stir to incorporate. Cook until the onions turn deeply golden and fragrant, about 40 minutes, stirring every 10 minutes.

—Remove from the heat and allow to cool to room temperature before transferring the jam to a mason jar. Seal and refrigerate. Will keep in the refrigerator for up to 1 month.

½ cup (1 stick/115 g) unsalted butter

1 pound (455 g) spring onions, thinly sliced

3 tablespoons extra-virgin olive oil

1 tablespoon sherry vinegar

3 tablespoons sugar

1½ teaspoons flake kosher sea salt

Chopped Chard and Apricot Salad with Feta, Crispy Pancetta, and Rosemary Dressing

— Serves 4 —

This is the part of the book where I talk about feta at length, so brace yourself for the cheesesplaining to come. At my family's Greek deli, we would get shipments of feta in these huge wooden barrels. The feta would come in giant blocks, and they were always completely submerged in brine, which helped preserve the cheese's fresh flavor and also kept it nice and moist. We'd then cut the feta into more manageable blocks and store them in the glass deli case in a clear tub, submerged in the brine. If someone bought a large amount of feta from us, we'd weigh it out, place it in a plastic tub, and then, you guessed it, we'd put more brine on it and seal it up. The takeaway here is to buy feta that is stored in brine. There are three main reasons to avoid nonbrined feta: First, it won't keep as long. Second, it will be much drier and rubbery in consistency, instead of the creamy texture it should have. Good feta should begin to melt and smooth out the second it touches the heat of your tongue. And third, it won't taste as fresh. If you can't find feta in brine in your area, go for the feta that is still in one large piece and not *precrumbled. When it is precrumbled, the surface area exposed to air is larger, and the cheese is probably already dried out and rubbery before you even open the container. Plus, if you buy it in one piece, you can make your own brine by dissolving 1 tablespoon salt in 2 cups (480 ml) water. Then you can place your unbrined feta in it, cover it, and allow it to rehydrate in the refrigerator for 24 hours before using it.*

As far as this salad goes, I love the way the tart and creamy feta contrasts with the sweet and juicy apricots. The sautéed pancetta bits add a welcome crisp texture and salty umami flavor to the mix, while the Rosemary Dressing gives it all a fresh and lightly herbal kick. It's the perfect mix for a filling-yet-refreshing spring salad.

ROSEMARY DRESSING

2 tablespoons extra-virgin olive oil

2 tablespoons fresh lemon juice

1 teaspoon flake kosher sea salt

½ teaspoon sugar

Pinch of freshly cracked black pepper

1 tablespoon finely chopped fresh rosemary leaves

SALAD

1 teaspoon extra-virgin olive oil

1 ounce (28 g) pancetta, cut into ¼-inch (6-mm) cubes

8 cups (240 g) chopped chard

6 large or 8 small apricots, pitted and thinly sliced

¾ cup (180 ml) freshly crumbled feta

—For the rosemary dressing, whisk together the oil, lemon juice, salt, sugar, and pepper in a small bowl until completely smooth. Add the rosemary and whisk until combined. Set aside.

—For the salad, in a small skillet, heat the oil over medium heat. Add the pancetta cubes and sauté until crispy, about 8 minutes, stirring every minute or so. Remove the pancetta from the pan using a slotted spoon and transfer it to a plate lined with paper towels, patting it with paper towels to help absorb any excess oil.

—In a large bowl, toss together the chard, apricots, feta, pancetta, and rosemary dressing. Serve immediately.

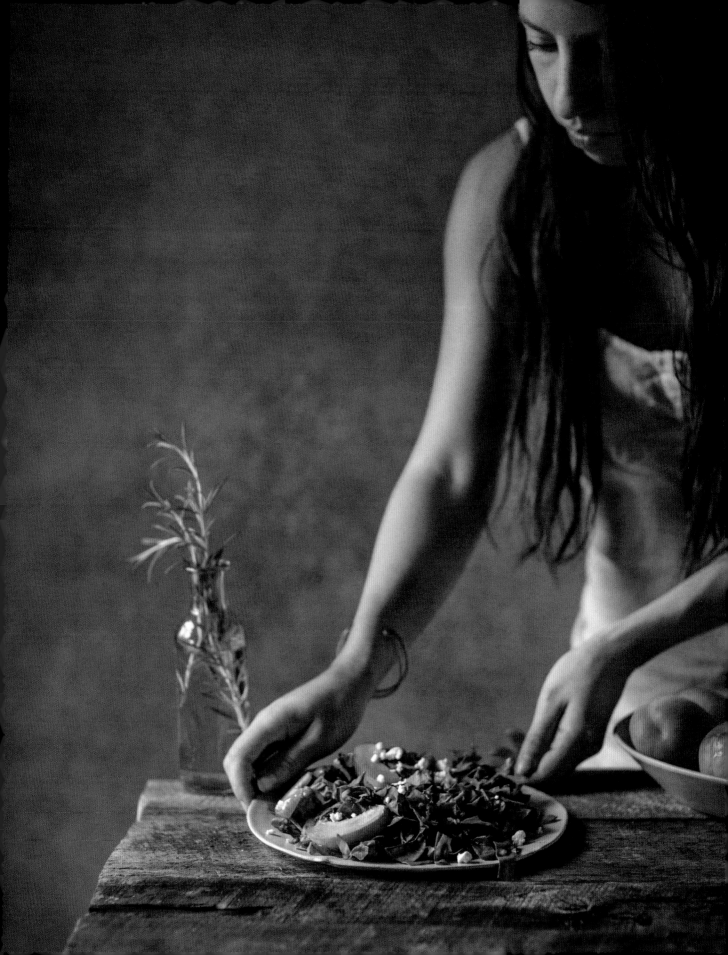

Roast Chicken with Sherry-Sautéed Morels

– Serves 2 to 4 –

If you want to embark on your own search for wild morels, there are a few tricks to successful foraging. First, make sure you study the defining characteristics of the mushroom you're looking for, and be aware of any poisonous look-alikes so that you can avoid them. When you find a morel, make sure to grasp it by the stem and pull firmly to get it out of the ground. Use a pocketknife to cut off the rooted bottom of the stem (usually only about ¼ inch/6 mm long) and toss it back on the forest floor, keeping the morel. This helps encourage more mycelium (the vegetative part of fungus that eventually shoots up mushrooms) to grow and keeps the wild mushroom population healthy. I recommend storing the mushrooms in plastic buckets as you forage to keep them from being damaged by brush and branches.

In this recipe, the woodsy umami flavor of the morels is paired with buttery chicken and a nutty, slightly sweet sherry. The bits of juice and fat from the chicken, onion, and sherry seep into the small holes of the mushrooms, making each bite of the morel burst with flavor. It's a hearty dish that's perfect for any rainy spring evening.

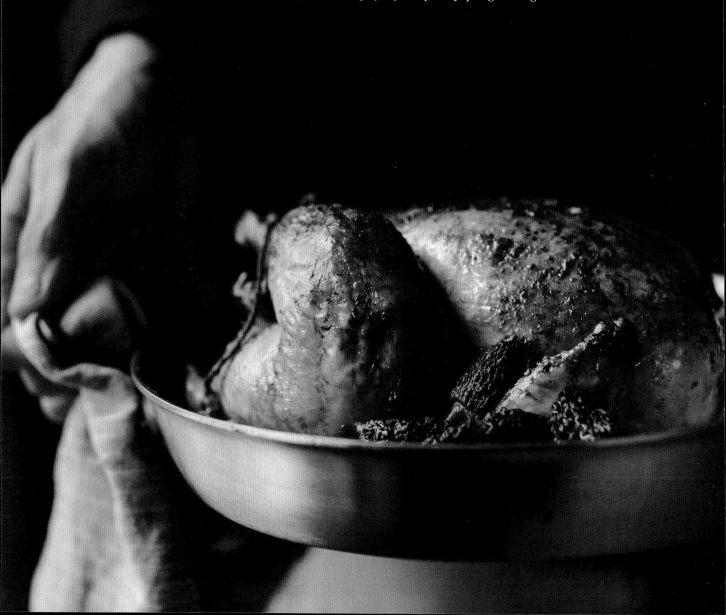

—To brine the chicken, stir together the water and table salt in a large bowl until the salt has dissolved. Place the chicken in a large resealable plastic bag and then add the brine to the bag. Seal it, place the bag in a casserole dish for storing ease, and refrigerate for at least 4 hours or up to 24 hours.

—Preheat the oven to 425°F (220°C).

—Remove the chicken from the brine, rinse it, and pat it dry.

—In a small bowl, mix together the kosher salt, garlic powder, thyme, rosemary, and oregano. Coat the chicken inside and out with the oil, then the salt mixture.

—Place the chicken in a small roasting pan and pour in the stock and sherry. Roast for 30 minutes, then reduce the oven temperature to 375°F (190°C) and roast until a thermometer inserted into the chicken thigh reads at least 165°F (75°C), an additional 1 hour to 1 hour 15 minutes, basting the bird every 15 minutes and adding water to the pan as needed to maintain at least 1 inch (2.5 cm) of liquid.

—During the last 30 minutes of cooking time, begin preparing the morels. In a large skillet, melt the butter over medium-low heat. Add the onion and salt and cook until the onion softens, about 5 minutes, stirring once.

—Add the morels and stir to coat in the butter. Cook, stirring every few minutes, until the onion becomes lightly golden around the edges and the morels darken in color, 10 to 14 minutes.

—Add the sherry to the pan and cook over low heat until the liquid has reduced by about one-third and is brown in color, 10 to 15 minutes more.

—Spoon out 3 tablespoons of the pan juices from the roasting pan and add it to the morels. Cook for 5 minutes more, then add ¼ cup (60 ml) of the pan juices to the morels, stirring to scrape up any browned bits from the bottom of the pan, and remove from the heat.

—Transfer the entire morel mixture into the roasting pan around the finished chicken. Taste the roasting pan juices and season with salt as needed. Carve the bird and drizzle the pan juices over it. Serve with the bread for dipping.

ROAST CHICKEN

1 quart (960 ml) warm water

3 tablespoons table salt

1 roasting chicken (about 5 pounds/ 2.3 kg)

1 teaspoon flake kosher sea salt, plus more as needed

½ teaspoon garlic powder

¼ teaspoon ground thyme

¼ teaspoon crushed dried rosemary

¼ teaspoon ground oregano

2 tablespoons extra-virgin olive oil

1½ cups (360 ml) chicken stock or Poultry Stock (page 34)

½ cup (120 ml) cream sherry

SHERRY-SAUTÉED MORELS

¼ cup (½ stick/55 g) unsalted butter

1 small white onion, finely chopped

¼ teaspoon flake kosher sea salt

4 ounces (115 g) fresh morels

½ cup (120 ml) cream sherry

Crusty bread, for serving

Spring Onion Crab Cakes with Dill Yogurt Sauce

— Serves 4 —

My theio (uncle) Soulis goes crabbing at the Oregon coast, and every so often, he saves me a few crabs from his catch. I have lofty ideas about what I'll do with them: "Maybe I'll make a crab ravioli, or a crab rangoon—or a crab filo pastry!" But without fail, I always end up making crab cakes. There's just something about the crispy exterior that I love on a textural level, and flavorwise, you can't get much better than the slightly sweet taste of crabmeat mixed with salty Old Bay seasoning, spring onions, lemon, and mustard. Like a true Greek, I found a way to incorporate yogurt into this, and it comes in the form of a ridiculously tasty dipping sauce. The tangy, smooth yogurt contrasts with the crisp crab cakes quite well, and the dill ends it all on a refreshing note that's perfect for a breezy spring afternoon.

DILL YOGURT SAUCE

¼ cup (60 ml) full-fat plain Greek yogurt

1 tablespoon fresh lemon juice

1 teaspoon finely chopped fresh dill

½ teaspoon Old Bay seasoning

CRAB CAKES

1½ cups (205 g) picked crabmeat

½ cup (85 g) chopped spring onions

¼ cup plus 2 tablespoons (37 g) plain bread crumbs

1 egg, beaten

2 tablespoons fresh lemon juice

1 teaspoon Old Bay seasoning

½ teaspoon flake kosher sea salt

1 heaping teaspoon grainy Dijon mustard

¾ teaspoon garlic powder

¼ teaspoon freshly cracked black pepper

Canola oil, for frying

—For the dill yogurt sauce, stir together the yogurt, lemon juice, dill, and Old Bay seasoning in a small bowl until combined. Cover and refrigerate until use.

—For the crab cakes, in a large bowl, stir together the crabmeat, onions, bread crumbs, egg, lemon juice, Old Bay seasoning, salt, mustard, garlic powder, and pepper until completely combined. Cover and refrigerate for 30 minutes.

—Pour 2 inches (5 cm) of canola oil into a large, high-sided skillet; be sure to leave at least 4 inches (10 cm) between the top of the oil and the top of the pan in case of splattering. Heat the oil over medium heat until it registers 365°F (185°C) on a deep-fry thermometer. Using your hands, shape the crab mixture into patties 2½ inches (6 cm) wide and 1 inch (2.5 cm) thick. Place the crab cakes in the oil using a slotted metal spatula and fry until golden, about 4 minutes per side, monitoring the temperature of the oil as you are frying the cakes and working in batches as necessary.

—Remove the crab cakes from the oil using the slotted spatula and place them on a large plate lined with paper towels. Serve immediately with the dill yogurt sauce.

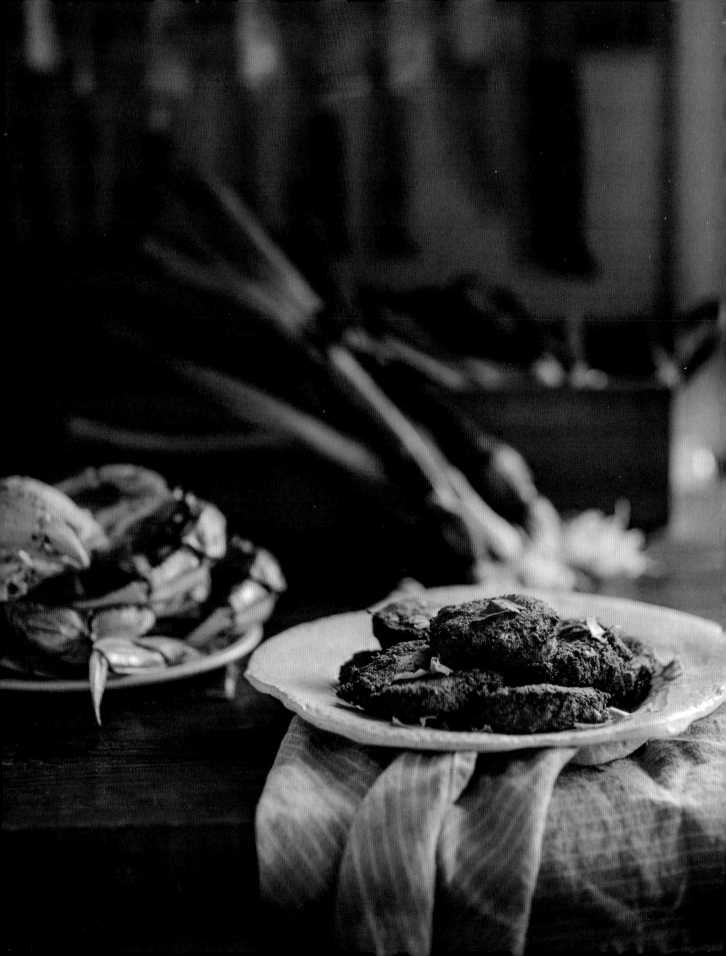

Pizza Bianca with Shaved Kohlrabi and Arugula

— Makes 2 (10 to 12-inch/25 to 30.5-cm) pizzas —

I'll be honest: I've eaten this entire pizza in under ten minutes before. It's so easy to make, and the flavor is unreal—so bright, so fresh, and yet slightly decadent thanks to the cheesy yogurt bianca sauce (yep, I brought yogurt into the mix again, but this time combined it with ricotta, cream cheese, and garlic. For real.). The pizza is baked with the sauce and asparagus and then topped with the raw shaved kohlrabi, arugula, and chive blossoms, making for a delicious affinity between the raw and cooked veggies. The pizza dough is made from scratch and only takes about 2 hours to make, most of which is just rising time, and is totally worth the minimal effort and slight time investment. The dough freezes really well, too, so I'll often make double or triple batches at once, then divide it and place the extra portions in freezer bags so I can accommodate any unforeseen potential pizza emergencies.

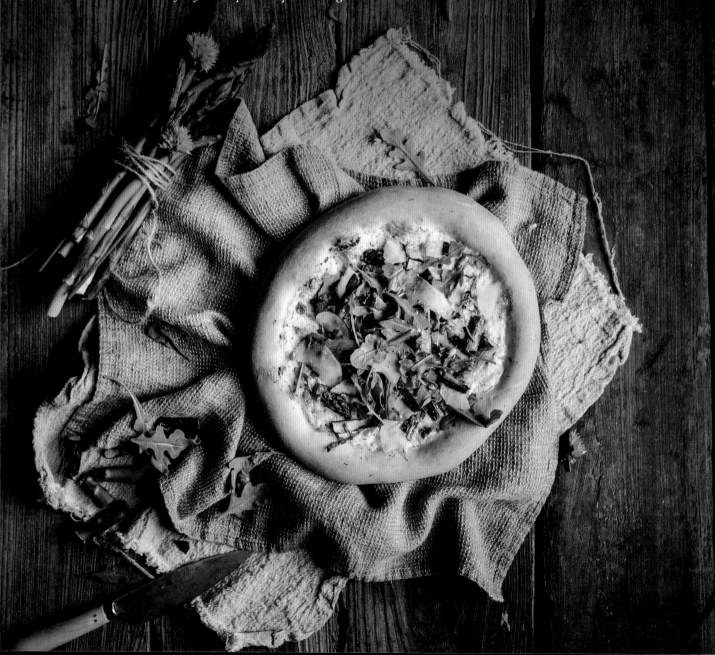

—For the dough, combine all ingredients plus 1 cup (240 ml) water in the bowl of a stand mixer fitted with the paddle attachment and mix on low speed until the dough just comes together, 1 to 2 minutes, adding more water, a tablespoon at a time, if needed. Switch to the dough hook attachment and mix on low speed until the dough is very smooth and soft, 5 to 7 minutes. (Alternatively, you can mix and knead the dough by hand: In a large bowl, stir the ingredients until they come together, then turn out the dough onto a lightly floured surface and knead until the dough is very smooth and soft, 10 to 15 minutes.) Cover the dough and allow it to rise at room temperature out of direct sunlight for 1 hour.

—Meanwhile, for the bianca sauce, in the bowl of a stand mixer fitted with the paddle attachment, combine the yogurt, ricotta, cream cheese, garlic, lemon zest, salt, dill, and pepper and mix on medium-low speed until smooth. Cover and refrigerate until ready to use.

—Divide the dough into two equal balls and shape them into flat circles, about 10 to 12 inches (25 to 30.5 cm) in diameter. Place each one on a sheet of parchment paper. Cover with a lightly greased sheet of plastic wrap and allow to rise at room temperature out of direct sunlight for 30 minutes.

—Preheat the oven to 500°F (260°C) with a baking stone inside of it. Alternately, you can cook the pizza on a metal round pizza pan.

—For the toppings, cut the bottom third off the asparagus spears and discard them, reserving the top two-thirds. Cut the stalks into 1-inch (2.5-cm) pieces and toss them with the oil and ¼ teaspoon of the salt.

—Pat down the centers of the raised pizzas to flatten slightly, leaving a 1-inch (2.5-cm) crust border around the edge that is slightly elevated. Spread the bianca sauce on the center of each of the two pizzas, leaving a 1-inch (2.5-cm) border for the crust. Sprinkle half the Parmesan on each of the pizzas, and evenly distribute the asparagus between the two pizzas.

—Bake the pizzas one at a time. To transfer the pizza onto the baking stone, keep the pizza on the parchment paper and put it on a flat surface like a large cutting board. Open the oven and hold the cutting board next to the baking stone, using your other hand to pull the parchment paper off the cutting board and onto the baking stone. Close the oven and bake until the crust is deeply golden and the tops of the Parmesan shavings begin to turn gold, 12 to 15 minutes. Repeat with the second pizza.

—Top the pizzas evenly with the arugula, kohlrabi, and chives. Give the lemon half one good squeeze above each of the pizzas, moving it in a small circle as you do to distribute the juice evenly. Evenly distribute the remaining ½ teaspoon salt and the pepper between the two pizzas and serve.

PIZZA DOUGH

2 cups (250 g) all-purpose flour, plus more for dusting

1 cup semolina (125 g) flour, plus more for dusting

1 teaspoon instant or active dry yeast

1 teaspoon sugar

½ teaspoon dried thyme leaves

¼ teaspoon garlic powder

1½ teaspoons flake kosher sea salt

3 tablespoons extra-virgin olive oil

BIANCA SAUCE

½ cup (120 ml) plain full-fat Greek yogurt

½ cup (125 g) full-fat ricotta cheese

¼ cup (60 g) cream cheese, at room temperature

3 garlic cloves, minced

1 teaspoon finely grated lemon zest

½ teaspoon flake kosher sea salt

½ teaspoon finely chopped fresh dill

¼ teaspoon freshly cracked black pepper

TOPPINGS

4 ounces (34 g) asparagus

1 teaspoon extra-virgin olive oil

¾ teaspoon flake kosher sea salt

1½ ounces (42 g) shaved Parmesan

1 cup (15 g) lightly packed arugula

¼ cup (30 g) shaved kohlrabi

1 tablespoon chive blossoms or finely chopped fresh chives

½ lemon

¼ teaspoon freshly cracked black pepper

Parmesan Rind and Roasted Rapini Soup

— Serves 4 —

If you've been throwing away Parmesan cheese rinds your whole life, you've been making a terrible mistake. If you hoard them in a freezer bag, you can make some of the most amazing soup stock ever just by boiling them in the water for a few hours. This savory, slightly funky stock provides the base for this soup, and it pairs incredibly well with the earthy and lightly charred flavor of the roasted rapini. Rapini is also known as broccoli rabe and is basically the skinnier, less bushy version of broccoli. You can also substitute broccolini, which is very similar.

18 individual rapini, about
 10 ounces (283 g), ends trimmed

3 garlic cloves, skin on

2 tablespoons plus 1 teaspoon
 (31 ml) extra-virgin olive oil

½ teaspoon flake kosher sea salt

1 Parmesan rind

1 can (15 ounces/430 g) cannellini
 beans, rinse and drained

¾ cup (180 ml) half-and-half

2 teaspoons distilled white vinegar

2 teaspoons fresh thyme leaves

1 teaspoon diced fresh rosemary
 leaves

½ teaspoon garlic powder

⅛ teaspoon cayenne pepper

Flake kosher sea salt, to taste

4 slices toasted bread, for serving

4 teaspoons edible flowers
 (optional)

—Preheat the oven to 400°F (205°C).

—Put the rapini, garlic cloves, and 1 tablespoon of the oil in a large bowl and gently toss for 1 minute, massaging the leaves and mixing until the oil coats every part of the rapini. Spread out on a baking sheet and sprinkle with the salt. Roast until the rapini is golden brown at the tips and the stems are a deep dark green, 20 to 25 minutes. Once cool enough to handle, remove the papery skin from the garlic cloves and reserve the roasted garlic. Reserve 4 roasted rapini on the side to use as a garnish.

—Bring 4 cups (960 ml) water to a boil in a small saucepan. Add the Parmesan rind and reduce the heat to low; cook, uncovered, for 30 minutes, stirring occasionally. Remove from the heat and allow to cool for 15 minutes.

—In a food processor or blender, combine the charred rapini, roasted garlic, Parmesan rind and cooking water, beans, ½ cup (120 ml) half-and-half, vinegar, thyme, rosemary, garlic powder, and cayenne and puree until completely smooth. Add salt to taste. Evenly distribute the soup among four bowls and garnish each with 1 teaspoon of the olive oil, 1 teaspoon of the half-and-half, and a pinch of edible flowers (if using). Serve immediately with the bread.

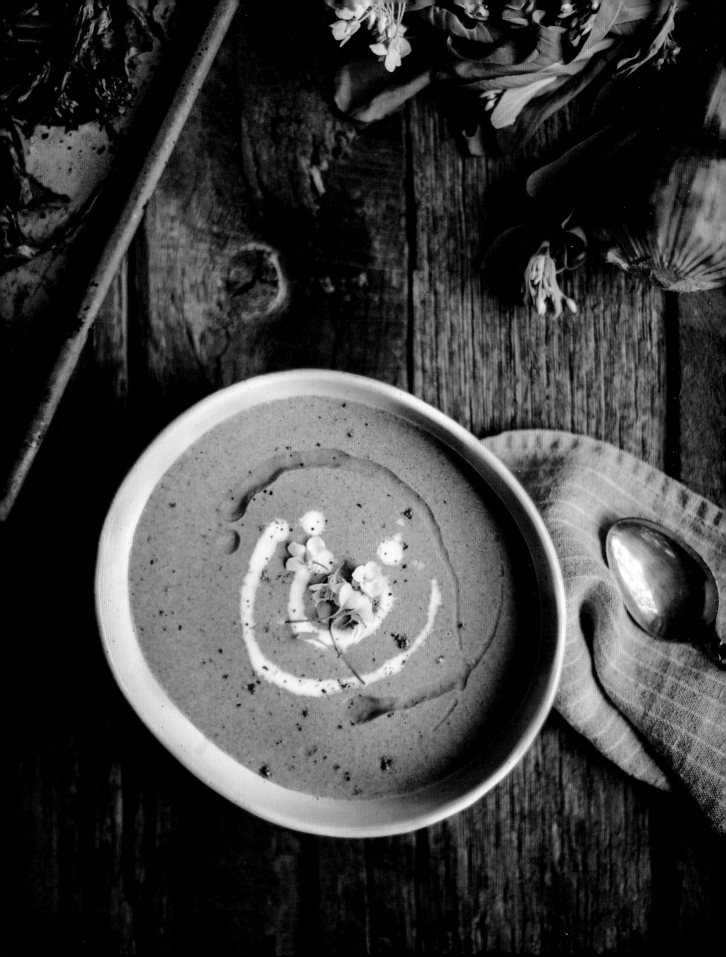

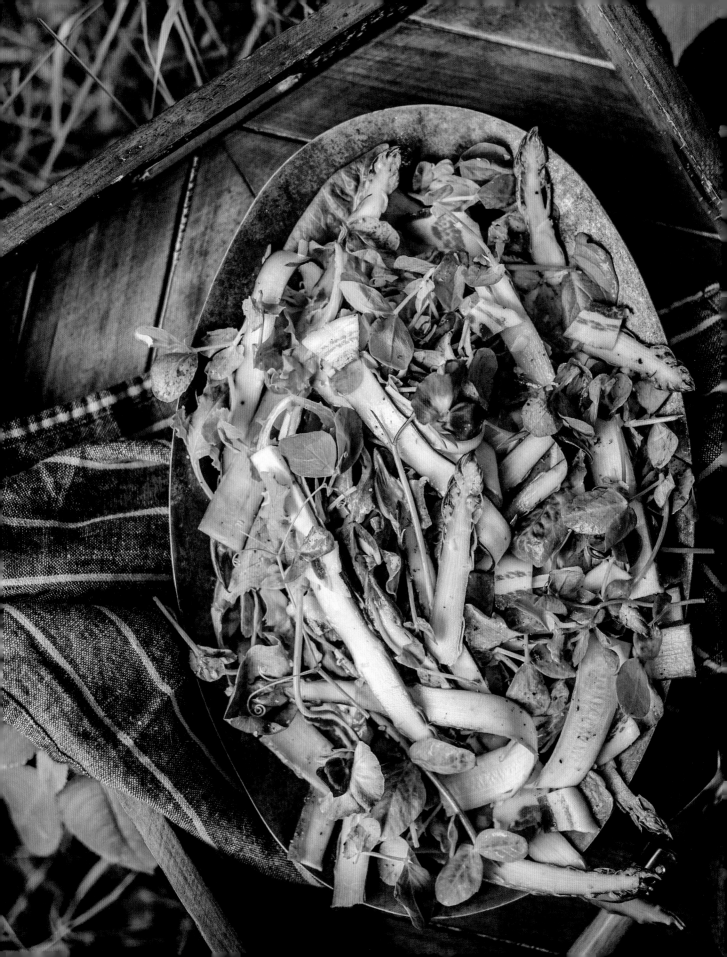

Pea Shoot, Pancetta, and Shaved Asparagus Salad

— Serves 2 to 4 —

Peas are my second-favorite thing to grow in the springtime (right after rhubarb). I actually love them more for their shoots and edible flowers than the peas themselves. If you're not sure what a pea shoot is, it's the green vine of the pea plant that tangles around things and tries to grow up toward the sun. All of the leaves, stems, and blossoms of the pea plant are edible, as are the peas themselves, of course, but you only want to eat the leaves and stems when they're young. If you wait until mid-summer, they will be very tough and much less pleasant for fresh eating in salads. The other fun thing is that the color of the pea blossom itself varies depending on the variety of pea you are growing. The Blue-Podded Pea (aka Blauwschokkers) has lovely magenta flowers, the Oregon Sugar Pod has white ones, and the Golden Sweet Snow Pea has lavender ones. You can also find pea shoots and edible pea flowers at the farmers' market this time of year, too. If you are growing your own, though, please note that flowers from sweet pea flower vines are not the same as the edible flowers from the vegetable pea plants. Only eat the blossoms and leaves from actual pea plants, not from sweet pea flowers (which are quite lovely but also very toxic). The flavor of pea shoots is very mild, and has a wonderfully bright lettucelike flavor with a hint of pea pod at the finish. It pairs really well with the earthier flavor of the shaved asparagus spears, and it contrasts nicely with the rich pancetta bits scattered throughout the salad.

—For the basil dressing, in a small bowl, whisk together the lemon juice, crème fraîche, oil, pepper, and salt until smooth and completely combined. Stir in the basil and set aside.

—For the salad, cut off and discard the bottom third off the asparagus stalks. Use a vegetable peeler or mandoline to shave the asparagus spears lengthwise into thin strips.

—In a large bowl, toss together the asparagus, pea shoots, salad greens, pancetta, Parmesan, and basil dressing. Serve immediately.

BASIL DRESSING

1 tablespoon fresh lemon juice

2 teaspoons crème fraîche or sour cream

1 teaspoon extra-virgin olive oil

¼ teaspoon freshly cracked black pepper

¼ teaspoon flake kosher sea salt

1 tablespoon finely chopped fresh basil

SALAD

½ pound (225 g) asparagus

2 cups (32 g) pea shoots

2 cups (30 g) bitter salad greens, such as arugula

1 ounce (28 g) thinly sliced pancetta, cut into roughly ½ by 1-inch (12 mm by 2.5-cm) rectangles

2 tablespoons shredded Parmesan cheese

Snap Pea Salad with Preserved Lemon and Goat Cheese Medallions

— Serves 2 to 4 —

I am always looking to create the perfect "salad triangle," which is how I describe a dish that has a balance of freshness (like raw veggies), fats (cheese, prosciutto, and the like), and acid (think an awesome lemon- or vinegar-based dressing). Preserved lemons are my favorite ingredient for providing that bit of acidic zing, and they do an excellent job here, with the peel being used in the salad and the juice being used in the dressing. For the fats, we have the rich goat cheese medallions, which are sliced, breaded, and fried to create a crispy exterior and a smooth and melty interior. Then you throw in the crunch and juiciness of the fresh snap peas, and you have all the makings of an excellent spring salad on your hands.

GOAT CHEESE MEDALLIONS

1 log (4 ounces/115 g) goat cheese

3 tablespoons canola oil

1 cup (80 g) plain panko bread crumbs

1 teaspoon garlic powder

1 teaspoon flake kosher sea salt

½ teaspoon ancho chile powder

½ teaspoon freshly cracked black pepper

1 egg, beaten

SALAD

1 tablespoon extra-virgin olive oil

1 teaspoon fennel and coriander preserved lemon juice (page 31)

3 cups (48 g) pea shoots

1 cup (60 g) snap peas, strings removed

¼ cup (13 g) fresh mint leaves

1 tablespoon finely chopped fennel and coriander preserved lemon rind (page 31)

—For the goat cheese medallions, cut the goat cheese crosswise into 6 thick slices.

—Heat the canola oil in a medium skillet over medium heat. When a drop of water flicked into the pan sizzles, it is ready for frying.

—In a medium flat-bottomed shallow dish, combine the bread crumbs, garlic powder, salt, chile powder, and pepper. Put the egg in a shallow bowl.

—Take one of the slices of goat cheese and dip it in the egg, letting any excess drip back into the bowl. Dredge it in the bread crumb mixture, then place it in the skillet. Repeat with the remaining goat cheese. Fry the medallions until golden, about 4 minutes on each side. Remove using a slotted metal spatula and place on a plate lined with paper towels.

—For the salad, in a small bowl, whisk together the oil and lemon juice.

—In a large bowl, toss together the pea shoots, snap peas, mint, and lemon rind. Add the oil–lemon juice mixture and toss until evenly distributed. Transfer the salad to a serving platter, garnish with the cheese medallions, and serve.

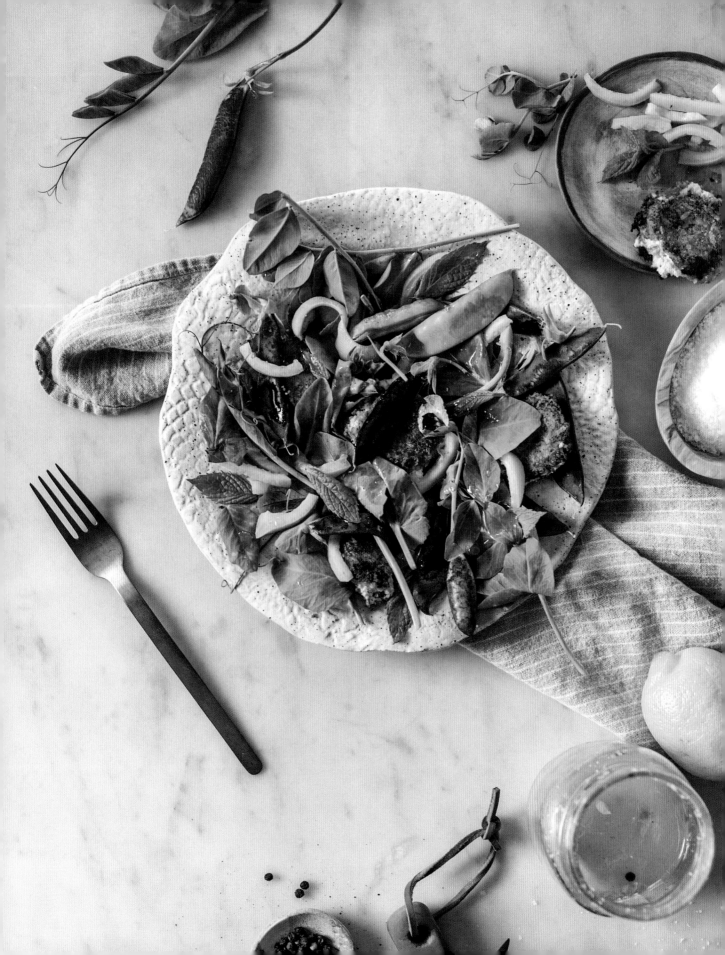

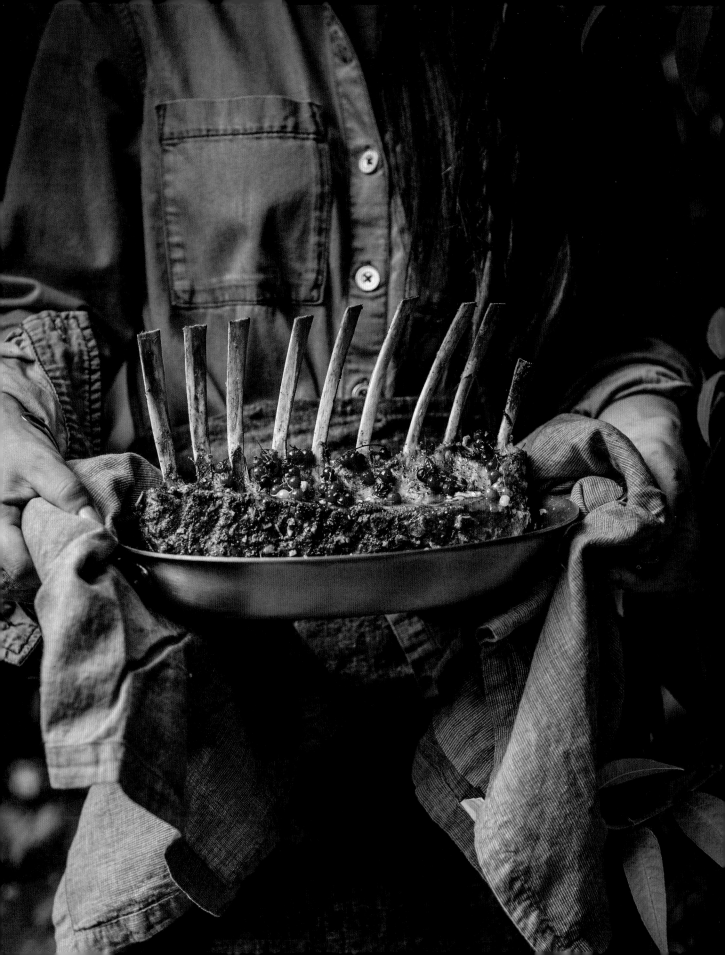

Black Pepper Rack of Lamb
with Red Currant and Rhubarb Glaze

— Serves 4 —

Red currants have a wonderfully tart and slightly sweet flavor, which makes them a natural pairing for rhubarb in all its sour glory. I combined the two here for a bright and fruity glaze that cuts through the hearty, rich lamb with intense ferocity. The lamb itself is coated in a heavy dusting of black pepper, which brings a bit of heat to the mix and complements the sweet-and-sour sauce very well. I love making this when I have guests over, because the actual cook time is very short (the lamb is only in the oven for about fifteen minutes) and the sauce is something I can make ahead of time and reheat once the lamb is ready to be served. Please note, though, that the recipe does call for the lamb to be marinated overnight, so keep that in mind when planning your meal.

—For the rack of lamb, use a knife to poke holes that are 1-inch (2.5-cm) deep into the lamb between each bone. Rub the lamb all over with the oil, garlic, salt, and pepper, making sure to rub the spices and garlic inside each hole as well. Cover and marinate overnight in the refrigerator.

—For the glaze, in a medium saucepan, combine the rhubarb, currants, sugar, and ½ cup (120 ml) water and bring to a boil over medium-high heat. Reduce the heat to low and cook until the rhubarb begins to disintegrate and the berries burst, about 20 minutes. Strain the glaze into a bowl and discard the solids.

—Preheat the oven to 475°F (245°C). Place the lamb in a small roasting pan and arrange the currants on and around it. Roast for 10 minutes for rare, 15 minutes for medium-rare, or 20 minutes for medium.

—Remove from the oven and allow to rest for 5 minutes before carving and serving with the glaze.

RACK OF LAMB

1 rack of lamb (1¾ pounds/800 g)

1 tablespoon extra-virgin olive oil

3 garlic cloves, minced

1 teaspoon flake kosher sea salt

¾ teaspoon freshly cracked black pepper

1 pint (224 g) red currants

GLAZE

3 rhubarb stalks, thinly sliced

1 cup (95 g) stemmed red currants

⅓ cup (65 g) sugar

Fennel-Pistachio Pesto Lasagna

— Serves 8 —

My papou and yiayia had a small pistachio farm on the island of Aegina, where my Greek family still lives to this day. My aunts, uncles, and cousins maintain the farm now, and on my most recent visit to Greece, it was the first thing I wanted to see. I'd heard many stories about this place, so being able to see it in person was surreal. The vegetable garden still had some of the plants growing in it that my yiayia had planted, like a persimmon tree, grape vine, and a planter full of succulents. I have an old picture of her standing in her garden, leaning on her rake, smiling, with her chickens foraging at her feet and giant tomato plants all around her. For me, this photo has become an embodiment of who she was: a kind, loving, and hardworking woman. Standing in that exact spot decades later left me feeling warm and loved. Even though I'll never be able to see her or touch her or tell her how much she's inspired me, I'll always be able to connect with her through food—through making her recipes or making recipes with the ingredients she knew and loved, like this one. Rich and nutty pistachios are ground alongside fennel, basil, and tarragon to make this delicious herbal pesto, which is then mixed with ricotta and layered with lasagna noodles and lots and lots of Parmesan and white cheddar. It's a recipe I think she would have loved, and I know you will, too.

FENNEL-PISTACHIO PESTO

3 cups (228 g) coarsely chopped fennel stems and fronds

1 cup (120 g) shelled, salted, and roasted pistachios

½ cup (20 g) fresh basil leaves

¼ cup (13 g) coarsely chopped fresh tarragon

¾ teaspoon flake kosher sea salt

½ teaspoon freshly ground black pepper

½ cup plus 1 tablespoon (135 ml) extra-virgin olive oil

LASAGNA

½ pound (225 g) lasagna noodles

2 cups (480 ml) fresh full-fat ricotta

½ cup (120 ml) heavy cream

4 cups (400 g) grated Parmesan cheese

1 cup (115 g) grated white cheddar cheese

—For the pesto, in a blender or food processor, combine the fennel, pistachios, basil, tarragon, salt, and pepper and blend until smooth. With the motor running, slowly add the oil in a thin, steady stream through the hole in the cap or feed tube. Blend for 10 seconds more, or until thick and smooth. Cover and set aside.

—Preheat the oven to 375°F (190°C).

—For the lasagna, bring a large pot of water to a boil. Place the lasagna noodles in the water, working in batches as necessary, and cook until slightly bendable, 4 to 5 minutes. Remove with tongs and transfer to a colander to drain.

—In a medium bowl, mix the pesto, ricotta, and cream together until combined.

—Place 3 or 4 of the noodles in the bottom of a 9 by 13-inch (23 by 33-cm) rectangular casserole dish, keeping them in a flat, even layer. Take 1 cup (100 g) of the Parmesan and set it aside for later use. Spread one-third of the ricotta mixture over the noodles, then sprinkle with one-third of the Parmesan. Place 3 or 4 noodles in an even layer on top of the Parmesan and repeat two more times, so you have three layers of the ricotta mixture and are left with the noodles on top.

—Sprinkle the cheddar and reserved Parmesan evenly over the top. Place the casserole dish on a baking sheet and place it in the oven. Bake until the cheese is bubbling around the edges, about 35 minutes. Allow to cool for 15 minutes before slicing and serving.

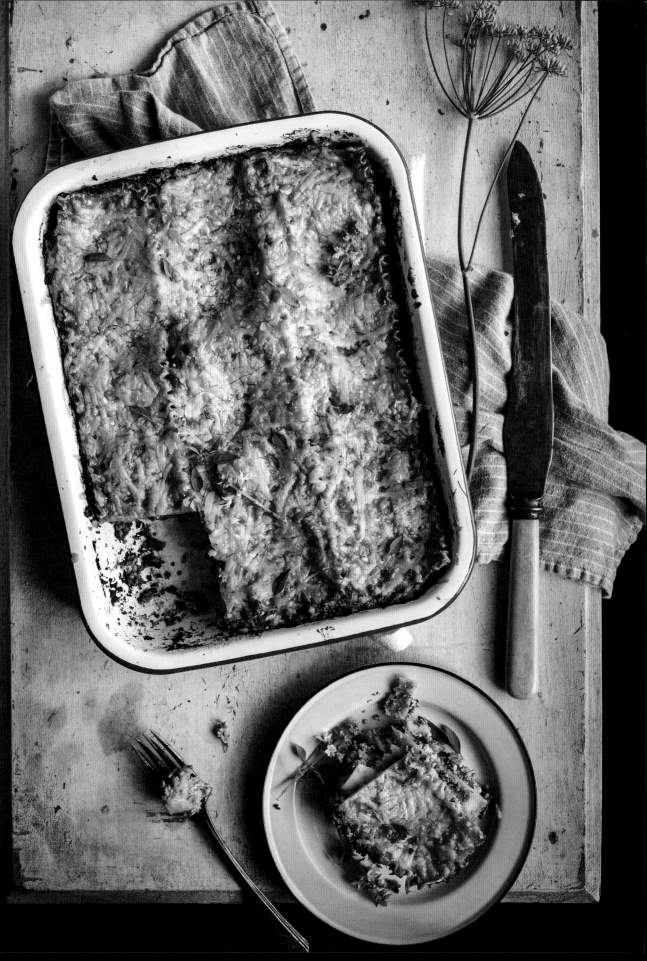

Milk-Braised Pork Butt Roast with Leeks and Fennel

— Serves 4 to 6 —

I first heard about braising pork in milk during a pig-butchering class I took at the Portland Meat Collective. I was really intrigued by the idea, and after my first attempt at it, I was absolutely hooked on the rich and creamy broth that emerged. This recipe also calls for leeks and fennel, which caramelize in the milk mixture as the pork braises, providing a slightly sweet and herbal flavor that gives the stock even more dimension. The milk does curdle as it braises, but after the pork is done, you remove it from the pot and strain the sauce, creating the most incredible pork jus to drizzle over your roast. You can serve it as is, or with a side of rice or crusty bread, if you want a little something extra to help absorb the sauce. Note that if you use a smaller pork roast than called for, your cooking time will change, so in that case, it's best to go by the internal cooking temperature of pork, which is 145°F (65°C).

—Preheat the oven to 325°F (165°C).

—In a large Dutch oven, melt the butter over medium-high heat. Add the fennel bulbs and leeks and cook, stirring every minute, until the layers of the leeks begin to fall out of their rings and the fennel pieces soften slightly, about 5 minutes.

—In a small bowl, mix together the salt and thyme. Rub the salt mixture all over the pork.

—Push the fennel and leeks to one side in the Dutch oven. Place the pork on the empty side and sear each side of the roast until deeply golden, about 4 minutes per side, stirring the side with the vegetables every few minutes to keep them from burning.

—Add the stock to the pan and stir, scraping up any dark brown bits from the bottom of the pan with a wooden spoon. Add the milk, cream, bay leaves, and fennel fronds and stir to combine.

—Cover the pot, leaving the lid ajar by about 1 inch (2.5 cm). Place the pot in the oven and roast for about 2 hours, turning the pork every 30 minutes. Remove the lid and roast for 30 minutes more. Remove from the oven. Gently remove the roast from the pot and set it aside on a platter.

—Pour the contents of the pot through a mesh sieve placed over a large bowl. Press the bottom of another bowl over the solids in the sieve to help get all the juices out. Discard the solids.

—Pour the strained sauce back into the Dutch oven and place it over low heat. Add the wine and whisk to combine. Season with salt, as desired. Once the mixture is hot but not boiling, remove it from the heat and return the pork to the pot. Pull the roast apart into large chunks and serve with the sauce and rice, if desired.

4 tablespoons (½ stick/55 g) unsalted butter

½ pound (225 g) fennel bulbs, thinly sliced

2 large leeks, well washed, white and light green parts thinly sliced

2 teaspoons flake kosher sea salt, plus more for seasoning

½ teaspoon ground thyme

1 pork butt roast (3 pounds/1.4 kg)

2 cups (480 ml) Vegetable Stock (page 34)

3 cups (720 ml) whole milk

½ cup (120 ml) heavy cream

2 bay leaves

1 tablespoon finely chopped fennel fronds

⅓ cup (75 ml) dry white wine

4 cups (788 g) cooked rice, for serving (optional)

Balsamic-Cherry Pork Tenderloin

— Serves 4 —

We have a giant cherry tree in our backyard, and each year, the branches are heavy with ripe fruit for a one-week period. There are so many of them that the ground underneath the tree ends up being littered with little red spots, since we're unable to go through them fast enough, even with all my compulsive food preservation neurosis. After making the traditional sweet cherry dishes, I stumbled upon something extremely special—the magic that happens when you cook pork and cherries together. Pork, as a whole, is my favorite meat to pair with seasonal fruits. There's something about the way pork fat interacts with fruit sugars that creates the most wonderful interplay between sweet and savory flavors, and this recipe is no exception. There are also pearl onions caramelized with prosciutto bits, and I incorporated some balsamic for a little acidity to help cut through the richness of the pork.

3 tablespoons plus 1 teaspoon (50 ml) extra-virgin olive oil

3 tablespoons unsalted butter

1½ pounds (680 g) pearl onions, peeled

1 tablespoon plus 2 teaspoons high-quality balsamic vinegar

1 ounce prosciutto, cut into cubes

1 pound (455 g) black cherries, pitted and halved

1 tablespoon dark brown sugar

1 teaspoon flake kosher sea salt

½ teaspoon freshly cracked black pepper

½ teaspoon ground thyme leaves

1 pork tenderloin (about 1⅓ pounds/605 g)

—In a medium skillet, heat 3 tablespoons of the oil and the butter over medium heat until the butter has melted. Add the onions and 1 tablespoon of the balsamic vinegar and sauté, stirring every 5 minutes, until the onions become translucent and very soft, about 15 minutes.

—Add the prosciutto and stir to combine. Cook, stirring every 5 minutes, until the onions turn golden around the edges and the prosciutto cubes are a bit crispy, about 15 minutes.

—Stir in the cherries and brown sugar and cook, stirring once, until the cherries have softened and have just begun to release their juices, about 5 minutes. Remove from the heat and set aside.

—Preheat the oven to 375°F (190°C).

—In a small bowl, mix together the salt, pepper, and thyme until combined. Set aside.

—Make an incision lengthwise along the center of the tenderloin, cutting about halfway through the meat. Fold the tenderloin open like a book and lay it flat on a cutting board. Use a meat tenderizer mallet to pound the tenderloin until it is ½ inch (12 mm) thick. Massage the meat with the remaining 1 teaspoon olive oil and 2 teaspoons balsamic vinegar and then rub it all over with the thyme mixture. Use a spoon to place some of the cherry filling in a line on the tenderloin alongside the longest edge. Wrap the tenderloin over the filling and roll it up. Use cooking twine to make several ties across the tenderloin to keep the filling in place. Put the remaining cherry filling in a small roasting pan. Place the tenderloin on top of the cherry filling, seam side down, and use a pastry brush to brush the top with some of the cherry mixture.

—Add ⅓ cup (75 ml) water to the pan with the cherry mixture and place the pan in the oven. Roast until the interior of the tenderloin reaches 145°F (65°C), 35 to 45 minutes. Remove the twine before slicing and serving, spooning the cherries and pan juices over each slice.

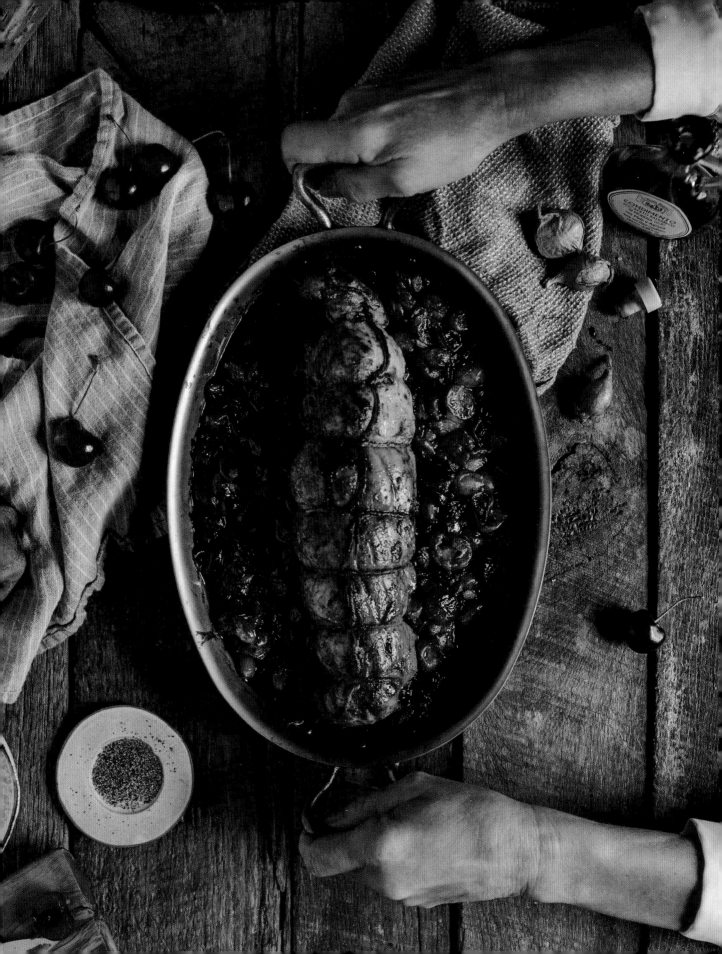

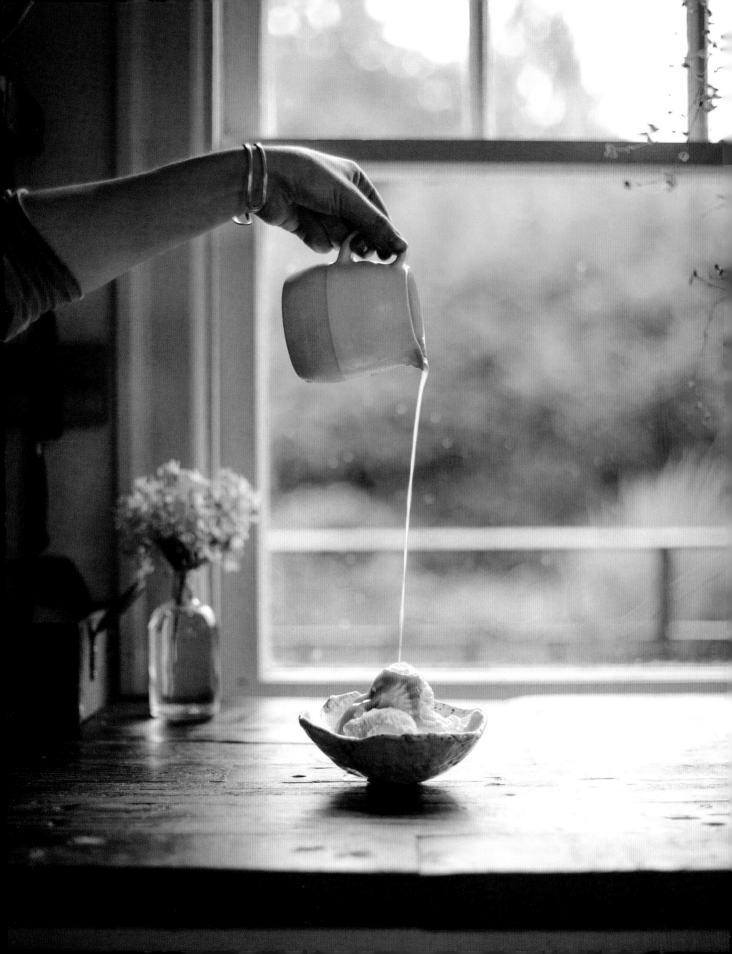

Rhubarb Tarragon Ice Cream

— Makes about 1½ pints (528 g) —

I acquired my now-epic rhubarb bush two years ago on a weekend getaway to Whidbey Island up in Washington. I made Jeremy stop at some antiques shops (which is very much my kind of thing and definitely not his kind of thing), and one of them was part of the owner's house. Her shop was fine, but her garden was magic. I ended up wandering around out there and asking her a wide range of questions about plants. Then I came across her rhubarb, which had leaves about two feet in diameter. It looked like a plant for dinosaurs, and I kinda freaked out about how amazingly huge it was. I think she was really entertained by how excited I was, so she gave me some of a small rhubarb plant that she'd just divided from her big one, and that's how I ended up with a huge rhubarb bush in the middle of my garden just two years later. One of my favorite ways to savor its flavor is by making this tasty ice cream, which combines the tartness of rhubarb with the herbal complexity of tarragon and the light licorice flavor of star anise. It comes together in the most strangely perfect way and creates a rich yet refreshing ice cream flavor that is unlike any you've had before.

—In a very small saucepan, stir together the condensed milk and tarragon. Heat over low heat until hot but not boiling, stirring every minute. Remove from the heat and allow to rest at room temperature for 1 hour. Strain the infused condensed milk into a bowl, discarding the tarragon.

—In a medium saucepan, combine the rhubarb, sugar, star anise, and ½ cup (120 ml) water and bring to a boil over medium-high heat. Reduce the heat to low and simmer, stirring every 5 minutes, until the rhubarb has become pulpy and partially disintegrated, 20 to 25 minutes. Remove from the heat and allow to cool to room temperature. Strain the syrup through a mesh sieve into a bowl and discard the solids. You can double the syrup recipe, and serve half alongside of the ice cream for garnish. The syrup can be stored in an airtight container in the refrigerator for up to 1 month.

—In a medium bowl, whisk together the egg yolks and the rhubarb syrup until the mixture lightens in color, 3 to 5 minutes.

—Bring water in the bottom of a double boiler to a boil over medium heat. Reduce the heat to low. In the top of the double boiler, whisk together the infused condensed milk and the egg yolk mixture. Whisk until the mixture thickens enough to coat the back of a spoon, 10 to 12 minutes. Remove from the heat and allow to cool to room temperature. Cover and refrigerate for at least 4 hours or overnight.

—In the bowl of a stand mixer fitted with the whisk attachment, beat the cream on medium-high speed until it holds soft peaks. Cover and refrigerate.

—Fold the whipped cream into the chilled egg yolk mixture, then pour the mixture into an ice cream machine and churn according to the manufacturer's directions. Transfer the ice cream to an airtight freezer-safe container. Cover and freeze. Best if eaten within 6 months.

½ cup (120 ml) sweetened condensed milk

¼ cup (13 g) coarsely chopped fresh tarragon

3 large rhubarb stalks (about 1 pound/455 g), cut into 1-inch (2.5-cm) slices

1 cup (200 g) sugar

2 star anise

2 egg yolks

1 cup (240 ml) heavy cream

Brown Butter Sprouted Grain Cake
with Rhubarb Meringue Buttercream

— Makes one 8-inch (20-cm) round cake —

I love baking with sprouted grain flours because of the additional nutrients contained within them. When you sprout seeds, you're releasing the stored-up nutrients and enzymes that help little plants grow, which makes them more readily accessible for your digestive system. And while cake itself isn't healthy by any means, using a sprouted grain flour does help give it a little wholesome kick and a wonderfully subtle nutty flavor. It also gives the cake a heavier crumb, which contrasts with the light and airy rhubarb meringue buttercream perfectly.

CAKE

1 cup (2 sticks/225 g) unsalted butter, plus more for greasing the pans

3 cups (375 g) sprouted whole wheat flour

1 tablespoon baking powder

1 teaspoon ground cinnamon

½ teaspoon flake kosher sea salt

2 cups (400 g) sugar

4 large eggs

2 teaspoons pure vanilla extract

½ teaspoon pure almond extract

1 cup (240 ml) whole milk

RHUBARB MERINGUE BUTTERCREAM

1 rhubarb stalk, thinly sliced

½ cup (100 g) granulated sugar

6 egg whites

1½ cups (293 g) superfine sugar

1½ cups (3 sticks) plus 3 tablespoons (395 g) unsalted butter, cut into cubes, at room temperature

—For the cake, in a large shallow skillet, melt the butter over medium heat. Swirl the pan around a bit every couple of minutes to help it cook evenly. Over a period of several minutes, you'll notice the foam at the top of the butter start to change from a light yellow to dark tan. Once it reaches the dark tan stage and the butter looks light brown and golden, smell it. It should smell nutty and similar to toffee. Remove from the heat and set aside to cool completely.

—Preheat the oven to 350°F (175°C). Grease two 8-inch (20-cm) round cake pans with butter and line the bottoms with parchment paper cut to fit.

—In a large bowl, stir together the flour, baking powder, cinnamon, and salt until combined. Set aside.

—In the bowl of a stand mixer fitted with the paddle attachment, mix together the cooled brown butter and the sugar on medium speed until smooth. Add the eggs, one at a time, beating well after each addition. Add the vanilla and almond extracts and mix until combined. Add the milk and the flour mixture in four separate additions, alternating between the two, and mix until combined.

—Evenly distribute the batter between the prepared cake pans and place them in the oven. Bake until lightly golden on top and a toothpick inserted into the center of each cake comes out clean, 35 to 45 minutes. Remove the cakes from the pans and place on a wire rack to cool completely.

—For the rhubarb meringue buttercream, bring the rhubarb, sugar, and 3 tablespoons water to a boil over medium heat. Reduce the heat to low and continue cooking until the syrup is very pink and the rhubarb disintegrates slightly, about 20 minutes. Strain, reserving the syrup.

—Bring water in the bottom of a double boiler to a boil over medium heat. Reduce the heat to low. In the top of the double boiler, whisk together the egg whites, superfine sugar, and rhubarb syrup; cook, whisking continuously, until the sugar has dissolved and the mixture is hot but not boiling. Transfer

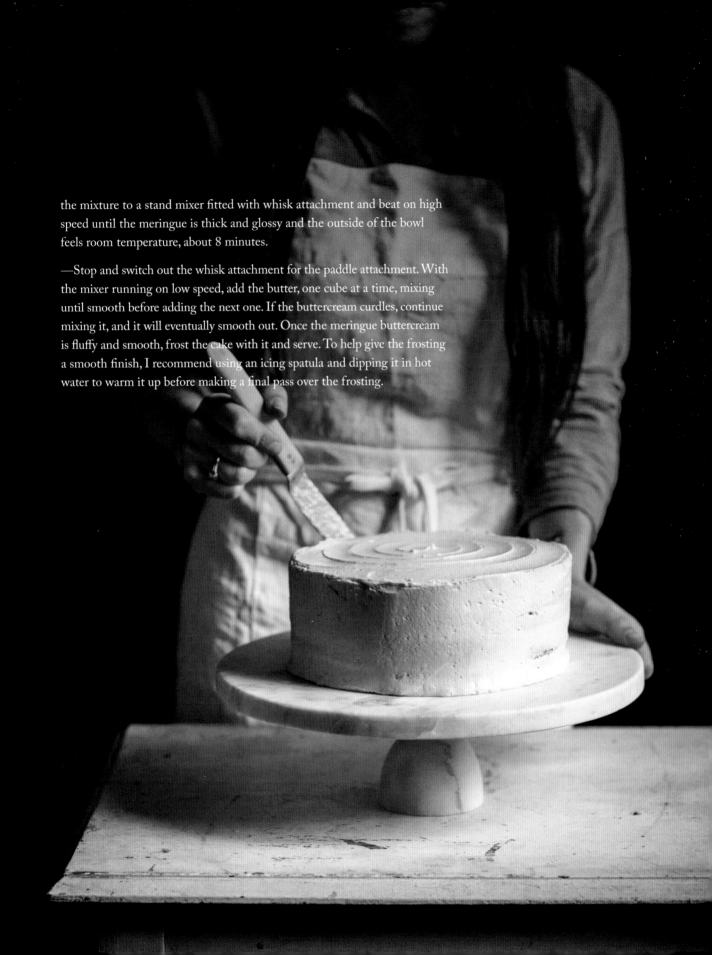

the mixture to a stand mixer fitted with whisk attachment and beat on high speed until the meringue is thick and glossy and the outside of the bowl feels room temperature, about 8 minutes.

—Stop and switch out the whisk attachment for the paddle attachment. With the mixer running on low speed, add the butter, one cube at a time, mixing until smooth before adding the next one. If the buttercream curdles, continue mixing it, and it will eventually smooth out. Once the meringue buttercream is fluffy and smooth, frost the cake with it and serve. To help give the frosting a smooth finish, I recommend using an icing spatula and dipping it in hot water to warm it up before making a final pass over the frosting.

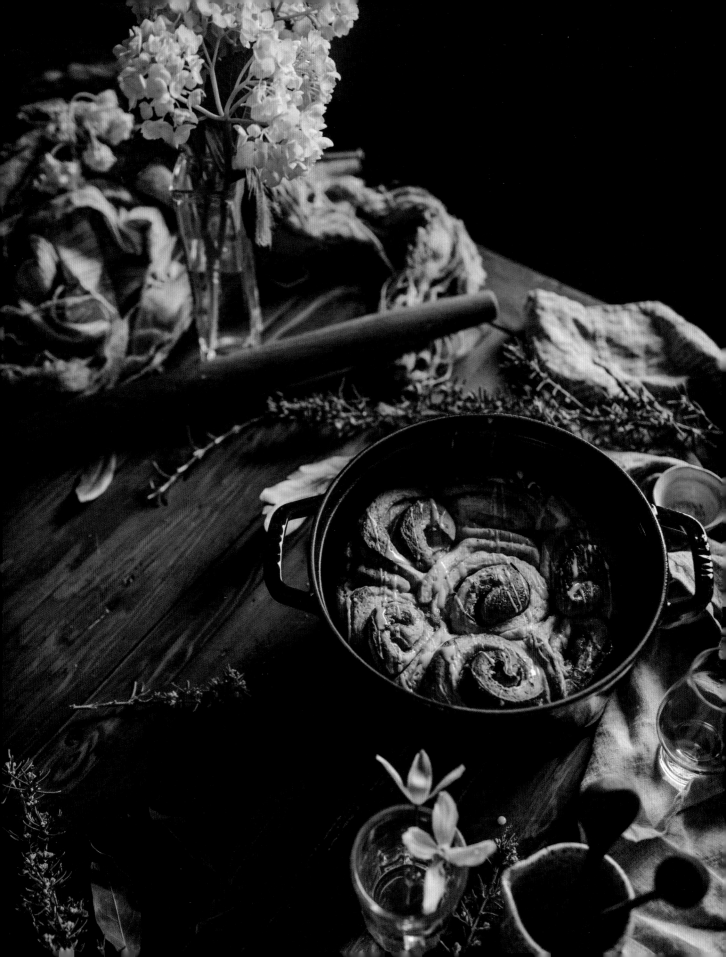

Rosemary-Jasmine Rolls with Whiskey Glaze

— Serves 6 —

Every spring my rosemary bush is sprinkled with beautiful blue blossoms, and I love to put the new growth and blooms to use in a sweet and simple pastry. I put fresh rosemary in the swirls of the rolls and incorporate some dried rosemary into the dough to allow the rosemary flavor to really soak into the mixture. I also infuse the milk used in the dough with jasmine blossom tea, which gives it a very subtle but alluring floral note. To top it all off, I cover the rolls with a ridiculously tasty whiskey glaze. All the flavors come together to make the most refreshing, sweet, buttery, and flavorful rolls I've ever had. And, if you place them in a large Dutch oven like I do, when they're rising, they'll puff up together and form a giant beautiful rosemary roll collage, too.

—For the rosemary-jasmine tea rolls, put the loose tea in a tea ball or strainer and put the ball in the hot milk. Steep for 15 minutes, until the milk has cooled to lukewarm. Remove and discard the tea leaves. Stir the yeast into the lukewarm milk and set aside for 5 minutes.

—In the bowl of a stand mixer fitted with the paddle attachment, combine the eggs, flour, butter, brown sugar, granulated sugar, salt, rosemary, and milk mixture until a rough dough forms. Knead the dough by hand or with the dough hook attachment of your stand mixer until smooth. Place the dough in a bowl lightly greased with oil. Cover and set aside out of direct sunlight to rise until doubled in size, about 1 hour.

—Roll out the dough into a rectangle about ½ inch (12 mm) thick.

—For the rosemary filling, spread the butter over the dough rectangle, then sprinkle the brown sugar and fresh rosemary over it. Roll up the dough like a jelly roll, then use a sharp knife to cut it crosswise into roughly 2-inch (5-cm) slices.

—Place the rolls, cut side up, in a large Dutch oven or casserole pan greased with unsalted butter. Cover and set aside out of direct sunlight to rise until the rolls are puffy and touching one another in the pan, about 1 hour.

—Preheat the oven to 400°F (205°C).

—Uncover the rolls, transfer to the oven, and bake until golden on top, 15 to 20 minutes.

—For the whiskey glaze, in a small bowl, whisk together the confectioners' sugar, milk, sour cream, whiskey, and vanilla until completely smooth. Set aside.

—Once the rolls are done, allow them to cool for 15 minutes before drizzling the glaze over the top. Serve any leftover glaze along with the rolls for dipping.

ROSEMARY-JASMINE TEA ROLLS

1 tablespoon loose jasmine green tea

1 cup (240 ml) hot whole milk

2½ teaspoons instant yeast

2 large eggs, at room temperature

4¾ cups (1 kg) bread flour

⅓ cup (75 g) unsalted butter, cut into pea-size pieces, plus more for greasing the pan

¼ cup (55 g) packed light brown sugar

¼ cup (50 g) granulated sugar

1¾ teaspoons flake kosher sea salt

½ teaspoon dried rosemary

Extra-virgin olive oil, for greasing the bowl

ROSEMARY FILLING

⅓ cup (75 g) unsalted butter, at room temperature

1 cup (200 g) packed light brown sugar

¼ cup (20 g) chopped fresh rosemary leaves

WHISKEY GLAZE

1½ cups (155 g) confectioners' sugar

3 tablespoons whole milk

2 tablespoons sour cream

1 tablespoon whiskey

½ teaspoon pure vanilla extract

Cherry-Almond Custard Tart

— Makes one 9-inch (23-cm) tart —

This tart shows off the beautiful color, shape, and texture of Pacific Northwest cherries in all their glory. There are many cherry orchards lining the Willamette Valley and Columbia Gorge. One of the customers at my parents' deli owned one of these orchards and would drop off a giant box of cherries for us every spring, which was how my obsession with fresh cherries began. It would also kick off the first of now-annual week-long periods where my hands, lips, and teeth are stained blood red due to excessive cherry consumption. My favorite way to snack on them as a kid was to eat one cherry, then an almond, and then a cherry again, and this usually went on until I ran out of either cherries or almonds. To make a fancier version of this snack, I created an almond-based custard and poured it into my go-to tart crust along with halved pitted cherries. The deep tannic flavor of the cherries pairs perfectly with the sweet creamy almond filling and creates a simple and classic dessert that you'll want to make a springtime tradition. As a side note, the almonds need to be soaked for 3 to 8 hours before using, so keep that in mind when you're getting ready to dive in.

TART CRUST

2 cups (270 g) bread flour, plus more for the pan

1 tablespoon sugar

½ teaspoon ground cinnamon

¼ teaspoon flake kosher sea salt

½ cup plus 3 tablespoons (155 g) unsalted butter, frozen, plus room-temperature butter for greasing the pan

1 egg yolk

About ⅓ cup (75 ml) ice water

CHERRY-ALMOND CUSTARD FILLING

½ cup (45 g) blanched slivered almonds

¾ cup plus 1 tablespoon (195 ml) whole milk

¼ cup (60 ml) crème fraîche

3 tablespoons granulated sugar

½ teaspoon pure vanilla extract

½ teaspoon vanilla bean paste

2 egg yolks

4 to 5 ounces (113 to 142 g) cherries, pitted and halved

1 tablespoon confectioners' sugar, for garnish

—For the tart crust, in a large bowl, mix together the flour, sugar, cinnamon, and salt until combined. Grate the frozen butter over the bowl, stirring it every 30 seconds to help coat the individual shards of butter in the flour mixture. Make a well in the center of the mixture and add the egg yolk and half of the ice water. Stir the flour into the well with a fork until a dough starts to form. Add the remaining water around the well and begin to knead the entire mixture together until a cohesive dough forms, adding another tablespoon or two of water, if necessary, to get the dough to come together. Cover with plastic wrap and refrigerate for 30 minutes.

—Grease a 9-inch (23-cm) tart pan well and lightly flour it. Tap out any excess flour.

—Roll out the dough into a circle ¼ inch (6 mm) thick. Press the dough into the prepared tart pan and trim off any excess. Cover with plastic wrap and freeze for 30 minutes.

—Preheat the oven to 350°F (175°C).

—Remove the plastic wrap from the crust and prick it all over with a fork. Bake for 20 minutes. Remove and allow to cool slightly while you prepare the custard.

—For the cherry-almond custard filling, soak the almonds in a bowl of filtered water for 3 to 8 hours. Place a large casserole dish three-quarters full of water on the bottom rack of the oven. Strain the almonds and discard the soaking liquid. In a blender or food processor, combine the soaked almonds, milk, crème fraîche, sugar, vanilla extract, and vanilla bean paste and puree on high speed until completely smooth.

↪ *recipe continues*

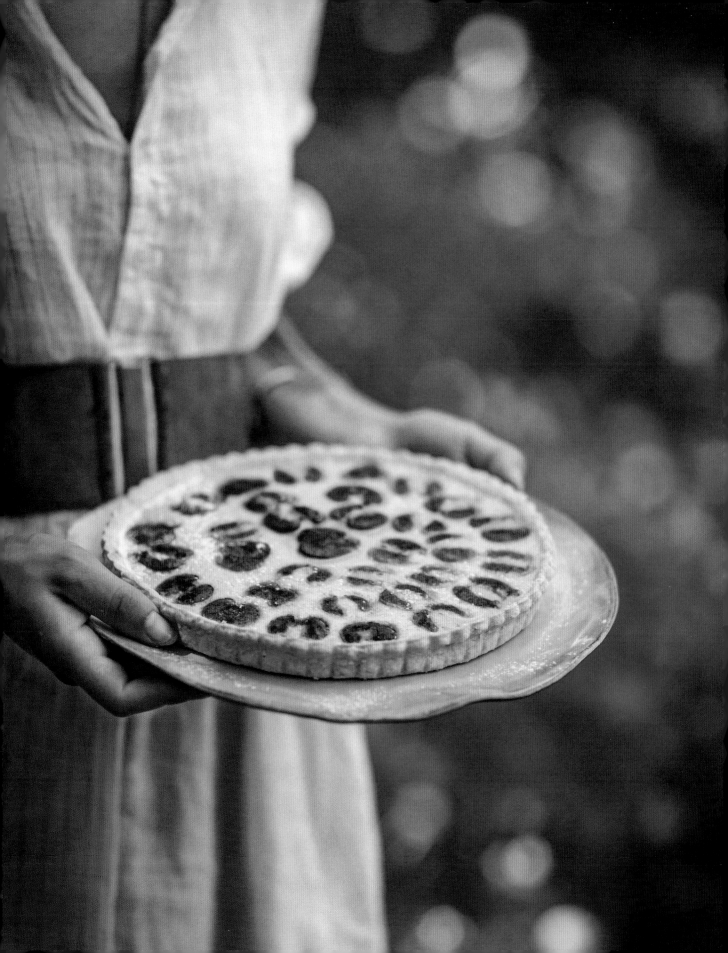

—Pour the mixture into a small saucepan and place over medium-low heat. Cook, stirring every 3 minutes, until it is hot but not boiling. Remove from the heat. Put the egg yolks in a medium bowl and while whisking rapidly, ladle some of the hot milk mixture over them. Continue adding the milk mixture, whisking all the time, until you've added about half, then return the yolk mixture to the saucepan with the remaining milk mixture and place over low heat. Cook, whisking every minute, until the custard has thickened slightly, about 5 minutes.

—Remove the custard from the heat and pour it into the tart crust, filling it about three-quarters full. Arrange the cherry halves in the custard cut side up. Bake until the crust is lightly golden and the edges of the custard are set but the middle is still slightly jiggly, 15 to 20 minutes. Remove and allow to cool to room temperature before sprinkling with the confectioners' sugar and serving.

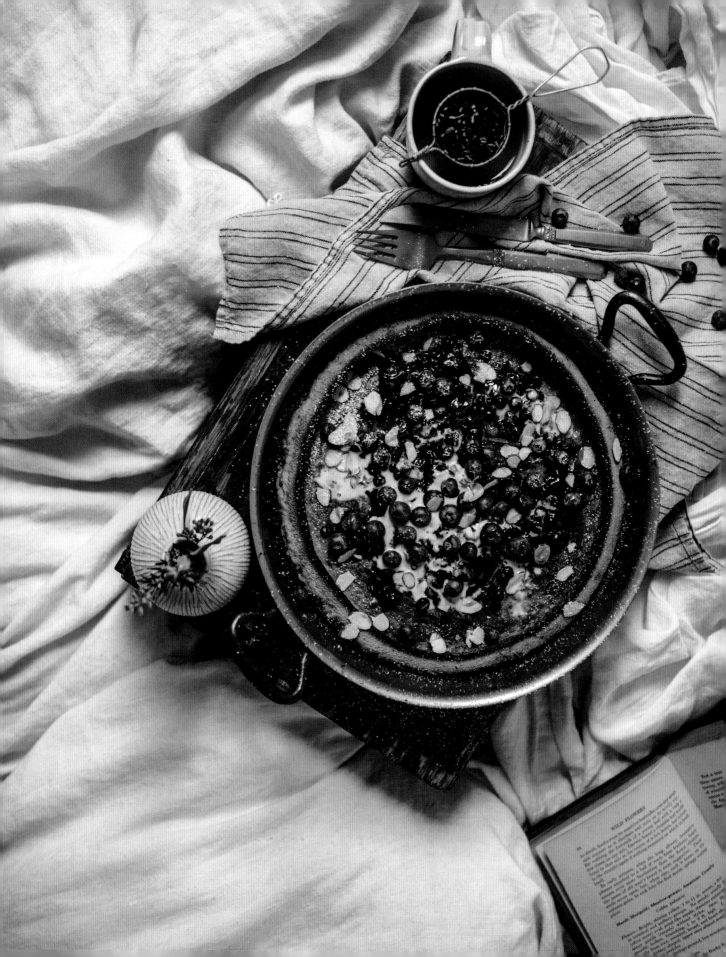

Blueberry Dutch Baby

— Serves 4 —

A Dutch baby is basically one giant, delicious, custardy pancake. If you're from the United Kingdom, you know it as a Yorkshire pudding, and it's more of a savory supper accompaniment, but here in the States, it is mainly a breakfast thing. You preheat the oven to a high temperature with a skillet inside, pour the batter into the skillet when it's hot, and bake. The edges of the pancake curl up and get really puffy, giving this dish major presentation points. You can throw any bits of seasonal fruit into the batter for extra flavor, but my all-time favorite for this is late-spring blueberries. I incorporate some into the batter, and I also make a simple blueberry sauce for serving on top along with a dollop of crème fraîche and sliced almonds. This recipe goes particularly well with my Rosemary and Vanilla Bean Maple Syrup. You can, of course, use regular maple syrup, but this special syrup really kicks it up a notch.

—For the blueberry sauce, combine the blueberries, sugar, and ¼ cup (60 ml) water in a small saucepan. Bring to a boil over medium-low heat. Reduce the heat to low and cook until the blueberries burst and the sauce cooks down and becomes thick and jammy, 10 to 14 minutes. Remove from the heat and set aside.

—For the Dutch baby, preheat the oven to 425°F (220°C). Set an 11-inch (28-cm) au gratin pan or oven-safe skillet inside to preheat for at least 30 minutes.

—In a medium bowl, whisk together the flour, cinnamon, nutmeg, ginger, and salt. Set aside.

—In the bowl of a stand mixer fitted with the whisk attachment, beat the eggs on medium-high speed until frothy, about 2 minutes. Reduce the speed to medium and add the milk, sugar, and vanilla. Add the flour mixture and mix until just combined. Stir in 1 cup (145 g) of the blueberries by hand.

—Carefully remove the hot pan from the oven and add the butter to the pan, swirling it slightly to help the butter melt quickly. Take care, as the butter will hiss and spit a bit when it hits the hot pan. Pour the batter into the pan and place it back in the oven. Bake until the pancake looks puffy and the edges curl up and are golden brown, 16 to 18 minutes.

—Remove and garnish with the crème fraîche or yogurt and blueberry sauce. Top with the almonds, edible flowers (if using), and the remaining ½ cup (75 g) blueberries and serve along with the maple syrup, if desired.

BLUEBERRY SAUCE

1 cup (145 g) fresh blueberries

⅓ cup (65 g) sugar

DUTCH BABY

⅔ cup (90 g) bread flour

½ teaspoon ground cinnamon

¼ teaspoon grated nutmeg

¼ cup (50 g) ground ginger

¼ teaspoon flake kosher sea salt

3 large eggs, at room temperature

⅔ cup (165 ml) whole milk, at room temperature

⅓ cup (65 g) sugar

½ teaspoon pure vanilla extract

1½ cups (220 g) fresh blueberries

4 tablespoons (½ stick/55 g) unsalted butter, cut into individual tablespoons, at room temperature

2 tablespoons crème fraîche or full-fat vanilla yogurt

2 tablespoons sliced almonds

1 teaspoon edible flowers (optional)

Rosemary and Vanilla Bean Maple Syrup (page 25), for serving (optional)

Lilac Cupcakes with
Vanilla-White Chocolate Buttercream

— Makes about 14 —

Lilacs are my favorite edible flower. They taste exactly as they smell, which is absolutely incredible. Their slightly sweet floral quality pairs perfectly with creamy, milky flavors, which is why a white chocolate buttercream is the perfect home for them. I also infuse the cake's milk with fresh lilac blossoms to impart some extra flavor to the cupcakes—please note, though, that the milk needs to infuse overnight. And if you want to make these guys really special, you can candy fresh lilac blossoms and use them as a beautiful and delicate garnish for this dessert. If you've never candied flowers before, I highly recommend it! You brush the petals with a light egg-white wash and then sprinkle them with superfine sugar and set them aside to dry. Once dry, they become crisp, sweet little flower candies and sparkle slightly in the light (so basically, they're the cutest things ever, and you should definitely make them).

CANDIED LILACS
¼ cup (8 g) lilac blossoms

1 egg white, beaten until smooth

⅓ cup (65 g) superfine sugar

CUPCAKES
½ cup (120 ml) whole milk

¼ cup (8 g) lilac blossoms

1½ cups (195 g) cake flour

1¼ teaspoons baking powder

¼ teaspoon flake kosher sea salt

½ cup (1 stick/115 g) butter,
 at room temperature

1 cup (200 g) sugar

2 large eggs

1 teaspoon pure vanilla extract

½ teaspoon vanilla bean paste

VANILLA-WHITE CHOCO-
LATE BUTTERCREAM
6 ounces (170 g) white chocolate

½ cup (1 stick/115 g) unsalted
 butter, at room temperature

¾ cup (75 g) sifted confectioners'
 sugar

½ teaspoon vanilla bean paste

—For the candied lilacs, lightly brush the lilacs with the egg white, then place them in a bowl with the superfine sugar and turn them to coat. Place on a plate lined with a paper towel and set aside to dry completely, about 2 hours. Store in an airtight container in the refrigerator overnight.

—For the cupcakes, in a very small saucepan, heat the milk over low heat until hot but not boiling. Pour into a small bowl with the lilac blossoms and stir. Allow to cool to room temperature, then cover and refrigerate overnight.

—Preheat the oven to 375°F (190°C). Line 2 muffin pans with cupcake liners.

—In a medium bowl, stir together the flour, baking powder, and salt until combined. Set aside.

—In the bowl of a stand mixer fitted with the paddle attachment, cream together the butter and sugar on medium speed until smooth, about 1 minute. Add the eggs, one at a time, mixing well after each addition. Add the vanilla extract and vanilla bean paste and mix until combined.

—Strain the lilacs out of the milk, reserving the milk. With the mixer running, alternate between adding the infused milk and flour mixture in three increments. Beat until just combined. Evenly distribute the batter among the cupcake liners, filling them about three-quarters full. Bake until the cupcakes are golden brown on top and a toothpick inserted into the center comes out clean, 16 to 18 minutes. Remove from the oven and allow to cool to room temperature.

—Meanwhile, for the vanilla–white chocolate buttercream, bring water in the bottom of a double boiler to a boil over medium heat. Reduce the heat to low. In the top of a double boiler, melt the white chocolate, stirring continuously until completely smooth.

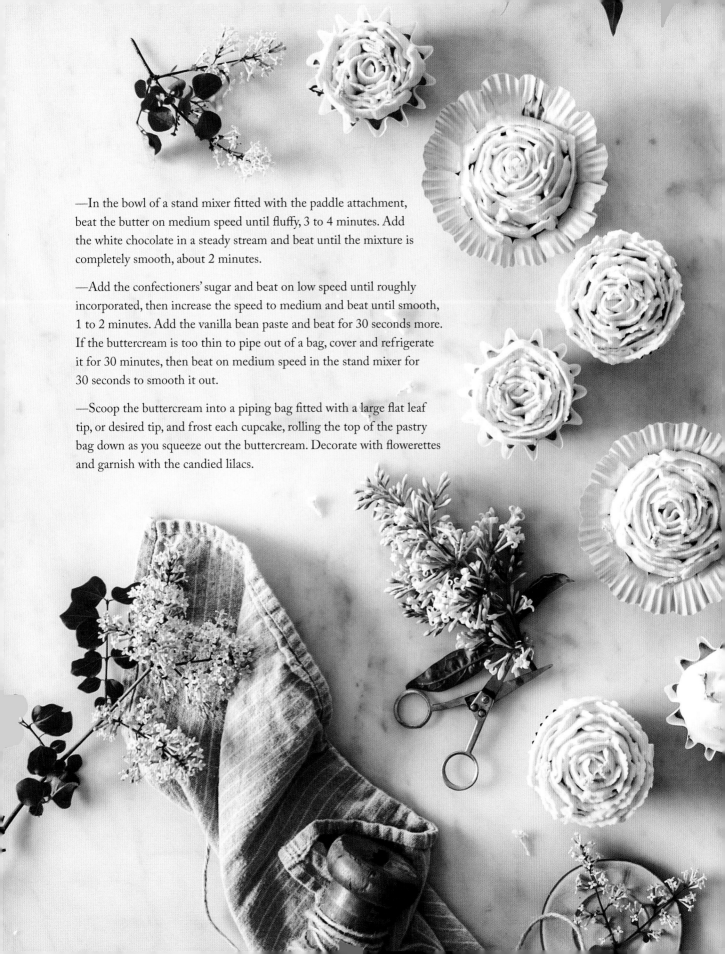

—In the bowl of a stand mixer fitted with the paddle attachment, beat the butter on medium speed until fluffy, 3 to 4 minutes. Add the white chocolate in a steady stream and beat until the mixture is completely smooth, about 2 minutes.

—Add the confectioners' sugar and beat on low speed until roughly incorporated, then increase the speed to medium and beat until smooth, 1 to 2 minutes. Add the vanilla bean paste and beat for 30 seconds more. If the buttercream is too thin to pipe out of a bag, cover and refrigerate it for 30 minutes, then beat on medium speed in the stand mixer for 30 seconds to smooth it out.

—Scoop the buttercream into a piping bag fitted with a large flat leaf tip, or desired tip, and frost each cupcake, rolling the top of the pastry bag down as you squeeze out the buttercream. Decorate with flowerettes and garnish with the candied lilacs.

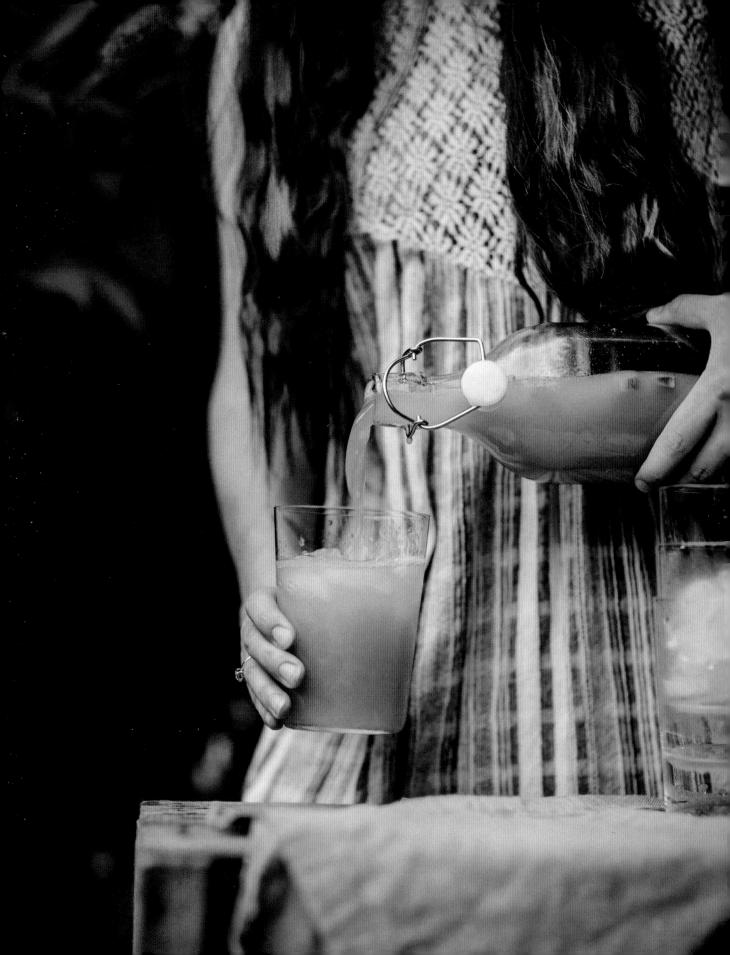

Rhubarb-Ginger Planter's Punch

— Serves 4 —

Planter's punch is my favorite warm-weather drink to make for parties. It involves rum (my favorite liquor), pineapple juice (my favorite mixer), lime juice (my favorite citrus), and, traditionally, grenadine syrup, which I always nix and instead use as an opportunity to insert some seasonal fruit syrup into the drink. For this cocktail, I made a tangy, bright syrup using fresh ginger and rhubarb from my garden. The syrup is super-easy to make—you pretty much just simmer all the ingredients together for a bit and then strain them—and the punch just involves dumping everything into a pitcher and stirring it for a few seconds. It's a great go-to cocktail that you can always change up simply by subbing in different fruits for the syrup. I've also made this with a strawberry-balsamic syrup and a blueberry-mint one, and I highly recommend trying out both!

—For the rhubarb-ginger syrup, in a small saucepan, combine the rhubarb, ginger, sugar, and ¾ cup (180 ml) water and bring to a boil over medium-high heat. Reduce the heat to low and cook until the rhubarb has nearly disintegrated and the ginger has softened, 10 to 15 minutes. Remove from the heat and allow to cool for 5 minutes. Strain the syrup into a bowl and discard the solids.

—For the planter's punch, in a large pitcher, stir together the pineapple juice, rum, lime juice, ¼ cup (60 ml) of the rhubarb-ginger syrup, and the rhubarb slices. Distribute among four ice-filled glasses and serve.

RHUBARB-GINGER SYRUP

3 rhubarb stalks, cut into slices ½-inch (12-mm) thick

1 (2-inch/5-cm) piece fresh ginger, peeled and cut into 4 slices

¾ cup (150 g) sugar

PLANTER'S PUNCH

2 cups (480 ml) pineapple juice

1½ cups (360 ml) golden rum

¼ cup (60 ml) fresh lime juice

1 (6-inch/15-cm) piece rhubarb, cut into slices ½-inch (12-mm) thick

Lilac Iced Latte

— Makes ½ cup (120 ml) lilac syrup and 1 iced latte —

I am a latte kind of gal, and by that, I mean that when I need a caffeine boost, I usually put about 2 tablespoons of coffee in a mug, sprinkle a pinch of sugar on it, and dump about a cup of whole milk on top. I definitely have a milk thing. But I understand that most people don't have my milk-heavy predilection, so I changed up my recipe for a more standard milk-to-coffee ratio in this latte, and I incorporated a bit of delicious fresh lilac syrup. I know it might sound strange to have floral flavors mixed with coffee, but I swear that it actually tastes incredibly refreshing, very soothing, and gives the latte a slightly sweet flavor in the same way that vanilla bean does. As far as the coffee goes, I recommend using quality beans from a roaster that you trust. Using burnt beans from a giant coffee conglomerate will not make for as tasty a latte as gently roasted ones from the coffee nerds at the local roastery. And, unlike the other beverages in this book, this recipe is for one serving, since you'll probably just be making this for yourself for a little caffeine kick. The lilac syrup makes enough for lots of iced lattes, though, so I recommend storing it in the refrigerator and using it to make yourself a little iced latte every day during the warmer months.

LILAC SYRUP
¼ cup (8 g) lilac blossoms
¼ cup (50 g) sugar

LATTE
¼ cup (60 ml) chilled coffee
¼ cup (60 ml) whole milk

—For the lilac syrup, combine the lilac blossoms, sugar, and ¼ cup (60 ml) water in a very small saucepan and bring to a boil over medium-low heat. Reduce the heat to its lowest setting and simmer, uncovered, for 5 minutes. Remove from the heat and allow to cool to room temperature. Strain into a bowl and discard the solids. Store the lilac syrup in an airtight container in the refrigerator for up to 2 weeks.

—For the latte, in a tall glass, stir together 2 teaspoons of the lilac syrup and the chilled coffee. Pour the coffee mixture into a separate large glass filled with ice cubes, then add the milk and serve.

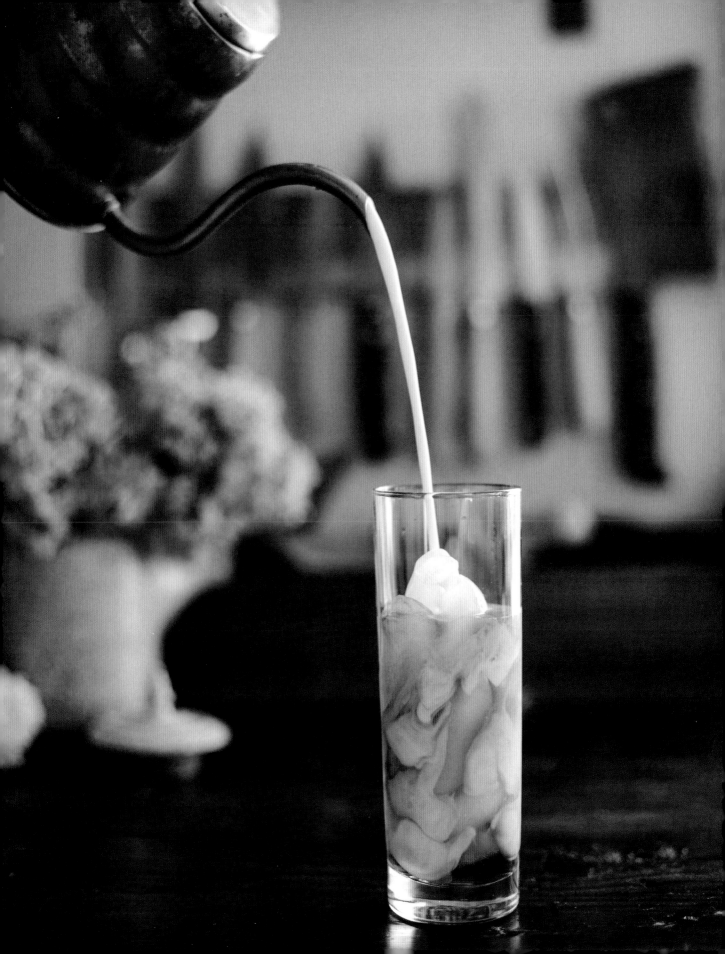

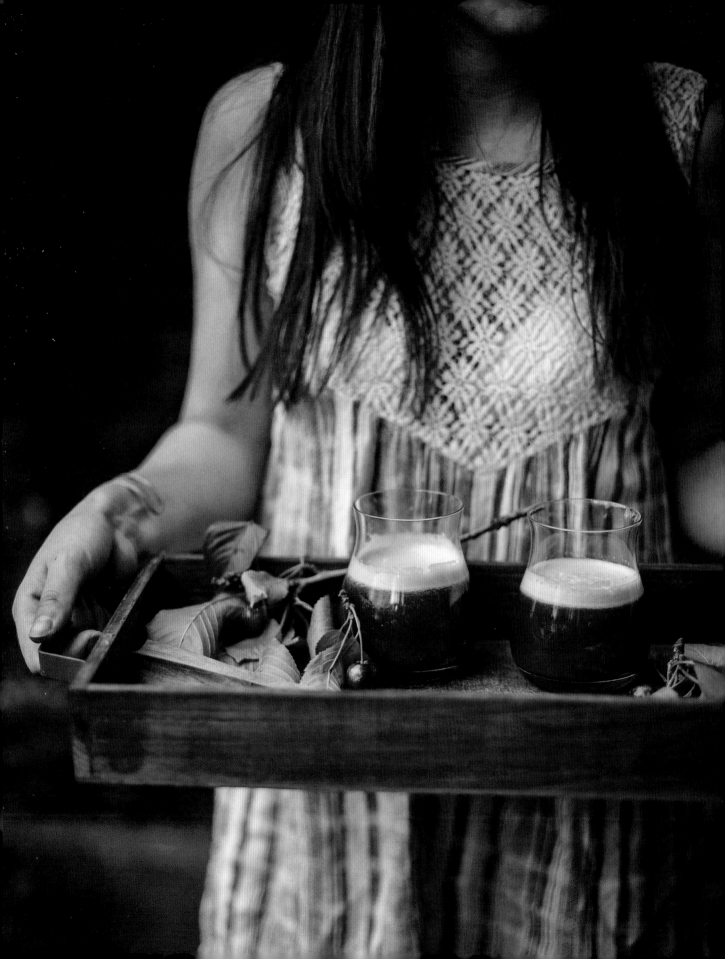

Black Cherry–Tarragon Shrub and The Silky Black Cocktail

— Cocktail serves 2, 2½ cups (590 ml) shrub —

Because of the heatwaves we've had in the Northwest the past couple of years, our cherry tree has been especially heavy with fruit the past few springs. So this year, I decided to take full advantage of its abundant crop, pushed my wobbly ladder right up against the fence, and leaned over the neighbor's garden to reach the ripest branches that had, of course, grown away from our house (why, why does this always happen with fruit trees?). I was able to fill up a few colanders' worth, until a horsefly startled me by flying right into my eye, which I took as a sign to get off the ladder and stop hanging into my neighbor's yard.

I used some of my harvest in a refreshing shrub to wage my own miniature battle against the high temperatures. Back in the days before refrigeration, vinegar and sugar were used to help preserve the juices of fresh fruit. You'd basically just macerate together a bunch of fruit, sugar, and vinegar and let it sit for a few days, then strain out the pulp and save the liquid, which would usually keep for over a week. As a lover of kombucha and all flavors both sweet and sour, I can say that sipping a cool shrub on a hot day is a particular kind of refreshing. And to make it even more pleasurable, I made it into a cocktail. I wanted it to be fruity and dark with a wonderfully smooth mouthfeel, so I paired the shrub with golden rum, egg white, and crème de cassis, a French liqueur made from blackcurrant berries, that is incredibly rich and fruity without being cloyingly sweet, one of the few liqueurs to toe that line perfectly. The result is a silky cocktail with lightly herbal tones and a deep, dark-fruited flavor that's sure to keep you feeling cool no matter what the temperature.

—For the black cherry–tarragon shrub, pulse all the ingredients together in a blender a couple of times until the cherries are chopped and pulpy. Pour the cherries into a bowl and cover with plastic wrap. Refrigerate overnight.

—Strain the syrup into a bowl and discard the solids. Distribute the liquid between two clean mason jars. Screw on the caps and refrigerate until ready to use. You can drink it as is, combined with sparkling water for a bit of carbonation, or mixed into cocktails.

—For the silky black cocktail, combine 4 ounces (120 ml) of the shrub, 4 ounces (120 ml) of the rum, 2 ounces (60 ml) of the crème de cassis, and 1 egg white in a cocktail shaker with the crushed ice. Shake aggressively for 1 to 2 minutes, then strain into a glass. Repeat with the remaining ingredients and the ice in the cocktail shaker to make a second drink.

BLACK CHERRY–TARRAGON SHRUB

2 pounds (910 g) black cherries, stemmed and pitted

1 cup (200 g) sugar

¼ cup (60 ml) sherry vinegar

2 tablespoons chopped fresh tarragon

THE SILKY BLACK COCKTAIL

8 ounces (240 ml) golden rum

4 ounces (120 ml) crème de cassis (blackcurrant liqueur)

2 large egg whites

½ cup (65 g) crushed ice

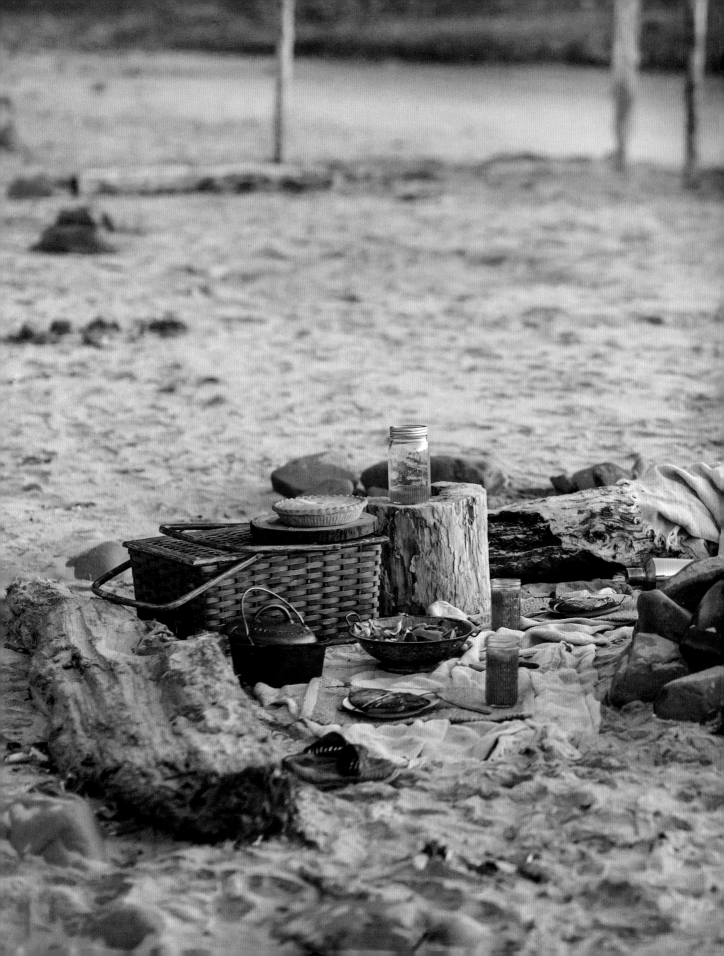

— MENU FOR A SUMMER COOKOUT —

Summer in the Pacific Northwest is a wonderful time to be alive. The weather is sunny and warm, the forests are bright green, the plants in the garden are heavy with fruit—there's just an abundance of life exuding out of every living thing, and it is absolutely glorious. Once the weather gets warm, my favorite place to go is the coastline along northwestern Oregon. The ocean is still too cold for swimming, but you can lay out in the sand, soaking up the sunshine, and get a little campfire going on the beach for some tasty woodfire cooking. I have a delicious and summery cookout menu for you below, and while doing cookouts in the great outdoors is super fun, this menu tastes just as good at home on the patio as it does kickin' back on the beach.

Fig, Prosciutto, and Spinach Salad with Chèvre
and Preserved Lemon Vinaigrette
page 135

Mussels in Tomato and White Wine Broth
page 121

Fire-Roasted Lime Fish
page 122

Huckleberry Pie
page 149

Strawberry-Habanero Daiquiri
page 162

"Ô, Sunlight! The most precious
gold to be found on Earth."

—ROMAN PAYNE

Transplanting and Maintaining Plants

—

YOU ARE READY TO TRANSPLANT your seedlings to their permanent home when their little roots are poking out of the bottom of the containers. I recommend using a soil mix that meets the needs of the specific type of plants you're trying to grow. If you're container gardening (growing things in pots rather than in the ground), a general potting soil mix should be fine for most fruit and vegetable varieties (I recommend Black Gold). You can add organic fertilizers, as needed.

While there are many minerals and nutrients that help plants grow, fertilizers provide three basic nutrients that are critical to plant health: nitrogen (N), phosphorus (P), and potassium (K), or potash. Nitrogen is necessary to create chlorophyll, which helps plants grow faster and have healthy green leaves. Phosphorus helps with root and flower development, and potassium helps plants distribute water and nutrients evenly throughout the plant (it basically helps keep their circulatory systems running smoothly). When you look at fertilizer blends, there are usually three numbers listed, and each number corresponds to a percentage. So, in a fertilizer labeled 20-05-10, the fertilizer is made up of 20 percent nitrogen, 5 percent phosphorus, and 10 percent potassium, in that order.

I recommend shying away from the chemical fertilizer blends, because these contain harsh ingredients that will build up in the soil over time. This can have really damaging long-term effects on water runoff, which is harmful to beneficial insects, like earthworms, and the animals who eat those insects or drink that water, like birds and deer. Instead, I suggest using natural fertilizers, like compost, blood meal, bone meal, earthworm casings, chicken manure, and/or kelp meal. I talk in more detail about making your own compost on page 169, but compost basically is a nutrient-rich substance that contains all three of the main nutrients, as well as healthy bacteria, insects, and micronutrients that promote biodiversity within the soil and provides overall nourishment for plants. Blood meal is really high in nitrogen and makes a great fertilizer for nitrogen-loving plants like lettuce and rhubarb. Bone meal is high in phosphorus and is perfect for plants like tomatoes that rely on healthy and prolific blossoms to create fruit. Kelp meal is high in potassium and is useful for most types of plants, but be careful with acid-loving plants like blueberries and hydrangeas, because adding too much phosphorus or potassium can make the pH of the soil too alkaline for these guys.

As long as you keep in mind the nutritional needs of the plant that you're trying to grow, you'll be fine. A quick Internet search about soil requirements should yield the information you need, and there's no harm in investing in a good gardening encyclopedia, too. So get out there and start growing your own—your stomach and taste buds will thank you! And the following tips on transitioning your seedlings to their permanent home should help make the process simple.

Getting Started

—

TOOLS

Gardening trowel

Kneeling mat (optional)

Watering can

Plant stakes (Popsicle sticks work great)

Organic fertilizer

Compost

—If you are transplanting a young seedling, prepare the soil and then dig out an area that's wide enough and deep enough to accommodate the existing root ball of the seedling, plus about 4 inches (10 cm) around it and 3 inches (7.5 cm) deeper. If you are transplanting a larger, more-mature plant that's in a container about 12 inches (30.5 cm) in diameter, you'll need to dig out twice the diameter of the root ball of the plant around it, and 6 to 10 inches (15 to 25 cm) deeper than the root ball of the plant (depending on how large the plant is—a larger plant should have a deeper hole).

—To remove the plant from its current container, gently squeeze the sides of the container. If it is a small seedling, slowly and gently turn the container to a 45-degree angle and tap it against your hand until the seedling and its root ball of soil begin to slide out of the container. Pull it out holding the soil ball and *not* the stem. Seedling stems are very fragile and can snap easily if you pull on them. If it is a larger, more-mature plant, also hold the stem and pull on it gently to help get the root ball and soil to come out of the container.

—Hold the seedling by its root ball or adult plant by its stem over the hole, positioning it so that the top of the root ball of the plant is just below the soil surface. Add just enough of the prepared soil underneath the plant so that it touches the roots. Remove the plant, water the hole thoroughly, and place the plant back in the hole by its stem if it's a mature plant, and by its soil ball if it's a delicate seedling. Gently fill in the hole around the plant's roots with the prepared soil until it is even with the surface soil. Pat the soil down gently around the stem of the plant to secure it in place, but don't press down hard, otherwise you can damage the roots of the plant. Use your trowel to mound the ground soil to create a raised ring of soil 12 inches (30.5 cm) in diameter around the plant. This will help keep the water near the plants' roots when you water it. Water the area around the plant very thoroughly.

—It's best to water either in the early morning or late evening to reduce the amount of water that evaporates due to direct sun exposure. As you're watering, try not to splash the leaves, especially in hot weather, otherwise you risk fungus latching on to the wet leaves and infecting the plant. Water as needed for your plant variety, and enjoy your harvest!

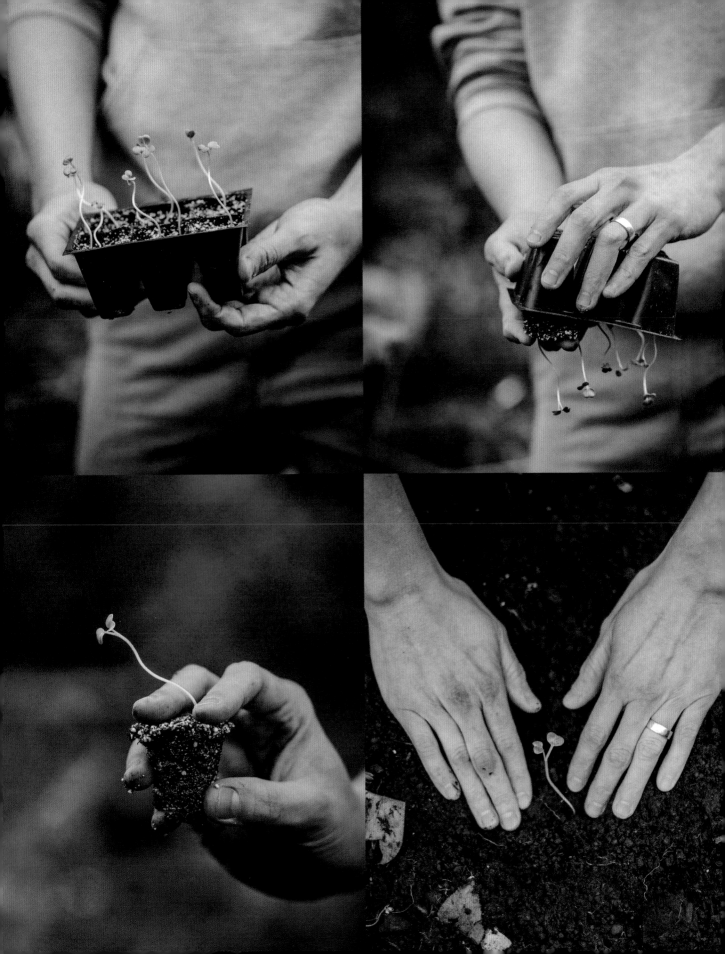

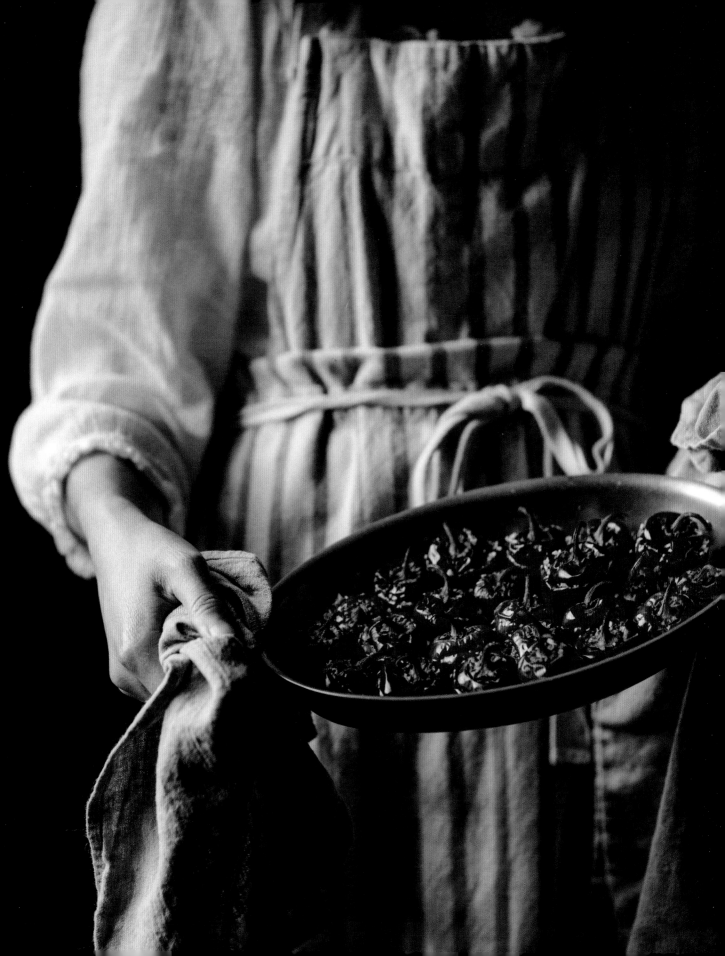

Manchego-Stuffed Petite Peppers

— Makes about 24 —

I love using red mini bell peppers from my garden for this recipe—they're about 1½ inches (4 cm) in diameter and length and make for the perfect little bite-size pepper snack. I stuff these little guys with a mixture of garlic, rosemary, bread crumbs, and delicious grated Manchego cheese. Manchego, a firm, aged Spanish sheep's milk cheese, has a wonderfully mild, almost hazelnutty flavor that makes an ideal complement to the sweet and juicy bell pepper flesh. Please note that if you use a different variety of pepper that is larger, you will not have enough stuffing for twenty-four peppers.

—Preheat the oven to 400°F (205°C).

—In a small skillet, heat the oil over medium-low heat. Add the garlic and cook, stirring every minute or so, until fragrant and lightly golden around the edges, about 5 minutes. Set aside.

—Cut the caps off the tops of the peppers, reserving them for later, and remove the seeds. Arrange the peppers in a small roasting pan or casserole dish so that the tops are facing up. Set aside.

—In a small bowl, combine the cheese, bread crumbs, rosemary, garlic, and any oil from the pan. Use a small spoon to stuff the filling inside each pepper. Replace the tops.

—Roast until the cheese has melted and the peppers have deepened in color and some of them have slight char marks on the top, 25 to 30 minutes.

2 tablespoons extra-virgin olive oil

3 garlic cloves, minced

24 petite red sweet bell peppers (about 1 pound/455 g)

2½ cups (287 g) Manchego cheese, grated

½ cup (40 g) panko bread crumbs

1½ teaspoons finely chopped fresh rosemary leaves

Roasted Sweet Pepper Spread

— Makes about 1½ cups (360 ml) —

My parents sold ajvar, *a Slavic sweet pepper and eggplant spread, at their deli, and the eastern-European immigrants of Portland would buy the jars in bulk. I was always very curious about the bright red-orange paste, but I never actually tried it until I went to Croatia, where it was absolutely everywhere. When I took my first spoonful, I completely understood what the fuss was about. A smooth, creamy blend of caramelized sweet peppers, savory garlic, and rich olive oil hit me full force, and it was love at first bite. I became so obsessed with the sweet pepper flavor that I ended up omitting the eggplant entirely in my subsequent versions of the dish, and so it has just become a simple but very delicious sweet pepper spread. I personally am a big fan of ajvarski peppers, but any would work well here. Just note that if you use small sweet peppers, the cooking time will be shorter, so keep a close eye on them while they're roasting and place them on a separate pan from the onions, since the onions will likely take longer to cook.*

2 pounds (910 g) ajvarski or other sweet bell peppers

1 large yellow onion, cut into eighths

1 tablespoon extra-virgin olive oil

3 garlic cloves, crushed

1½ teaspoons flake kosher sea salt

½ teaspoon paprika

½ teaspoon sugar

¼ teaspoon freshly cracked black pepper

Bread or crackers, for serving (optional)

—Preheat the oven to 450°F (230°C).

—Lightly brush the bell peppers and onion with the oil and place them on a baking sheet. Roast until the pepper skins are very soft and have light char marks, and the onion slices turn golden brown around the edges, 30 to 40 minutes, turning the peppers once halfway through. Remove and allow to cool slightly.

—Peel and discard the skin from the peppers; remove the stems and seeds. Place the peppers and onion mixture, garlic, salt, paprika, sugar, and black pepper in a food processor or blender and blend on high speed until completely smooth.

—Serve with bread or crackers, if desired, or use as a condiment on sandwiches, wraps, and burgers. Will keep in an airtight container in the refrigerator for up to 2 weeks.

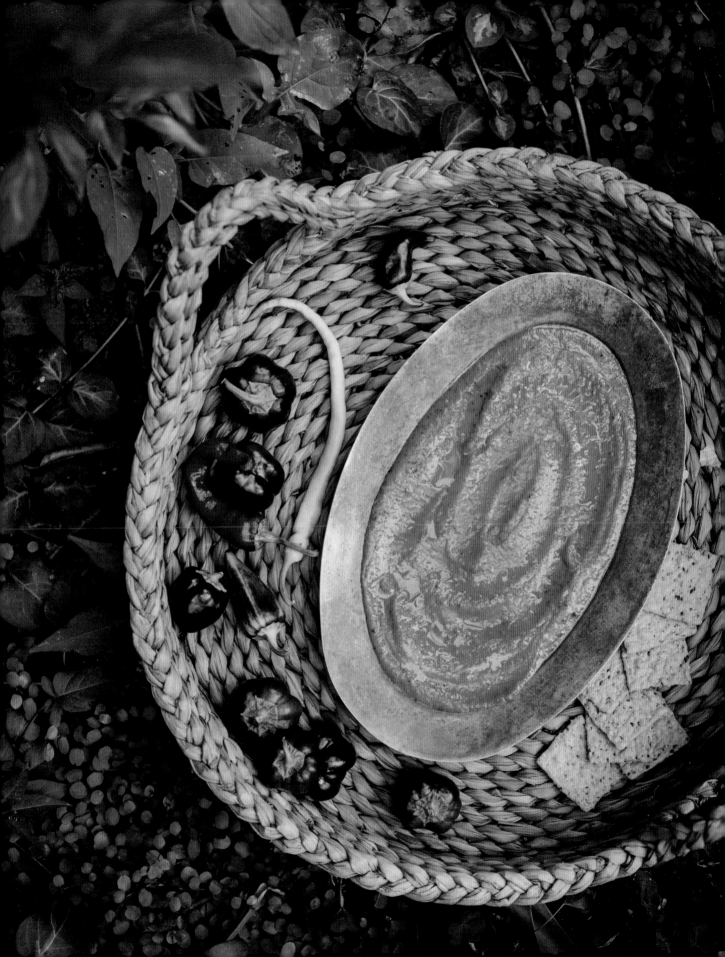

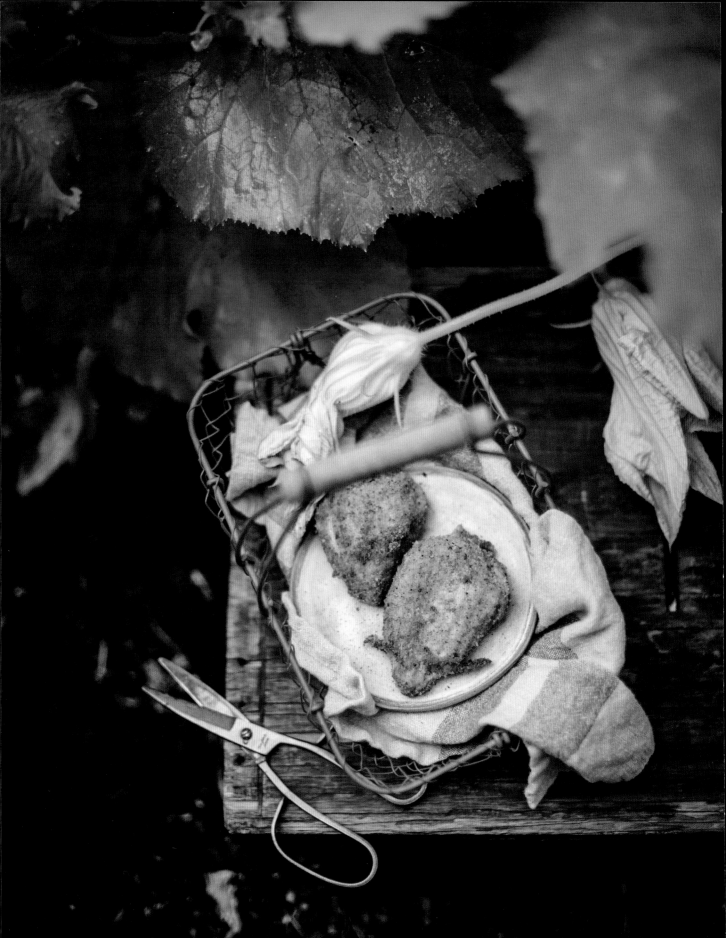

Feta-and-Paprika–Stuffed Squash Blossoms

— Makes 12 —

Squash plants are studded with large yellow blossoms beginning in early summer and sometimes keep them all the way into early fall. They are easy to find in farmers' markets and can vary in size, depending on the squash variety, but tend to be just a slight bit bigger than a tulip blossom. The ease with which their petals can be gently pried apart and stuffed makes them a perfect natural vessel for other delicious foods, which, in this case, is a mixture of feta cheese, cream, and paprika. This is a very rich appetizer—Jeremy aptly likened it to mild jalapeño poppers in squash blossom form—and it pairs really well with a light and fresh snack like lightly salted sliced cucumbers or tomatoes with olive oil.

—For the stuffed squash blossoms, combine the feta, bread crumbs, and cream in a blender and blend on medium-high speed until smooth, stopping to scrape down the sides of the container with a spatula, as needed. Pour the mixture into a medium bowl, add the eggs, and stir until combined.

—Fill each squash blossom about two-thirds full with the feta mixture. Fold the last third of the petals over the filling and press down gently to seal. Set the stuffed squash blossoms aside on a plate.

—For the bread crumb coating, in a small bowl, mix together the bread crumbs, paprika, and salt. In another small bowl, beat the egg. Dip the stuffed blossoms in the egg, then roll them in the bread crumbs until evenly coated.

—Fill a large skillet with 2 inches (5 cm) of oil; be sure there is at least 4 inches (10 cm) between the top of the pan and the top of the oil. Heat the oil over medium-high heat until it registers 350°F (175°C) on a deep-fry thermometer.

—Working in batches, add the squash blossoms to the oil using a slotted spoon, leaving at least 1 inch (2.5 cm) of space around each blossom. Fry until they are golden brown on each side, about 3 minutes per side.

—Remove with a slotted spoon and set aside on a plate lined with paper towels. Serve immediately.

STUFFED SQUASH BLOSSOMS

18 ounces (510 g) feta cheese

1 cup (100 g) plain bread crumbs

2 tablespoons heavy cream

2 eggs, beaten

12 squash blossoms

Canola oil, for frying

BREAD CRUMB COATING

¾ cup (75 g) plain bread crumbs

1½ teaspoons paprika

¾ teaspoon flake kosher sea salt

1 egg

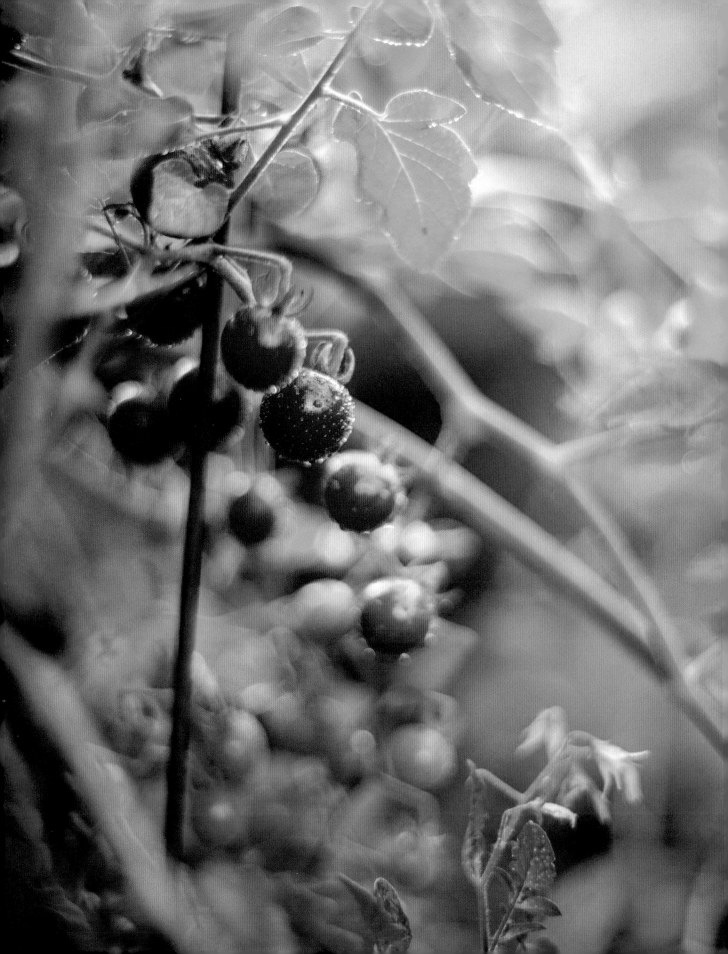

Roasted Cherry Tomato Chips

— Makes about 2 cups (100 g) —

My tomato plants are the most prolific things in my garden, and as a result, I've come up with a wide variety of uses and preservation methods. I originally tried slicing plum tomatoes in half and roasting them to make a pureed tomato spread, but then I started using cherry tomatoes, since my cherry tomato plant had essentially exploded, and I couldn't eat the little buggers as quickly as it was producing them. When I pulled the first batch out of the oven, the tiny tomato halves had cooked so quickly that they were a bit too dry to puree into a paste, but instead had turned into these amazing little papery tomato chips that had concentrated all the sweet, tangy, and savory flavors of a rich tomato sauce into one tiny sliver of heaven. It was one of the best mistakes I've ever made, and I've been whipping up big batches of these ever since, enjoying them in place of potato chips and popcorn as a flavorful and summery snack.

—Preheat the oven to 350°F (175°C).

—In a medium-sized bowl, gently toss the tomatoes with the olive oil to coat. Put the tomatoes on a baking sheet cut side up, and sprinkle with the salt and pepper. Roast the tomatoes, watching them closely, until they have reduced by half, have released most of their moisture, are very wrinkled, and are golden brown around the edges, 40 minutes to 1 hour, depending on the juiciness of the tomatoes.

—Remove from the oven and allow to cool to room temperature before enjoying as a snack. Will keep in an airtight container in the refrigerator for up to 1 week. You can also place them in an even layer on a baking sheet lined with parchment paper, freeze them, and then transfer them into an airtight jar in the freezer to toss into soups and stocks for concentrated tomato flavor throughout the fall and winter months.

1 pound (455 g) cherry tomatoes, halved

1 tablespoon extra-virgin olive oil

¾ teaspoon flake kosher sea salt

¼ teaspoon freshly ground black pepper

Summer Squash Fritters with Cucumber Tzatziki

— Serves 4 —

My mother makes zucchini fritters every summer, and there's just something about their crunchy exterior and smooshy squash-filled interior that makes me drool a little bit at the thought of them. I like my fried goodies dipped in other spreadable goodies, so I pair them with one of my all-time favorite dips, my father's tzatziki recipe. It is so cooling and refreshing in the summer and goes incredibly well with anything rich or bold in flavor (think proteins like beans, lamb, and beef, or fried foods like these fritters or calamari). If you're having a party, these can make great appetizers for the group, or you can enjoy them as a main dish for a few people.

CUCUMBER TZATZIKI

1 large cucumber, peeled and seeded

1¼ cups (300 ml) plain whole Greek yogurt

3 garlic cloves, minced

½ teaspoon minced fresh dill

¾ teaspoon distilled white vinegar

½ teaspoon flake kosher sea salt

¼ teaspoon freshly cracked black pepper

SUMMER SQUASH FRITTERS

3 large eggs, beaten

2 large grated summer squash (about 4 cups/480 g)

⅔ cup (165 ml) sour cream

½ cup (50 g) grated Parmesan cheese

1 tablespoon chopped fresh basil

2 teaspoons flake kosher sea salt

2 teaspoons finely chopped peppercorn preserved lemon rind (page 31), or 1 tablespoon freshly grated lemon zest

1 teaspoon garlic powder

Canola oil, for frying

—For the cucumber tzatziki, grate the cucumber on the large holes of a box grater or use the large-hole grating blade (¼-inch/6-mm diameter) of a food processor.

—Place three medium bowls out on your work surface. Fill one bowl with the grated cucumber. Grab a handful of it and squeeze it between your hands over the second bowl, expressing as much liquid from the cucumbers as you can. Place the compressed grated cucumber in the third bowl. Repeat until all the cucumber has been compressed. You can either discard the cucumber water, or refrigerate it and enjoy it as a refreshing beverage.

—Add the yogurt, garlic, dill, vinegar, salt, and pepper to the bowl with the cucumber and stir until combined. Cover and refrigerate.

—For the summer squash fritters, in a medium bowl, mix together the eggs, squash, sour cream, Parmesan, basil, salt, preserved lemon rind, and garlic powder until combined. Set the batter aside to rest for 20 minutes.

—Fill a large skillet with 1 inch (2.5 cm) of oil. Heat over medium-high heat until it registers 350°F (175°C) on a deep-fry thermometer. Add ⅓ cup (75 ml) of the batter to the pan and use the back of a spoon to help flatten it into a disk shape. You can cook several fritters in one batch, as long as you leave at least 1 inch (2.5 cm) of space between the fritters in the pan. Cook until golden on each side, 3 to 4 minutes per side. Use a slotted spoon to transfer the cooked fritters to a plate lined with paper towels. Serve immediately with the cucumber tzatziki.

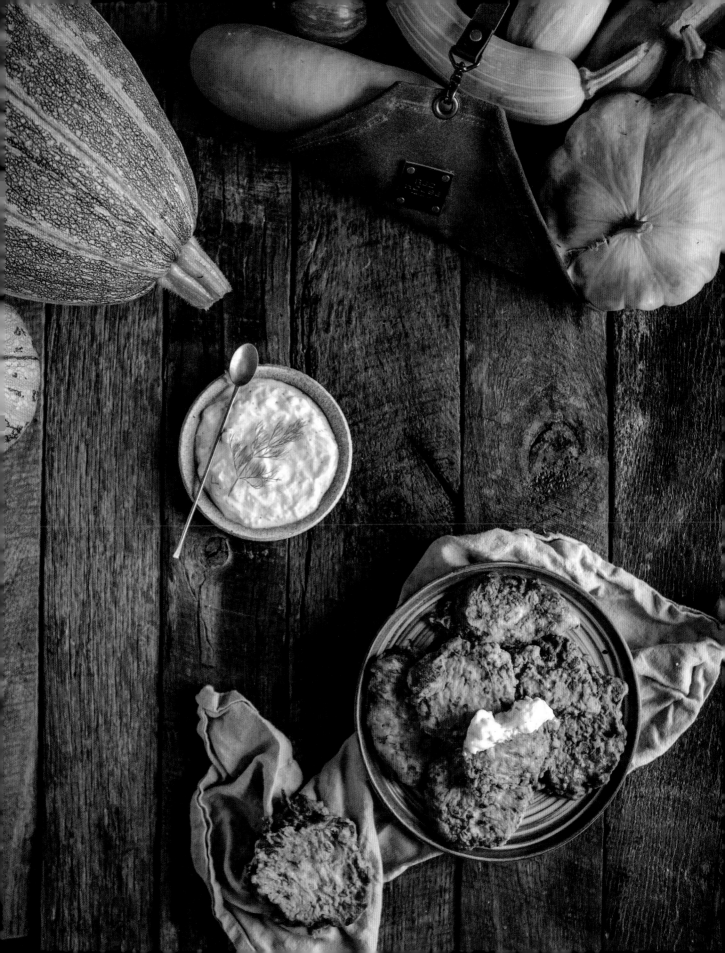

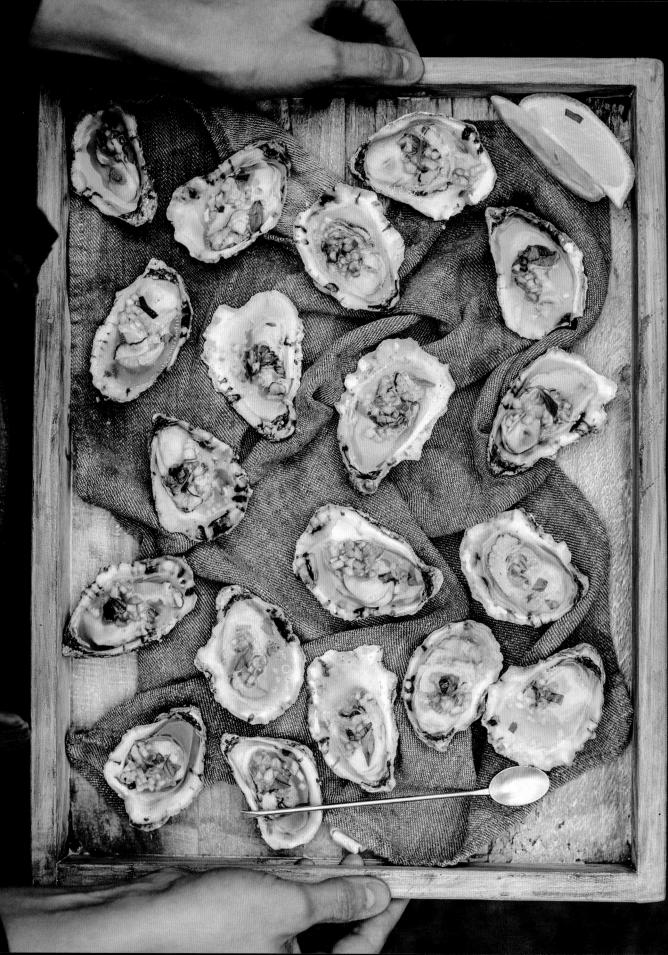

Grilled Oysters with Shallot and Sherry Vinegar Mignonette

— Makes 24 —

This is a summer staple at the Kosmas-Flores household. We have incredibly delicious oysters from Netarts Bay here in Oregon, and when I first put one to my lips, it started a long and delicious addiction. A good oyster should be meaty, have traces of brine from the sea, and have the slightest almost-mineral taste to it. Their flavor is actually quite mild, and that's why they hold the light smokiness from hot coals so well. It's also why they pair so wonderfully with bold flavors like sherry vinegar, shallots, lemon juice, and fresh basil in the bright and piercing mignonette that tops them here. Best of all, this recipe is super-quick and easy to make. The oysters take less than five minutes on the grill at the right temperature, and the mignonette takes about five minutes to toss together. It's the perfect meal for those lazy summer days when all you want to do is hang out on the deck with an ice-cold beer and really, really good food.

—In a small bowl, whisk together the vinegar, shallot, lemon juice, oil, and salt until combined. Cover and refrigerate.

—Heat a charcoal grill until the coals are pale gray and glowing orange, or heat a gas grill to medium.

—Wipe down the oysters with a towel and place them on the grill rack with the deepest side of the shells on the bottom. Close the grill lid and cook until the oysters start popping open, checking after 3 to 4 minutes.

—Immediately remove them from the grill using gloves or tongs and place on a serving platter. Shuck the oysters, removing the top shell, and drizzle a spoonful of the mignonette over each one. Garnish each one with a small pinch of the chopped basil and serve immediately with the lemon wedges.

⅓ cup (75 ml) sherry vinegar

3 tablespoons finely chopped shallot

2 tablespoons fresh lemon juice

1 tablespoon extra-virgin olive oil

¾ teaspoon flake kosher sea salt

24 oysters

3 tablespoons finely chopped fresh basil

1 lemon, cut into eighths

Charred Broccolini and Avocado Tacos with Roasted Tomatillo Salsa

— Serves 2 to 4 —

These tacos are a great use of fresh summer broccolini. My favorite method of cooking broccolini is by either roasting or grilling it just until the ends of each floret get crispy and the stems turn bright green. If you can't find broccolini, you can use broccoli instead, but you will need to make sure that the broccoli is broken into individual florets about 1 inch (2.5 cm) in diameter, since broccoli heads are much more tightly packed. You get a wonderful crunchy and lightly charred flavor from the florets and a meaty denseness from the stems. When you pair that with a roasted tomatillo salsa, sliced avocadoes, cotija cheese, and purple cabbage, you have a really rockin' taco on your hands. And if you're considering just going out and buying salsa to put on these rather than making your own, I'd highly encourage you to give this one a try because it is really *easy (basically just roast the ingredients and pulse them in a blender) and it is super-duper delicious, too. My friends John and Jessie tried out some recipes for this book, and this salsa was the recipe they couldn't stop gushing about. Seriously, go make this.*

ROASTED TOMATILLO SALSA

10 ounces (280 g) tomatillos, papery husks removed, rinsed well

½ large onion, cut into thirds

2 garlic cloves, minced

1 green bell pepper, seeded and coarsely chopped

3 tablespoons fresh lime juice

¾ teaspoon flake kosher sea salt

CHARRED BROCCOLINI TACOS

1½ pounds (680 g) broccolini

1 tablespoon extra-virgin olive oil

1 teaspoon flake kosher sea salt

¾ teaspoon garlic powder

½ teaspoon ground cumin

½ teaspoon ancho chile powder

8 (6-inch/15-cm) corn tortillas

1 avocado, peeled, pitted, and thinly sliced

4 ounces (60 g) crumbled cotija cheese

½ cup (45 g) shredded purple cabbage

—Preheat the oven to 450°F (230°C).

—For the roasted tomatillo salsa, place the tomatillos and onion on a baking sheet and roast until golden brown spots appear on the tomatillos and the onion is dark golden brown at the edges, about 25 minutes, flipping them halfway through with a pair of tongs to ensure even cooking. Remove from the oven and allow to cool slightly.

—In a food processor or blender, combine the tomatillos and onions, the garlic, pepper, lime juice, and salt and puree on high speed until the desired consistency is reached. For a chunkier salsa, blend for a few seconds; for a smoother salsa, blend for up to 30 seconds.

—For the charred broccolini tacos, cut the stems of the broccolini into pieces that are 1-inch (2.5-cm) long. If the floret end is larger than 2 inches (5 cm) in diameter, cut it in half vertically to make two smaller florets. Toss the broccolini and oil in a large bowl, massaging the oil into the florets to turn them a slightly deeper shade of green. Add the salt, garlic powder, cumin, and chile powder and toss until the broccolini is evenly coated in the spice mixture.

—If you are baking the broccolini, spread the florets out on a baking sheet in one even layer and place in the oven. Roast until the stems turn deep green and the ends of the florets are slightly crisp and light brown, about 15 minutes. If you are grilling the broccolini, heat a charcoal grill until the coals are gray on the outside and glowing orange. Place the florets in a

grill basket and grill, stirring the florets gently with a pair of tongs every 3 minutes, until the floret ends are lightly charred and the stems are a deep bright green, 10 to 15 minutes.

—Heat a cast-iron skillet over medium heat and lightly toast each of the tortillas, about 1 minute per side.

—To assemble, place a few broccolini florets in a line down the center of a tortilla. Evenly distribute the avocado, cotija cheese, cabbage, and salsa among the tortillas. Serve immediately.

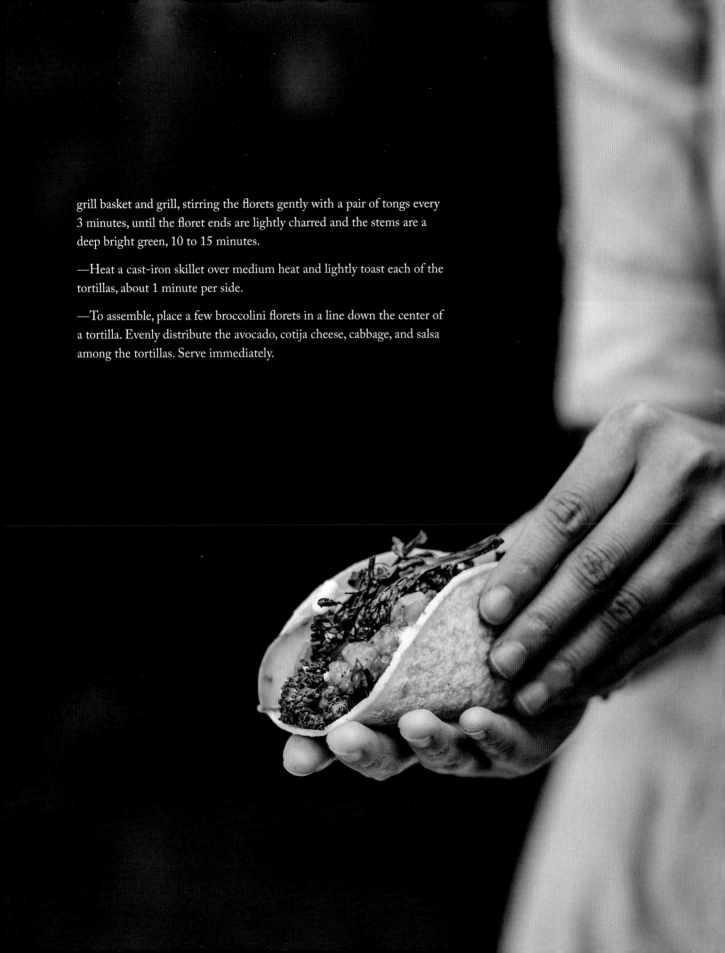

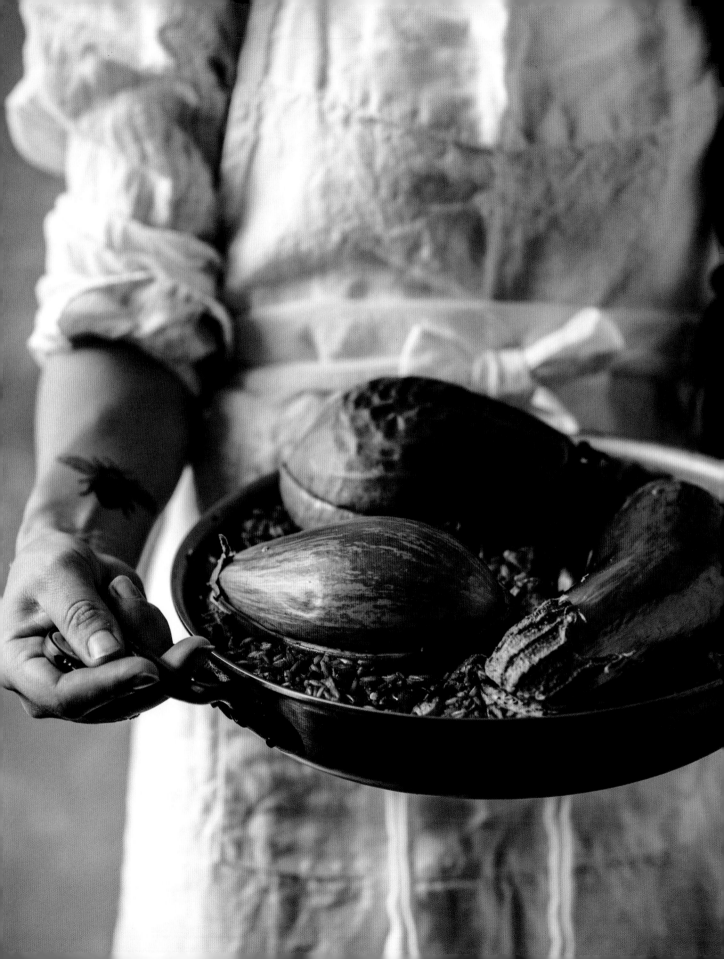

Farro-Stuffed Eggplants with Feta

— Serves 6 —

Farro is a type of wheat grain that was originally popularized in Italy and is great in stuffing and salads. It has a firmer texture than most grains and holds its shape really well when tossed around with other ingredients. Covered in a slightly waxy husk, the interior is soft and meaty with a wonderfully nutty flavor. Its mild, pleasing taste makes it the perfect complement to the bold flavors of this Mediterranean-inspired dish. We used to have a version of this recipe growing up, but the vessel would always change depending on what we had on hand. Sometimes, it was hollowed-out eggplants, sometimes large tomatoes, and sometimes sweet bell peppers. You can feel free to change up the vessel depending on what fresh ingredients you have on hand, but I love the creamy texture the eggplants have after roasting. The eggplant flesh absorbs all the oils and flavors of the filling as it roasts, so I highly recommend taking your spoon and scraping every little bit of eggplant off the skin after you go through the filling—there's nothing quite like ending a meal on the tastiest note!

—Rinse the farro. Bring the stock to a boil in a medium saucepan over medium-high heat. Add the farro and cook, uncovered, until soft but slightly chewy, 12 to 14 minutes. Drain through a sieve set over a bowl and set aside, reserving the farro and the stock separately.

—Preheat the oven to 375°F (190°C).

—Cut the eggplants in half lengthwise down the center. Scoop the center out of the eggplants and cut any scooped-out eggplant pieces without a large amount of seeds into roughly ½-inch (12-mm) cubes.

—In a large Dutch oven, heat the oil over medium heat. Add the garlic and shallot and cook, stirring, until softened and the oil becomes fragrant, about 5 minutes.

—Add the lamb and chopped eggplant and cook, stirring every 2 minutes and breaking the lamb up with your spoon as it cooks, until the lamb is nearly cooked through, about 10 minutes.

—Add the tomatoes and raisins and cook, stirring, until the raisins soften and a few of the tomatoes begin to burst. Remove from the heat and stir in the farro, feta, salt, oregano, cinnamon, allspice, cloves, and pepper. Place the bottom half of the eggplants in a casserole dish. Fill them generously with the farro mixture. Spoon the remaining farro mixture into the pan around the eggplants. Place the top halves on top of the eggplants and drizzle ½ cup (60 ml) of the reserved farro cooking liquid over the farro mixture in the pan.

—Bake until the tops of the eggplants are golden brown, 25 to 30 minutes.

2 cups (400 g) farro

4 cups (960 ml) Vegetable Stock (page 34)

3 large eggplants

1 tablespoon extra-virgin olive oil

2 garlic cloves, minced

1 large shallot, thinly sliced

1 pound (455 g) ground lamb

¾ pound (340 g) cherry tomatoes

¼ cup (35 g) raisins

¼ cup (40 g) freshly crumbled feta cheese

2 teaspoons flake kosher sea salt

1 teaspoon dried oregano

½ teaspoon ground cinnamon

½ teaspoon ground allspice

¼ teaspoon ground cloves

¼ teaspoon freshly cracked black pepper

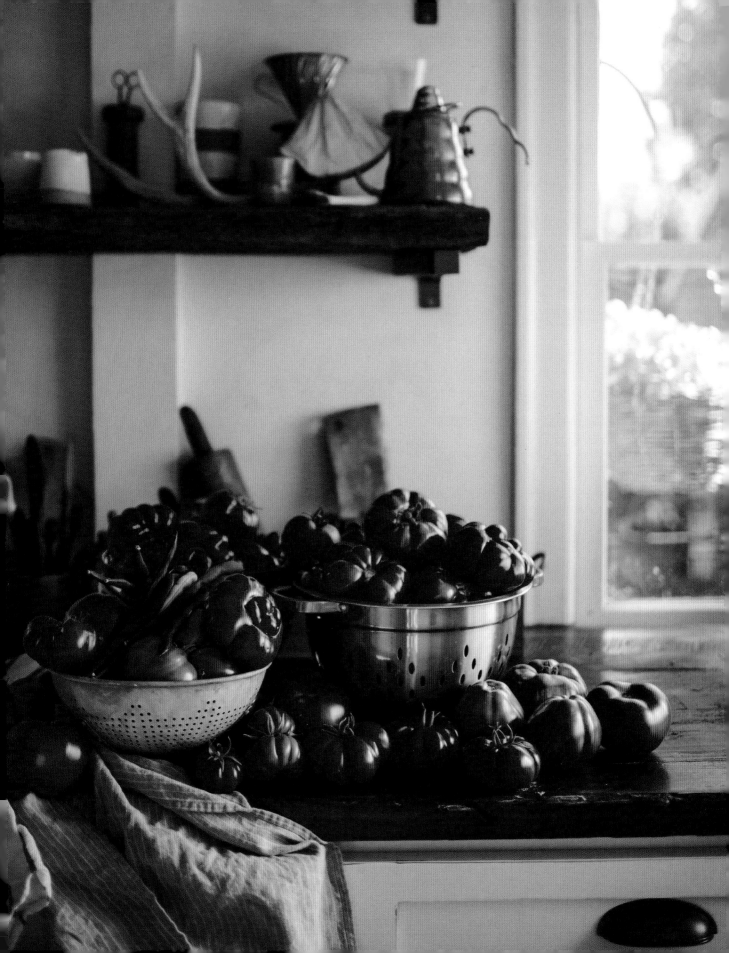

Mussels in Tomato and White Wine Broth

— Serves 4 —

This recipe is incredibly basic in its ingredients and execution, yet the flavor is so incredibly layered and rich that it proves that, sometimes, the best foods are the simplest foods. All you need are good-quality ingredients for this one, the ripeness of the tomatoes being especially important. If you can get them from the farmers' market to ensure that they're slightly soft to the touch, that is ideal. You want the skin of the tomato to give a little when squeezed gently, but you also want it to bounce back after squeezing. If it stays indented from your fingers, it is overripe. When you have a perfectly ripe tomato, the wonderful array of sugars inside will concentrate down and caramelize when cooked, making for an incredibly flavorful stock. If you use unripe tomatoes, you miss out on most of that process, and the stock won't be quite as magical. If you're making this outside of tomato season, I recommend using canned or jarred crushed tomatoes because those are packaged when the tomatoes are ripe.

—In a large pot, melt the butter over medium-high heat. Reduce the heat to medium-low and add the garlic and shallot. Cook until softened slightly, about 4 minutes. Add the tomatoes and wine and raise the heat to medium-high. Bring the mixture to a boil and cook, uncovered, stirring every 5 minutes, until the tomatoes have disintegrated completely, about 20 minutes.

—Add the mussels, cover, and cook until the mussels open wide, 6 to 8 minutes. Remove from the heat and discard any mussels that have not opened. Stir in the salt and thyme, and serve immediately.

3 tablespoons unsalted butter

5 garlic cloves, minced

1 large shallot, halved lengthwise and thinly sliced

3½ pounds (1.6 kg) tomatoes, chopped

1¾ cups (420 ml) dry white wine

2 pounds (910 g) mussels, scrubbed and debearded

2½ teaspoons flake kosher sea salt

2 teaspoons fresh thyme leaves

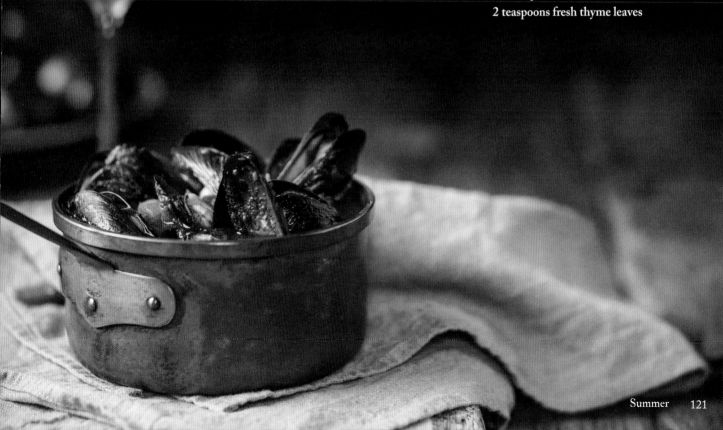

Fire-Roasted Lime Fish

— Serves 1 or 2 —

I love recipes that are flexible and can be adapted to use ingredients you have on hand, and this one definitely falls under that umbrella. You can really use any whole fish for this recipe—just stick to a smaller one (around 1 pound/455 g) and the rest of the ingredients will be properly proportioned to it. If you want to go crazy and use a really big fish, just multiply the ingredients in proportion to the additional pounds of fish, and know that the cooking time will be longer. This recipe calls for Thai ingredients, most of which should be fairly easy to find in the fresh produce section of your grocery store. If you can't find them there, I recommend calling around to your local Asian markets to see if they have them. Just a word of note: Lemongrass is similar to bay leaves in that you use them for flavoring but don't actually eat the piece itself. It has a rough texture that is hard to chew, but it releases a delicious aromatic flavor when cooked along with other ingredients. Lemongrass comes in a long stalk and you don't need much for this recipe, but it does freeze very well. I recommend cutting the whole stalk into pieces that are 4-inches (10-cm) long, slicing what you need for this recipe, and tossing the other pieces in a freezer-safe resealable plastic bag to pull from, as needed, for future cooking adventures. If you're not sure what to use lemongrass for, think vibrant soups, curries, and even really refreshing herbal tea. It's the best!

1 pound (455 g) whole fish of your choice, cleaned

2 tablespoons extra-virgin olive oil

½ teaspoon freshly cracked black pepper

1½ teaspoons flake kosher sea salt

1 lime

1 (1-inch/2.5-cm) piece fresh lemongrass, thinly sliced

3 sprigs Thai basil

1 medium tomato, cut into slices ½-inch (12-mm) thick

2 large fig or grape leaves

—Soak a length of kitchen twine in a bowl of water. Get a wood or coal fire going and allow it to burn down until the logs/coals are white and ashy around the edges, are glowing red, and have a nice low flame.

—Rub the interior and exterior of the fish with the oil, then rub the interior with the pepper and 1 teaspoon of the salt. Cut the lime in half and cut one of the halves into slices that are ¼-inch (6-mm) thick. Set the other half aside.

—Arrange the lime slices, lemongrass, and basil inside the fish (it's all right if they're sticking out a little). Place the tomato slices on the outside of the fish, then wrap the outside of the fish in the fig or grape leaves over the stuffing opening and the tomatoes. Tie the fish to a sturdy stick using the soaked twine. Hold the fish over the fire, adjusting the distance as necessary, to ensure that the fish is cooking but not burning (a little char is okay, but you don't want it to catch on fire). You can also grill the stuffed and wrapped fish over medium-low heat, flipping it several times during cooking to ensure that it's cooked evenly on both sides.

—Cook until the fish is completely cooked through and flakes easily with a fork. Remove it from the stick, discard the wrapping and stuffing, and flake the meat off the bones using a fork. Squeeze the remaining lime half over it and sprinkle with the remaining ½ teaspoon salt. Serve immediately.

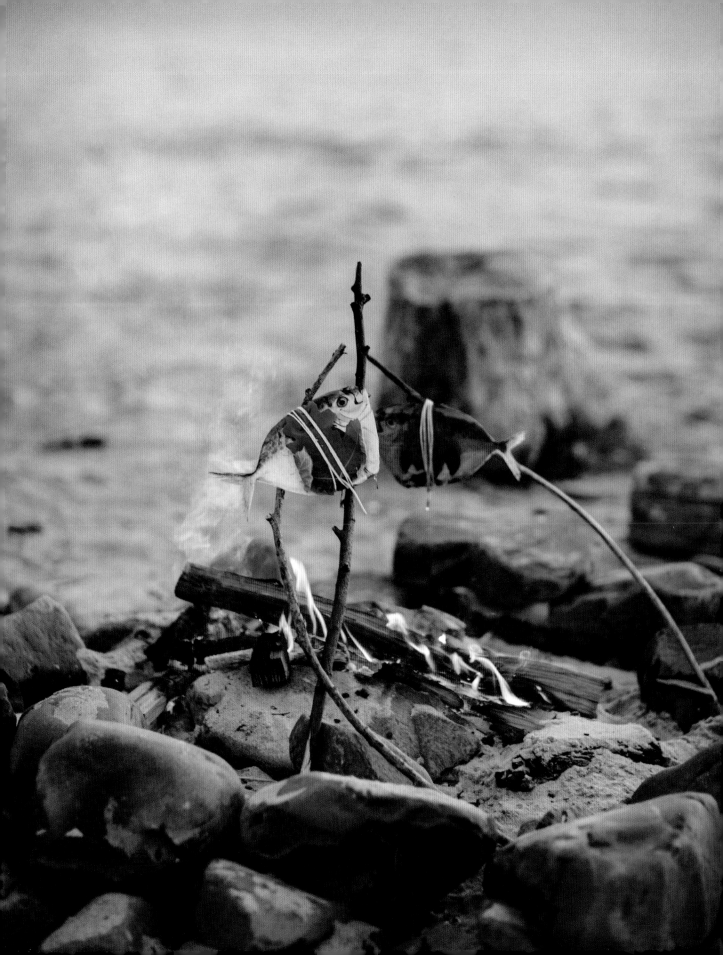

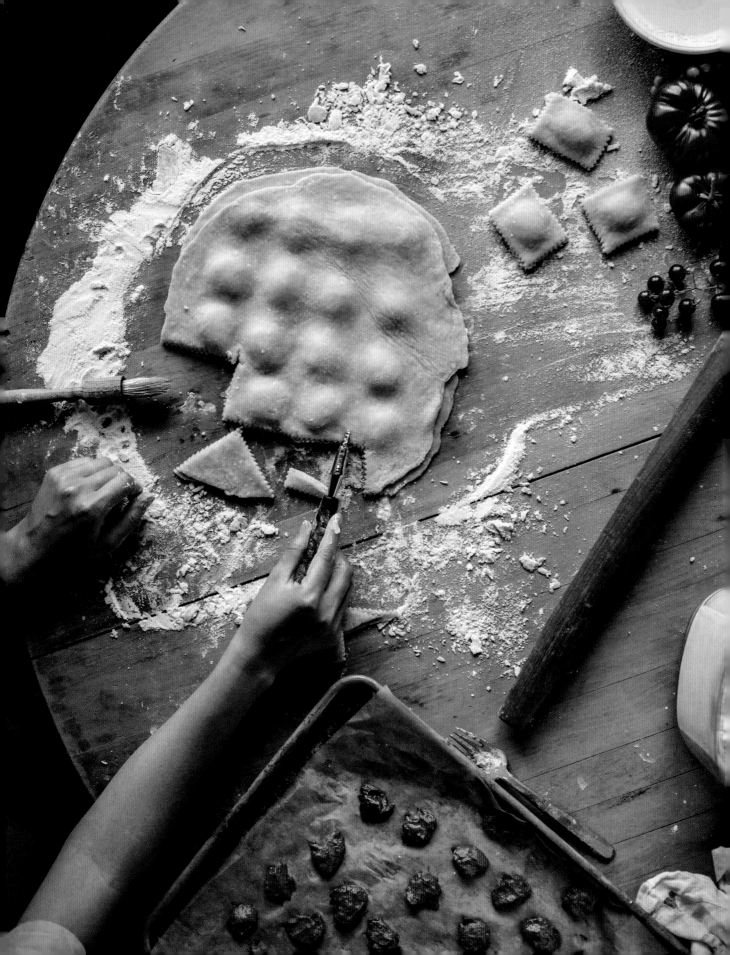

Roasted Tomato and Goat Cheese Ravioli

— Makes about 60 2-inch (5-cm) square ravioli, about 2 pounds 3 ounces (990 g) —

Roasting tomatoes is probably one of my favorite things about summer. Roasting a tomato is similar to caramelizing an onion, in that it completely alters and intensifies the flavor of the ingredient. A raw tomato is juicy, slightly sweet, and mildly tangy. A roasted tomato, however, is velvety, crispy around the edges, incredibly tangy, and sweet in a way that is simply unforgettable. The only way to describe it is savory sweetness, which is slightly contradictory, but if you've ever had a roasted tomato on its own, you know exactly what I'm talking about. I particularly love roasting San Marzano and Costoluto Genovese tomatoes for sauces and fillings, because they roast down and have more flavor and more meat, since they're not mostly juice and seeds inside.

I started making this ravioli as a way to preserve tomatoes from the summer, since ravioli freezes really well. I like having a lot of filling in my ravioli, but it can be hard to get enough filling in there without it coming out through the edges when you're pressing down to secure the two pieces of pasta dough together. So, to overcome this hurdle and satisfy my filling demands, I started freezing the filling in heaping teaspoons on a baking sheet for a couple of hours beforehand; that way, the filling is solid when I assemble the ravioli and won't seep out everywhere, breaking the seal. So, not only does this result in a ravioli that's less likely to spring a filling leak when cooking but it also means you get more filling in each one. And who doesn't love more filling?

—Preheat the oven to 425°F (220°C).

—For the roasted tomato and goat cheese filling, lay the tomatoes flat on a baking sheet, cut side up. Drizzle them with the oil, rubbing it in with your fingers or a pastry brush to make sure the entire exposed surface has a thin layer of oil on it. Sprinkle the tomatoes with the salt and pepper.

—Roast until the tomatoes have shrunken slightly, wrinkled, and are a very deep red, about 1 hour to 1 hour 10 minutes, depending on the juiciness of the tomatoes. They should have lost a lot of height and should be very aromatic. Allow to cool to room temperature, then transfer the tomatoes to a food processor or blender, add the ricotta and goat cheese, and puree, working in batches, if necessary.

—Line a baking sheet with parchment paper and grease a teaspoon with oil. Take a teaspoon of the filling and place it on the parchment paper, trying to keep it in a relatively domed shape. Repeat until you have 60 domes. Cover and refrigerate any excess filling, reserving it for another use (it's great spread on sandwiches or with crackers). Place the pan in the freezer until the individual scoops of filling have frozen slightly, 1 to 2 hours.

—Meanwhile, for the pasta dough, in a large bowl, mix together the flours, basil, salt, and garlic powder. Turn the mixture out onto a clean work surface and form it into a mound. Make a large well in the middle of the mound

recipe continues

ROASTED TOMATO AND GOAT CHEESE FILLING

6 large Roma (plum) tomatoes, halved (1 pound 2 ounces) (550 g)

2 teaspoons extra-virgin olive oil

¼ teaspoon flake kosher sea salt

Pinch of freshly cracked black pepper

½ cup (125 g) full-fat ricotta

5 ounces (68 g) goat cheese

PASTA DOUGH

3½ cups (475 g) bread flour

½ cup (90 g) semolina flour

2 tablespoons chopped fresh basil

½ teaspoon flake kosher sea salt

½ teaspoon garlic powder

5 eggs

2 egg yolks

2 tablespoons extra-virgin olive oil, plus more for greasing

and put the eggs, egg yolks, and oil in the well. Using a fork, gently start to swirl together the eggs, yolks, and oil, slowly incorporating the flour into the wet ingredients and taking care not to break the walls holding in the liquid ingredients. Continue mixing until the center is thick enough that you can stir in the flour walls without the mixture spilling out everywhere.

—Stir until the dough comes together enough that you can begin to knead it. Knead the dough until it is very smooth and elastic, 3 to 5 minutes. Separate the dough into four equal balls. Pat one of them down into a long oval shape, then roll out the dough until it is about ¼ inch (12 mm) thick.

—You can either roll the dough out by hand, which is more physically demanding and time consuming, or you can use a pasta machine to roll out the dough, which is easy, fast, and more precise. To roll the dough out by hand, roll it until it is about ⅛ inch (3 mm) thick. If the dough keeps shrinking back as you try to roll it, cover it and place it in the freezer for 20 minutes before attempting to roll it out more. To use a pasta machine, begin passing the dough through the rollers starting at level 1, working down to level 7, passing the dough through the machine at each level in between (i.e., once at level 2, once at level 3, etc.). Repeat the rolling process with another dough section so that you have 2 sheets of dough.

—Lay the sheets of dough out flat next to each other. Use a 2-inch (5-cm) square ravioli cutter to gently press squares into one of the sheets, just leaving the shape of a square but not cutting through the dough.

—Use a pastry brush or your finger to lightly brush the edge of each square with water. Place a frozen filling dollop in the center of each square. Slowly lay the second sheet of pasta over the one with the filling, using your pointer and middle fingers spread apart in a peace sign to help shape the second sheet around the filling and press out any air. Press down a bit firmer around the filling with your fingertips to secure the sheets together. Use the cutter to cut out the filled ravioli. The ravioli can be cooked immediately or transferred to a baking sheet, frozen, then stored in an airtight freezer-safe container in the freezer for up to 6 months.

—To cook, bring a pot of water to a boil and add the desired amount of ravioli, taking care not to crowd the pot. Cook for 4 to 6 minutes (if frozen, cook for 7 to 9 minutes), or until cooked through. I recommend serving these with garlic and olive oil or a light tomato or an Alfredo sauce.

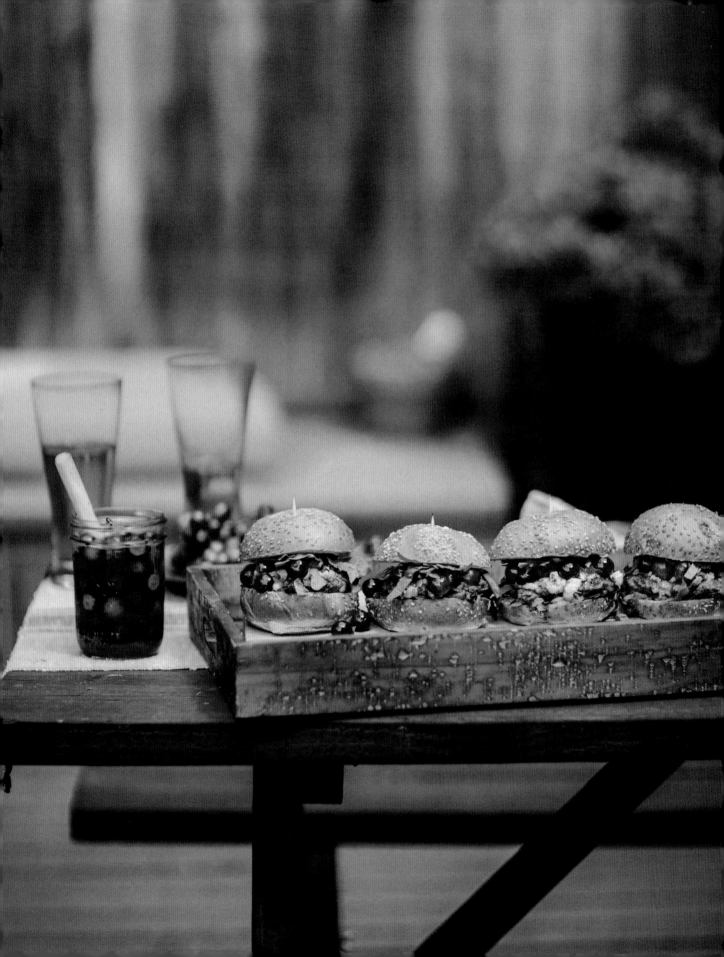

Blue Cheeseburgers with Sherry Caramelized Onions and Pickled Grapes

— Serves 4 —

My favorite cheeseburgers are the ones that combine the tanginess of blue cheese and the sweetness of caramelized onions, so I decided to meld the two together in my own delicious burger concoction. This burger also has quick-pickled grapes on it, which pop out an amazing burst of sweet and simultaneously tart juice when you bite down on them, helping to cut through the richness of the burger and cheese. Also, did I mention that these onions are caramelized in cream sherry? You're welcome, friends.

—For the pickled grapes, cut off the tips of the grapes where they attach to the stems and discard. Cut the grapes in half and set aside.

—In a medium saucepan, combine the red wine vinegar, sugar, white vinegar, cloves, peppercorns, star anise, and ⅓ cup (75 ml) water and bring to a boil over medium-high heat. Cook until the sugar has dissolved completely, 3 to 5 minutes. Add the grapes and cook for 3 minutes more, then remove from the heat and allow to cool to room temperature. Transfer them to a mason jar, seal, and refrigerate.

—For the sherry caramelized onions, in a large skillet, heat the oil over medium heat. Add the onions and cook, stirring every few minutes, until softened and transparent, about 10 minutes. Add the sherry and stir to incorporate. Cook, stirring every 5 minutes, until the onions have turned a deep gold color and smell sweet, 20 to 30 minutes.

—For the blue cheeseburgers, in a medium bowl, mix together the beef, egg, Garlic and Bay Leaf Salt, thyme, and pepper until thoroughly combined. Form into 4 equal-sized patties.

—Heat a gas grill to medium, or heat a charcoal grill until the coals are white on the outside and glowing orange on the inside. To cook on the stovetop, heat a cast-iron grill pan over medium heat. Lightly toast the buns for 1 to 3 minutes per side.

—Use a pastry or grill brush to lightly brush the grill grate with oil (this helps keep the burgers from sticking to the grate). Place the patties on the grill and cook until the desired doneness is reached, sprinkling 1 ounce (30 g) of the Stilton on each patty during the last few minutes of cooking.

—Place a cooked patty on each bun bottom. Top with the caramelized onions, pickled grapes, and chopped spinach. Spread 1 tablespoon of the mayonnaise on each top bun and place on the burger. Serve immediately.

PICKLED GRAPES

1 pound (455 g) red grapes, rinsed clean

⅔ cup (165 ml) red wine vinegar

⅔ cup (135 g) sugar

⅓ cup (75 ml) distilled white vinegar

¼ teaspoon whole cloves

¼ teaspoon whole black peppercorns

1 star anise

SHERRY CARAMELIZED ONIONS

3 tablespoons extra-virgin olive oil

2 large yellow onions, diced

3 tablespoons cream sherry

BLUE CHEESEBURGER

1 pound (455 g) ground beef

1 egg

1½ teaspoons Garlic and Bay Leaf Salt (page 22) or 1 teaspoon flake kosher sea salt and ½ teaspoon garlic powder

¾ teaspoon fresh thyme leaves

½ teaspoon freshly cracked black pepper

4 brioche buns

Extra-virgin olive oil, for greasing the grill

4 ounces (115 g) Stilton blue cheese

1 cup (30 g) chopped fresh spinach

4 tablespoons (60 g) mayonnaise

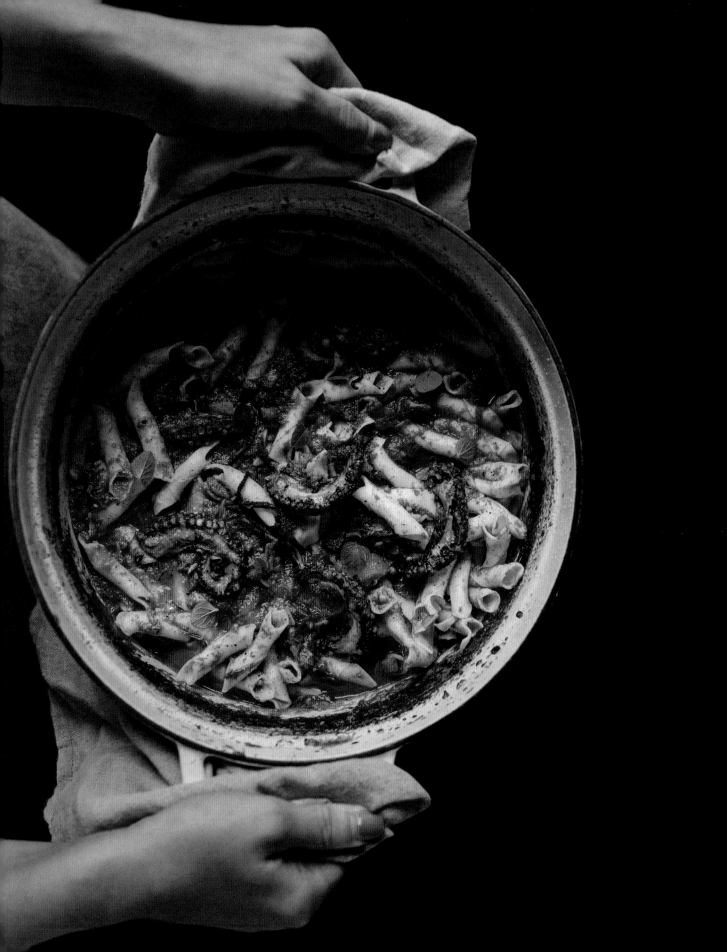

Evi's Braised Octopus in Tomato Sauce

— Serves 4 —

When I was twenty-eight, I went back to Aegina, the small island in Greece where my father is from. It was the first time I'd been there since I was eleven years old. I have lots of family on the island, and being able to see them for the first time as an adult and feel that connection to them, the earth, and the food was really special to me. I spent some of the afternoons on my trip cooking with my cousin Evi and talking with her about food and our family, and how it all blended together. She made this braised octopus in tomato sauce for me while I was there; it was one of the recipes my yiayia (grandmother) would make for my father and his siblings growing up. The octopus is boiled alone in water to help tenderize it a bit, and the resulting stock is then used in the tomato sauce (freeze the excess stock and use it for seafood dishes, like shellfish risotto). I recommend using my recipes for roasted tomatoes and my go-to tomato sauce, but if you want to use store-bought sources for those, try using San Marzano marinara sauce as a substitute for the tomato sauce and rehydrated sun-dried tomatoes instead of the roasted tomatoes. To rehydrate them, place them in a large bowl and cover them with hot liquid, such as water or Vegetable Stock (page 34), so that they are completely submerged. Cover the bowl and let them rest until the flesh is soft and the skin is very easily pierced with a fork, ten to fifteen minutes, then drain. Once they are rehydrated, you can weigh them to match the quantity called for in the recipe.

—Cut the head off the octopus and discard it. Fill a large Dutch oven with water and a few pinches of salt and bring to a boil over high heat. Add the octopus, reduce the heat to low, and cover, with the lid slightly ajar. Simmer for 30 minutes.

—Preheat the oven to 350°F (175°C). Remove the Dutch oven from the heat and remove the octopus from the pot, reserving 2 cups of the cooking liquid. Transfer the cooking liquid to a large bowl and set aside. Cut each leg off the body of the octopus, leaving the legs whole, and cut the body into roughly 1-inch (2.5-cm) cubes. Set aside.

—In the same Dutch oven, heat 3 tablespoons of the oil over medium-low heat. Add the onion and garlic and cook, stirring every minute or so, until softened and fragrant and the onions are slightly transparent, about 5 minutes.

—Add the roasted tomatoes, tomato sauce, 2 cups (480 ml) of the reserved octopus cooking water, the wine, and the octopus pieces and bring the mixture to a boil.

—Bake, uncovered, until the octopus is tender and the liquid has reduced and thickened, about 1 hour 15 minutes, stirring every 15 minutes and making sure to keep the octopus submerged in the liquid after stirring. If there isn't enough liquid for the octopus to be submerged, add a little water.

—Bring a pot of water to a boil. Add a pinch of salt and the remaining 1 teaspoon oil. Add the pasta and cook according to the package directions until al dente. Drain the pasta and add it to the octopus mixture. Season with salt and pepper and serve.

1 small adult octopus (about 2½ pounds/1.2 kg)

Flake kosher sea salt

3 tablespoons plus 1 tablespoon extra-virgin olive oil, plus more for pan

1 small yellow onion, chopped

3 garlic cloves, minced

1¾ pounds (800 g) Roasted Tomatoes (page 27)

3 cups (720 ml) Tomato Sauce (page 28)

1 cup (240 ml) dry white wine

8 ounces (225 g) dry hollow pasta, such as hand-formed penne, elbow macaroni, campanelle, or rigatoni

½ teaspoon cracked black pepper

Grilled Chicken with Peach-Basil Glaze

— Serves 2 to 4 —

I love grilling whole chickens because it gives you the option to enjoy both the dark and light meat, as well as the presentation value of taking an entire golden, glistening, and slightly charred chicken off the grill. The best way to ensure that the chicken cooks evenly and quickly in its whole form is to spatchcock it. When you spatchcock a chicken, you're essentially just cutting out the backbone with a pair of kitchen shears and then opening it like a book to lay the whole bird out flat. This recipe also calls for the chicken to be brined, which I highly recommend doing. It will make the bird juicier and help keep it from drying out on the grill. There's also a delicious peachy marinade that you brush on the bird as it cooks, and once the chicken is done, you can dress it with a slightly sweeter peach and basil glaze. The end result is smoky, salty, bright, and sweet—everything you'd want from a summer barbecue. As far as the grill goes, I'm very partial to coals because they impart a delicious smoky flavor to the meat that you just don't get from a gas grill, but to each her own. You'll enjoy the bird no matter what you choose.

GRILLED CHICKEN

3 tablespoons flake kosher sea salt

1 whole roasting chicken
 (4 to 5 pounds/1.8 to 2.3 kg)

3 sprigs fresh basil

Extra-virgin olive oil, for brushing
 the grill

PEACH-BASIL GLAZE

3 large ripe peaches (about 1 pound
 10 ounces/735 g)

¼ cup (10 g) coarsely chopped fresh
 basil

¼ cup (60 ml) soy sauce

¼ cup (60 ml) extra-virgin olive oil

2 tablespoons honey

1 tablespoon rice vinegar

1 tablespoon sugar

—For the grilled chicken, in a small saucepan, bring 1 quart water and the salt to a boil over medium heat, stirring until the salt has dissolved. Remove from the heat, cool to room temperature, and place in a poultry or brining bag along with the chicken and the basil. Tie or seal the bag, place it in a small pan, and refrigerate for at least 4 hours or up to 24 hours.

—For the peach-basil glaze, in a blender or food processor, combine the peaches, basil, soy sauce, oil, honey, and vinegar and blend until smooth. Pour half the peach mixture into a saucepan and bring to a boil over medium heat. Reduce the heat to low, add the sugar, and simmer until thickened, about 15 minutes. Remove from the heat and set aside.

—Remove the chicken from the brine, rinse, and pat dry with paper towels. To spatchcock the chicken, lay it on its breast so that its back is facing up. Use a pair of kitchen shears to cut along each side of the backbone and remove it from the bird. Flip the bird over so that the breast is facing up and the back muscles are splayed out on either side of the breast. Use the heel of your hand to press down firmly on the breast until you feel/hear a small snap, which is the breastbone breaking.

—Rub the chicken with 2 tablespoons of the nonsugared glaze. Transfer it to a large resealable plastic bag and refrigerate for 1 hour.

—Remove the chicken from the bag and push two long wooden skewers through the chicken so that they form an X shape, inserting each one into a leg quarter and exiting through the opposite upper corner of the chicken's breast.

—Heat a charcoal grill until the coals are pale gray and glowing orange, or heat a gas grill to medium-low heat. If using a charcoal grill, push the coals to one side of the grill. Lightly brush the grill grate with oil to keep the chicken from sticking.

—Place the chicken, skin side up, on the opposite side of the grill from the coals. Cook until the juices run clear and the interior temperature of the chicken thigh joint reaches 165°F (75°C), 1 hour 15 minutes to 1 hour 45 minutes, flipping three times and brushing the chicken with the nonsugared glaze every 15 minutes during cooking.

—Once done, carve the chicken and drizzle with the sugared glaze. Serve immediately.

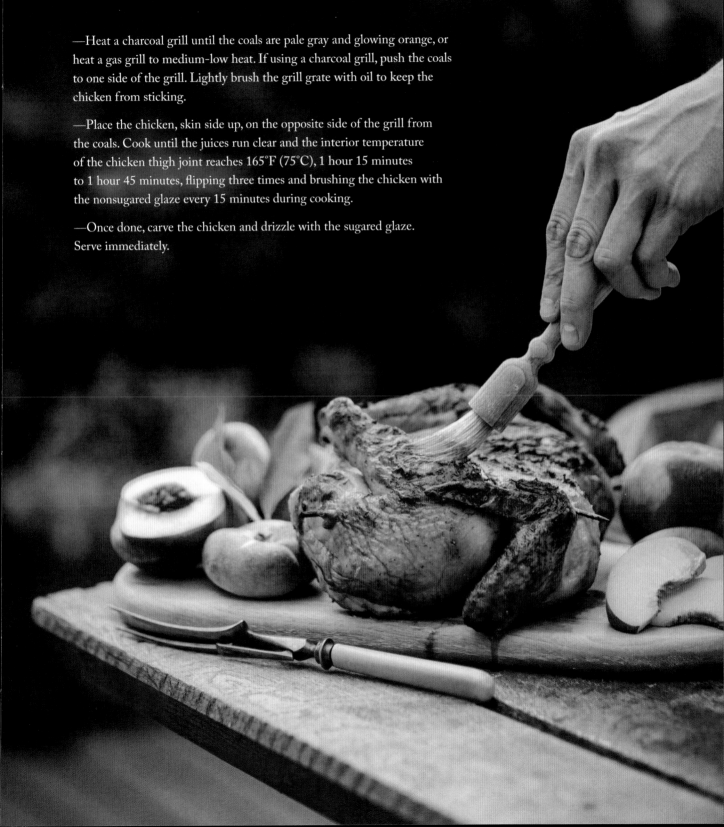

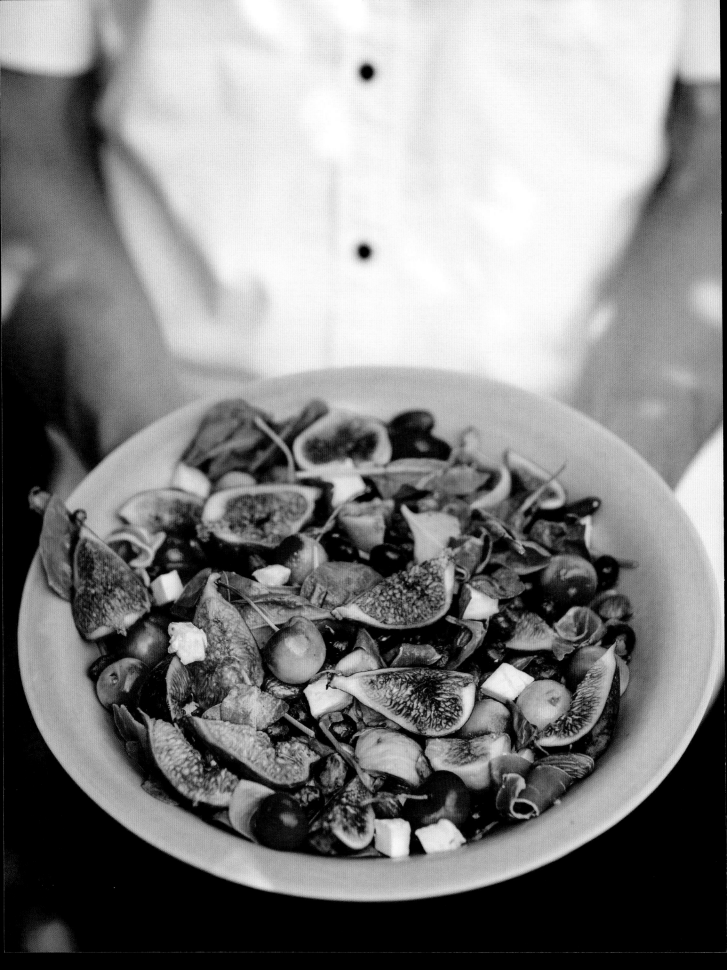

Fig, Prosciutto, and Spinach Salad with Chèvre and Preserved Lemon Vinaigrette

— Serves 4 —

I love this salad because it basically involves taking all the delicious fresh fruits of summer and combining them in a catchall salad with some bitter spinach, rich prosciutto, aged goat cheese, and an insanely vibrant and refreshing preserved lemon vinaigrette. You can feel free to swap out some of the berries, depending on what you have around, but I definitely recommend keeping the fresh figs as a part of the dish, since they pair so well with the prosciutto. Besides, what's an all-encompassing summer salad without fresh figs?

—For the preserved lemon vinaigrette, whisk together the lemon rind, oil, honey, vinegar, and salt in a small bowl until completely combined. Set aside.

—For the salad, in a large bowl, toss together the spinach, almonds, figs, cherries, blueberries, crottin, and prosciutto until the components are evenly distributed throughout the salad. Drizzle with the vinaigrette and toss gently to coat. Serve immediately.

PRESERVED LEMON VINAIGRETTE

1 tablespoon finely chopped vanilla bean preserved lemon peel (page 31)

1 tablespoon extra-virgin olive oil

1¼ teaspoons honey

½ teaspoon balsamic vinegar

¼ teaspoon flake kosher sea salt

SALAD

4 cups (80 g) packed baby spinach leaves

½ cup (70 g) almonds, toasted

1 pound (455 g) fresh figs, quartered

4 ounces (115 g) cherries, about 1¼ cup

4 ounces (115 g) blueberries, about 1 cup

4 ounces (115 g) crottin or other chèvre cheese, crumbled or cut into ¼-inch (12-mm) cubes

2 ounces (55 g) prosciutto, thinly sliced

Green Bean and Lemon Soup

— Serves 4 —

I had a huge green bean harvest two summers back and was racking my brain for tasty ways to use them up. Eventually, I decided to try my hand at soup. I wanted it to be hearty but refreshing, and the "soupspiration" that came to mind was avgolemono, a Greek chicken soup made with eggs and lemon. I decided to attempt it with green beans instead, and the result was a much lighter and brighter version of the traditionally cold-weather soup. The lemon really brings out the fresh flavor of the green beans, and the eggs ensure that it will be a filling meal. It's perfect for any temperate summer day.

3 tablespoons unsalted butter

1 large or 2 small shallots, chopped

1 bay leaf

6 whole black peppercorns

1 pound (455 g) green beans, ends trimmed, cut into 1-inch (2.5-cm) pieces

½ teaspoon flake kosher sea salt

1 teaspoon fresh thyme leaves

1 teaspoon minced fresh rosemary leaves

2 cups (480 ml) Vegetable Stock (page 34)

1 egg

¼ cup (60 ml) fresh lemon juice

4 teaspoons heavy cream (optional)

4 teaspoons extra-virgin olive oil (optional)

—In a medium skillet, melt the butter over medium-low heat. Add the shallots, bay leaf, and peppercorns and cook, stirring about every 3 minutes, until the shallots are lightly golden, 7 to 10 minutes. Add the green beans, salt, thyme, and rosemary and cook, stirring every 3 minutes, until the beans have softened significantly, about 10 minutes more.

—Remove from the heat and carefully transfer the mixture to a food processor or blender (if necessary, work in batches). Add the stock. Blend on high speed until a smooth puree forms.

—Transfer the mixture to a medium saucepan and place it over medium heat. Bring to a simmer, then reduce the heat to low.

—In a small bowl, whisk together the egg and lemon juice. While whisking continuously, slowly add 1 cup (240 ml) of the green bean broth to the egg mixture. Pour the egg mixture into the saucepan with the rest of the green bean broth and stir to incorporate. Bring to a simmer, then cook for 5 minutes. Remove from the heat.

—Divide the soup among four bowls and garnish each one with 1 teaspoon of the cream (if using) and 1 teaspoon of the olive oil, if desired. Or, allow to cool to room temperature, then transfer to airtight freezer-safe containers and freeze for up to 6 months.

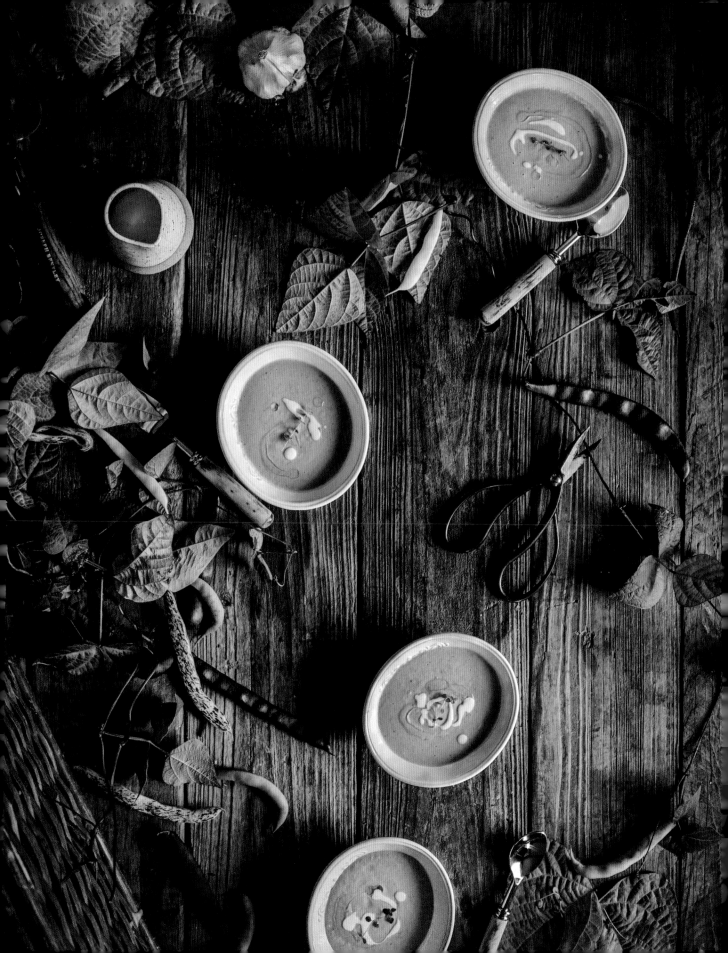

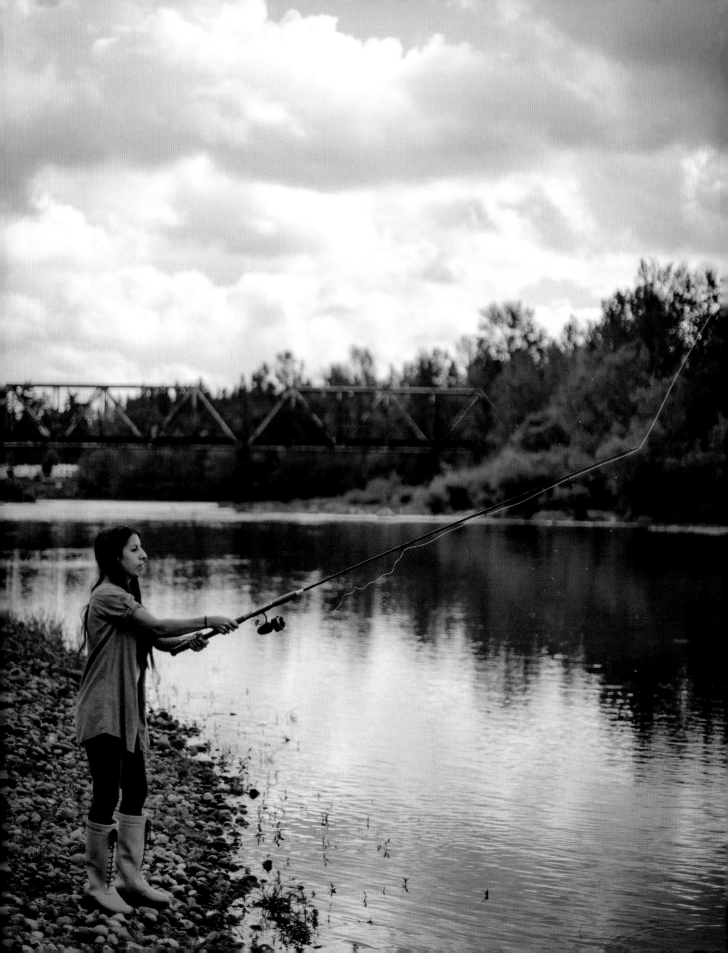

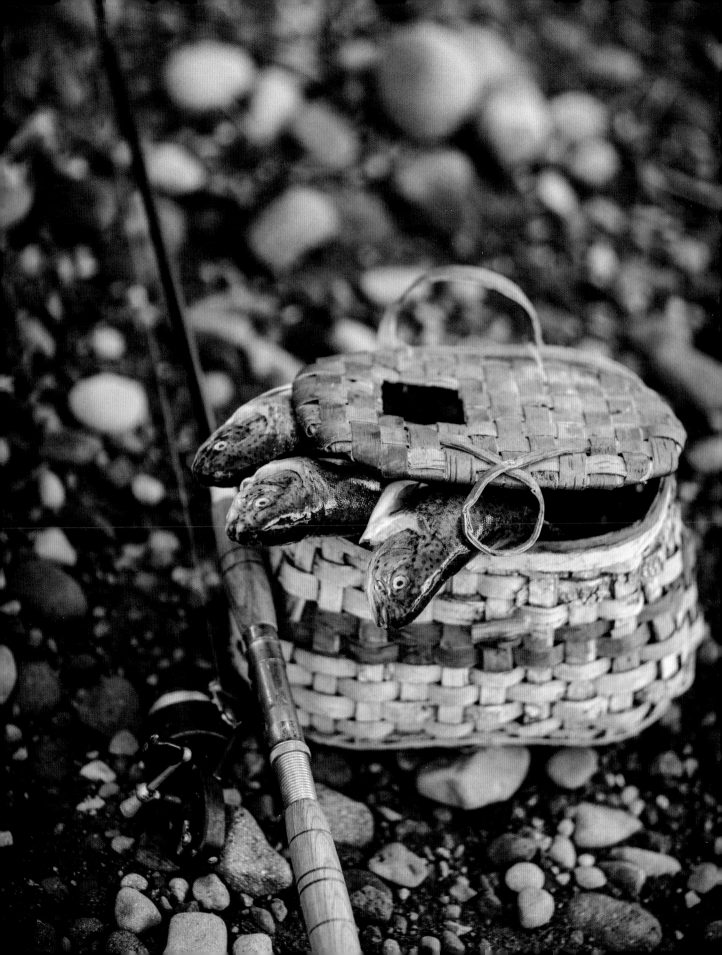

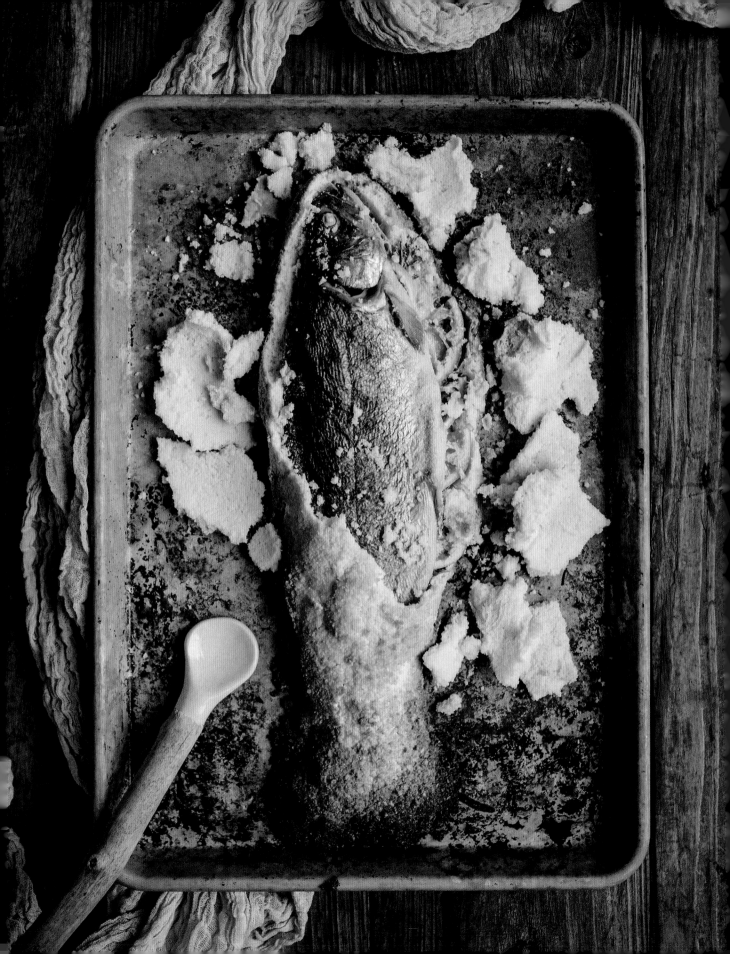

Salt-Baked Trout with Sweet Pepper and Lemon

— Serves 2 —

This is the best way I have found to cook trout. I've made it like this at least a half-dozen times, and the fish always comes out perfectly cooked, flavorful, and moist. The ingredients are very simple, too, so it's one of those recipes that you just start to memorize after the third time and eventually don't even need to look up. So, what's the deal with baking fish in salt? Well, the salt is combined with beaten egg whites and a bit of olive oil until a crumbly mixture, similar to sand, forms. After you stuff the fish with goodies and place it on the pan, you encase the outside of the fish in the salt mixture and then bake it. As it cooks, the salt hardens into a shell that simultaneously steams the fish, moderates its temperature, keeps it from overcooking and drying out, and seasons it. Then, at the end you get to crack open the hard, salty shell and serve everyone a super-impressive-looking fish. It's pretty much a win all around.

—Preheat the oven to 450°F (230°C).

—Rub the inside of the trout with 1 tablespoon of the oil and the black pepper. Stuff the bell pepper in the trout, then lay the lemon slices in the trout in a single layer on top of the bell pepper. Stuff the rosemary sprigs in the trout, cover, and refrigerate until ready to use.

—In a large bowl, beat the egg whites until they hold soft peaks. Fold in the salt and then the remaining 3 tablespoons oil until completely combined and the texture resembles wet sand.

—Spread some of the salt mixture over a baking sheet so that it is roughly the length and width of the trout. Place the trout on the salt. Pack the rest of the salt mixture around and atop the fish. Use a thin, sharp knife to poke a hole through the salt mound into the thickest part of the fish (usually near the head) to allow steam to escape. Bake for 25 minutes, or until a thermometer inserted into the fish reads at least 145°F (65°C).

—Remove from the oven and allow to cool for 10 minutes. Crack the salt crust with the back of a spoon and break it off in large chunks, discarding the crust. Peel the skin off the trout and cut out the fillets, discarding the skin, spine, bones, lemon, and rosemary. Serve immediately along with the peppers.

1 medium trout (about 1 pound/ 455 g), cleaned and scaled

4 tablespoons (60 ml) extra-virgin olive oil

¼ teaspoon freshly cracked black pepper

⅓ cup (35 g) thinly sliced seeded bell pepper

½ lemon, thinly sliced

3 sprigs fresh rosemary

4 egg whites

3 cups (800 g) flake kosher sea salt

Watermelon and Mint Blossom Granita

— Serves 4 —

There are few things in the world that can relieve the heat of summer as well as a juicy slice of watermelon. This past summer, I grew two heirloom varieties, Chris Cross, a pink-fleshed melon whose exterior is striped light and dark green, and Small Shining Light, a red-fleshed melon with a skin so dark green that it looks nearly black. I ended up harvesting more than 100 pounds (45 kg) of watermelon from the garden, so I started experimenting with all the ways I could prepare it. After using it in dozens and dozens of recipes, I am sharing my absolute favorite one here. If you've never had granita before, it's a frozen treat that has the fluffy texture of freshly fallen snow. You don't need a fancy ice-shaving machine to make it, either—just a rimmed baking sheet, a freezer, and a fork. I use mint blossom to flavor the simple syrup that forms the base of the recipe, but feel free to substitute an equal amount of fresh mint leaves if you don't have blossoms on hand. It will still add a wonderfully minty flavor to the dish, just without the floral notes that fresh-cut blossoms bring.

1 cup (200 g) sugar

¼ cup (13 g) fresh mint blossoms
 or mint leaves

1¾ cups (420 ml) pureed
 watermelon

—In a small saucepan, bring 2 cups (480 ml) water and the sugar to a boil over medium heat. Cook, stirring, until the sugar has dissolved completely, about 5 minutes. Remove the pan from the heat, stir in the mint, and allow the syrup to cool to room temperature for the mint to infuse the syrup.

—Strain the syrup and discard the mint. Whisk together the syrup and pureed watermelon until combined.

—Pour the mixture out onto a large rimmed baking sheet; the liquid should be 1 inch (2.5 cm) deep or less in the pan. Carefully place the baking sheet in the freezer, taking care not to spill the liquid.

—Freeze for 30 minutes, then remove the pan and scrape the watermelon mixture with a fork to break up any ice crystals that are forming.

—Place the pan back in the freezer and freeze for 30 minutes more, then remove it and scrape the watermelon mixture with your fork again. Repeat this process four more times; you will have scraped the mixture a total of six times over a period of 3 hours. At this point, the granita should have the consistency of snow.

—Serve immediately, or freeze for up to 24 hours more before serving. If you wait 24 hours, you may need to scrape again to break it up before serving it.

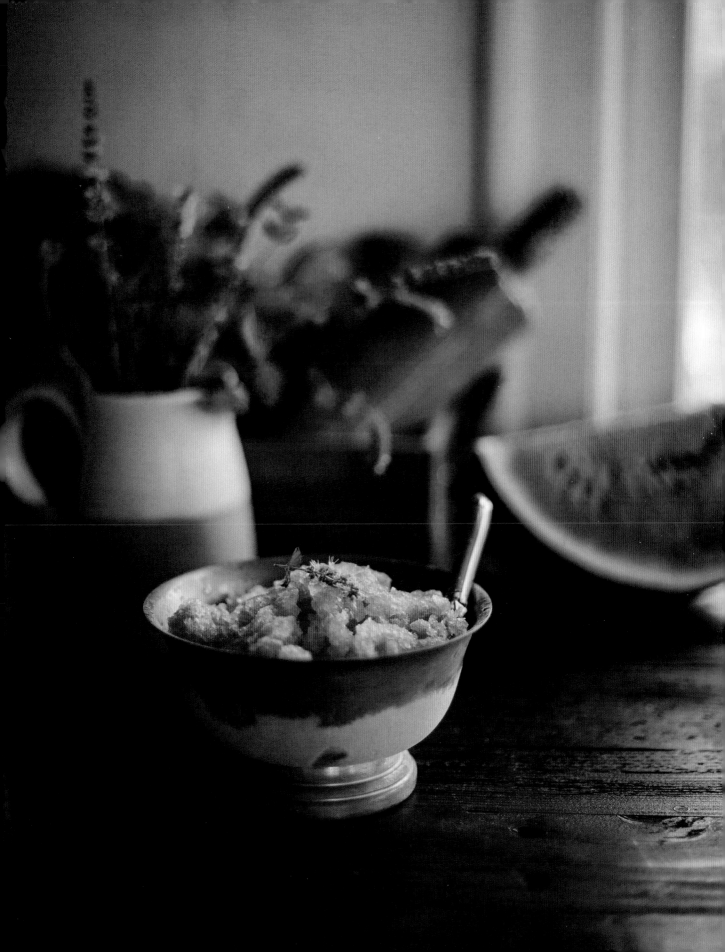

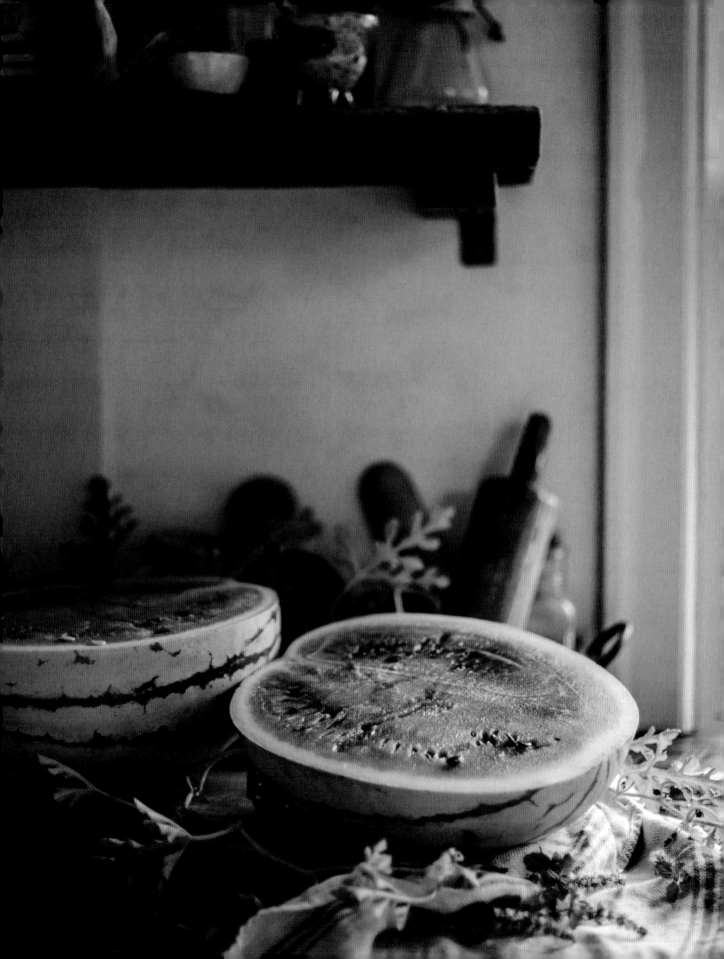

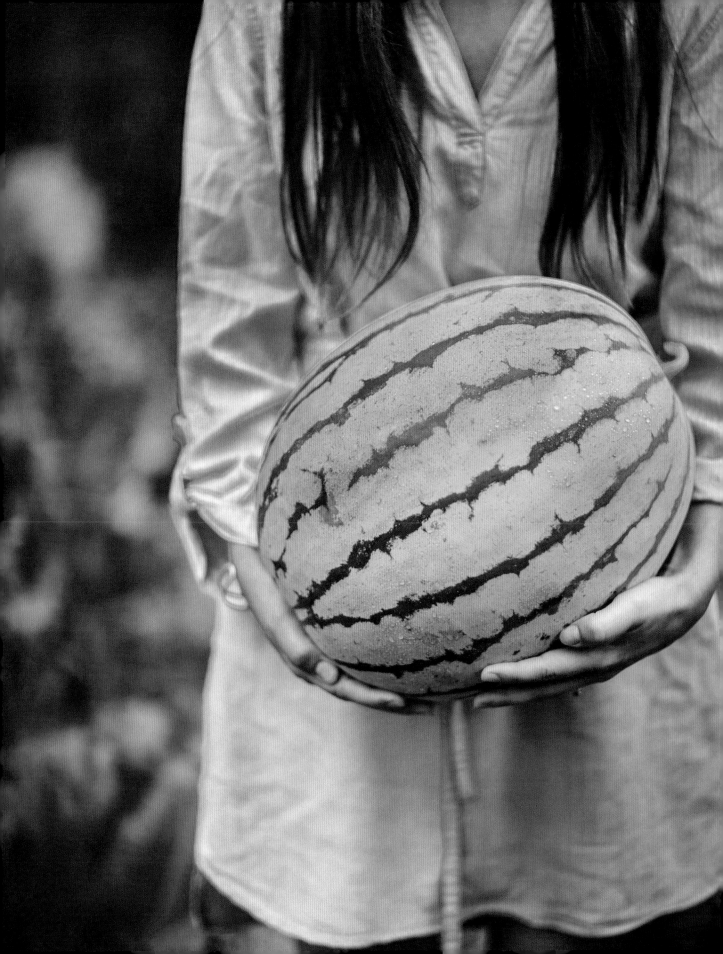

Stone Fruit Mini Pies

— Makes 4 —

My mother and father have a knack for convincing me that Jeremy and I can go through a huge amount of produce in several days' time. Twenty pounds of tomatoes? "No problem, you'll make sauce," they'll say. Ten pounds of cucumbers? "Just make tzatziki," my father will say with a dismissive wave of his hand. The ease with which they answer somehow always convinces me, and that's the roundabout way I ended up taking home 15 pounds of Italian plums. They sat there in my refrigerator for a week while I figured out what to make with them. In the end, I made these lovely little pies by combining the plums with some extra pluots (plum-apricot hybrids) I had lying around from the farmers' market (and then continued to make pickled plums, roasted plum butter, vanilla plum jam, and a caramelized onion and plum spread). If you've never cooked with Italian plums, you're in for a real treat. Their dark skin is full of flavor and color that seeps into the yellow flesh when cooked, creating a little ombré from gold to purple. They're the go-to plum for drying into prunes, but they taste just as delicious baked into sweets. Also, this recipe calls for the pies to be baked in little 5-inch (12-cm) pie plates, so make sure you grab four of those before diving in.

CRUST

3 cups (405 g) bread flour

3 tablespoons sugar

½ teaspoon flake kosher sea salt

½ teaspoon ground allspice

½ teaspoon ground cloves

½ teaspoon ground nutmeg

1 cup (2 sticks/225 g) unsalted butter, frozen

6 to 10 (90 to 150 ml) tablespoons ice water

FILLING

1 pound (455 g) plums and/or pluots, pitted and cut into 16 pieces each

3 tablespoons sugar

1 tablespoon all-purpose flour

½ teaspoon ground allspice

—For the crust, in a large bowl, stir together the flour, sugar, salt, allspice, cloves, and nutmeg. Grate the frozen butter over the bowl, stirring it every 30 seconds to help coat the individual shards of butter in the flour mixture.

—Add the ice water to the mixture, 1 tablespoon at a time, stirring, then kneading, until the dough just comes together. Grab a handful of the dough in your fist and then release it. If it generally sticks together when you let go, it is fine. If it completely crumbles apart, it needs another tablespoon or two of water.

—Once the dough holds its shape, divide it into eight balls: Four of them should be slightly larger than the other four. Roll out one of the larger balls to ⅛-inch (3-mm) thickness on a well-floured surface. Transfer it to a 5-inch (12-cm) mini pie plate about 1¼ (3 cm) inches deep, and center it so that an even amount of crust hangs over the sides. Press the crust into the bottom of the pan so it is nice and snug (you don't want any air bubbles appearing), still allowing the extra crust to hang over the sides. Set aside. Repeat with the remaining three larger dough balls. Cover and refrigerate the pans, and cover and refrigerate the smaller balls of dough.

—Preheat the oven to 375°F (190°C).

—For the filling, in a large bowl, toss together the plums and/or pluots, sugar, flour, and allspice until the fruit is coated. Set aside.

of them out into a circle. You can either cut a decorative hole out of each of them with a cookie cutter or you can cut them into strips to make a lattice pattern, or cut shapes out to use as the topping. You must have some kind of hole, though, for the steam to escape as the pies cook.

—Evenly distribute the filling among the four pie plates, and place the top sheet of dough, cut shapes, or lattice on top. Seal the edges together with your thumbs and trim off any excess dough hanging over the edge. If you just have a decorative shape on top, use your thumbs to press thumbprints along the edge of the crust.

—Place the pans on a large baking sheet and place it in the oven. Bake for 30 to 40 minutes, or until the crusts are deeply golden and the exposed portions of the fruit filling have deepened in color, wrinkled slightly, and are very fragrant. Remove and allow to cool for 15 minutes before serving.

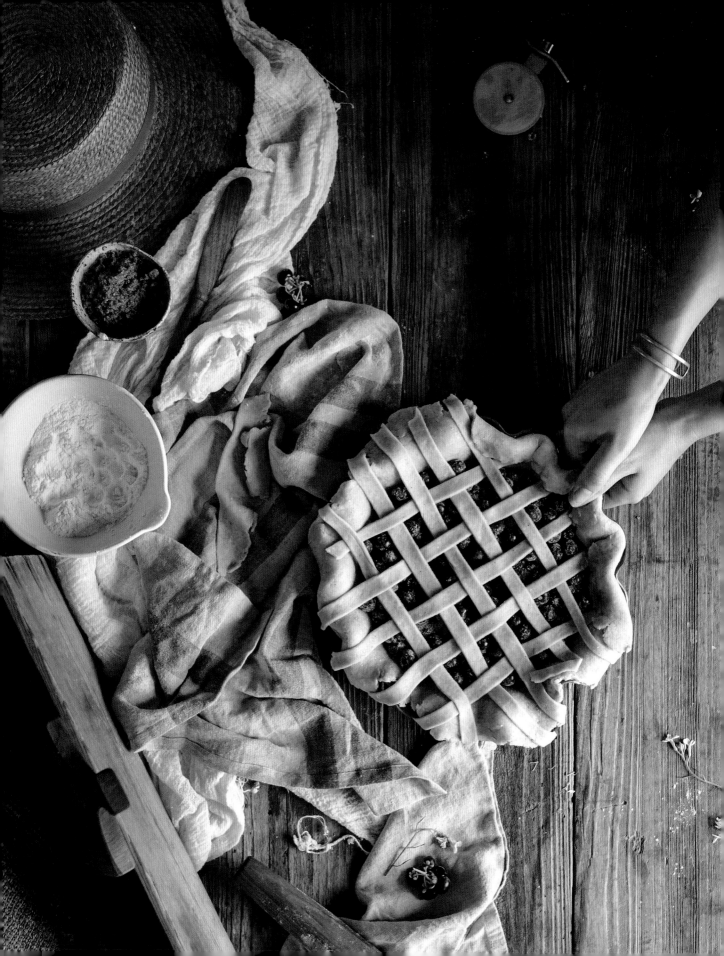

Huckleberry Pie

— Make one 9½-inch (24-cm) pie —

There's nothing like the cool breath of fall that starts to seep in on late summer mornings, letting you know that relief from the sweltering heat and searing sun is on its way. I love waking up snuggled under the blanket nice and cozy-like with a pup on either side of me—a delightful contrast to the usual wake-up call of sweat-soaked pajamas and deep panting that plagues our non-air-conditioned attic bedroom during the height of the summer. It's during this summer-to-fall transition that I begin to crave pie morning, noon, and night. This pie is one of my favorites because of its simplicity and deep, ripe flavor, relying on an effortless filling of wild huckleberries. Several varieties of huckleberries grow wild in the forests of the northwestern and eastern United States between mid-August and mid-September. They look like tiny blueberries, ranging in color from black to blue to purple and red. If you can't find wild huckleberries at your local farmers' market, you can easily substitute blueberries or even blackberries. Really, almost any type of berry would taste good here (I feel like this statement applies to any berry-based recipe). And the crust in this thing is heaven. Delicious spices are combined with he butter, and if you follow the directions about the chilling, you'll end up with an extra-flaky and unforgettable crust. The filling itself is basically sweetened, spiced stewed berries, and you really can't go wrong with that. There are bread crumbs sprinkled at the bottom of the filling (a little trick I learned from Dorie Greenspan, cookbook author extraordinaire) that help absorb the excess juice from the berries and keep it from being too watery when you slice it for serving. I like serving dark-berried pies à la mode, but feel free to serve it however you'd like. It's your pie now, after all!

—For the spiced crust, in a large bowl, stir together the flour, sugar, salt, cardamom, cinnamon, and cloves. Grate the frozen butter over the bowl, stirring it every 30 seconds to help coat the individual shards of butter in the flour mixture. Add 6 tablespoons (90 ml) of the ice water, 1 tablespoon at a time, stirring, then kneading, until the dough just comes together. Grab a handful of the dough in your fist and then release it. If it generally sticks together when you let go, it is fine. If it completely crumbles apart, it needs another tablespoon or two of water.

—Once the dough holds its shape, divide it into two balls, one just slightly larger than the other. Roll out the larger ball to ¼-inch (12-mm) thickness on a well-floured surface. Transfer it to a 9½-inch (24-cm) pie plate and center it so that an even amount of crust hangs over the sides. Press the crust into the bottom of the pan so it is nice and snug (you don't want any air bubbles appearing), still allowing the extra crust to hang over the sides. Cover and refrigerate the pan, and cover and refrigerate the smaller ball of dough.

—Preheat the oven to 375°F (190°C).

—For the filling, in a large bowl, toss together the huckleberries and vanilla until coated. Add the sugar, flour, cinnamon, cloves, and salt and toss until combined. Set aside.

🖙 *recipe continues*

SPICED CRUST

3 cups (405 g) bread flour

3 tablespoons sugar

½ teaspoon flake kosher sea salt

½ teaspoon ground cardamom

½ teaspoon ground cinnamon

¼ teaspoon ground cloves

1 cup (2 sticks/225 g) unsalted butter, frozen

6 to 8 (90 to 120 ml) tablespoons ice water

FILLING

4 cups (580 g) huckleberries

¾ teaspoon pure vanilla extract

¾ cup (150 g) sugar

3 tablespoons all-purpose flour

1 teaspoon ground cinnamon

¼ teaspoon ground cloves

Pinch of flake kosher sea salt

3 tablespoons plain dried bread crumbs

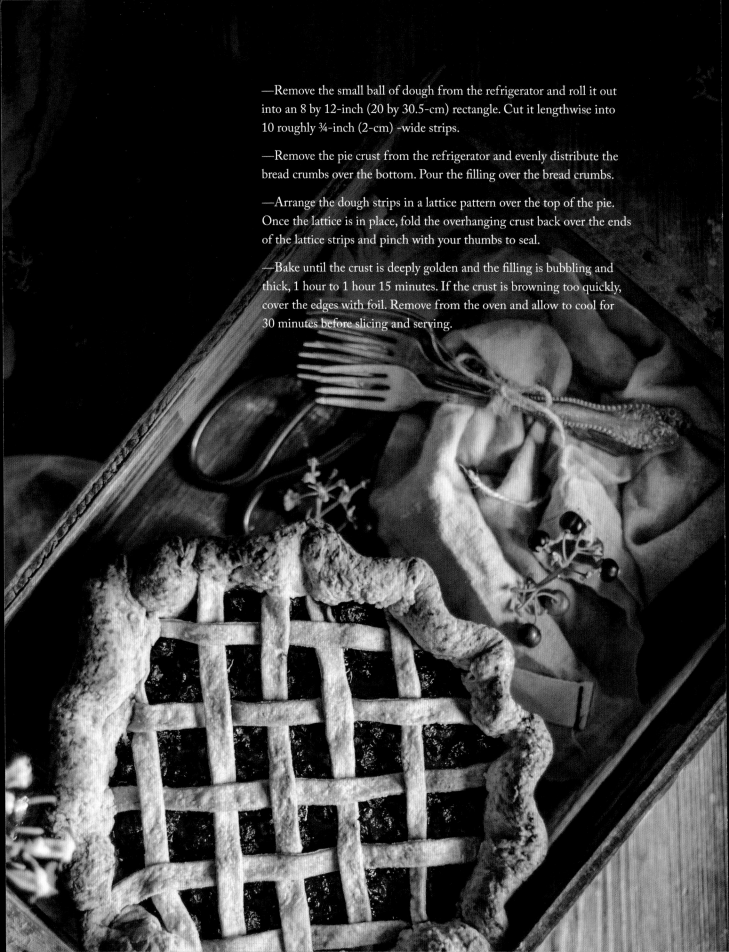

—Remove the small ball of dough from the refrigerator and roll it out into an 8 by 12-inch (20 by 30.5-cm) rectangle. Cut it lengthwise into 10 roughly ¾-inch (2-cm) -wide strips.

—Remove the pie crust from the refrigerator and evenly distribute the bread crumbs over the bottom. Pour the filling over the bread crumbs.

—Arrange the dough strips in a lattice pattern over the top of the pie. Once the lattice is in place, fold the overhanging crust back over the ends of the lattice strips and pinch with your thumbs to seal.

—Bake until the crust is deeply golden and the filling is bubbling and thick, 1 hour to 1 hour 15 minutes. If the crust is browning too quickly, cover the edges with foil. Remove from the oven and allow to cool for 30 minutes before slicing and serving.

Blackberry–Black Pepper Cheesecake with a Brown Butter Crust

— Makes one 9-inch (23-cm) cheesecake —

Last spring, I stopped into a little French restaurant in Portland called Maurice. It's run by the incredibly kind and talented Kristen D. Murray, a savant of sweets and all things pastry. Her dessert menu is something to aspire to, including goodies like crème brûlée pops and birdseed nougatine, but what she's best known for (and just so happens to be my favorite) is her black-pepper cheesecake. I knew I had to try my hand at something similar at home, so off to the kitchen I went. After several attempts, I found the perfect marriage of spicy black pepper, silky cheese filling, and sweet-tart berries in this decadent, swirly cheesecake. The crust is a traditional graham cracker one, but with browned butter instead of the plain melted stuff. This adds a toasty and slightly nutty element that will kind of blow your mind. Even though the filling is so good, everyone who has tried this always immediately remarks on the crust first, so you may even want to double the crust portion and use it as a topping on other sweet summer goodies, like ice cream, pie, and panna cotta.

—Line the sides of a 9-inch (23-cm) springform pan with strips of parchment paper.

—For the brown butter crust, in a medium bowl, stir together the graham cracker crumbs, brown sugar, and cinnamon.

—In a small shallow skillet, melt the butter over medium heat. Swirl the pan around a bit every couple of minutes to help it cook evenly. Over a period of several minutes, you'll notice the foam at the top of the butter start to change from a light yellow to dark tan. Once it reaches the dark tan stage and the butter looks light brown and golden, smell it. It should smell nutty and similar to toffee. Remove the pan from the heat and set aside to cool for 5 minutes.

—Stir the brown butter into the bowl with the graham cracker crumb mixture. Pour the crust mixture into the prepared pan and press into an even layer over the bottom of the pan. Set aside.

—For the blackberry–black pepper compote, in a small saucepan, combine the blackberries, sugar, black pepper, and cinnamon and bring to a boil over medium-low heat. Reduce the heat to low and cover. Cook for 7 to 8 minutes, then uncover and cook until the sugar has melted and the blackberries are very soft and have partially disintegrated, about 5 minutes more. Allow to cool for 15 minutes. Transfer to a blender or food processor and puree until smooth.

—In a small bowl, sprinkle the gelatin over the water and set aside for 1 minute to bloom. In a small saucepan, combine the gelatin mixture and the blackberry puree. Cook over low heat, stirring continuously, until the gelatin mixture dissolves completely. Remove from the heat and set aside.

☞ *recipe continues*

BROWN-BUTTER CRUST

1¼ cups (150 g) graham cracker crumbs

⅓ cup (75 g) packed light brown sugar

½ teaspoon ground cinnamon

4 tablespoons (½ stick/55 g) unsalted butter

BLACKBERRY–BLACK PEPPER COMPOTE

1 pound (455 g) ripe blackberries

⅓ cup (65 g) sugar

1 teaspoon freshly cracked black pepper

¼ teaspoon ground cinnamon

1 packet (0.3 ounce/7 g) unflavored gelatin

3 tablespoons cold water

BLACKBERRY–BLACK PEPPER CHEESECAKE

⅔ cup (165 ml) heavy cream

2 (8-ounce/225-g) packages cream cheese, at room temperature

⅓ cup (35 g) confectioners' sugar

1 tablespoon honey

¾ teaspoon pure vanilla extract

¼ cup (35 g) frozen blackberries

—For the blackberry–black pepper cheesecake, in the bowl of a stand mixer fitted with the whisk attachment, beat the heavy cream on high speed until it holds soft peaks. Transfer the whipped cream to a separate bowl and set aside.

—In the clean bowl of the stand mixer fitted with the paddle attachment, beat the cream cheese on medium-low speed until smooth. Add the confectioners' sugar, honey, and vanilla and beat until combined. Add ½ cup (120 ml) of the blackberry compote and mix until completely smooth. Remove the bowl from the stand mixer and fold in the whipped cream with a spatula. Pour the filling over the crust and even the surface with a spatula. Tap the pan down on the counter several times to help release any air bubbles in the cheesecake and flatten its surface.

—Pour the remaining blackberry compote in concentric rings on top of the cheesecake so it looks like a target symbol. Use a toothpick to drag across the compote, creating swirling patterns on the surface of the cheesecake. Cover, taking care not to let the covering material touch the surface of the cheesecake, and refrigerate for at least 6 hours. Remove the springform pan ring, garnish with the fresh blackberries, slice, and serve.

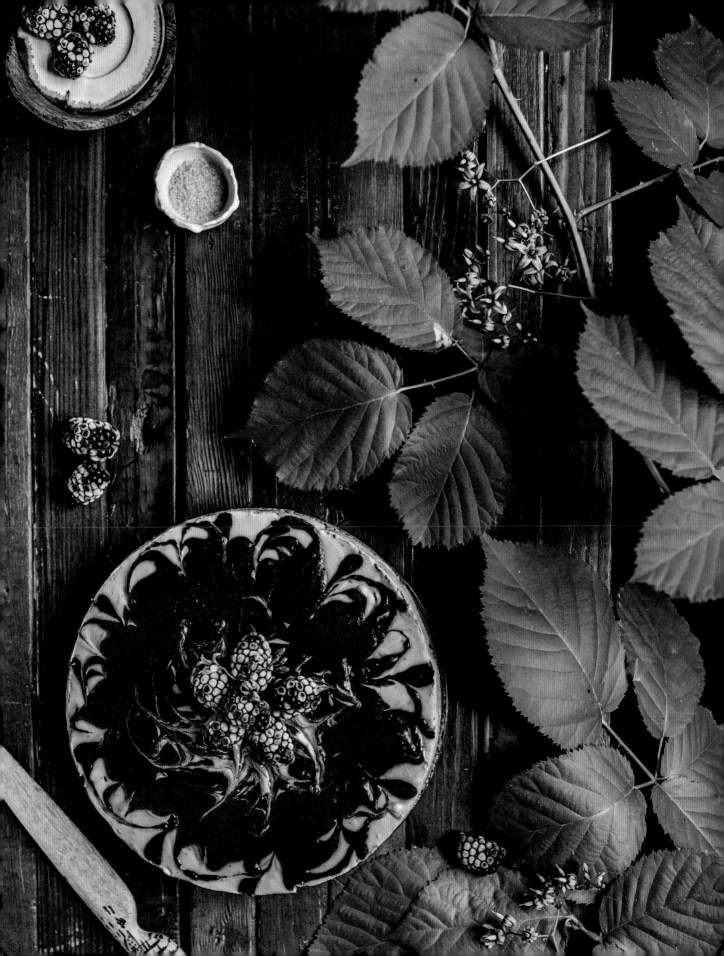

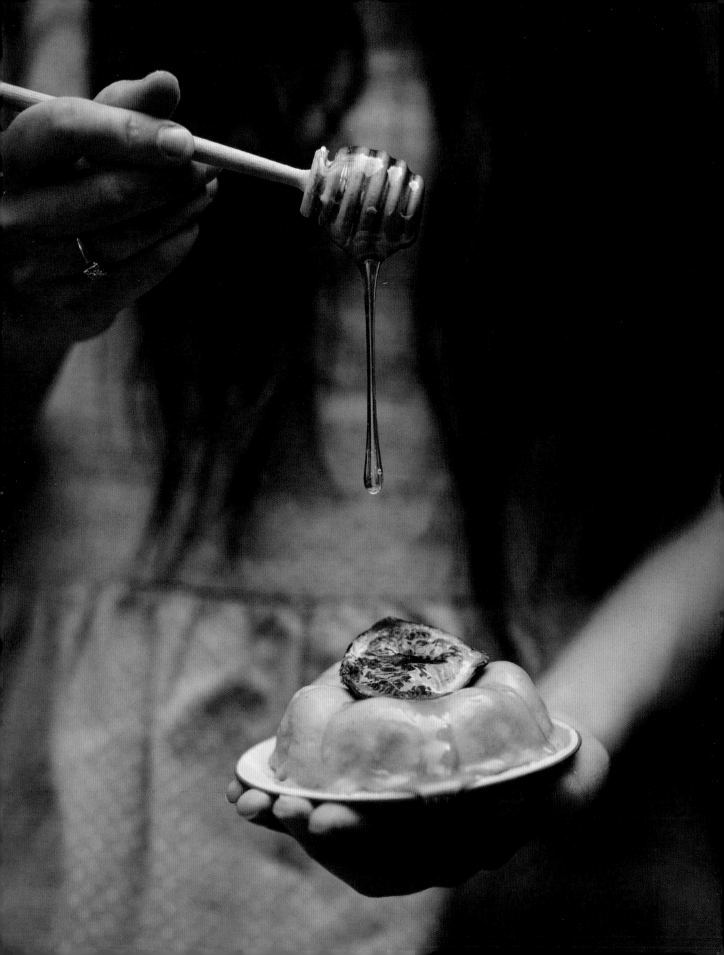

Raspberry-Mascarpone Panna Cotta

— Makes 7 —

I always thought panna cotta was one of those desserts that was incredibly temperamental and difficult to make, like macarons, but it's actually quite the opposite. True life: Panna cotta is just fancy Jell-O. Sure, there's cream and sugar and fruit in there, but there's gelatin, too, and if you've ever made Jell-O before, the same concepts apply here. The trickiest part of making panna cotta is unmolding it from the ramekin. You want to place the ramekin in a bit of hot water to warm up the sides just enough to soften the exterior so that the panna cotta will slide out when you flip it upside down, but still maintain its shape and doesn't turn into a sad blob of melted panna cotta glorp. I highly recommend following the directions for straining the raspberry puree, since removing the seeds will keep the texture of this sweet, creamy dessert smooth and luxuriously silky. This is also a great make-ahead sweet, since you can keep the ramekins in the fridge right up until serving time, and then unmold each one just before plating them. If I know the weather is going to be miserably hot, I'll make a batch of these and keep them in the fridge to enjoy at the hottest part of each day. It's like air-conditioning for the soul.

—Puree the raspberries in a blender or food processor until smooth. Strain through a mesh sieve to remove the seeds, using a pestle to help pass the juice and puree through. Discard the seeds.

—Stir the water into the raspberry puree. Sprinkle with the gelatin and allow to soften for 5 minutes.

—Pour the mixture into a small saucepan and bring to a simmer over medium heat. Reduce the heat to low and stir in the cream, milk, and sugar. Cook, stirring every minute, until hot but not boiling and the sugar has dissolved completely, 7 to 10 minutes. Turn off the heat, add the vanilla and mascarpone, and stir until the mascarpone has melted completely, about 3 minutes.

—Pour through a sieve to ensure no stray seeds are in the mixture, then divide the mixture among seven ½-cup (120-ml) ramekins. Allow to cool to room temperature, then cover and refrigerate for at least 4 hours or overnight.

—When you're ready to serve them, dip the bottoms of the ramekins one at a time into a bowl of hot water for 3 seconds, taking care not to submerge them (you don't want the hot water getting inside the ramekin, only touching the exterior of it). Remove from the water and run a small, thin knife around the inside edge of each ramekin, then invert it onto a small serving plate. Garnish each panna cotta with a fig half and 1 teaspoon of the honey. You'll have a fig half leftover to enjoy on its own! Serve immediately.

8 ounces (225 g) fresh raspberries

1 tablespoon cold water

1 packet (0.3 ounce/7 g) unflavored gelatin

1¾ cups (420 ml) heavy cream

¾ cup (180 ml) whole milk

⅓ cup (65 g) sugar

½ teaspoon pure vanilla extract

⅓ cup (80 g) mascarpone cheese

4 ripe figs, cut vertically in half

7 teaspoons honey

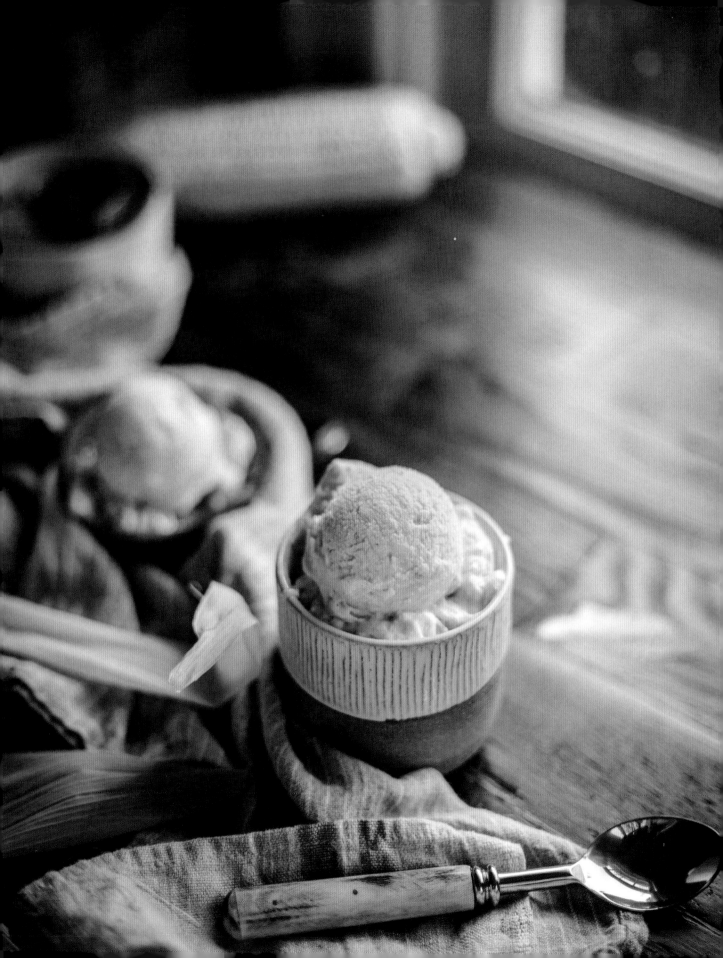

Cinnamon–Sweet Corn Ice Cream

— Makes about 2 pints (960 ml) —

My mother is from Indiana, where corn is king, and we still have family back that way around Gary, South Bend, and Gaston. A couple of years ago, one of my mother's cousins sent her some corn seeds, saying they grew the sweetest corn they'd ever come across. And they weren't kidding. My parents gave some to me, and I watched wide-eyed as they grew to more than 8 feet (2.4 m) tall. There's something almost shocking about the intense sweetness that a fresh ear of summer corn has. I decided to ue the harvest in an ice cream, made by grating fresh sweet corn and using the corn juices and pulp to flavor the rich custard base. Silky smooth in texture, with a comforting warmth from the cinnamon and a hint of sweet richness from the corn, its familiar flavor is pleasing to every palate.

—Remove the husk and silk from the sweet corn. Stand a box grater in a bowl and use the large hole setting to grate the corn off each ear into the bowl. Discard the cobs and set the corn aside.

—Bring water in the bottom of a double boiler to a boil over medium heat. Reduce the heat to low. Put the egg yolks and sugar in the top of the double boiler. Whisk vigorously without stopping until the mixture turns a very pale yellow, a steady ribbon of yolk falls from the whisk when you lift it above the pan, and you don't feel any sugar granules when you pinch the mixture between your thumb and forefinger, 2 to 3 minutes.

—Transfer to a blender or food processor. Add the corn, cream, milk, vanilla, cinnamon, and salt and blend until completely smooth. Pour the mixture into an ice cream machine and churn according to the manufacturer's directions. Transfer the ice cream into an airtight freezer-safe container and freeze for 4 hours or overnight before serving.

4 ears sweet corn
4 egg yolks
½ cup (100 g) sugar
1½ cups (360 ml) heavy cream
1½ cups (360 ml) whole milk
¾ teaspoon pure vanilla extract
¾ teaspoon ground cinnamon
Pinch of flake kosher sea salt

Melon Agua Fresca

— Serves 4 —

The heat of summer can make any sort of oven-related cooking in our non-air-conditioned house an intensely sweaty and unpleasant experience. This, coupled with the fact that I plant an absurd amount of tomatoes every year, means that I end up eating caprese salad at least once a day. But even with the juiciness of a fresh tomato, on especially hot days, the heat still gets to me, and I find myself cursing at the sky, just angrily staring out the window at the sun, stuck inside avoiding heatstroke instead of actually enjoying the summer like I should. On days like those, even water doesn't quench my thirst, so I lean on my old friend agua fresca. It's one of the simplest things to make and the most refreshing drink ever.

5 pounds (2.3 kg) summer melon,
 any variety
1 tablespoon honey
1 tablespoon fresh lime juice
Ice (optional)

—Seed the melon. Cut the flesh off the rind into roughly 2-inch (5-cm) chunks. Discard the rind.

—Place half the melon flesh in a large blender or food processor and add 1 cup (240 ml) water, ½ tablespoon of the honey, and ½ tablespoon of the lime juice. Blend on medium-high speed until smooth, then transfer the mixture to a large pitcher. Repeat with the remaining ingredients and add the desired amount of ice to the pitcher before serving.

—If you're not serving it immediately, the agua fresca can be stored in an airtight container in the refrigerator for up to 3 days. It will separate as it sits, so make sure to give it a stir before serving.

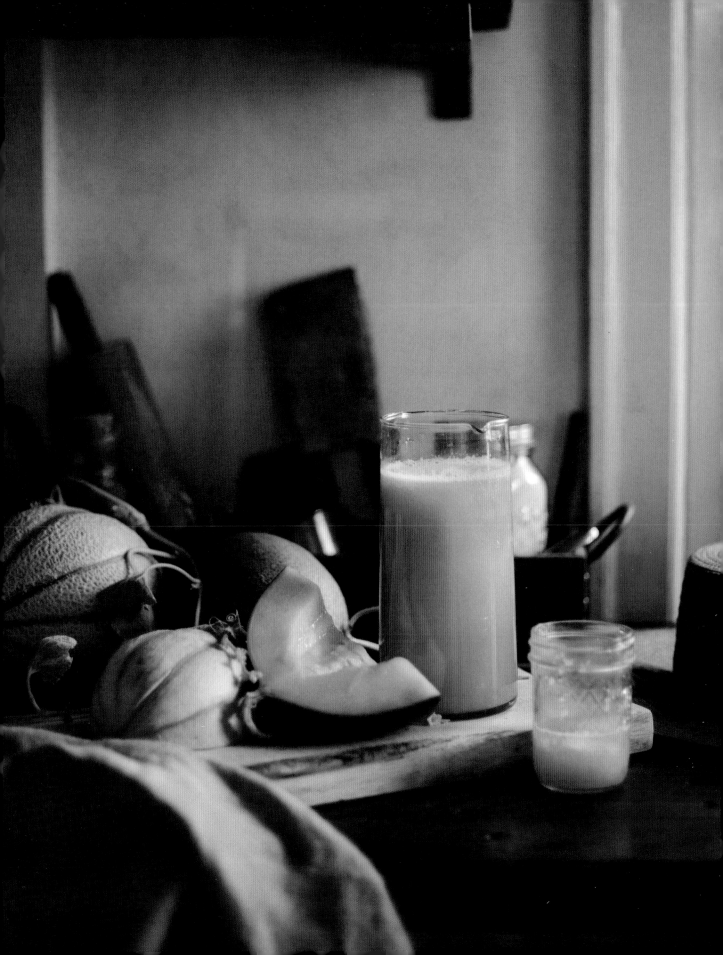

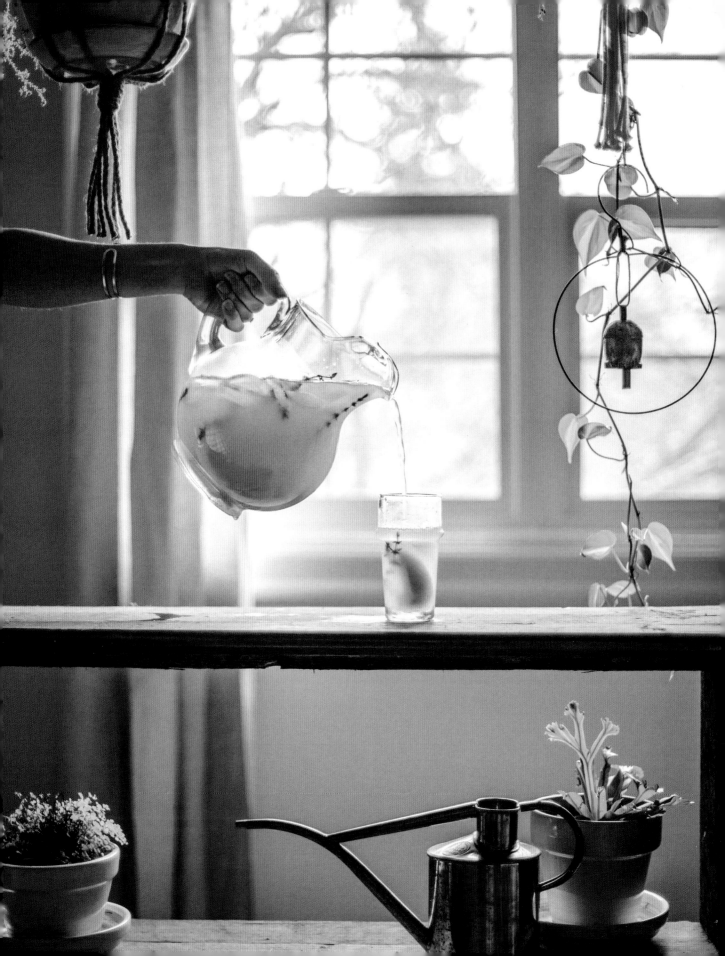

Peach and Thyme Lemonade

— Serves 4 —

My first foray into entrepreneurship began with an attempt at a lemonade stand when I was about five years old. I had drawn up a whole plan about how I was going to build it (using the leftover wood scraps from my father's greenhouse project) and where I was going to place it (curbside to get the most foot traffic, obviously). Before diving into the building process (I envisioned it to be an exact replica of Lucy's psychiatry stand from Peanuts*), I made a test batch. I juiced a ton of lemons into a pitcher, dumped some sugar into it, stirred it up, and drank it. It was probably the sourest thing I'd tasted in my life at that point. Since the juice was cold, the sugar didn't dissolve and instead pooled at the bottom of my sad little pitcher, leaving me with a mouthful of lemon juice and some unpleasant grainy sugar granules stuck at the corners of my mouth. I begrudgingly admitted that maybe I wasn't ready to for a lemonade stand yet and quickly moved on to putting together a camping adventure for Samantha, my American Girl doll. Luckily, I've learned a lot more about making citrus-based beverages since then, and I can proudly say that I make a pretty mean lemonade. This has the perfect balance of sweet, fruit, and tart—plus the thyme adds a little herbal element that gives an extra-refreshing quality to the drink.*

—In a medium saucepan, combine the sugar, peach, thyme, and 7 cups (1.7 L) water and bring to a boil over medium-high heat. Reduce the heat to medium-low and cook until the sugar has dissolved and the mixture smells strongly of peaches, about 20 minutes.

—Remove from the heat and allow to cool to room temperature. Stir in the lemon juice and refrigerate. Serve chilled.

1¼ cups (250 g) sugar

1 ripe peach, pitted and cut into eighths

1 sprig fresh thyme

1 cup (240 ml) fresh lemon juice

Strawberry-Habanero Daiquiri

— Serves 4 —

The first time I had habanero in a cocktail was on Jeremy's and my five-year anniversary. We went out to a nice now-defunct restaurant in Los Angeles called Waterloo and City, and since it was our anniversary, I ordered a cocktail. At that point, we had just graduated college and were both extremely poor, so ordering a drink with dinner was a big deal. I don't recall the name of the drink, but I remember that it contained strawberries, tequila, and a house-made habanero simple syrup, and that I loved it. Over the years, I ended up creating something similar, albeit even more tasty, with this spicy take on a classic strawberry daiquiri. I make a habanero simple syrup with sugar, water, and habaneros (Pretty simple, right? . . . Sorry, I couldn't help myself.). And, just as an FYI, habaneros are very, very hot peppers, so it's a good idea to use rubber gloves or disposable gloves when cutting them to keep the oils from getting on your hands. Then pure, fresh strawberry juice is extracted by shaking sliced fresh strawberries in a cocktail shaker with crushed ice. The ice smashes against the strawberries, squeezing out their juices while mixing them together with the lime juice, rum, and simple syrup. This technique results in the purest, most vibrant strawberry flavor and creates my favorite daiquiri of all time (and I have a sneaking suspicion that it will be yours, too!).

HABANERO SIMPLE SYRUP
¾ cup (150 g) sugar

1 habanero pepper, stemmed, seeded, and finely chopped

STRAWBERRY-HABANERO DAIQUIRIS
2 cups (330 g) sliced strawberries

2 cups (480 ml) crushed ice

⅔ cup (165 ml) fresh lime juice

1 cup (240 ml) spiced rum

—For the habanero simple syrup, in a small saucepan, combine the sugar, habanero, and ¾ cup (180 ml) water. Bring the mixture to a boil over medium-low heat. Cook for 10 minutes, then remove from the heat and allow to cool to room temperature. Strain the syrup into an airtight container and discard the habaneros. Refrigerate the syrup until ready to use.

—For the strawberry-habanero daiquiris, in a cocktail shaker, combine 1 cup (165 ml) of the strawberries, 1 cup (240 ml) crushed ice, ⅓ cup (75 ml) of the lime juice, ½ cup (120 ml) of the rum, and ¼ cup (60 ml) of the habanero simple syrup. Secure the lid and shake for 30 seconds. Strain into two glasses. Repeat to make two more servings.

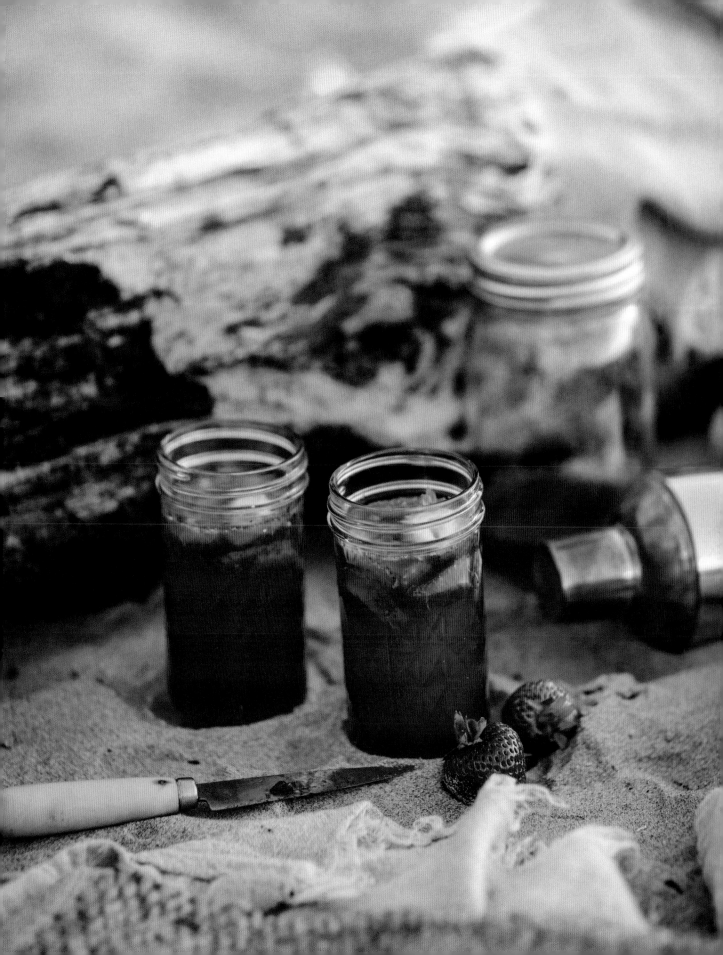

– MENU FOR A HARVEST SUPPER –

Autumn is my favorite time of the year. Once the air turns crisp and the leaves on the trees begin to change to a spectrum of golds, oranges, and reds, I start nesting at home. I spend time catching up on all the indoor housework I neglected during the summer, drinking hot tea, and cooking with any and all squash I can get my hands on. (Seriously, guys. Squash is the BEST). Jeremy and I also like to drive up to this strip of U-pick orchards in Hood River known as the "fruit loop" and wander through the trees; occasionally picking apples but mostly just sipping hot local cider, eating fresh-baked apple cinnamon rolls, and taking in the beauty of our surroundings. To celebrate the rich and comforting flavors of the autumn harvest, I put together this menu for you with some of my favorite seasonal dishes. I hope it inspires you to gather with your family and friends and share some good food, company, and spirits.

Buttermilk Cornbread with Caramelized
Onions and Black Pepper
page 176

Brussels Sprouts au Gratin
page 179

Pumpkin and Date Cassoulet
page 190

Cider and Cinnamon Babka
page 215

Brandy Spiced Cider
page 230

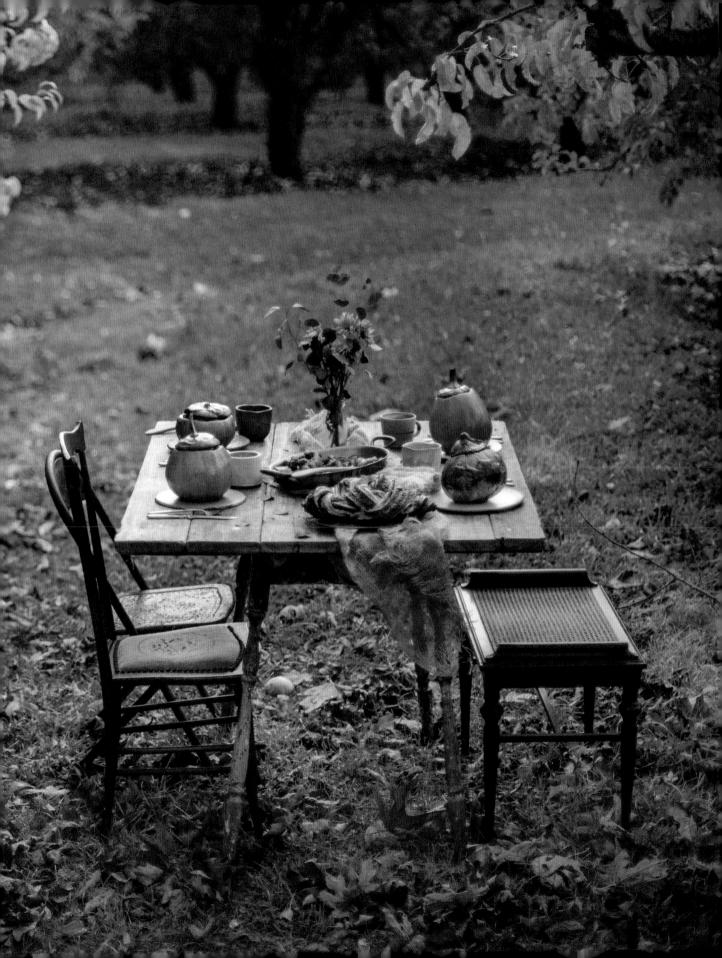

"In the garden, Autumn is, indeed the crowning glory of the year, bringing us the fruition of months of thought and care and toil. And at no season, safe perhaps in Daffodil time, do we get such superb colour effects as from August to November."

—*ROSE G. KINGSLEY*

Composting

—

COMPOSTING AT HOME ALLOWS YOU to reuse decomposing organic matter such as leaves, plant-based kitchen scraps, eggshells, and grass, turning it into what gardeners call black gold. Contrary to popular belief, composting isn't just limited to those with large backyards—there are several composting bins that work well for those with apartment patios and balconies, too. Good compost is chock-full of nutrients and beneficial microbes that will boost the overall health and productivity of the plants in your garden when incorporated into the soil. Since autumn provides an abundance of fallen leaves, it's the perfect time to try your hand at a homemade batch of compost. Once you get the hang of it, you can make it an annual fall tradition. Making your own compost is much easier than you'd think, and the benefits are multifold. You're cutting down on landfill waste, reducing air pollution, and saving money on garden fertilizers. Here is my beginner's guide to composting.

HOW COMPOSTING WORKS
Aerobic (oxygen-loving) bacteria and other microbes are the driving force behind the activity of the compost pile, helping to speed up the decomposition process. The types of bacteria and microbes change as the temperature of the pile itself heats up from the activity of the microbes. Compost piles can get up to 140°F (60°C) in the center at the height of microbial activity. Snails and worms also help break down the organic matter, eating their way through leaves and vegetable peels and leaving behind vitamin-rich little poops. At the end of its decomposition cycle, finished, healthy compost resembles dark brown, almost black damp dirt, but it is a little crumblier in texture. To help speed up the decomposition process, it's helpful to break up any scraps you have into smaller pieces before putting them in your bin.

THE WONDERFUL WORLD OF COMPOST BINS
First things first: You need a composting bin. There are four main types of bins out there.

Standing compost bins: These are cylindrical and have a big hole at the top for the scraps to go in, small holes along the side for aeration, and one medium hole toward the bottom that has a removable flap on it. The medium hole allows for finished compost to be released from the bottom while newer, less-decomposed materials remain slightly separated toward the top, encouraging a continuous cycling of added compost materials. There is no bottom on most of these, which lets the compost maintain physical contact with the ground and lets beneficial insects and microbes find their way into the compost more readily.

Barrel compost bins: As their name suggests, these are shaped like barrels and are typically suspended horizontally by metal rod stands at each end. They also have small holes on the sides for air circulation. This setup allows the compost bins to spin, so it's very easy to stir up the contents. However, the finished compost is always mixed with the new materials, so you can't really have a continuous cycling of compost with this bin. Instead, you need to fill it, allow it to compost, and empty it before starting again on a new batch. There is also no contact with the ground, so you need to add a few shovelfuls of garden soil and a cup of earthworms to it to get the microbes going.

Homemade composting bins: You can make this one yourself, using four 4 by 4-inch (10 by 10-cm) wooden posts driven into the ground and wrapped with chicken wire to create a square bin with an open top and bottom. You can attach wooden slats to the sides for more stability. The benefits of this setup are similar to the standing compost bin.

Worm composting bins: These consist of a series of trays for the organic materials to be housed in along with worms, kind of like a composting filing cabinet but with short trays instead of tall drawers. The trays have small holes along their bottoms that allow the worms to travel up and down through the different layers. Every week or two, you add new organic material to one of the trays and place it in the top slot, moving all the other trays down one slot, with the idea being that that bottom drawer will have the oldest, most-composted materials in it ready to be incorporated into the garden. This is a very effective system for quickly composting materials, and it is good for people who only produce a small amount of scraps. This setup is different from traditional compost, however, since it lacks the same biodiversity as the traditional compost heap, and it mostly yields earthworm casings rather than traditional compost. The casings are still incredibly beneficial for your garden, though, and this bin is great for those with small spaces, since one of these can easily fit on an apartment balcony.

WHAT TO PUT IN A COMPOST BIN

Once you have the compost bin and have placed it in a shaded location near a water source, it's time to start adding things to it. First, it's best to add a few inches of twigs or straw at the bottom to help aerate it (skip this step if you have the worm drawer composting bin). Now you can begin adding organic materials, ideally working in alternating layers of wet and dry (wet materials being things like plant scraps and used coffee grinds, and dry materials being things like wood chips, wood ash, paper, or leaves). Dry materials should be moistened slightly with water before adding. To keep the compost pile healthy, you need to maintain the proper balance of "greens" and "browns." Greens are nitrogen-rich raw materials like grass, fruit and vegetable bits, flowers, and chicken manure. Browns are carbon-rich materials like dead leaves, shredded uncolored paper, and wood chips. As a general rule, your compost heap should be made up of one-third green and two-thirds brown materials.

COMPOST MAINTENANCE

To keep the microorganisms and insects happy and hydrated, you need to keep the contents of the bin nice and moist. If you live in a rainy climate, nature can take care of this for you, but if you live in a drier location, you'll need to do this manually, by adding water to the pile until it is slightly damp all the way through. There shouldn't be any standing water inside the bin, however. Any excess should be able to drain out of aeration holes. It's also important to stir up the bin contents every couple of weeks to incorporate fresh oxygen for the aerobic microbes. If you have a standing or homemade compost bin, you should use a pitchfork to give its contents a good stir; if you have a barrel bin, you can just rotate it; and if you have a worm bin, you just need to follow the manufacturer's directions on keeping up with swapping out the trays. In between stirring sessions, it's best to keep the top of the compost pile covered with wood or plastic sheeting to help the pile retain moisture and warmth. As you add new materials to your established compost pile, it's best to stir them in rather than keep them in their own separate layer. Your compost is finished and ready to be distributed to your garden when it's very dark brown and crumbly.

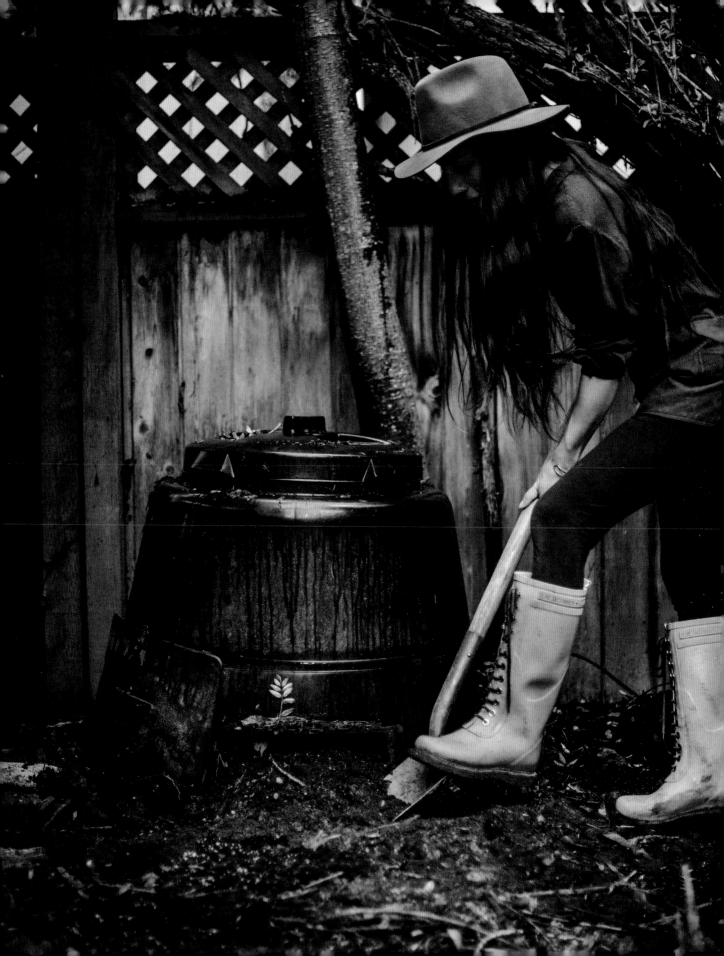

Sweet, Salty, and Spicy Skillet Pecans

— Makes about 5 cups (600 g) —

Candied nuts are one of my favorite appetizers to serve at gatherings. They're quick, easy, tasty, and store well, so they can be made ahead of time. This rendition calls for a little vanilla extract for some extra sweetness in addition to the brown sugar but counters the sweet with spice in the form of ancho chile, cayenne pepper, and a dash of hot sauce. I love making these at home on the stovetop, but they also make for good campfire cooking above ember-rich fires or hot coals. Just make sure you use a cast-iron skillet and make sure that the heat level is consistent, cooking them over hot, glowing-red embers rather than active, large fires.

—Line a rimmed baking sheet with parchment paper and set aside.

—In a medium saucepan, melt the butter over medium heat. Add the brown sugar and vanilla and stir. Raise the heat to medium-high and cook until the mixture starts bubbling. Add the pecans and stir to coat.

—Reduce the heat to medium-low and cook, stirring every 2 to 3 minutes, until the pecans are lightly browned and smell toasted, 10 to 15 minutes, taking care not to allow the nuts or sugar to burn.

—Turn the pecans out onto the baking sheet and spread them evenly using a spatula. Immediately sprinkle with the salt, chile powder, and cayenne, and drizzle with the hot sauce. Allow to cool to room temperature.

—Once cooled, break apart any large chunks and serve as a snack or a topping.

4 tablespoons (½ stick/55 g) unsalted butter

⅔ cup (145 g) packed light brown sugar

¼ teaspoon pure vanilla extract

4½ cups (450 g) pecan halves

2 teaspoons flake kosher sea salt

½ teaspoon ancho chile powder

¼ teaspoon cayenne pepper

1 teaspoon vinegar-based hot sauce, such as Tabasco

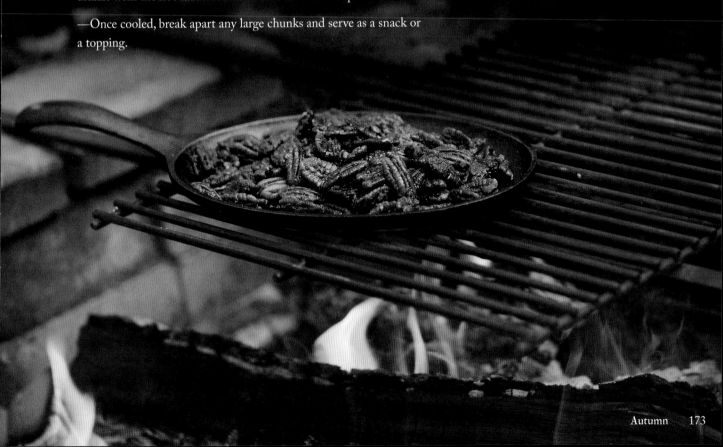

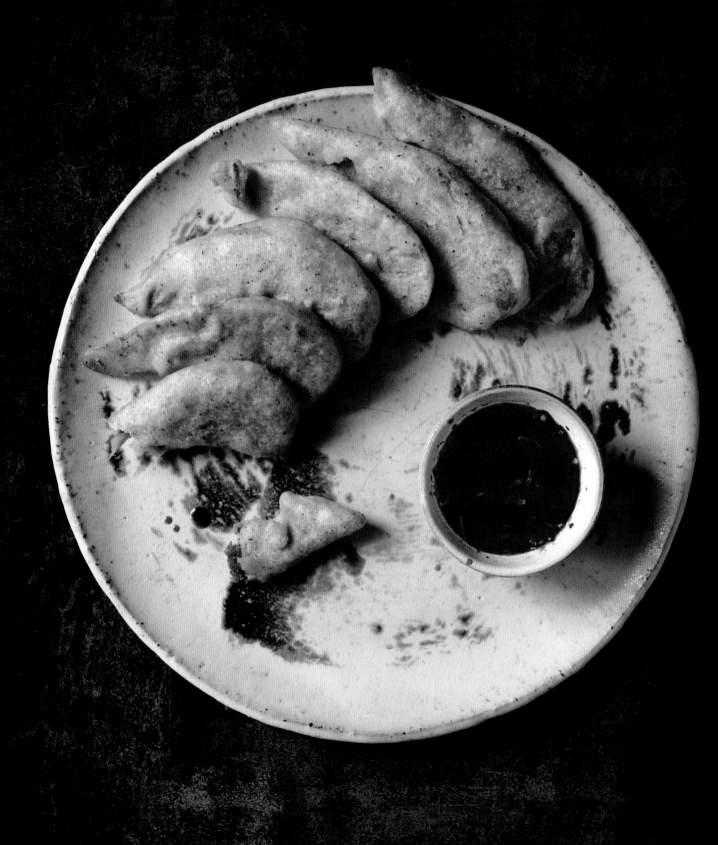

Tempura-Fried Squash
with Ginger-Soy Dipping Sauce

— Serves 4 —

Back when I lived in Los Angeles, Jeremy and I used to frequent a Japanese restaurant called Marugame Monzo that specialized in homemade udon noodles. The kitchen was enclosed in glass so you could see them stretching the noodles by hand, and the smell of enticing soup filled the little dining room. The soup we'd order would change nearly every time, but we always got the same appetizer. They made the most incredible fried pumpkin, with soft, fluffy pumpkin on the inside and a crunchy, savory shell of tempura on the outside. After we moved back to Portland, I began to crave it desperately in the fall, so I tried my hand at it. Even though I'm mildly terrified of frying things, it ended up being insanely easy, and I was kicking myself for not trying to make it sooner. I whipped up a simple dipping sauce, made with soy sauce, fresh lime juice, fresh ginger, and some red pepper flakes, for a kick. If you're not into spicy stuff, you can feel free to omit those. Or, you can definitely bump up the amount of red pepper flakes, as desired, or even add a dash of your favorite hot sauce to really heat things up.

—For the ginger-soy dipping sauce, mix together the soy sauce, lime juice, ginger, and red pepper flakes (if using) in a small bowl and set aside.

—For the tempura-fried squash, cut the squash into slices that are ¼- to ½-inch (6- to 12-mm) thick, then peel them. In a medium shallow dish, toss together ⅓ cup (55 g) of the rice flour, 1 teaspoon of the salt, and ¼ teaspoon of the black pepper.

—Lightly brush the slices with the egg and then dredge them in the rice flour mixture to very lightly coat. Set aside.

—In a medium bowl, whisk together the remaining 1½ cups (220 g) rice flour, 2 teaspoons salt, ½ teaspoon black pepper, the buttermilk, garlic powder, cayenne, and ½ cup (120 ml) water until smooth.

—Fill a medium skillet with 2 inches (5 cm) of canola oil; be sure there is at least 2 inches (5 cm) between the top of the pan and the top of the oil, in case of splattering. Heat the oil over medium-high heat until it registers 300°F (150°C) on a deep-fry thermometer. Working in batches, slide the squash into the hot oil and fry until the batter is lightly golden at the edges and the squash is cooked through, 5 to 7 minutes per side; make sure that the squash pieces don't touch one another in the pan.

—Remove with tongs and set aside on a plate lined with paper towels, patting the pieces with another paper towel to help remove excess oil. Serve with the dipping sauce.

GINGER-SOY DIPPING SAUCE

¼ cup (60 ml) soy sauce

3½ teaspoons fresh lime juice

1 (1-inch/2.5-cm) piece fresh ginger, peeled and minced

Pinch of red pepper flakes (optional)

TEMPURA-FRIED SQUASH

1½ pounds (680 g) acorn squash, halved and seeded

1½ cups plus ⅓ cup (275 g) rice flour

3 teaspoons flake kosher sea salt

¾ teaspoon freshly cracked black pepper

1 egg, beaten

1 cup (240 ml) buttermilk

1 teaspoon garlic powder

¼ teaspoon cayenne pepper

Canola oil, for frying

Buttermilk Cornbread with Caramelized Onions and Black Pepper

— Serves 8 —

I know a lot of folks make cornbread in the summer for barbecues, but its dense richness always feels a little out of place to me in the searing heat of July and August. Digging into a warm and sweet-yet-savory slice of this stuff on a crisp October day, however, is a totally different experience—one that is meant to be relished. To keep the cornbread from being too dry and crumbly, I combine the cornmeal with both creamed corn and buttermilk. Because I like my cornbread a little sweet, I also incorporate some caramelized onions. To give it the littlest bit of a kick, there's a generous amount of black pepper. Western cultures don't typically employ a heat-inducing amount of black pepper in foods, so it can be a little disorienting at first. It feels like a tickling heat in the back of your throat, rather than the numbing sensation on your tongue that you might feel from a fresh pepper like a jalapeño. I find the heat of black pepper to be much more pleasing, and I think you will, too!

2 tablespoons extra-virgin olive oil

1 medium yellow onion, chopped

1 cup plus 2 tablespoons (150 g) cornmeal

¾ cup plus 2 tablespoons (120 g) bread flour

¼ cup (50 g) sugar

¾ teaspoon baking soda

¾ teaspoon freshly cracked black pepper

½ teaspoon flake kosher sea salt

1 cup (240 ml) creamed corn

¾ cup (180 ml) buttermilk

1 egg

⅔ cup (65 g) freshly grated Parmesan cheese

1 tablespoon hulled pumpkin seeds

—In a large cast-iron skillet, heat the oil over medium-low heat. Add the onion and stir to coat. Reduce the heat to low and cook, stirring every 5 minutes, until the onion turns golden, 30 to 40 minutes. Remove from the heat and set aside.

—Preheat the oven to 350°F (175°C).

—In a large bowl, stir together the cornmeal, flour, sugar, baking soda, pepper, and salt. Set aside.

—In the bowl of a stand mixer fitted with the paddle attachment, combine the creamed corn, buttermilk, and egg and beat on medium-low speed until smooth. Add the flour mixture and mix on low speed until just combined. Remove the bowl from the stand mixer and stir in the Parmesan and caramelized onions by hand until just incorporated.

—Pour the batter into the skillet, sprinkle the top with the pumpkin seeds, and place the skillet in the oven. Bake until the top is lightly golden and a toothpick inserted into the center comes out clean, 25 to 35 minutes.

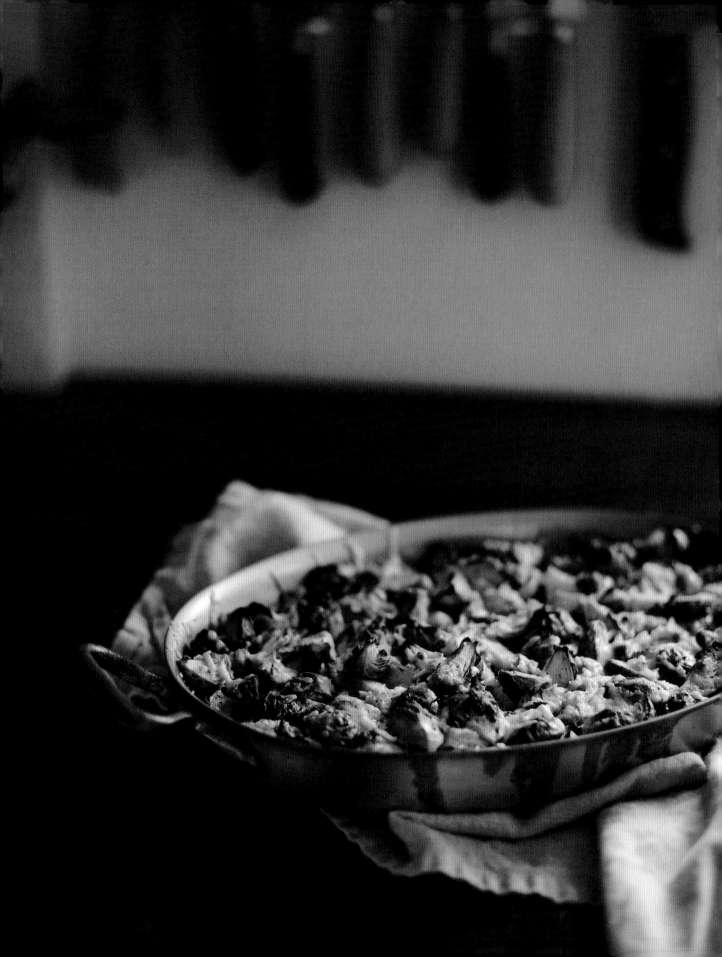

Brussels Sprouts au Gratin

— Serves 4 —

I never had Brussels sprouts growing up, because my mother had been served steamed Brussels sprouts on the regular as a child, thus incurring a deep and searing hatred for them. The sour smell of these mini cabbage-like vegetables when they are over-boiled makes me understand her aversion. But there is something magical that happens when you expose the little layers of leaves on each sprout to the heat of an oven. The ends of each leaf crisp up and caramelize, while the internal base of the sprout softens and absorbs all the sumptuous caramelized flavors seeping into it from its leaves. Then, when you add herbs and cream and cheese to the mix, you get something almost obscenely flavorful. This is super-easy to throw together in a pinch, too, so I love making it as an appetizer when I'm entertaining, but it's also hearty enough to be a stand-alone meal for a small group.

—Preheat the oven to 425°F (220°C).

—In a small bowl, whisk together the cream, garlic, rosemary, salt, thyme, and pepper until combined.

—In a large bowl, toss the Brussels sprouts with the oil until coated.

—Grease a 2½-quart (2.4-L) casserole dish with the butter and spread half of the Brussels sprouts on the bottom of the pan. Dot them with half the butter and sprinkle them with half the Parmesan and half the cheddar. Drizzle half the cream mixture over them, then spread the remaining Brussels sprouts over the top and repeat.

—Roast until the tips of the Brussels sprouts are golden and crisp and the cheese has melted, 25 to 30 minutes.

⅔ cup (165 ml) heavy cream

3 garlic cloves, minced

1 teaspoon finely chopped fresh rosemary

1 teaspoon flake kosher sea salt

¼ teaspoon ground thyme

¼ teaspoon freshly cracked black pepper

2 pounds (910 g) Brussels sprouts, trimmed and quartered

2 tablespoons extra-virgin olive oil

3 tablespoons unsalted butter, cut into ¼-inch (6-mm) cubes, plus more for the pan

½ cup (50 g) grated Parmesan cheese

1 cup (115 g) grated white cheddar cheese

Ponzu-Sautéed Mushrooms on Toast
with Poached Quail Eggs

— Serves 4 —

Think of this recipe as your go-to fall breakfast—the avocado toast of the cold-weather months, if you will. Yes, this recipe calls for quail eggs, and no, it's not just to be fancy. For a long time, I didn't really understand the draw of quail eggs—they're beautiful, of course, but why use them when you need four or five to equal the volume of one awesome chicken egg? Well, it turns out that they're crazy easy to poach. Quail eggs cook very quickly, and their tiny size makes it really easy to transfer them successfully from pot to plate without accidentally puncturing them. As for the mushrooms, I love sautéing them with a bit of ponzu and oyster sauce to make the umami flavor of this dish extra-punchy.

2 teaspoons distilled white vinegar

8 quail eggs

7 tablespoons (95 g) unsalted butter, at room temperature

10 ounces (280 g) mushrooms, halved or quartered, if large

2 tablespoons ponzu

1 tablespoon oyster sauce

4 thick slices French bread

—Fill a large skillet with 2 inches (5 cm) of water and add the vinegar. Bring to a low boil over medium-low heat.

—Hit the tops of the quail eggs with the tip of a metal spoon and then peel just the tips of the tops open. Pour an egg into the pan and cook until the egg whites turn white but the center is still jiggly, 2 to 3 minutes; you can cook up to 4 eggs at a time, nudging them gently with the back of a spoon to make sure that they are spaced several inches away from one another in the pan.

—Use a small spoon to remove the eggs from the pot and place them in a bowl of cold water. Repeat with the remaining eggs.

—In a large skillet, melt 3 tablespoons of the butter over medium heat. Add the mushrooms and cook, stirring every 2 minutes, until they release their moisture, 6 to 8 minutes. Add the ponzu and oyster sauce and stir to coat. Cook until most of the moisture in the pan has evaporated and the mushrooms have shrunk slightly, about 10 minutes.

—Meanwhile, spread the remaining 4 tablespoons (55 g) of the butter on the 4 slices of bread, using 1½ teaspoons of the butter per side of each slice. Heat a skillet over medium heat and place the bread on the bottom of the skillet in an even layer, working in batches as necessary. Cook until golden on each side, 3 to 5 minutes per side. Remove and place each slice of toast on a plate.

—Distribute the mushrooms among the toasts and use a small spoon to transfer the eggs onto the toasts, topping each toast with 2 poached quail eggs. Serve immediately.

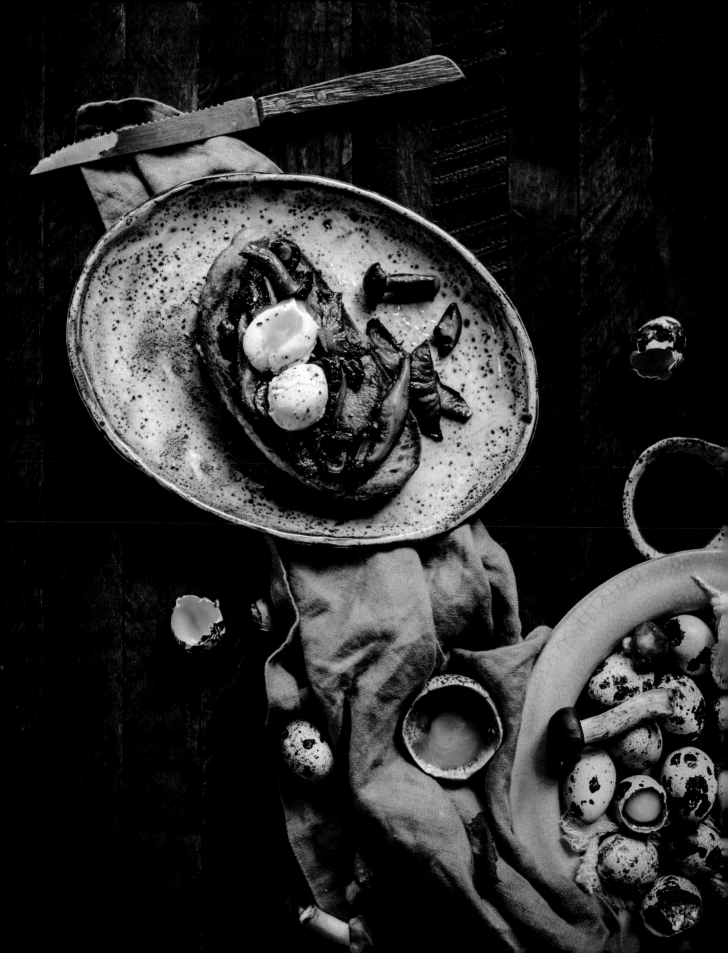

I didn't have my first taste of Thai food until I was about eighteen years old, and then it became an immediate flavor obsession. Thai noodles, curries, rice, salads—I loved and inhaled it all. This fascination eventually led to Jeremy and me spending our honeymoon in Thailand, trying dishes from all over the northern, central, and southern parts of the country. While we were there, we took a northern Thai cooking class in Chiang Mai, and I finally found a Thai curry recipe that gave the full range of rich, sour, sweet, and savory flavors that I'd been scouring the Internet for. Over the years, I've made many versions of it, but my favorite has steadfastly remained this duck-and-squash rendition.

—In a medium Dutch oven, heat the coconut oil over medium-low heat. Add the duck legs and cook until browned on each side (they will not be cooked through), then remove them and cut the meat away from the bones, reserving both the meat and the bones. Cut the meat into roughly 1-inch (2.5-cm) pieces.

—Add the ginger and garlic to the pan and sauté until softened slightly and very fragrant, 3 to 4 minutes. Add the curry paste and toast lightly in the pan for 30 seconds, stirring every 10 seconds. Add the coconut milk, stock, half the squash, and the duck bones and stir to combine.

—Bring to a boil, then reduce the heat to low and simmer until the mixture has thickened and the squash is so soft that it can be crushed easily with your spoon, 40 to 45 minutes, stirring every 10 minutes.

—Add the remaining squash and the duck meat and cook until the squash is tender when poked with a fork, about 15 minutes, and the duck is cooked through. Stir in the fish sauce, brown sugar, and lime juice and season with salt. Serve the curry over the top of or alongside the rice.

2 tablespoons coconut oil

2 duck legs (about 1 pound/455 g)

1 (1-inch/2.5-cm) piece fresh ginger, peeled and grated

3 garlic cloves, minced

1 tablespoon Thai red curry paste

3 cans (13.5 ounces/405 ml each) full-fat coconut milk

3 cups (720 ml) chicken stock or Poultry Stock (page 34)

1 pound (455 g) winter squash, peeled, seeded, and cut into 1-inch (2.5-cm) cubes

2 teaspoons fish sauce

1 tablespoon packed light brown sugar

1 tablespoon fresh lime juice

Flake kosher sea salt

4 cups (760 g) cooked jasmine rice, for serving

Hazelnut-and-Maple-Crusted Pork Loin Chops with Apples and Sage

— Serves 2 —

Once fall hits Oregon, it's prime apple season. We have an incredible variety of apple orchards growing old heirloom varieties just an hour east of Portland in the Columbia River Gorge area—they call it the fruit loop, and you can drive your car around to all the different U-pick orchards, stocking up on ripe fruits, fresh-pressed cider, and apple-based baked goods. I always go a little crazy during apple season and buy much more than a normal two-person household would be expected to consume. I've gotten really creative with ways to use this autumnal fruit, and this pork loin is my favorite savory application for apples. The key to a good pork loin is twofold: You need to keep the loin on the bone (this adds extra flavor as it cooks), and you need to brine it. Brining helps break down the proteins in meat, which tenderizes it, but the residual salts that remain in the brined chop also help it retain moisture as it cooks, which makes for a supremely tender and juicy cut. In this recipe, the pork is covered in a hazelnut-maple mixture and then cooked, toasting the hazelnuts while caramelizing the sugars in the maple syrup. It's then topped with apples that have been sautéed in butter with sage and maple syrup, creating the ideal mixture of sweet and savory fall flavors.

SAGE BRINE

2 cups (480 ml) lukewarm water

2 tablespoons flake kosher sea salt

¼ teaspoon rubbed sage

PORK LOIN CHOPS

2 bone-in pork loin chops (about 1½ pounds/680 g)

2 tablespoons pure maple syrup

2 teaspoons flake kosher sea salt

1 teaspoon extra-virgin olive oil

½ cup (45 g) coarsely ground hazelnuts

2 tablespoons unsalted butter

1 large apple, cored and cut into tenths

1 teaspoon finely chopped fresh sage

—For the sage brine, in a medium bowl, stir together the water, salt, and sage until the salt has dissolved completely.

—For the pork loin chops, place the pork in a resealable plastic bag and add the brine. Seal the bag, place it in a casserole dish, and refrigerate for at least 4 hours or up to 24 hours.

—Preheat the oven to 400°F (205°C). Set a large cast-iron skillet in the oven to preheat.

—Remove the pork from the bag, rinse thoroughly, and pat dry. In a small bowl, whisk together 1 tablespoon of the maple syrup, the salt, and oil and coat the pork chops. Then, coat the pork chops with the hazelnuts.

—Carefully remove the pan from the oven and place it on the stovetop over medium heat. Sear the pork chops until golden, 3 to 4 minutes. Flip the pork chops and then immediately return the pan to the oven.

—Roast until the interior temperature of the pork chops reaches 145°F (65°C) in the thickest part of the chop, 7 to 10 minutes, depending on the thickness.

—Meanwhile, in a medium skillet, melt the butter over medium heat. Add the apple, the remaining 1 tablespoon of maple syrup, and sage and stir to coat the apples well. Cook, stirring, until the apples have softened, puffed up, and turned golden, about 15 minutes, flipping the slices halfway through. Top the pork chops with the apples and serve.

Caramelized Pear and Pancetta Polenta

— Serves 4 to 6 —

Polenta is basically just a rustic corn porridge, made from cornmeal that's cooked with a liquid until a soft and thick mixture forms. In this recipe, little bits of pear are caramelized alongside shallots until they're nice and sweet and golden. Then, you add some pancetta bits and fry those up until they're crispy. This savory mixture serves as the base for the polenta, since you basically deglaze the pan with vegetable stock and then cook the cornmeal in all that flavorful goodness. The salt in this recipe is to taste, mainly because the pancetta will have a bit of salt in it and the vegetable stock likely will too, so it's best for you to give it a taste at the end, and add a few pinches as needed.

—In a cast-iron Dutch oven, melt the butter over medium heat. Add the shallots and cook, stirring, until softened and translucent, about 5 minutes. Add the pears and cook, stirring every 5 minutes, until the shallot bits turn golden and the pears nearly disintegrate, 20 to 30 minutes.

—Add the pancetta and cook, stirring every minute until the pieces are lightly crisped around the edges, about 5 minutes. Add the stock, stir, and raise the heat to high. Bring the stock to a boil, then add the cornmeal and reduce the heat to low.

—Cook, stirring every 3 to 5 minutes, until it is very smooth and thick, 20 to 30 minutes. Add the milk and thyme and stir to incorporate. Continue cooking, stirring every 3 to 5 minutes, until the milk has been absorbed completely, 5 to 10 minutes more. Remove from the heat, season with salt, and serve.

2 tablespoons unsalted butter

2 large shallots, finely chopped

2 large ripe pears, peeled, cored, and diced

2 ounces (55 g) pancetta, cut into ¼-inch (6-mm) cubes

4 cups (960 ml) Vegetable Stock (page 34)

1 cup (135 g) yellow cornmeal

½ cup (120 ml) whole milk

¼ teaspoon ground thyme

Flake kosher sea salt

Pumpkin and Date Cassoulet

— Serves 4 —

If you want to make something that sounds fancy and impressive but is actually very straightforward and simple, then cassoulet is for you. It's a traditional French bean stew made with a base of pork fat from bacon, pork skin, or sausage. This version has a bit of a twist to it, with the addition of chopped dates for little pops of caramelized sweetness, and then there's the pumpkin. After you make the stew, you scoop it into hollowed-out little pumpkins and roast them until they're cooked through. As they're roasting, the stew seeps into the flesh of the pumpkins, simultaneously cooking them and infusing them with savory goodness. Once the pumpkins are done, you serve the stew plated in the pumpkin, and you can scoop out the softened pumpkin flesh with each spoonful of stew. Think of it as an autumnal bread bowl. It's the squash that keeps on giving!

12 ounces (340 g) uncured smoke-house bacon

1 medium yellow onion, chopped

1 pound (455 g) pork sausage, casings removed

8 ounces (225 g) carrots, peeled and cut into slices ½-inch (12-mm) thick

4 cups (960 ml) Pork Stock (page 34)

2 cups (480 ml) pure pumpkin puree

1⅓ pounds (607 g) Yukon Gold potatoes, peeled and cut into 1-inch (2.5-cm) cubes

4 small pumpkins or winter squash (about 3 pounds/1.4 kg each)

2 tablespoons extra-virgin olive oil

2 cans (15 ounces/430 g each) cannellini beans, rinsed and drained

1½ cups (215 g) chopped pitted dates

1 teaspoon flake kosher sea salt

1½ teaspoons dried rosemary

½ teaspoon freshly cracked black pepper

—Heat a Dutch oven over medium heat. Working in batches as necessary, put the bacon in an even layer on the bottom of the pot and cook until crispy, 2 to 3 minutes per side. Remove the bacon and chop into ½-inch (12-mm) squares. Set them aside on a lipped plate, leaving the bacon grease in the pan.

—Add the onion to the pot and reduce the heat to low. Cook, stirring every couple of minutes, until the onion is softened and translucent, about 5 minutes. Add the sausage and cook, breaking it up with your spoon, until it is nearly cooked through.

—Add the carrots and cook, stirring, for 5 minutes. Add the stock, pumpkin puree, and potatoes and stir until combined. Cook, uncovered, until it has reduced by one-third and the potatoes are very soft when poked with a fork, 1 hour to 1 hour 15 minutes.

—Preheat the oven to 375°F (190°C).

—Cut the caps off the pumpkins 2 inches (5 cm) down, and set the caps aside (it's fine if there are short stems on the pumpkins). Use a spoon to scoop out and discard the seeds and pulp. Use a pastry brush to lightly brush the outside of the pumpkins with the oil and place them on a baking sheet.

—Add the beans, dates, salt, rosemary, pepper, and the bacon to the sausage and vegetable mixture and stir to incorporate. Simmer for 5 minutes, then remove from the heat.

—Spoon the stew into the pumpkins, filling them all the way to the top. Place the pumpkin caps back on and place the pan in the oven. Roast until the pumpkins' hue has darkened slightly on the outside and the flesh is soft when poked with a fork, 1 hour to 1 hour 15 minutes.

—Remove from the oven and allow to cool for 10 minutes before serving.

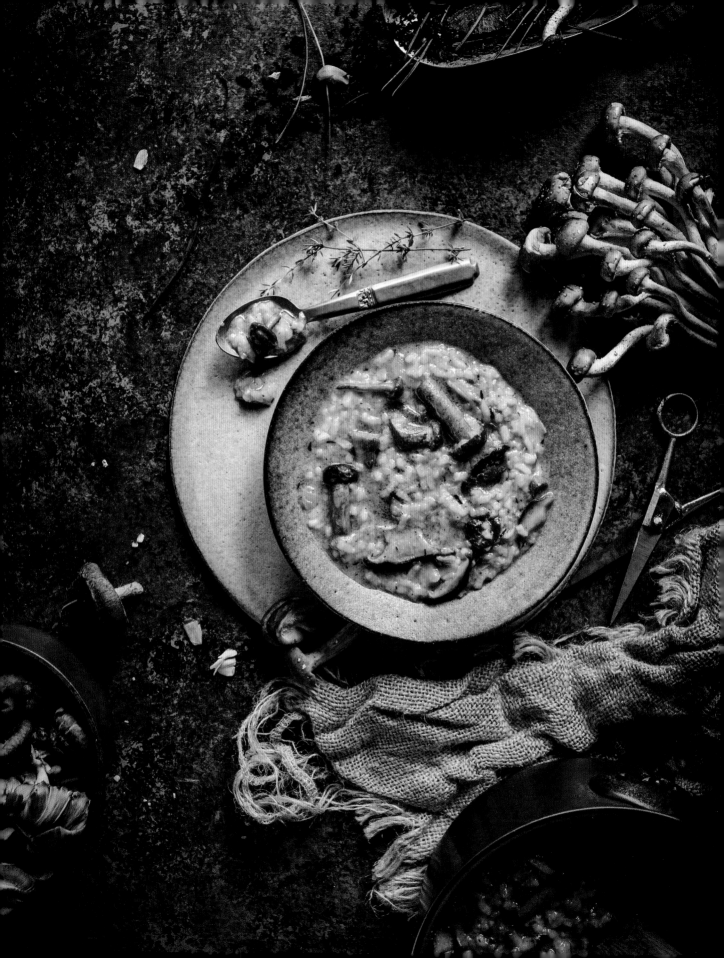

Mushroom Risotto

— Serves 4 to 6 —

This dish is a great catchall for any mushroom varieties you have in your fridge. My personal favorite for it is nameko (aka butterscotch mushroom), but I like to mix in a little bit of good old brown button and shiitake mushrooms for this, too. Nameko has a slightly nutty flavor and is one of the key ingredients in creating the base for traditional miso soup— so just visualize umami nutty goodness, and you can get the gist of its flavor. You can usually find them at Asian supermarkets, and you might be able to find them at the farmers' market in the autumn (which is where I was able to source mine). There's also a touch of white wine, cream, and fresh chèvre to give the risotto a little extra richness and a slightly tangy quality. The key for consistency with this risotto, like all other risottos, is to stir it on the regular, especially more frequently toward the end of cooking time, once it's thickened and has a greater risk of burning onto the bottom of the pan.

—In a large Dutch oven, melt 4 tablespoons (55 g) of the butter over medium-low heat. Add the onion and garlic and stir to combine. Cook, stirring every minute, until the onion has softened and become slightly translucent, about 5 minutes.

—Raise the heat to medium and add the remaining 6 tablespoons (84 g) butter. Once the butter has melted, add the mushrooms and stir to coat them in the butter. Cook, stirring every 2 to 3 minutes, until the mushrooms have softened, turned a deeper shade, and released their moisture, 10 to 15 minutes. Stir in 1 teaspoon of the salt, ½ teaspoon of the thyme, the sage, and ¼ teaspoon of the pepper and cook for 5 minutes more. Remove the mushrooms from the pot using a slotted spoon, leaving the melted butter in the pot. Set the mushrooms aside.

—Add the rice and wine to the pot and reduce the heat to medium-low. Cook until the rice is slightly translucent around the edges, about 5 minutes. Add 1 cup (240 ml) of the stock and stir. Cook until the rice has absorbed most of the liquid, 3 to 4 minutes. Add another cup (240 ml) of the stock and repeat, continuing to add the stock in 1-cup (240-ml) increments, stirring and waiting until the rice has absorbed most of the liquid before adding the next cup (240 ml).

—Once 6 cups (1.4 L) of stock have been added, stir in the mushrooms, then add the remaining 1 cup (240 ml) vegetable stock and stir until all the stock has been incorporated.

—Stir in the cream and chèvre and the remaining 1 teaspoon of salt, 1 teaspoon of thyme, and ¼ teaspoon of pepper. Cook, stirring every minute, until the liquid has been mostly absorbed by the rice, about 5 minutes more. Taste to ensure that the rice grains are cooked all the way through. If they're still a bit firm in the center, cook them for a few minutes more, stirring continuously, and taste again. Once finished, remove from the heat and serve.

10 tablespoons (1¼ sticks/140 g) unsalted butter

1 medium yellow onion, chopped

2 garlic cloves, minced

1⅓ pounds (607 g) mixed fresh mushrooms, such as nameko, shiitake, and brown button, stemmed and halved, quartered, or chopped (larger mushrooms)

2 teaspoons flake kosher sea salt

1½ teaspoons dried thyme leaves

½ teaspoon ground sage

½ teaspoon freshly cracked black pepper

1⅓ cups (255 g) Arborio rice

½ cup (120 ml) dry white wine

7 cups (1.7 L) Vegetable Stock (page 34), room temperature

½ cup (120 ml) heavy cream

2 ounces (55 g) fresh chèvre

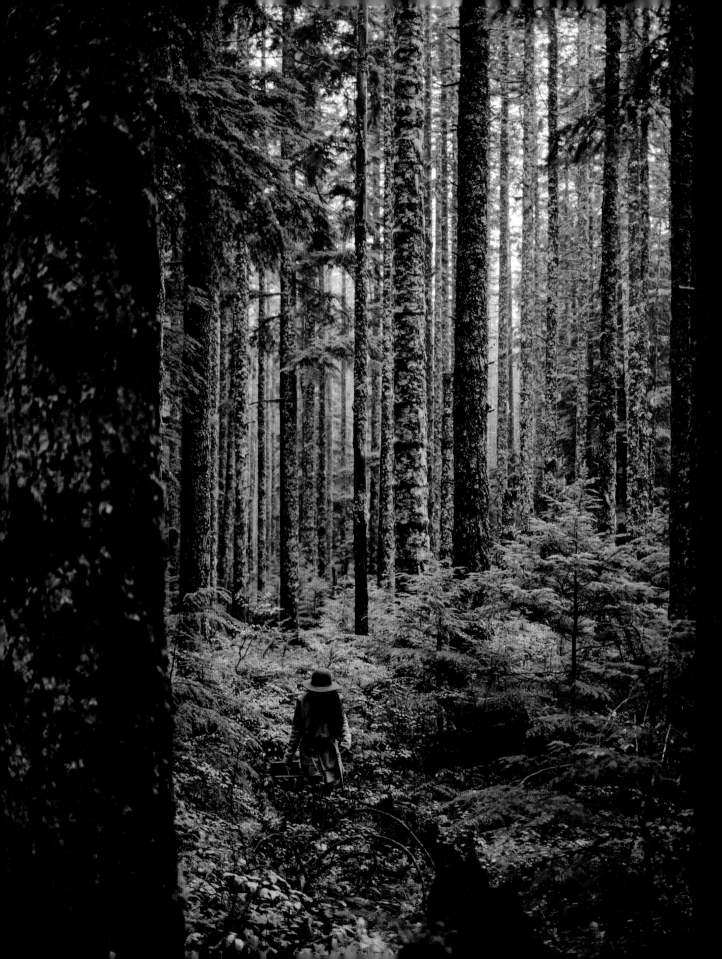

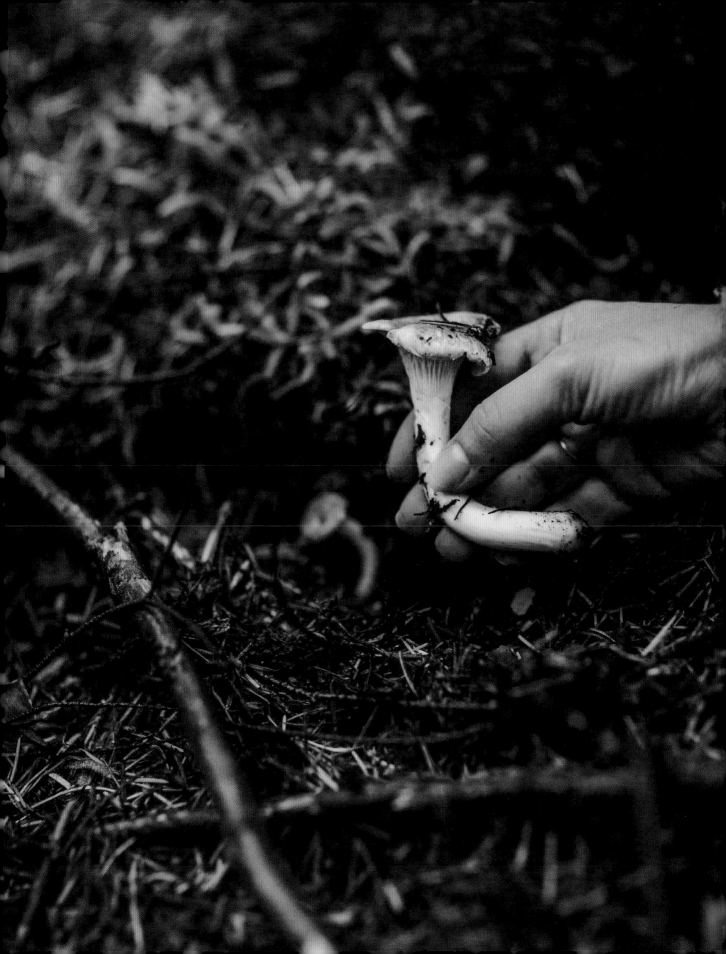

Butternut Tortellini with Brown Butter, Hazelnuts, and Crispy Sage

— Serves 3 —

Tortellini's shape, which is built to trap sauce and hold lots of delicious stuffing, makes it the optimum vessel for this flavorful recipe. Forming these little morsels is much easier than you'd think, and I always make extra so I can freeze them and keep them on hand for easy weeknight meals. The key lies in getting the pasta dough very thin. The thinner the dough, the more pliable it will be and the more readily it will hold the shape. I recommend using a pasta machine to slowly get the dough down to a nice, thin, and workable layer (around level 7 on the pasta machine). It will save you a lot of time and result in the perfect proportion of filling to pasta in your little tortellini. You can still make this if you don't have a pasta machine; you'll just have to be very attentive about rolling the dough out very thin.

BUTTERNUT FILLING

1 butternut squash (about
 1 pound 6 ounces/625 g)
1 teaspoon extra-virgin olive oil
2½ teaspoons flake kosher sea salt
2 tablespoons unsalted butter
½ teaspoon rubbed sage
½ teaspoon garlic powder
¼ teaspoon freshly cracked black
 pepper

PASTA DOUGH

3½ cups (475 g) bread flour
1 cup (180 g) semolina flour
1 teaspoon flake kosher sea salt,
 plus more for cooking water
1 teaspoon rubbed sage
6 eggs
2 egg yolks
2 tablespoons extra-virgin olive oil

SAUCE

5 tablespoons (70 g) unsalted butter
¼ cup (20 g) crushed pecans
¼ cup (20 g) crushed hazelnuts
8 fresh sage leaves

—Preheat the oven to 400°F (205°C).

—For the butternut filling, cut off the stem of the squash and discard it. Use a spoon to scoop out and discard the seeds. Rub the inside of the squash halves with the olive oil and ¾ teaspoon of the salt and place them on a baking sheet, cut side up. Roast until the flesh is soft when pierced with a fork and the exposed flesh is very faintly wrinkly, 45 to 55 minutes. Allow to cool for 15 minutes.

—Scoop out the flesh of the squash with a spoon and place it in a blender or food processor. Add the butter, sage, garlic powder, pepper, and the remaining 1¾ teaspoons of salt and puree until completely smooth. Transfer the filling to a bowl, cover, and refrigerate.

—For the pasta dough, in a large bowl, mix together the flour, semolina, salt, and sage. Turn the mixture out onto a clean, flat work surface.

—Make a large well in the middle of the flour pile and add the eggs, egg yolks, and oil. Using a fork, gently start to swirl together the eggs, yolks, and oil, slowly incorporating the flour into the wet ingredients and taking care not to break the walls holding in the liquid ingredients. Continue mixing until the center is thick enough that you can stir in the flour walls without the mixture spilling out everywhere.

—Stir until the dough comes together enough that you can begin to knead it. Knead the dough until it is very smooth and elastic, 3 to 5 minutes. Separate the dough into four equal balls. Pat one of them down into a long oval shape, then roll the dough out until it is about ¼ inch (12 mm) thick.

↪ *recipe continues*

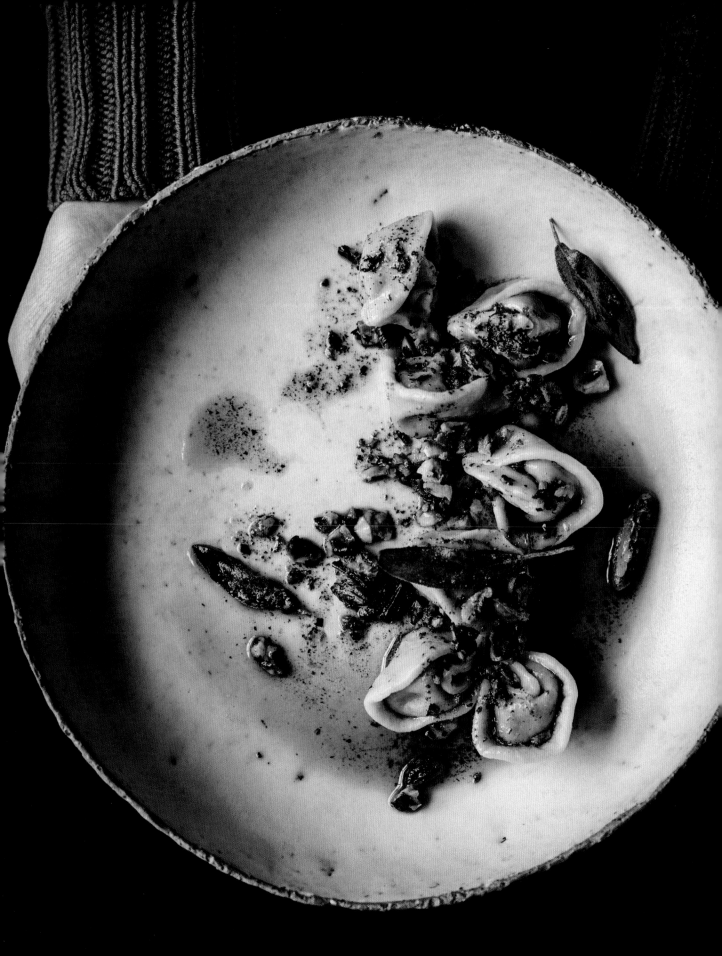

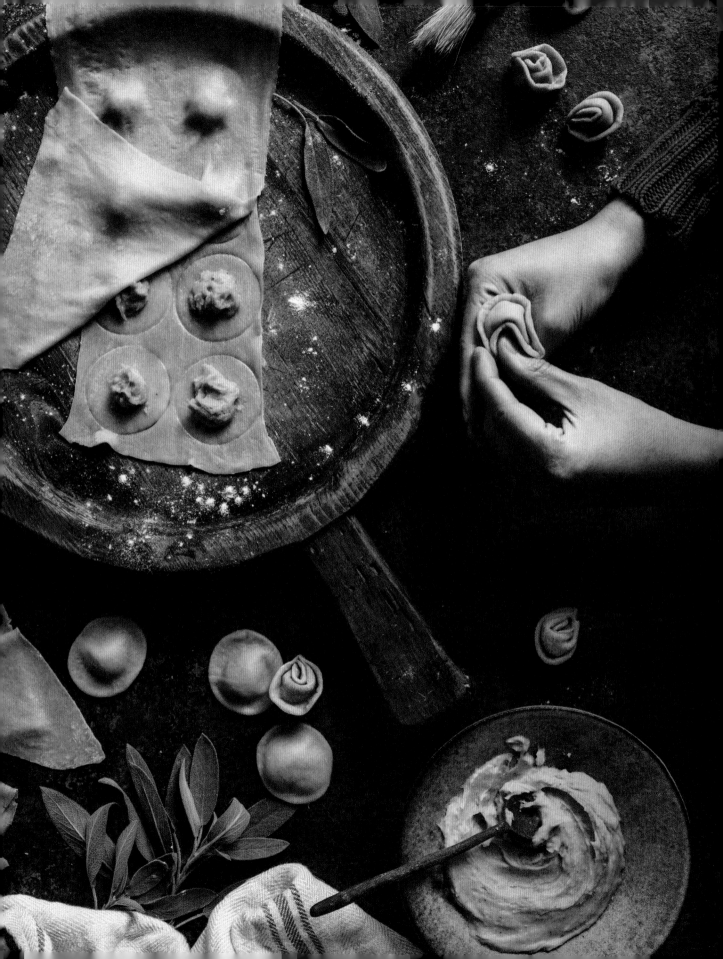

—You can now either roll the dough out by hand, which is more physically demanding and time consuming, or you can use a pasta machine to roll out the dough, which is easy, fast, and more precise. To roll the dough out by hand, roll it until it is about ⅛ inch (6 mm) thick. If the dough keeps shrinking back as you try to roll it, cover and place it in the freezer for 20 minutes before attempting to roll it out more. To use a pasta machine, begin passing the dough through the rollers starting at level 1, working down to level 7, passing the dough through the machine at each level in between (i.e., once at level 2, once at level 3, etc.).

—Lay a sheet of dough out flat. Use a 2-inch (5-cm) circular cookie cutter to gently press circles onto the dough, leaving a circle indent without actually cutting through the dough completely.

—Use a pastry brush or your finger to lightly brush the edge of each circle with water. Place 1 heaping teaspoon of filling in the center of each circle. Lay another sheet of dough over the top, using your fingers to press out any air as you seal the two layers of dough together around the heaps of filling. Use a 2-inch (5-cm) circular cookie cutter to cut the individual filled discs out of the sheet of dough.

—Form the tortellini by folding up the unfilled edges around the filling. Press a side of the disc against your thumb to bend it into a C-shape, then pinch the ends of the C together firmly. Repeat with the remaining dough and filling. They can be used immediately or frozen on a baking sheet in an even layer and then transferred to an airtight freezer-safe container and stored for up to 1 year.

—To cook, bring a pot of lightly salted water to a boil over medium-high heat. Cook 21 fresh tortellini for 4 to 6 minutes or 21 frozen tortellini for 7 to 9 minutes or until cooked through, and then drain.

—For the sauce, heat the butter in a large, shallow stainless steel skillet over medium heat until melted. Swirl the pan around a bit every couple of minutes to help it cook evenly. Add the pecans and hazelnuts. Over a period of several minutes, the foam at the top of the butter will change from light yellow to dark tan: Make sure to stir the nuts every minute or two throughout the cooking process. Once the butter reaches the dark tan stage, smell it. It should smell nutty and toasted. Remove from the heat, stir in the sage leaves, and allow the flavor to infuse for 3 minutes before tossing with 21 prepared tortellini and serving.

Cauliflower Steaks with Mushroom Gravy

— Serves 4 to 6 —

I think cauliflower is one of the most underrated vegetables of all time. I never had it growing up aside from raw cauliflower chunks in random crudités platters at my parents' friends' dinner parties, and, even then, it had kind of a bland, slightly funky taste and mealy texture. But when I met Carey Nershi, that all changed. Carey is my good friend, travel buddy, and co-host of our First We Eat food and photography workshops. Most important, though, as a former vegetarian, she can cook the crap out of any cauliflower. The first time I fell in love with it was when she made it into an insanely good creamy, cheesy, and velvety soup at our Asheville workshop. Since then, she has roasted, seared, and braised it at countless other workshops over the years. She opened my eyes to brand-new ways of appreciating this incredibly versatile plant. In this recipe, the cauliflower steaks are both seared on the stovetop and then roasted in the oven, making for the most wonderfully crunchy edges and a soft-but-solid meaty interior. I like to top them off with a rich and savory mushroom gravy for a little extra somethin' somethin'. The flavors of the veggies are so abundant and fulfilling that you don't need a lot of extra ingredients for this dish to shine.

CAULIFLOWER STEAKS

4 to 6 tablespoons (½ stick/55 g) unsalted butter

2 heads cauliflower, cut into steaks ¾-inch (2-cm) thick

1½ teaspoons flake kosher sea salt

½ teaspoon freshly cracked black pepper

MUSHROOM GRAVY

6 tablespoons (84 g) unsalted butter

1 small yellow onion, finely chopped

6 ounces (170 g) mushrooms, finely chopped

½ cup (70 g) bread flour

2¼ cups (540 ml) whole milk

¼ teaspoon freshly cracked black pepper

Flake kosher sea salt

—Preheat the oven to 400°F (205°C).

—For the cauliflower steaks, in a large cast-iron skillet, melt 2 tablespoons of the butter over medium-high heat. Place the cauliflower steaks in the pan and place a slightly smaller skillet on top of them to help press them down. Sear until golden on each side, working in batches as necessary, adding a tablespoon or two of butter between each batch. The searing time will be longer in the first batches and shorter in the second and third batches, as the pan heats up. Place the cauliflower steaks on a baking sheet in one layer and season with the salt and pepper. Roast in the oven until deep golden brown, about 20 minutes.

—For the mushroom gravy, in the same skillet you used to cook the cauliflower, melt 2 tablespoons of the butter over medium-low heat. Add the onion and cook, stirring, until softened and transparent, about 5 minutes. Add the mushrooms, stirring to coat, and raise the heat to medium. Spread out the mushrooms and onion so they cover the bottom of the pan in an even layer. Cook, stirring every 2 minutes, until the mushrooms release their moisture, shrink, and darken in color, about 10 minutes.

—Add the flour, 1 tablespoon at a time, stirring until a thick paste forms with the mushrooms and onion. Add the milk and whisk continuously until the gravy is smooth and thick. Cook until the gravy is heated through, about 6 minutes, stirring every minute. Add the pepper and season with salt, as desired, stirring to incorporate.

—Serve the cauliflower steaks topped with a ladle of the mushroom gravy.

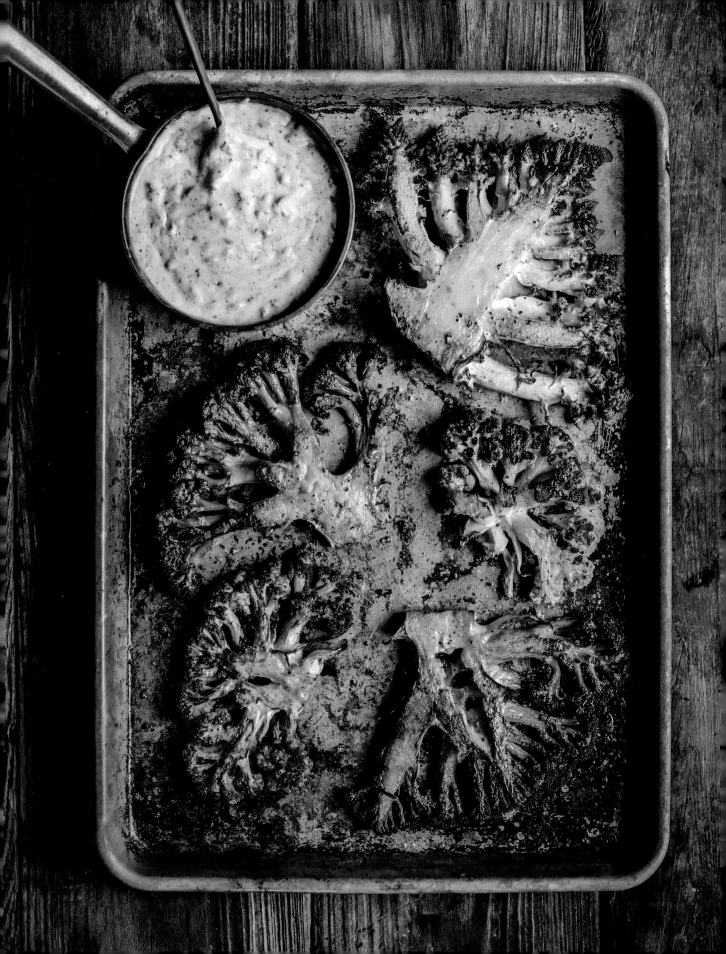

Mushroom and Squash Enchiladas

— Serves 8 to 10 —

My theio *(uncle) Niko is a seasoned chanterelle forager, and he taught me how to find this delicious mushroom by taking me to one of his favorite spots in the mountains between Portland and the Oregon coast. He told me to keep my expectations low, warning me that we might not find anything because it can be very hit-or-miss with chanterelles. We parked the car along an old logging road, and after about ten minutes of walking, we came across a portion of the forest floor dusted heavily with decomposing Douglas fir needles and dotted with golden spots. And then I saw Niko smiling. Those golden spots turned out to be an obscene number of chanterelles. So many that he was laughing because he couldn't believe what we were seeing. There were many more than we possibly could have carried back in the plastic buckets we had brought with us, so after we got our fill, we just enjoyed the view.*

Over the years, I've experimented with lots of different applications for chanterelles, and these enchiladas are one of my favorites. The sauce has roasted pureed winter squash in it, along with piquant New Mexico chiles, and the filling has sautéed mushrooms, more bits of roasted squash, and some garbanzo beans for a little bit of meatiness. You can use whatever kind of mushrooms you like in this recipe; I just love chanterelles. I recommend going to your local farmers' market in the fall to find a wider array of mushrooms that are in season, rather than the grocery store, which typically sells the same varieties year-round.

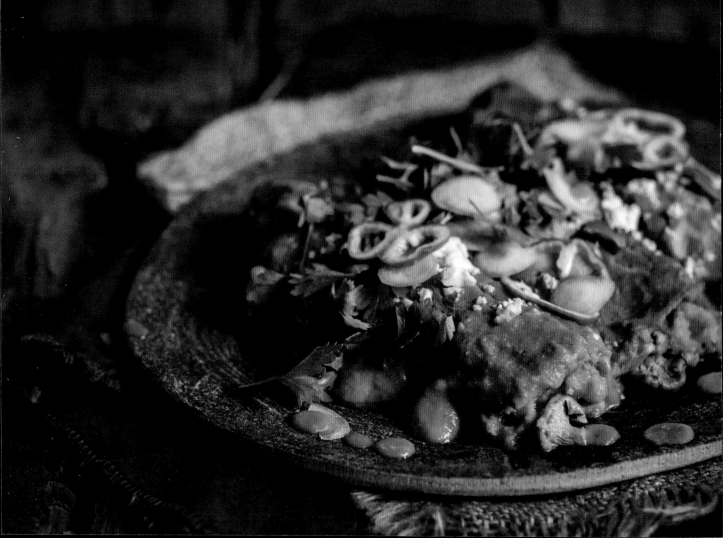

—Preheat the oven to 400°F (205°C).

—For the squash enchilada sauce, rub the inside of the squash halves with 1 tablespoon of the oil and 1 teaspoon of the salt and place on a baking sheet, cut side up. Roast until the flesh is soft when pierced with a fork and the exposed flesh is very faintly wrinkly, 50 to 60 minutes. Scoop out the cooked flesh into a large bowl and set aside.

—In a large Dutch oven, heat the remaining 3 tablespoons of oil over low heat. Add the chiles and cook, stirring every 3 minutes, until they have softened slightly and released a bit of their color into the oil, 6 to 10 minutes.

—Add the onion and garlic and cook, stirring every couple of minutes, until the onion is softened and transparent, 5 to 7 minutes. Add the stock, crushed tomatoes, tomato paste, cumin, oregano, garlic powder, salt, and ½ cup (120 ml) water and stir to incorporate. Raise the heat to medium and bring the mixture to a boil.

—Reduce the heat to low and cook until the tomatoes and the chiles have softened, about 45 minutes. Remove from the heat and allow to cool for 15 minutes. Transfer the mixture to a blender or food processor, add half the roasted squash and puree, working in batches as necessary. Transfer the blended sauce to a large bowl. Set aside to cool to room temperature.

—Preheat the oven to 350°F (175°C).

—For the filling, in a large skillet, heat the oil over medium heat. Add the mushrooms and stir to coat. Cook, stirring, until the mushrooms are wrinkled and slightly darkened around the edges and most of the liquid in the pan has evaporated, 10 to 15 minutes. Remove from the heat and toss the mushrooms in a bowl with the garbanzo beans, salt, oregano, cumin, garlic powder, and remaining butternut squash.

—Lightly dampen two paper towels and place one of them on a plate. Place the stack of corn tortillas on the towel and place the other damp paper towel over them. Microwave on high for 5 seconds.

—To assemble, pour the enchilada sauce ¾ inch (2 cm) deep into two 9 by 13-inch (23 by 33-cm) casserole dishes. Dip a tortilla in the bowl of enchilada sauce so that it is completely coated and lay it flat in one of the casserole dishes. Place a few tablespoons of the filling mixture in a line down the center of the tortilla. Gently fold the flaps on each side over the filling, then flip the enchilada over and place it seam side down. Repeat with the remaining tortillas. Sprinkle the feta cheese over the tops of the enchiladas and place the pans in the oven. Bake until the sauce on the tops of the enchiladas has darkened slightly and looks a little dried around the edges, 20 to 30 minutes. Sprinkle the cilantro, carrots, and peppers over the enchiladas and serve.

SQUASH ENCHILADA SAUCE

1 winter squash (3 pounds/1.4 kg), halved and seeded

4 tablespoons (60 ml) extra-virgin olive oil

2 teaspoons flake kosher sea salt

5 dried New Mexico chiles, stemmed and seeded

1 large yellow onion, chopped

5 garlic cloves, minced

4 cups (960 ml) Vegetable Stock (page 34)

12 ounces (340 g) crushed tomatoes, with juices

2 tablespoons tomato paste

1¼ teaspoons ground cumin

1 teaspoon dried oregano

1 teaspoon garlic powder

1 teaspoon flake kosher sea salt

FILLING

3 tablespoons extra-virgin olive oil

1 pound (455 g) mushrooms, larger mushrooms chopped and smaller mushrooms halved or quartered

1 can (15 ounces/430 g) garbanzo beans, rinsed and drained

1 teaspoon flake kosher sea salt

¾ teaspoon dried oregano

½ teaspoon ground cumin

½ teaspoon garlic powder

14 (6-inch/15-cm) corn tortillas

8 ounces (225 g) feta cheese, crumbled

¼ cup (10 g) chopped fresh cilantro

2 small carrots, peeled and thinly sliced

2 large green bell peppers, seeded and chopped

Herb-Brined Roast Turkey with Pear and Honey Glaze and Cornbread-Sausage Stuffing

— Serves 10 to 12 —

My go-to recipe for Thanksgiving every year, this turkey has the best combination of complementary flavors—you get some umami from the turkey itself, a little acid from the white wine, some sweetness from the honey, a hint of fruitiness from the pears, and an enticing herbal taste from the sage, rosemary, and thyme. And then there's my favorite part—the cornbread-sausage stuffing. This recipe does call for the turkey to be brined ahead of time, and this is a step you cannot skip. It will make all the difference in terms of the bird having moist breast meat. Also, because of the high sugar content of the glaze, this bird tends to brown rather quickly, so make sure you have foil at the ready to tent the bird, as needed, to ensure that the skin stays nice and golden, rather than getting overly crispy too early on in the cooking process.

HERB BRINE

1 gallon (3.8 L) lukewarm water

1 cup (292 g) flake kosher sea salt

1 tablespoon rubbed sage

2 teaspoons ground thyme

1 whole turkey (about 14 pounds/6.3 kg), giblets removed

PEAR AND HONEY GLAZE

1 cup (240 ml) turkey stock or Poultry Stock (page 34)

¾ cup (180 ml) honey

¾ cup (1½ sticks/170 g) unsalted butter or duck fat

⅔ cup (165 ml) dry white wine

1 very ripe Bosc pear, peeled, cored, and chopped

1 sprig fresh thyme

CORNBREAD-SAUSAGE STUFFING

1 tablespoon extra-virgin olive oil

1 pound (455 g) pork breakfast sausage, removed from casing

1 large yellow onion, chopped

1 cup (240 ml) whole milk

¼ cup (½ stick/55 g) unsalted butter

☞ ingredients continue

—For the herb brine, in a large bowl, stir together the water, salt, sage, and thyme until the salt has dissolved. Place the turkey in an extra-large resealable plastic bag and then place the bag in a roasting pan (this will make it easier to take in and out of the refrigerator without accidentally puncturing the floppy liquid-filled bag). An extra set of hands is helpful for this next part. Pour the brine into the bag and press as much air as possible out of the bag before sealing it tightly. Refrigerate the turkey in the brine for at least 12 hours or up to 48 hours.

—For the pear and honey glaze, in a small saucepan, stir together the stock, honey, butter, wine, pear, and thyme. Bring to a boil over medium-high heat, then reduce the heat to medium-low and cook, stirring every 5 minutes, until the pear is very soft, about 20 minutes. Remove from the heat, allow to cool for 20 minutes, then transfer to a blender or food processor and blend until completely smooth. Set aside.

—For the cornbread-sausage stuffing, in a medium Dutch oven, heat the olive oil over medium-low heat. Add the sausage and cook until it is nearly cooked through, breaking it apart with a spoon as it cooks. Remove the sausage using a slotted spoon and set it aside in a bowl, leaving the rendered fat in the pan. Add the onion and cook, stirring every 5 minutes, until the onion just starts to turn light golden around the edges, about 20 minutes.

—Meanwhile, in a small saucepan, heat the milk and butter over low heat until the butter has melted, whisking every minute. Remove from the heat.

—Remove the Dutch oven from the stovetop and stir in the celery, pears, sage, rosemary, thyme, and salt. Add the cornbread and toss to combine, then pour in the milk mixture and stir. Set aside.

☞ recipe continues

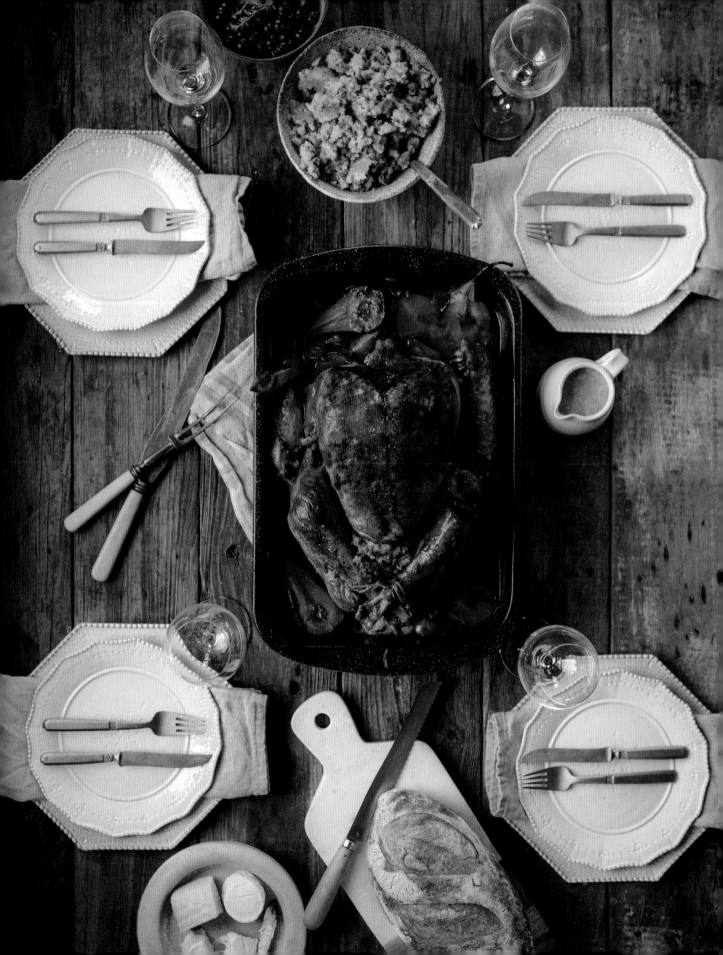

—Preheat the oven to 425°F (220°C) with the rack in the lowest position.

—For the roast turkey, remove the bird from the brine, rinse it, and pat it dry *very* thoroughly (if the skin is still wet, the butter will not stick to it and instead will just run off into the pan). Place it on a large rimmed baking sheet to catch any juices.

—In a small bowl, mix together the butter, sage, salt, rosemary, thyme, and pepper until a smooth paste forms. Coat the bird inside and out with the butter mixture, making sure to get underneath the skin of the turkey breast but taking care not to tear the skin. Evenly distribute the onion over the bottom of a large roasting pan. Place the turkey on top of the bed of onions, breast side up, and use a large spoon to stuff the cavity of the bird with the cornbread-sausage stuffing. Place any excess stuffing in a small casserole dish. Truss the bird with cooking twine and arrange the pear halves in the roasting pan around the turkey. Whisk together the stock and 1 cup (240 ml) of the glaze, then pour the mixture into the pan around the bird.

—Roast for 30 minutes, then reduce the heat to 350°F (175°C) and roast for 15 to 20 minutes per pound of turkey. Baste the bird every 20 minutes with the juices from the roasting pan, but every third basting (i.e., once per hour), baste the bird with the pear and honey glaze. Rotate the roasting pan once per hour to help the bird cook evenly (since you will be opening the oven every 20 minutes to baste the bird, the side facing the oven door will lose a bit of heat).

—If the bird is browning too quickly, tent foil over it, taking care not to touch the turkey skin with the foil (otherwise, the skin will cook onto the foil and get pulled off when the foil is removed). During the last 45 minutes of cooking, place the casserole of excess stuffing in the oven and bake until it is lightly golden on top. When the bird looks golden brown on the exterior, and it reaches 165°F (75°C) in the breast, thigh, and the thickest part of the stuffing, it is done. Always be cautious when comsuming food cooked inside poultry. Transfer the bird to a platter, reserving the pan drippings in the roasting pan, and allow to rest for 30 minutes while you make the gravy.

—For the pan-dripping gravy, heat 3 cups (720 ml) of the pan drippings in a small pot over low heat. If you don't have 3 cups (720 ml) of pan drippings, you can add in equal parts melted butter and turkey stock until you have 3 cups (720 ml) total. Whisk in the cornstarch and flour until smooth. Add the thyme and rosemary and stir to combine. Season with salt and remove from the heat.

—Remove the stuffing from the cavity of the turkey and transfer to a serving dish. Carve the turkey and serve with the gravy and stuffing (optional).

1 cup (100 g) chopped fresh celery

2 Bosc pears, peeled, cored, and chopped

2 teaspoons rubbed sage

2 teaspoons dried crushed rosemary

1½ teaspoons dried thyme

1 teaspoon flake kosher sea salt

12 cups crumbled stale cornbread, about 2 pounds (910 g)

ROAST TURKEY

1 cup (2 sticks/225 g) unsalted butter or duck fat, at room temperature

1 teaspoon rubbed sage

1 teaspoon flake kosher sea salt

½ teaspoon dried rosemary

½ teaspoon dried thyme leaves

¼ teaspoon freshly cracked black pepper

1 large yellow sweet onion, diced

3 pounds (1.4 kg) Bosc pears, halved

4 cups (960 ml) turkey stock or Poultry Stock (page 34)

PAN-DRIPPING GRAVY

2 tablespoons cornstarch

2 tablespoons all-purpose flour

½ teaspoon dried thyme leaves

½ teaspoon dried crushed rosemary

Flake kosher sea salt

Bone Broth Ramen

— Serves 4 to 6 —

My slow-cooked pork stock recipe serves as the base for building this flavorful soup. When you use stock made from bones, especially when it comes to pork, the texture of the soup is wonderfully thick and silky. Since the base of the soup is so rich, I love adding lots of fresh vegetables to the ramen to help brighten it up and add a nice crunchy contrast to the soft noodles. Carrots, radishes, and green onions are my go-to veggies for this recipe, but if you have other root vegetable or onions around, feel free to experiment with those, too. If you like a little sour kick, you can also top it with any of the quick-pickled vegetables on pages 28 to 30.

6 cups (1.4 L) Pork Stock (page 34)

2 ounces (55 g) dried shiitake mushrooms, sliced

12 ounces (340 g) fresh ramen noodles, or 4 ounces (115 g) freeze-dried ramen noodles

1 tablespoon rice vinegar

2 carrots, peeled and thinly sliced

4 radishes, julienned

4 green onions, thinly sliced

4 teaspoons sesame seeds

—In a large saucepan, heat the stock over medium heat. Add the shiitake mushrooms and cook until they have softened completely and released some of their flavor into the stock, 15 to 20 minutes.

—Add the ramen noodles and cook until cooked through. If using fresh ramen noodles, this will take 2 to 3 minutes; if using freeze-dried ramen noodles this will take 7 to 10 minutes, stirring every minute or two.

—Add the vinegar and stir to incorporate. Remove from the heat and evenly distribute the ramen among four bowls. Top each one equally with the carrots, radishes, green onions, and sesame seeds. Serve immediately.

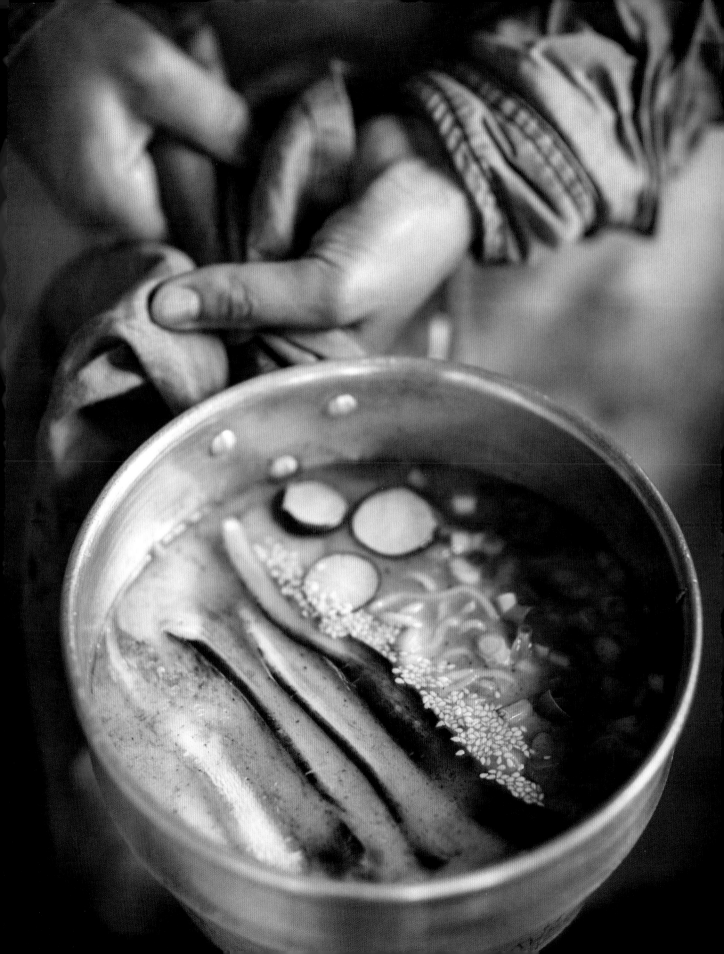

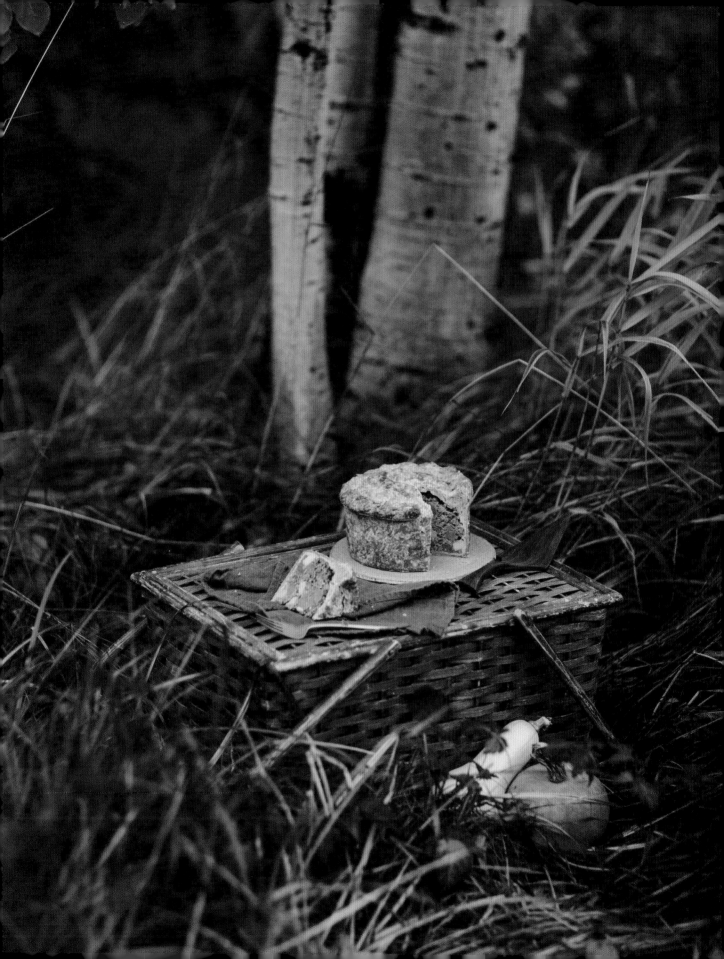

Lamb and Winter Squash Cottage Pie

— Serves 4 —

As a fan of food with crusts, I definitely believe there should be just as many savory pies out there as sweet ones. This is a bit of a riff on shepherd's pie, but instead of being topped with mashed potatoes, it is covered in crust and the potatoes are incorporated into the filling along with ground lamb, winter squash, and spices. You can use whatever type of winter squash you prefer—my favorites for this are kabocha and butternut.

—For the lamb and squash filling, in a large skillet, melt the butter over medium heat. Add the onion and cook, stirring until softened and transparent, about 5 minutes. Reduce the heat to medium-low and add the squash, potato, and oil and stir to combine. Cook, stirring every 5 minutes, until the squash and potato are soft when poked with a fork, 20 to 30 minutes. Move the contents to the side of the pan and place the lamb in the empty space. Cook until browned, breaking the meat apart with a spoon as it cooks. Once the lamb is cooked through, stir it into the squash mixture and add the salt, garlic powder, thyme, sage, pepper, and nutmeg. Cook, stirring every 2 to 3 minutes, until the excess moisture in the bottom of the pan has evaporated, about 10 minutes more. Remove from the stove, stir in the Gruyère, and allow to cool to room temperature.

—Preheat the oven to 350°F (175°C). Grease a 6-inch (15-cm) springform pan with unsalted butter.

—For the savory crust, in a large bowl, stir together the flour, salt, onion powder, garlic powder, and thyme. Grate the frozen butter over the bowl, stirring it every 30 seconds to help coat the individual shards of butter in the flour mixture. Add the water in small increments, stirring, until incorporated. Knead the dough for 1 to 2 minutes, then grab a handful of the mixture and squeeze. If it completely crumbles apart, it needs another tablespoon or two of water. Divide it into two balls, one slightly larger than the other with the large one making up about two-thirds of the dough. Cover each with plastic wrap and refrigerate for 20 minutes.

—Roll out the dough into two circles that are ¼-inch (12-mm) thick. Place the larger circle in the springform pan and press it down against the bottom and sides of the pan, letting the excess dough hang over the edge. Spoon the filling into the pan, pressing it down with the back of a large spoon to compress it so it all fits. Lay the smaller circle of dough over it and press the edges together to seal, trimming off the excess crust. Cut four 1-inch (2.5-cm) holes in the center of the top crust. Whisk together the egg and milk and lightly brush the exposed crust with the egg wash. Place the springform pan on a rimmed baking sheet and place in the oven.

—Bake until the crust is deeply golden brown, about 1 hour. Allow to cool for 45 minutes before slicing and serving.

LAMB AND SQUASH FILLING

2 tablespoons unsalted butter

1 medium yellow onion, chopped

1½ pounds (680 g) winter squash, peeled, seeded, and cut into 1-inch (2.5-cm) cubes

1 medium Yukon Gold potato, about 5 ounces, peeled and cut into 1-inch (2.5-cm) cubes

2 tablespoons extra-virgin olive oil

1 pound (455 g) ground lamb

2 teaspoons flake kosher sea salt

1 teaspoon garlic powder

½ teaspoon dried thyme leaves

½ teaspoon dried rubbed sage

¼ teaspoon freshly cracked black pepper

¼ teaspoon ground nutmeg

1 cup (110 g) freshly grated Gruyère cheese

SAVORY CRUST

2½ cups (340 g) bread flour

1½ teaspoons flake kosher sea salt

1 teaspoon onion powder

1 teaspoon garlic powder

1 teaspoon ground thyme

14 tablespoons (1¾ sticks/196 g) unsalted butter, frozen, plus more for greasing the pan

10 to 14 (150 to 210 ml) tablespoons ice water

1 egg

1 teaspoon whole milk

Caramel Apple Tarte Tatin

— Makes 1 (10-inch/25-cm) tarte tatin —

Jeremy and I love going to the apple orchards near us in Oregon, but our first foray into the world of U-pick apples wasn't so successful. Back when we lived in southern California, we drove out to Oak Glen's orchards to enjoy some rural scenery and tasty farmstand baked goods. What we didn't realize was that it was pumpkin-picking season and that all the apple orchards grow pumpkins as well. Since it was the first weekend of October, everyone and their mother headed into what I thought was my quaint little country hideaway and turned it into a crowded, traffic-jammed, pumpkin-filled nightmare. There we were, stuck in traffic, starving, with the smell of fresh food and apples everywhere, near ready to kill each other in a deep state of "hangriness." In the end, we were finally able to get some food, and I bought an insane number of apples to take back with us, which I used to make my very first version of this tarte tatin. It's basically an upside-down apple pie with lots of caramel sauce, spices, and a deliciously buttery crust. I like this even more than apple pie because the presentation is so incredibly beautiful, and since you have crust only on one side, it's a little bit less dense—perfect for fall entertaining, or just a sweet to snack on all week long.

CARAMEL SAUCE

⅓ cup (65 g) granulated sugar

½ cup (120 ml) heavy cream, at room temperature

4 tablespoons (½ stick/55 g) unsalted butter, at room temperature

⅓ cup (75 g) packed light brown sugar

½ teaspoon pure vanilla extract

½ teaspoon ground cinnamon

½ teaspoon flake kosher sea salt

CRUST

1½ cups (205 g) bread flour

1¼ teaspoons packed light brown sugar

¼ teaspoon flake kosher sea salt

½ teaspoon ground cinnamon

¼ teaspoon ground nutmeg

½ cup (1 stick/115 g) unsalted butter, frozen

7 to 9 tablespoons (105 to 145 ml) ice water

✏ ingredients continue

—For the caramel sauce, in a small saucepan, stir together 2 tablespoons water and the granulated sugar. Bring the mixture to a boil over high heat. Reduce the heat to medium and boil until the mixture turns a light caramel color, stirring once every 2 minutes or so. It can take up to 15 minutes for the clear syrup to turn a light caramel color. Quickly remove the pot from the heat and immediately stir in the cream, butter, and brown sugar until incorporated. Be careful when adding the ingredients, as the mixture will spit and hiss a bit. Place the pot on the stovetop over medium heat until the mixture reaches a boil. Once it is boiling again, stir it until any chunks of sugar dissolve and the mixture is smooth.

—After the caramel smooths out, simmer for 3 to 5 minutes more to thicken it slightly. Remove from the stovetop and stir in the vanilla, cinnamon, and salt. Set aside to cool to room temperature.

—For the crust, in a large bowl, stir together the flour, brown sugar, salt, cinnamon, and nutmeg. Grate the frozen butter over the bowl, stirring it every 30 seconds to help coat the individual shards of butter in the flour mixture. Add 7 tablespoons (105 ml) of the water in small increments, stirring, until all the water has been added. Knead the dough for 1 to 2 minutes to help disperse the moisture, then grab a handful of the mixture and squeeze. If it generally sticks together when you let go, it is fine. If it completely crumbles apart, it needs another tablespoon or two of water. Once the dough holds its shape, form it into a ball and roll it out until it is roughly the same diameter as the skillet you'll use to cook the apples in (it's okay if it is a bit smaller). Transfer to a baking sheet, cover with plastic wrap, and refrigerate.

✏ recipe continues

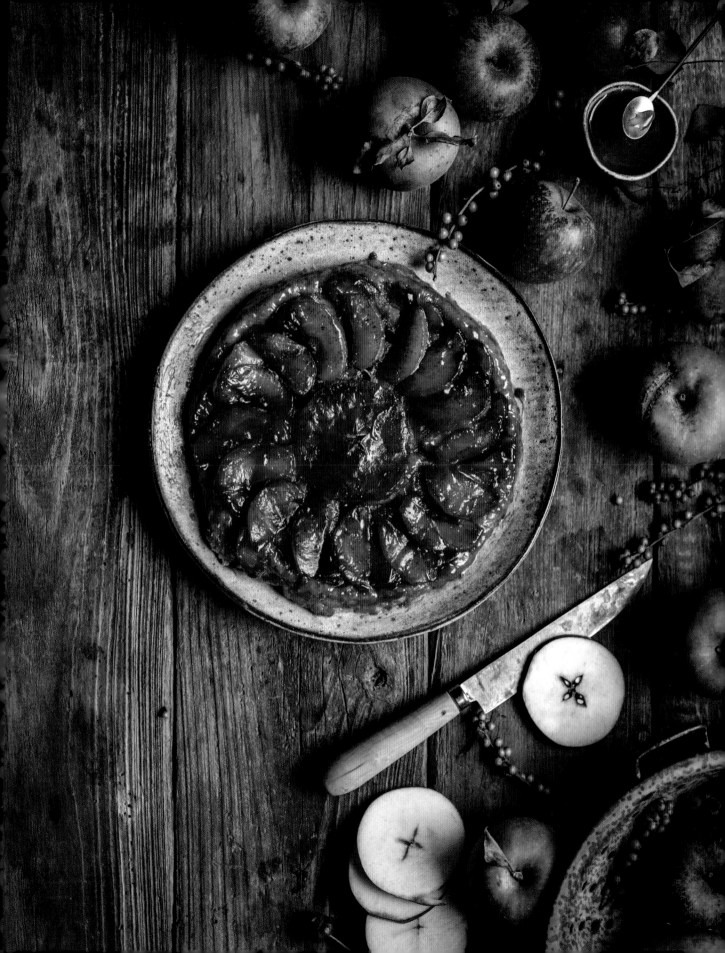

APPLE TARTE TATIN

3 tablespoons unsalted butter

½ cup plus 2 tablespoons (125 g)
 sugar

4 large apples (about 1 pound 6
 ounces/625 g), peeled, cored,
 and cut into eighths

1 teaspoon ground cinnamon

¼ teaspoon ground allspice

1 teaspoon pure vanilla extract

—Preheat the oven to 375°F (190°C).

—For the apple tarte tatin, in a 10-inch (25-cm) cast-iron skillet or Dutch oven, melt the butter over medium-high heat. Whisk in the sugar and cook until the mixture starts to turn a light golden color, about 6 minutes, whisking every minute or two. Remove it from the heat and place the apple slices in the pan in a concentric circle, starting at the outer edge and working your way to the middle of the pan. In a small bowl, mix together the cinnamon and allspice. Sprinkle the spice mixture and vanilla extract over the apples. Place the pan back over the heat and cook until the toffee sauce bubbles up around the apple slices and turns a deep caramel color, about 5 minutes.

—Remove the skillet from the heat and place the crust on top. Tuck in the edges using a blunt butter knife and poke three holes through the top of the dough to allow steam to escape. Place the skillet on a rimmed baking sheet and place it in the oven. Bake until the crust is lightly golden and cooked through, about 35 minutes.

—Remove the pan from the oven and invert the skillet onto a plate. Remove the skillet. The apples should now be on the top and the crust on the bottom. Drizzle with the caramel sauce, slice, and serve.

Cider and Cinnamon Babka

— Makes 2 (9 by 5-inch/23 by 12-cm) loaves —

This eastern European sweet bread combines light layers of slightly dry dough with alternating layers of moist filling. The filling is usually either cinnamon- or chocolate-based, and in this recipe, the cinnamon is rounded out with the addition of pecans, hazelnuts, apples, vanilla, and black cardamom. If you're unfamiliar with black cardamom, it's a type of cardamom pod that has been dried over flames, giving it an intriguingly smoky and oak-laden spiced flavor. The dough itself also has quite a bit of flavor packed in, namely vanilla bean, unfiltered cider, and cinnamon. Unfiltered cider is apple cider that hasn't been passed through a fine filter, so it's cloudy and has a slightly thicker mouthfeel. To get the beautiful swirl in this bread, you roll the dough out and then spread it with the filling before rolling it back up again, twisting it, and placing it in a loaf pan for baking. If you want to get even more spiral-y layers, you can try rolling it out even thinner. Just make sure that you spread the filling out thinner, too, since you're increasing the surface area but not the amount of filling. If this is your first time working with a layered loaf, though, I'd recommend sticking with the instructions, since the dough gets more delicate and temperamental the thinner it gets.

—For the dough, in a small saucepan, heat the milk over low heat, stirring continuously, until it is hot but not boiling. (If the milk accidentally begins to boil, toss it out, rinse out the pan, and start again.) Remove the pan from the heat, pour the milk into a small bowl, and let it cool until it is just warm.

—In the bowl of a stand mixer fitted with the paddle attachment, combine the warm milk, yeast, ½ cup (70 g) of the flour, and 1 tablespoon of the sugar and beat on low speed until smooth. Add the cider and mix until combined. Turn the mixer off and allow the mixture to rest at room temperature until the center of the batter puffs up slightly and smells strongly of yeast, 6 to 8 minutes.

—Add the remaining sugar, the vanilla, cinnamon, salt, and vanilla bean seeds. Mix on low speed until combined. Add the eggs and egg yolks, one at a time, mixing well after each addition.

—Switch out the paddle attachment for the dough hook attachment. With the mixer on low speed, add the remaining 3½ cups (475 g) flour, 1 cup (135 g) at a time, ensuring each addition is incorporated before adding the next cup. Knead for 3 minutes, then add the butter, 1 tablespoon at a time, making sure that each addition is incorporated before adding the next. Knead until a smooth and slightly sticky dough forms and the sides of the bowl are relatively clean.

—Turn the dough out into a bowl lightly greased with oil and cover with a lightly greased sheet of plastic wrap and a clean dish towel. Set aside at room temperature out of direct sunlight until it doubles in size, about 2 hours.

☞ *recipe continues*

DOUGH

½ cup (120 ml) whole milk

4 teaspoons instant yeast

4 cups (540 g) bread flour, plus more for dusting

⅓ cup (65 g) sugar

⅓ cup plus 3 tablespoons (120 ml) unfiltered apple cider, warm

1 teaspoon pure vanilla extract

1 teaspoon ground cinnamon

¼ teaspoon flake kosher sea salt

Seeds from ½ vanilla bean pod

2 eggs

2 egg yolks

6 tablespoons (¾ stick/84 g) unsalted butter, at room temperature

Extra-virgin olive oil, for greasing

1 egg

1 teaspoon milk

FILLING

1 tablespoon extra-virgin olive oil

½ cup (60 g) chopped pecans

¼ cup (30 g) chopped hazelnuts

1 apple, peeled, cored, and coarsely chopped

☞ *ingredients continue*

1 egg white

7 tablespoons (95 g) unsalted butter, at room temperature

⅔ cup (145 g) packed dark brown sugar

2 tablespoons confectioners' sugar

1 tablespoon plus 1 teaspoon ground cinnamon

Seeds from ½ vanilla bean pod

1 black cardamom pod

—For the filling, in a large skillet, heat the oil over medium-high heat. Add the pecans and hazelnuts and stir to coat. Reduce the heat to medium-low. Cook, stirring every minute, until the nuts are lightly toasted on all sides, 8 to 10 minutes. Remove from the heat and allow to cool for 10 minutes. Transfer the nuts to a food processor or blender. Add the apple, egg white, butter, brown sugar, confectioners' sugar, cinnamon, and vanilla bean seeds. Break open the black cardamom pod and empty the black seeds into the mixture. Blend until smooth, pausing to scrape down the sides as needed.

—Grease two 9 by 5-inch (23 by 12-cm) loaf pans with butter.

—Turn the dough out onto a lightly floured surface and divide it into two equal parts. Pat each ball into a rectangular shape and then roll each one out into a 10 by 18-inch (25 by 46-cm) rectangle. Use a spatula to evenly spread half the filling over the dough, leaving a 1-inch (2.5-cm) border around the edges.

—Lightly brush one of the long edges of the rectangle with water. Starting at the other long edge, roll the dough toward the brushed edge, jelly roll–style. Press firmly along the edge once it is rolled up to help secure it. Repeat with the other rectangle of dough and the remaining filling.

—Pick up one of the logs by the center and twist the ends hanging down from it together with the other hand, then place it in one of the prepared loaf pans. Repeat with the other log. Cover with lightly greased sheets of plastic wrap and set aside at room temperature out of direct sunlight to rise until doubled in size, 1 hour to 1½ hours.

—During the last 30 minutes of rising, preheat the oven to 325°F (165°C).

—Whisk together the egg and milk in a small bowl and lightly brush the tops of the dough. Bake until the tops are deeply golden and a toothpick inserted into the center comes out free of dough (it's okay if there is filling on it), about 50 minutes. Remove from the oven and allow to cool for 15 minutes. Invert the loaf pans onto a wire rack and remove the babkas from the pan. Allow them to cool to room temperature, then slice and serve.

Brown Butter–Honey Pie

— Makes one 9-inch (23-cm) pie —

The first iteration of this pie was made back when I lived in Los Angeles and was still working in the entertainment industry. I'd had a particularly brutal week at work and felt like I'd been carrying an emotional weight around with me. To cope with the stress, I did what I always do in times of deep internal anxiety—I baked. I made a pie based off a description that my mom gave me of one she had tried back home in Portland. When it was done, the whole apartment smelled like toasted honey and buttery crust, and I already felt a little less despondent. After it cooled a bit, I took my first bite, and it was like a warm, rich hug. The custardy filling was sweet without being cloyingly so, the salt on top gave it a bit of crunch, and the brown butter gave it the most deliciously toasted and nutty flavor. I could feel the warmth of it flowing through me, thawing out my nerves, soothing my spirits, and making home feel a little less far away. I can't guarantee it will do the same for you, but I do think you'll enjoy it just the same.

—For the crust, in a large bowl, stir together the flour, brown sugar, salt, cinnamon, and cloves. Grate the frozen butter over the bowl, stirring it every 30 seconds to help coat the individual shards of butter in the flour mixture. Add 10 tablespoons (150 ml) of water in small increments, stirring, until all the water has been added. Knead the dough for 1 to 2 minutes to help disperse the moisture, then grab a handful of the mixture and squeeze. If it generally sticks together when you let go, it is fine. If it completely crumbles apart, it needs another tablespoon or two of water. Once the dough holds its shape, cover it with plastic wrap and place it in the refrigerator.

—Preheat the oven to 350°F (175°C). Set an 8-inch (20-cm) cake pan filled two-thirds of the way with water on the lowest rack. The steam evaporating from this pan will help keep the custard filling of the pie from cracking as it bakes.

—For the filling, in a small stainless-steel saucepan, melt the butter over medium heat. Swirl the pan around a bit every couple of minutes to help it cook evenly. Over a period of several minutes, you'll notice the foam at the top of the butter start to change from a light yellow to dark tan. Once it reaches the dark tan stage and the butter looks light brown and golden, smell it. It should smell nutty and similar to toffee. Remove from the heat and set aside to cool completely.

—In a medium bowl, whisk together the eggs, cream, and vanilla until smooth. Set aside.

—In a separate large bowl, combine the brown sugar, cornmeal, and 1 teaspoon salt until well blended. Add the honey, lemon juice, and cooled brown butter and mix until combined, then fold in the egg mixture until incorporated. Set aside.

—Roll out the dough into a rectangle that is ¼-inch (6-mm) thick. Place it over a 9-inch (23-cm) pie plate and form it to the inside of the pan, cutting off and reserving the excess crust. Whisk together the egg and milk and brush the top quarter of the crust with the egg wash.

—Pour the filling into the pie crust and cut out decorative shapes from the excess crust, if desired, using a dab of water to help affix them to the crust edges around the filling. Brush the decorative shapes with the egg wash and place the pan in the oven. Bake until the crust is deeply golden-brown and the filling is golden on top but still wiggly in the center, 1 hour 5 minutes to 1 hour 15 minutes. Turn off the oven, tent the pan with foil, and allow it to cool to room temperature in the oven. If you have an electric oven, leave the oven door slightly ajar as it cools. Sprinkle with the remaining ½ teaspoon salt and serve.

CRUST

2¼ cups (305 g) bread flour

2 tablespoons packed dark brown sugar

1 teaspoon flake kosher sea salt

½ teaspoon ground cinnamon

¼ teaspoon ground cloves

1 cup (2 sticks/225 g) unsalted butter, frozen

10 to 12 tablespoons (150 to 180 ml) ice water

1 egg

1 teaspoon milk

FILLING

1 cup (2 sticks/225 g) unsalted butter

4 eggs

½ cup (120 ml) heavy cream

1 teaspoon pure vanilla extract

⅔ cup (145 g) packed dark brown sugar

5 tablespoons (40 g) cornmeal

1½ teaspoons flake kosher sea salt

¾ cup (180 ml) honey

1 tablespoon fresh lemon juice

Chai and Poppy Challah

— Makes 1 large loaf —

Sweet yeasted doughs have a special place in my heart. Greeks have several sweet bread recipes, my favorite of which is vasilopita, *an aromatic orange-laden braided bread loaf that's eaten at New Year's. My mother is an excellent bread braider. She gets the dough to the perfect consistency and whirls the strands together in no time. It took me a few tries to get the hang of it, but I was honestly a bit surprised at how straightforward the whole loaf-braiding thing is, once you get used to the weight and stickiness of the dough. This recipe takes that same tactic to the next level, though, and involves rolling out the dough, spreading it with filling, rolling it back up, cutting it in half lengthwise to expose the layers, and then weaving those bits together. I have the weaving steps broken down here in photos to help you get an idea of how it works, but my best advice is to keep your hands slightly oiled so the dough doesn't stick to them. Just follow the photos, and keep those hands nice and oily, and you'll end up with a beautiful, mouth-watering loaf of sweet bread awash in chai spices.*

DOUGH

½ cup (120 ml) whole milk, warmed

1 tablespoon active dry yeast

½ cup (100 g) sugar

3 eggs

1 egg yolk

1 teaspoon pure vanilla extract

¼ teaspoon pure almond extract

4½ cups (610 g) bread flour, plus more for rolling

1¼ teaspoons flake kosher sea salt

½ cup (1 stick/115 g) unsalted butter, cut into 8 equal pieces, at room temperature, plus more for greasing

Extra-virgin olive oil, for greasing the bowl

1 teaspoon whole milk

FILLING

½ cup (1 stick/115 g) unsalted butter, at room temperature

¼ cup (55 g) packed dark brown sugar

1 egg white

3 tablespoons unsweetened cocoa powder

☞ *ingredients continue*

—For the dough, in a small bowl, combine the milk and yeast and allow to rest until the mixture is beige in color and has small bubbles at the surface, about 5 minutes.

—In the bowl of a stand mixer fitted with the paddle attachment, combine the milk mixture with the sugar and beat on low speed until smooth. Add 2 of the eggs and the egg yolk, one at a time, mixing well after each addition. Add the vanilla and almond extract and mix until combined.

—Switch out the paddle attachment for the dough hook attachment. With the mixer running on low speed, add the flour, 1½ cups (205 g) at a time, waiting until the previous addition is incorporated before adding the next one. Add the salt and then immediately begin dropping in the butter, 1 tablespoon at a time. The dough will seem crumbly at first, but it will come together. Knead until the dough smooths out and the sides of the bowl are clean, 4 to 5 minutes.

—Place the dough in a large bowl lightly greased with oil and cover with a sheet of lightly greased plastic wrap, then a clean dish towel. Set aside at room temperature out of direct sunlight to rise until it has doubled in size, about 1½ hours.

—For the filling, in a blender or food processor, combine the butter, brown sugar, egg white, cocoa powder, poppy seeds, chai, cinnamon, and green cardamom. Split the black cardamom pod and shake the seeds out into the blender, discarding the pod. Blend until a smooth puree forms, stopping to scrape down the sides of the container, as needed. Cover and refrigerate until ready to use.

☞ *recipe continues*

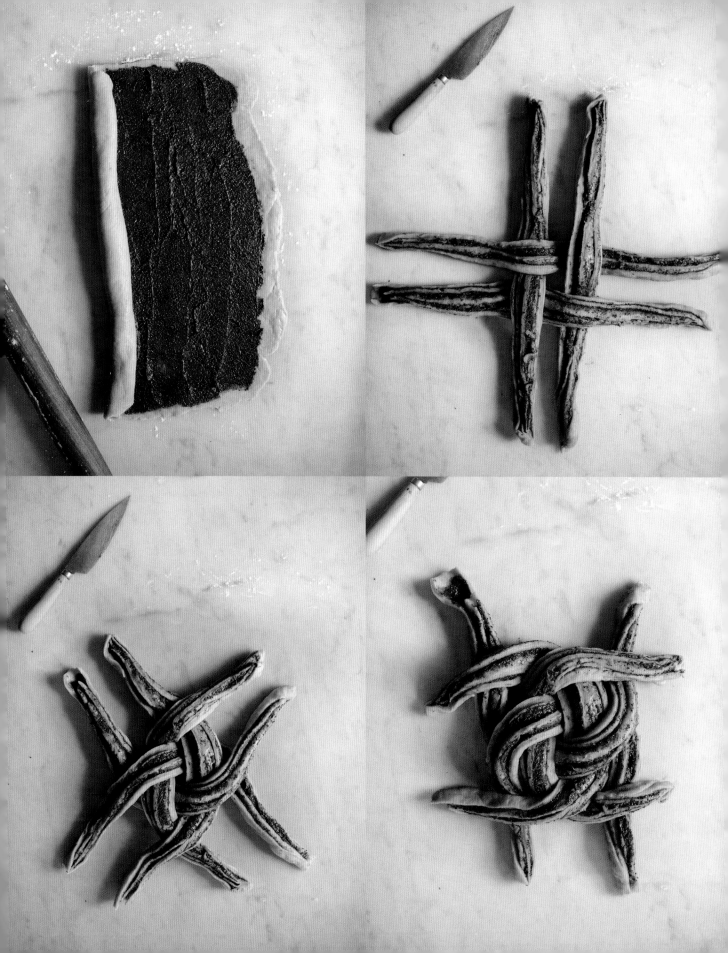

—Divide the dough in half. Roll out one of the dough halves into a 12 by 15-inch (30.5 by 38-cm) rectangle. Use a spatula to evenly spread half the filling over the dough, leaving a 1-inch (2.5-cm) border around the edges.

—Lightly brush one of the long edges of the rectangle with water. Starting at the other long edge, roll the dough toward the brushed edge, jelly roll–style. Press firmly along the edge once it is rolled up to help secure it. Place it on a surface lined with parchment paper, seam side down, and repeat with the other half of the dough and filling. Cover the dough logs with plastic wrap lightly greased with unsalted butter and then a dish towel and set aside at room temperature out of direct sunlight to rise for 1 hour.

—Place the logs on a lightly floured work surface and cut them in half lengthwise so that you have four long strips of dough. Place two of the strips parallel to each other. Run the other two strips perpendicularly across the center. Weave these strips, alternating them, so that the first strip goes over then under, and the second strip goes under then over to form a hashtag.

—Take the two ends of one side of the "hashtag" and cross them over each other. Repeat this, alternating going under and over as you cross them, until you are at the end of the strips of dough. Tuck the ends of the dough underneath the woven dough, using a dab of water to help secure them in place. Transfer the woven dough to a sheet of parchment paper and cover with a lightly buttered sheet of plastic wrap. Set aside at room temperature out of direct sunlight to rise for 1½ hours.

—During the last 30 minutes of rising, preheat the oven to 350°F (175°C).

—In a small bowl, whisk together the remaining egg and 1 teaspoon of milk until smooth. Remove the plastic wrap and lightly brush the dough with the egg wash. Transfer the parchment paper to a baking sheet and bake until it is deeply golden outside and a toothpick inserted into the center comes out without any dough on it (if there's filling on it, that's fine). Remove from the oven and allow to cool for 15 minutes before slicing and serving.

3 tablespoons poppy seeds
2 tablespoons loose chai tea
1 teaspoon ground cinnamon
2 green cardamom pods
1 black cardamom pod

Chocolate-Cayenne-Caramel Tartlets with Hazelnut–Graham Cracker Crusts

— Makes 6 —

I'm going to be straight with you—these guys are very, very rich, but also very, very good. They're decadent to the point that they're definitely a special-occasion food. They are also delicious to the point where you may start calling regular occurrences special occasions just as a pretext to eat more of them. (Mailed off your quarterly taxes? Guess you have to make these tarts again!) So, some details: The crust is made up of crushed hazelnuts, graham cracker crumbs, and butter, making for a perfectly nutty and crunchy vessel for the rich and lavalike filling. This "lava" is actually made up of a slightly spicy cayenne caramel swirled with a ganachelike mixture of chocolate, cream, and sugar. You'll become a bit of a "swirlspert" in this process. It's very simple and just involves moving a toothpick around in a swirly motion. It's an easy technique you can apply to the tops of cheesecakes, tarts, and cake batter. The dessert world is your swirly oyster.

HAZELNUT–GRAHAM CRACKER CRUSTS

1 pound (4 sticks/455 g) unsalted butter

3 cups (255 g) hazelnut meal

2½ cups (300 g) graham cracker crumbs

2 cups (440 g) packed dark brown sugar

2 eggs, beaten

2 teaspoons flake kosher sea salt

CAYENNE-CARAMEL FILLING

⅔ cup (135 g) granulated sugar

1 cup (240 ml) heavy cream, at room temperature

1 cup (2 sticks/225 g) unsalted butter, at room temperature

⅔ cup (145 g) packed dark brown sugar

1 teaspoon cayenne pepper

½ teaspoon flake kosher sea salt

CHOCOLATE FILLING

½ cup (100 g) sugar

⅔ cup (165 ml) heavy cream

10 ounces (280 g) 70% dark chocolate, broken into small pieces

½ teaspoon pure vanilla extract

—For the crusts, in a large stainless-steel skillet, melt the butter over medium heat. Swirl the pan around a bit every couple of minutes to help it cook evenly. Over a period of several minutes, the foam at the top of the butter will change from a light yellow to dark tan. Once it reaches the dark tan stage, smell it. It should smell nutty and toasted. Remove from the heat and allow to cool for 5 minutes.

—Transfer the brown butter to a medium bowl. Add the hazelnut meal, graham cracker crumbs, brown sugar, eggs, and salt and mix until combined. Evenly distribute the mixture among six 5-inch (12-cm) mini tart pans and press the mixture into the bottom and sides of each pan to form crusts. Place the pans on a baking sheet and bake until the crusts are golden brown, 20 to 25 minutes. Remove and allow to cool to room temperature before removing the tart crusts from the pans.

—For the cayenne-caramel filling, in a small saucepan, mix together ¼ cup (60 ml) water and the granulated sugar over medium-low heat until well blended. Bring the mixture to a boil and cook, stirring about once every 4 minutes, until the mixture turns a light caramel color, 8 to 12 minutes.

—Remove the pan from the heat and quickly stir in the cream, butter, and brown sugar until incorporated. Be careful, as the mixture will spit and hiss a bit. Place the pan back over the heat, bring it to a boil, and stir until any hardened sugar bits dissolve and the mixture is smooth, 5 to 7 minutes. Cook for 5 minutes more to thicken slightly. Remove from the stovetop and stir in the cayenne and salt. Set aside and allow to cool to room temperature.

—For the chocolate filling, bring water in the bottom of a double boiler to a boil over medium heat. Reduce the heat to low. In the top of a double boiler combine the sugar and cream and cook, stirring every minute, until the sugar

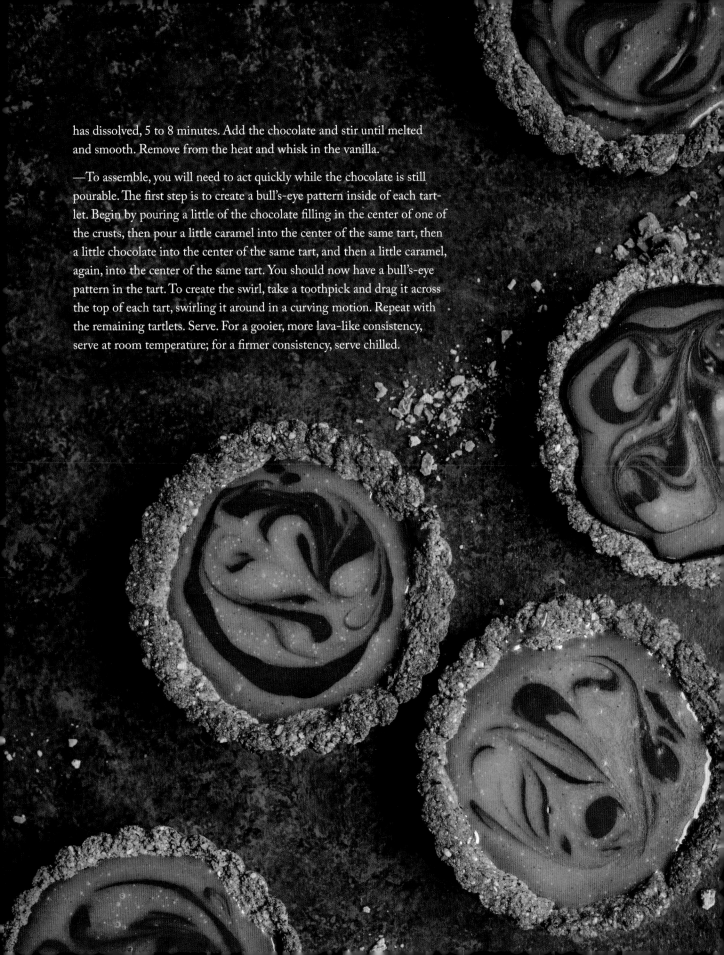

has dissolved, 5 to 8 minutes. Add the chocolate and stir until melted and smooth. Remove from the heat and whisk in the vanilla.

—To assemble, you will need to act quickly while the chocolate is still pourable. The first step is to create a bull's-eye pattern inside of each tart-let. Begin by pouring a little of the chocolate filling in the center of one of the crusts, then pour a little caramel into the center of the same tart, then a little chocolate into the center of the same tart, and then a little caramel, again, into the center of the same tart. You should now have a bull's-eye pattern in the tart. To create the swirl, take a toothpick and drag it across the top of each tart, swirling it around in a curving motion. Repeat with the remaining tartlets. Serve. For a gooier, more lava-like consistency, serve at room temperature; for a firmer consistency, serve chilled.

Winter Squash Filo Spiral with Honey Syrup

— Serves 8 —

This recipe is based off one my yiayia *(grandmother) used to make for my father when he was a boy. She would make the filo from scratch, rolling it out very thin, laying the squash filling in a long line, rolling it up, then curving the stuffed cylinder into a spiral shape in a large pan and baking it* sto fourno *(in the oven). After attempting it on my own a few times, based on my father's description, I made it for him as a surprise. He hadn't had it since he was a little boy, and it was really moving to see the warm memories of my* yiayia *wash over his face when he took his first bite. I love that food can do that to you—take you back to a place in time that you haven't been in years. The assembly is not as tricky as it might seem, either; the key to working with filo dough is to be quick and to keep the filo pile covered with a cloth to prevent it from drying out. You don't need to make the filo from scratch, either. Just look in the frozen desserts section of any large grocery store.*

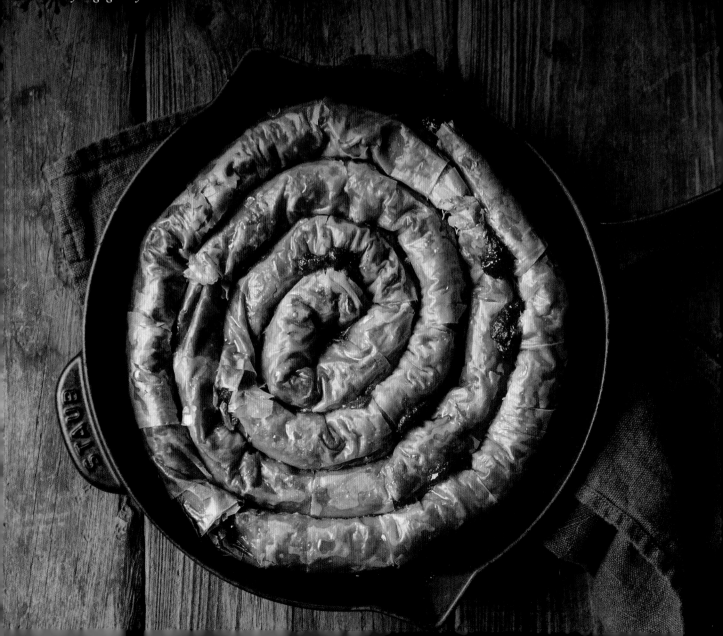

—For the honey syrup, in a small saucepan, combine the sugar, honey, cinnamon, and ⅓ cup (75 ml) water and bring to a boil over medium heat. Reduce the heat to low and cook, stirring every 5 minutes, until the sugar has dissolved and the syrup smells strongly of cinnamon, about 15 minutes. Remove from the heat, stir in the lemon juice, and allow to cool to room temperature.

—Preheat the oven to 350°F (175°C).

—For the filo spiral, in a medium bowl, mix together the squash or pumpkin, 1 cup (200 g) of the sugar, the cinnamon, and the vanilla until smooth. Set aside.

—Lightly grease a 10- to 12-inch (25- to 30.5-cm) round baking pan or oven-safe skillet with butter.

—Lay the filo dough flat on a clean working surface and cover it with a clean dish towel. Each time you grab a sheet of filo from the pile, make sure to cover the pile with the towel; otherwise, it will dry out very quickly, crumble around the edges, and become difficult to work with.

—Lay out one sheet of the filo dough and lightly brush it with oil, brushing all the way to the edges. Lay another sheet on top and lightly brush it with oil as well. Repeat four more times, so you have 6 sheets of filo dough on top of one another. Take a large tablespoonful of the squash mixture and, starting about 1 inch (2.5 cm) from the edge of one of the long sides of the filo, spread it in a straight line about 1 inch (2.5 cm) wide and that begins and ends about 1 inch (2.5 cm) from the edge of the dough, refilling the spoon with the filling as necessary, to complete the line. Take the edge of the filo closest to the filling line and roll it over the filling, taking care to keep the filling inside. Keep rolling it until all the filo is rolled up and you have a long cylinder of stuffed filo. Place the cylinder in the prepared pan, bending it as necessary to shape it to the circular edge of the pan. Brush the cylinder with oil.

—Repeat this process again so you have another cylinder of stuffing wrapped in filo, and line up the end of this cylinder with the end of the last one, forming a spiral in the pan. Brush the second cylinder with oil. Repeat until you have filled up the pan with stuffed filo cylinders and created a spiral, which will take 4 to 6 stuffed cylinders total, depending on the size of the pan. Discard any remaining dough, since it becomes dry and brittle after opening, but you can use any leftover filling as a spread on toast or breakfast pastries or pancakes.

—Sprinkle the remaining 2 tablespoons sugar over the filo spiral. Bake until the filo turns golden and smells very aromatic, 35 to 40 minutes. Remove from the oven and immediately pour the honey syrup over the spiral, leaving the spiral in the pan. Allow it to soak up the syrup and cool for 30 minutes before slicing and serving.

HONEY SYRUP

½ cup (100 g) sugar

3 tablespoons honey

1 stick cinnamon

1 tablespoon fresh lemon juice

FILO SPIRAL

2 cups (480 ml) pureed roasted winter squash or canned pumpkin

1 cup plus 2 tablespoons (225 g) sugar

1 teaspoon ground cinnamon

¼ teaspoon pure vanilla extract

Unsalted butter, for greasing

1 pound (455 g) filo dough, thawed if frozen

About 1 cup (240 ml) extra-virgin olive oil

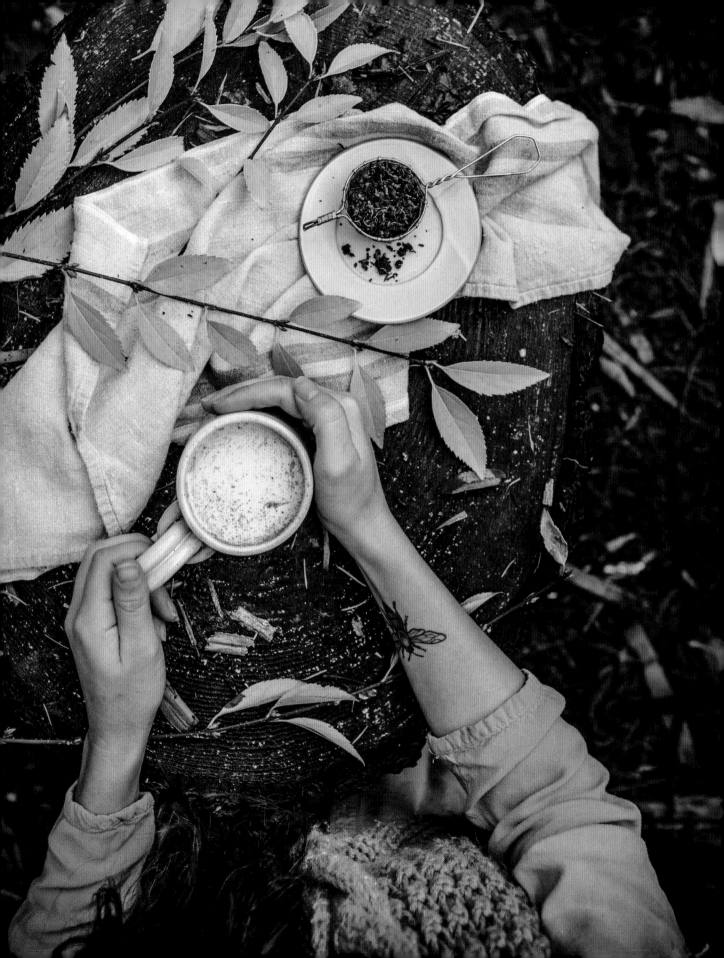

Homemade Chai Latte

— Makes 10 concentrate pellets —

I'm not a huge coffee drinker, mainly because I have a strong sensitivity to caffeine that leaves me feeling sweaty, anxious, and like my heart is about to beat out of my chest. To avoid this unpleasant sensation, I've been a tea enthusiast most of my life, and once the weather cools down, I immediately start drinking lots of chai lattes. They're my favorite cold-weather drink, and unlike most of the ones you get at coffee shops that are powdered and full of sweeteners, this one is made from scratch and doesn't use any sweeteners other than vanilla bean. There's some black tea in this chai mixture, but the amount of caffeine in the chai latte is much less than that of a cup of coffee. If you like really sweet chai, you can stir in a bit of honey or a pinch or two of sugar. To make it easy to put together, I have a recipe for bulk chai tea concentrate below that you can freeze in small spoonfuls for individual servings later on. It's full of delicious spices and ingredients like fresh ginger, vanilla bean, cardamom, black tea, cloves, anise, and cinnamon, and it makes for a wonderfully refreshing-yet-cozy cold-weather drink.

—For the homemade chai concentrate, in a food processor or blender, pulse together the cardamom pods, star anise, cloves, and peppercorns until coarsely ground. Add the ginger, tea, vanilla seeds, and vanilla bean pod. Blend on low speed until the ginger has been pureed and the whole mixture resembles a coarse paste, stopping to scrape down the sides of the container with a spatula as necessary. Transfer the mixture to a small bowl and stir in the cinnamon.

—Line a baking sheet with parchment paper. Scoop out 1 tablespoon mounds of the chai concentrate onto the baking sheet. Freeze for 2 hours. Remove the frozen chai pellets from the pan, place them in an airtight freezer-safe container, and store in the freezer.

—For the chai latte, in a small saucepan, bring the milk and ¼ cup (60 ml) water to a low boil over medium-low heat. Add a chai concentrate pellet and cook, stirring every minute, for 5 minutes more. Remove from the heat and steep for 10 minutes more, then strain through a fine-mesh sieve into a mug. (Alternatively, the chai concentrate can be placed in a tea strainer or ball, then placed in the milk mixture for easy removal post-steeping.) Serve immediately.

HOMEMADE CHAI CONCENTRATE

6 green cardamom pods

4 black cardamom pods

1 star anise pod

½ teaspoon whole cloves

½ teaspoon whole black peppercorns

1 (4-inch/10-cm) piece fresh ginger, peeled and thinly sliced

¼ cup (7 g) black tea, such as Ceylon or Assam

1 (2-inch/5-cm) vanilla bean, split lengthwise, seeds scraped out, and pod cut in half

1 teaspoon ground cinnamon

CHAI LATTE

¾ cup (180 ml) whole milk

1 tablespoon chai concentrate

Brandy Spiced Cider

— Serves 10 to 12 —

Gray and misty mornings are the first sign of fall here in the Northwest. They roll in around late September, with a chill and crispness that gets progressively more pronounced as the weeks pass by. It's around this time that I start turning to hot beverages again, usually just in the morning, and by the time November comes around, I'm having them at all hours of the day. Around the early evening, I crave a drink with a little more sustenance than tea, and this spiced cider fits the bill. A whole vanilla bean is simmered with cloves, a cinnamon stick, orange zest, and apple cider to create a wholesome and vibrant drink that is both comforting and refreshing. It is important to use just the orange part of the orange peel, though, as the white pith has a bitter flavor that can throw off the taste. After everything has mulled together for a while, and the flavors have infused deep into the stock of the cider, I slosh in a bit of my favorite brandy to give it a nice, warm kick. Ending the day near the fireplace with a mug of this cider in one hand, my pups curled up at each side, and the sound of the rain hitting my old windowpanes is my idea of the perfect fall evening.

2 quarts plus 2 cups (2.4 L) apple cider

Peel of 1 orange, with minimal amount of white pith attached

2 cinnamon sticks

2 star anise pods

½ teaspoon whole cloves

½ teaspoon freshly grated nutmeg

1 vanilla bean, split lengthwise and seeds scraped out

3 cups (720 ml) brandy

—In a large Dutch oven, combine the cider, orange zest, cinnamon sticks, star anise, cloves, nutmeg, and vanilla bean pod and seeds. Bring the mixture to a boil over medium heat, then reduce the heat to low and cook, uncovered, until all the flavors have thoroughly infused into the cider, 45 minutes to 1 hour. Add the brandy and stir to incorporate. Strain and serve hot.

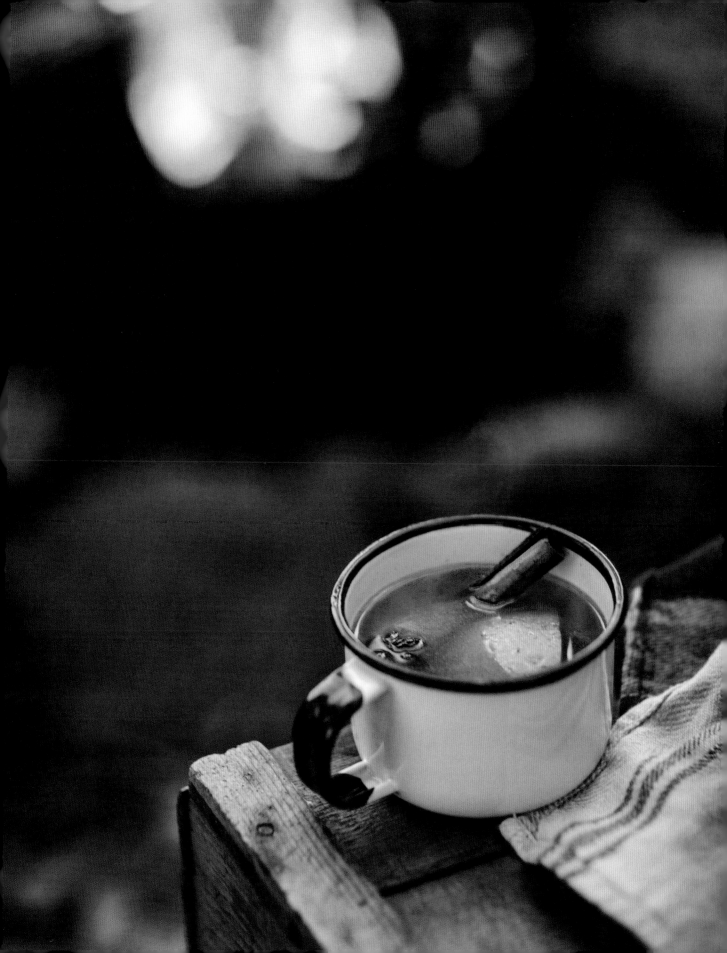

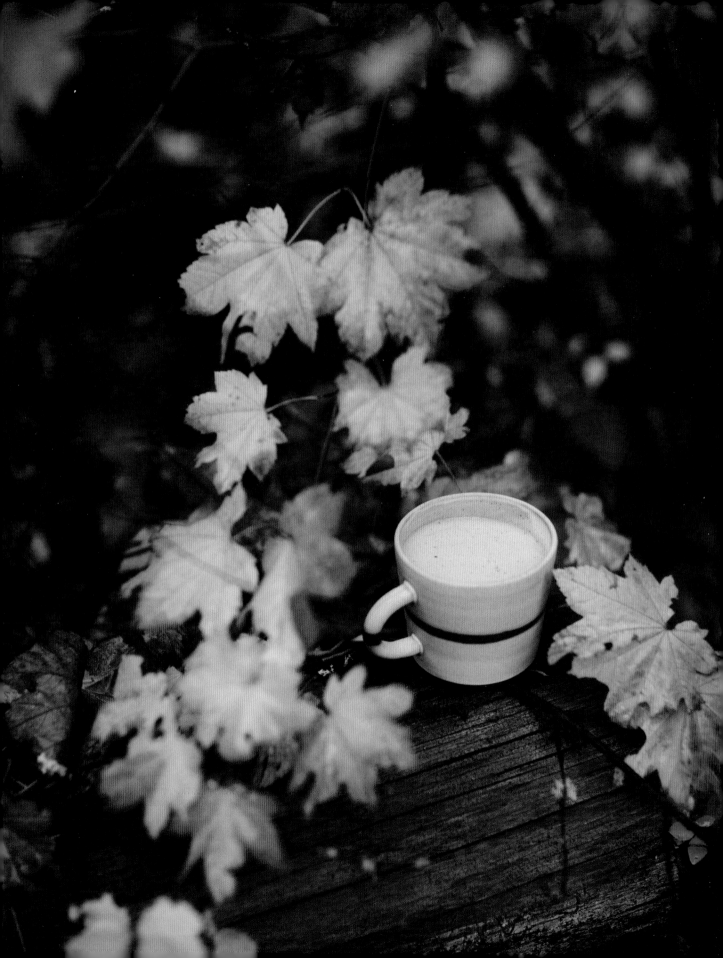

Hot Buttered Hazelnut Milk

— Makes about 3 cups (720 ml) —

Okay, guys, this is some serious stuff. Like, once-you-try-it-you-won't-be-able-to-get-it-out-of-your-mind kind of stuff. Think about how tasty roasted hazelnuts are, then imagine a slightly chocolatey liquid version of them. It's pretty great, and it hits the best of spots on cold fall days (or winter days, for that matter). This recipe is booze-free, but if you want to kick it up a notch, I recommend adding a dash of brandy or rum to it. This recipe does involve an overnight soak of the roasted hazelnuts, so keep that in mind before you start. I also recommend using a nut milk bag (yes, this is a thing that you can buy at natural food stores, and yes, saying that out loud is incredibly awkward) to strain out the milk from the pureed nuts. You can also just use muslin or cheesecloth, but those are a bit more prone to tearing than nut milk bags, which are built to stand up to twisting and squeezing. A-a-a-a-a-and joke.

—Preheat the oven to 375°F (190°C).

—Spread the hazelnuts in an even layer on a rimmed baking sheet and toast in the oven for 10 minutes, stirring them a bit halfway through.

—Remove from the oven and allow them to cool to room temperature, then transfer them into a medium bowl. Add water to cover the nuts by 1 inch (2.5 cm). Cover and allow to soak at room temperature overnight or up to 2 days.

—Drain the nuts and transfer them to a blender or food processor. Add 3¼ cups (780 ml) water, the cream, and the vanilla and blend until very smooth, about 5 minutes.

—Pour the mixture into a nut milk bag or cheesecloth set over a bowl and twist the top of the bag (or the gathered ends of the cheesecloth) to help release the hazelnut milk into the bowl. You will end up with about 3 cups (720 ml) hazelnut milk

—In a small saucepan, combine the hazelnut milk, half-and-half, butter, maple syrup, and cocoa powder. Heat over low heat, whisking until smooth, until hot but not boiling. Remove from the heat and serve immediately.

2 cups (270 g) whole hazelnuts

½ cup (60 ml) heavy cream

½ teaspoon pure vanilla extract

½ cup (60 ml) half-and-half

2 tablespoons unsalted butter

2 tablespoons dark amber pure maple syrup

1 tablespoon unsweetened Dutch-process cocoa powder

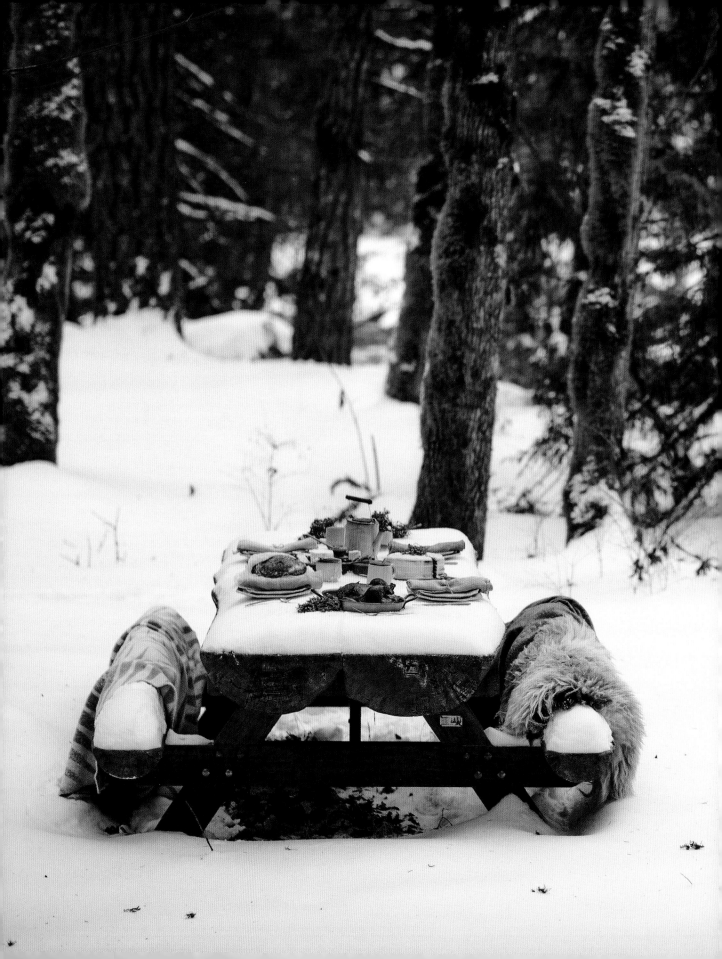

– MENU FOR A WINTER FEAST –

With the shorter days, cold weather, and abundance of gatherings, winter is probably the season
I cook the most. I love the way the oven warms up the whole drafty house and fills it with the
smell of something tasty, and we usually have the fireplace going on a daily basis at that point,
which mixes the smell of good food with that of a roaring fire, and the combination of the two
is probably one of my favorite smells in the world. I also love that so many friends and family come
into town during this time of year, so our house is always full of familiar and friendly voices.
When I'm entertaining, my go-tos are always things that can be made ahead of time, and in this
menu the Eggnog, Roasted Garlic Sourdough with Kopanisti, Winter Cheese Board with
Herbed Dates, and Buttermilk-Beet Cake with Cream-Cheese Buttercream can all be made either
earlier the same day or prepared the day before to cut down on the kitchen craziness of hosting
a big dinner (I recommend pulling the roast chicken out of the oven closer to serving time, though,
for optimum heat and tastiness). I hope this menu helps guide you through hosting holiday gatherings
of your own and provides you and your friends with a delicious array of hearty sustenance!

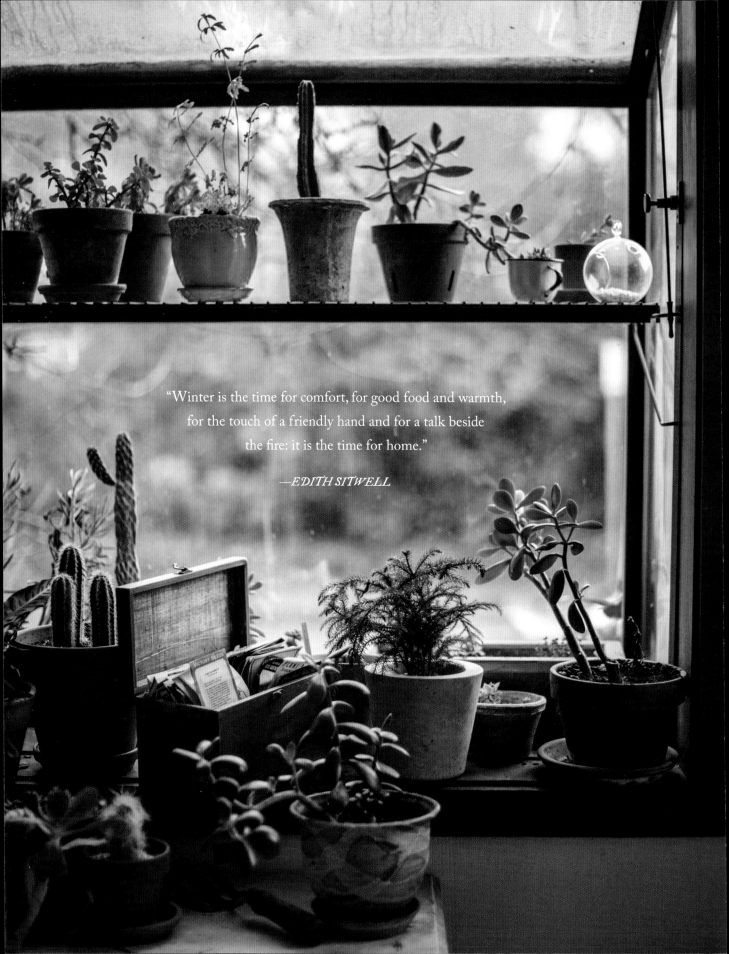

"Winter is the time for comfort, for good food and warmth,
for the touch of a friendly hand and for a talk beside
the fire: it is the time for home."

—*EDITH SITWELL*

Seed Saving, Cataloging, and Sourcing

—

MORE THAN 95 PERCENT OF the fruit and vegetable varieties that were available for sale in the United States in 1906 are extinct today. This is due both to the growth of factory farming, where a handful of varieties of each plant have been sown over and over again, and to the increase in urban populations. When society was more agrarian, people grew their own food and saved their own seeds, passing specific heirloom varieties down from generation to generation. Since the majority of society now lives in cities, the ability and desire of individuals to grow their own food has significantly decreased. If we continue down the road we're on in terms of food biodiversity, we'll be at risk of one plant disease being able to wipe out a huge amount of our food supply.

This is why it is so important to source seeds from organizations that are preserving and reproducing heirloom fruit and vegetable varieties. Not only are you creating a more biodiverse and disease-resistant garden, but you're opening up your kitchen to a new world of flavors, shapes, and colors. Deep purple potatoes, sweet green radishes with a neon pink interior, dark green watermelons dusted with bright yellow spots—there's a whole rainbow of food out there waiting to be shared and enjoyed. All you have to do is sow a single seed. (See page 297 for a list of recommended seed sources.)

I've been gardening my entire adult life (and some of my childhood), so I have quite the collection going at this point. I easily have more than twenty thousand seeds in my home, from hundreds of different varieties of plants. To keep things organized, I recommend grouping the seeds by season and placing them in alphabetical order within each season. That way, when it's early fall, you don't have to dig through the melon seeds to get to the cabbage. But first you need to get started. To follow are a few tips on how to collect seeds from the foods you have on hand.

Getting Started

—

To start saving your own seeds, make sure that you only collect those of open-pollinating plants. The seeds of hybrid varieties won't produce the exact same variety the next year (the original seed packet will tell you if the plant is open-pollinating or hybrid). I have tips for saving the seeds of different plants below, but a good rule of thumb as to whether or not a seed has dried out enough to be stored is whether the seeds break rather than bend. If they break, they're good to go; if they bend, they need more drying time. Once completely dried, seeds should be stored in a labeled, airtight, and waterproof container, such as a tiny resealable and reusable plastic bag. If kept in an airtight container in a cool, dark, dry place, they will keep for up to two years. After that, the germination rate starts to decrease.

—For cucumber, melon, and squash seeds, cut the fruit in half and use a spoon to gently scoop out the seeds. You can remove any remaining membrane by running the seeds under water, while gently scraping them against the inside of a sieve, or by letting them soak in water for two days before drying them off and setting them on a glass or ceramic plate to dry out completely. Cucumbers, melons, and summer squash should be grown in the summer, while winter squash can be grown during early to mid-autumn.

—For peppers, just scrape the seeds out of a ripe pepper and leave them on a glass or ceramic plate to dry out completely. Peppers should be grown in the summer months.

—For beans and pea seeds, allow the beans pods to ripen and dry out on the vine. When you shake it and hear seeds rattling around inside the dried husks, remove the husks from the plant. Allow them to continue to dry out indoors in an even layer for 2 to 3 weeks before shelling them and reserving the seeds. Pole and string beans should generally be grown in summer, while peas should be grown in the spring.

—For tomatoes, use a spoon to remove the membrane pouch with the seeds. Place it in a glass and add as much water as there are seeds and tomato membrane. Allow it to sit, fermenting, out of direct sunlight until a layer of white or gray mold develops on top and there are bubbles at the surface, which can take several days, depending on the temperature of the room. Add enough water to double the volume of the mixture and stir quickly. The mold and debris will float at the top and the good seeds will stay at the bottom. Use a spoon to scoop out the floating materials, add more water, and repeat until the seeds at the bottom are clean and free of debris. Remove the seeds, pat them dry with a paper towel, and set them out on a glass or ceramic plate to dry out completely. Tomatoes should be grown in the summer.

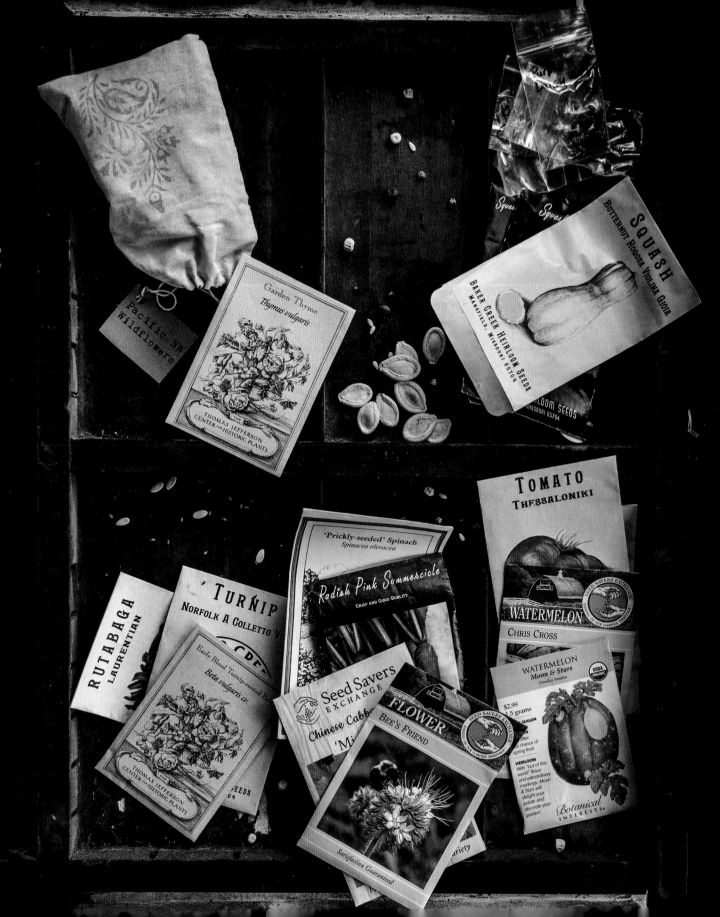

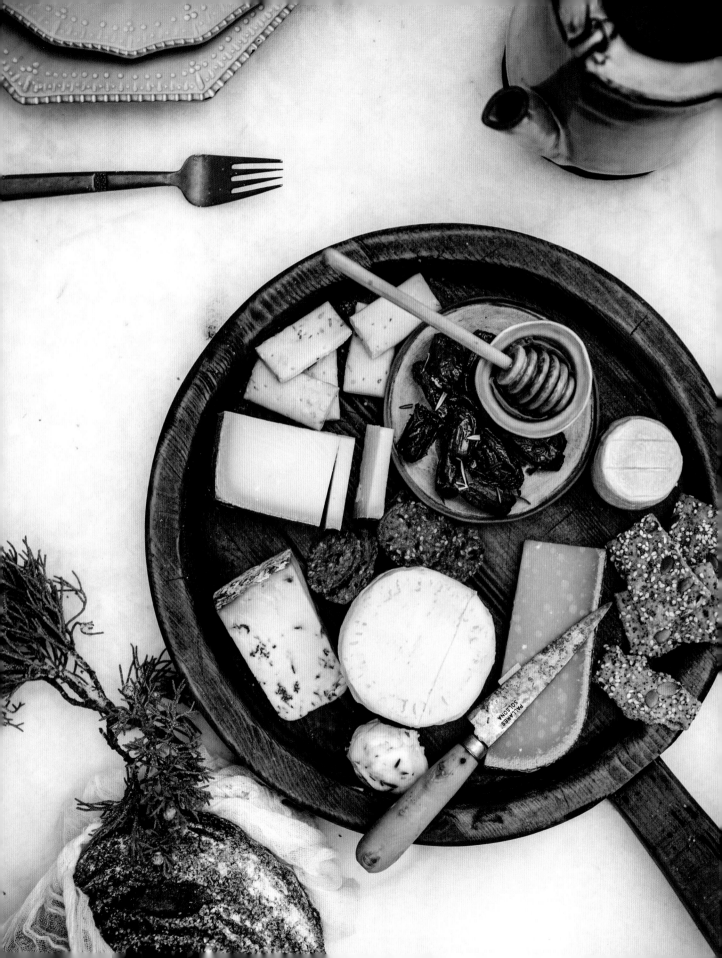

Winter Cheese Board with Herbed Dates

— Makes 1 cheese board and 2 cups (250 g) herbed dates —

The holidays are the busiest time of the year for home entertaining, and putting out a cheese plate is one of the most common appetizer solutions. The only problem is choosing from the never-ending variety of cheeses out there, which can be slightly overwhelming. So, to make things simple, I have a list of my favorite cheese varieties below, which, when served together, cover all the bases of cheesy flavor so that any one of your guests will be able to find a favorite. Going from softest to firmest, first there's Vermont Creamery Bijou. This is a mild aged goat cheese that comes in a pack of two delicious, mildly tangy, and very creamy medallions. Second is Cowgirl Creamery Mt. Tam, a triple-crème aged cow's-milk cheese with a tender white rind, soft spreadable interior, and notes of white mushroom. Third is Stilton, an aged English blue cheese that has a tart, sharp character. Fourth is Gruyère, an aged Swiss cow's-milk cheese with a slightly sweet, nutty, and salty flavor that gets more complex the longer it is aged. And fifth and last is aged Gouda, my favorite cheese of all, which is a Dutch cheese typically made from cow's or sheep's milk that is aged until a deep and rich burnt caramel flavor develops and little crunchy salt crystals form in the cheese. A few words of note: If you can't find the Mt. Tam, you can substitute any other triple-crème cheese. If you can't find the Bijou, you can substitute with any other aged goat cheese—and as for the Stilton, if you want it to be a little more nutty and a little less pungent, it's best to go for one that has been aged longer, which you can tell by the rind on the cheese. The thicker and more developed the rind, the longer the cheese has typically been aging. I also have some sweet complements for the cheeses below, namely some quick-and-easy herbed dates, a dollop of Maple, Rosemary, and Sea Salt Butter, and a dash of honey—all of these go great with any of the cheeses. As for the crackers, I like to get an assortment of wheat and rice crackers, in case there are any gluten-free folks (and also rice crackers have a strong crunch to them, which I really like), and I usually get the extra-seedy kind, since pumpkin and poppy seeds add more flavor as well as an extra pop of color and texture to the board.

—For the herbed dates, in a small skillet, heat the oil over medium-low heat. Add the dates and sage and cook, stirring, until the mixture is very fragrant and the dates have lightened slightly on the points that have been in contact with the pan, 6 to 8 minutes. Remove from the heat, toss with the rosemary, and season with salt.

—For the winter cheese board, arrange the cheeses, crackers, butter, and dates on a platter. Put some honey in a small bowl and place it on the platter along with a honey dripper for serving.

HERBED DATES

2 teaspoons extra-virgin olive oil

2 cups (250 g) pitted dates

4 fresh sage leaves

2 teaspoons fresh chopped rosemary

Flake kosher sea salt

WINTER CHEESE BOARD

Gruyère

Aged Gouda

Stilton

Cowgirl Creamery Mt. Tam, or other triple crème cheese

Vermont Creamery Bijou, or other aged goat cheese

Crackers

Maple, Rosemary, and Sea Salt Butter (page 32), at room temperature

Honey

Balsamic-Sautéed Kale, Chèvre, and Pomegranate Crostini

— Makes about 16 —

This dish is based on a savory toast I had at an Italian restaurant called Ava Gene's here in Portland. It was absolute heaven, and I immediately wanted to figure out a way to make it at home. After several trials, I got my own version down pat, and I'm sharing it with you here. It's one of my favorite crostini because of the wonderful contrast of flavors and textures throughout. The caramelized onions give a little sweetness, the kale adds earthiness, the bread gives a little crunch, the pine nuts provide a bit of meatiness and a lightly toasted flavor, the fresh pomegranate jewels release little bursts of sweet and tart pomegranate juice with every bite, and the chèvre provides a tangy creamy base for it all that contrasts with the tart balsamic vinegar in the most perfect, tantalizing way. The way these flavors and textures meld together is almost musical, and they just so happen to look very festive for the holidays, too!

½ cup (120 ml) extra-virgin olive oil

½ baguette, cut into slices ½-inch (12-mm) thick

1 medium sweet onion, chopped

5 teaspoons balsamic vinegar

3 tablespoons pine nuts

6 cups (390 g) chopped kale leaves

1 teaspoon honey

¼ teaspoon flake kosher sea salt

4 ounces (115 g) chèvre, crumbled

⅓ cup (28 g) pomegranate kernels

—In a medium skillet, heat 1 tablespoon of the oil over medium heat. Brush ¼ cup (60 ml) of the oil on both sides of the baguette slices. Toast the baguette slices in the hot skillet until lightly golden on each side, 2 to 4 minutes per side. Remove and set aside.

—In a Dutch oven, heat 2 tablespoons of the oil over medium heat. Add the onion and 3 teaspoons of the vinegar, stir to coat, and reduce the heat to medium-low. Cook, stirring every 3 minutes, until golden around the edges, 15 to 20 minutes. Add the remaining 2 teaspoons vinegar and the pine nuts and cook, stirring every minute, until lightly toasted, about 5 minutes more.

—Add the kale and remaining 1 tablespoon oil and stir to incorporate. Cook, stirring, until the kale is very wilted, about 8 minutes. Remove from the heat and stir in the honey and salt. Evenly distribute the chèvre on the tops of the crostini, then top each one with a tablespoon of the sautéed kale mixture and a generous pinch of the pomegranate kernels.

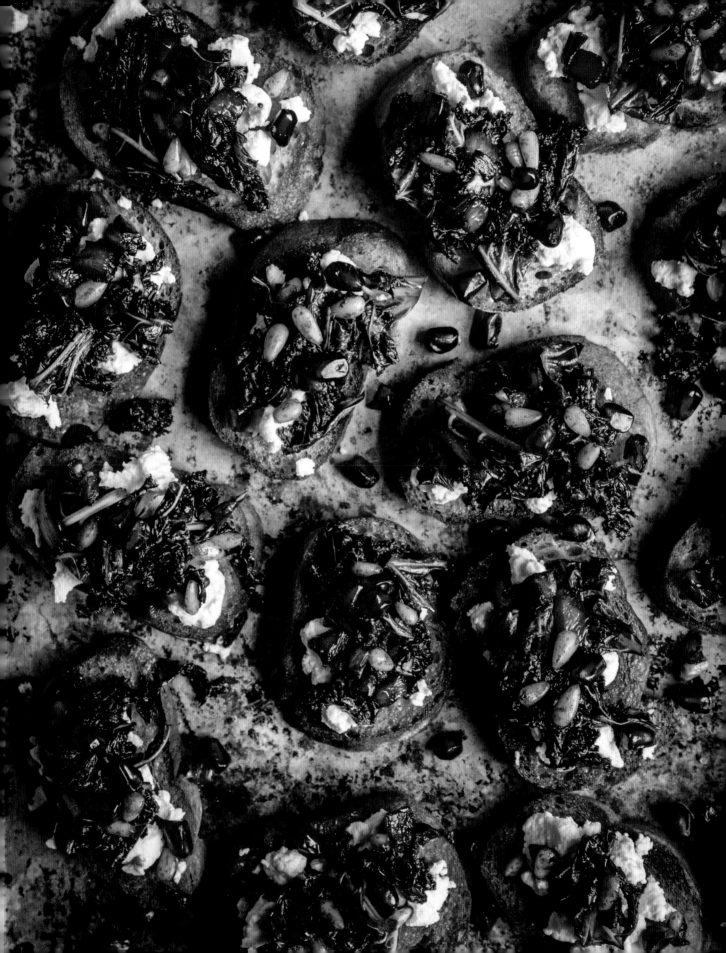

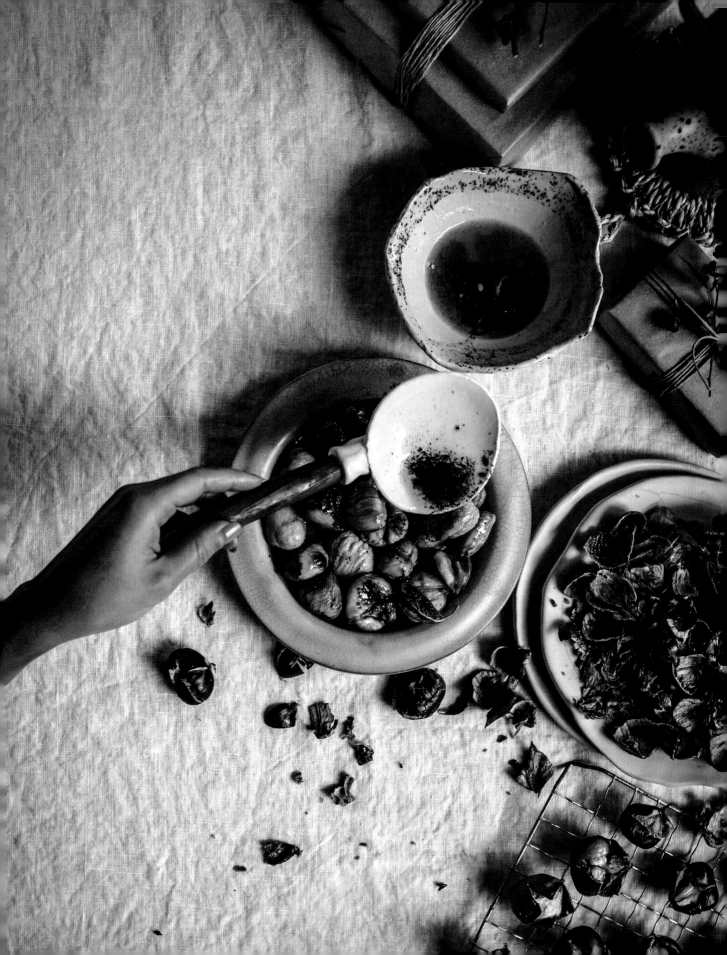

Roasted Chestnuts with Brown Butter–Sage Sauce

— Serves 4 —

Chestnuts are not for the lazy cook. They require time, effort, and dedication, but if you stick with them, you will end up with one of the most delicious foods of the winter season. The meat of the chestnut is golden in color with a slightly sweet flavor and an almost potato-like texture. As far as the prep work goes, you need to cut an X through both the chestnut's shells and skin before cooking them. There's a semi-glossy dark brown hard shell on the outside of the nut, but underneath that is a papery skin that is stuck onto the chestnut, which you need to get off before eating—it's thick and has a really unpleasant texture. This is a fun activity to do with a friend to make the cutting go by a bit more quickly—after a little conversation you'll get to the eating part in no time! I love serving these as a rich-and-hearty appetizer along with a lighter main dish.

—For the brown butter–sage sauce, in a large shallow stainless-steel skillet, melt the butter over medium heat. Swirl the pan around a bit every couple of minutes to help it cook evenly. Over a period of several minutes, the foam at the top of the butter will change from a light yellow to dark tan. Once it reaches the dark tan stage, smell it. It should smell nutty and toasted. Remove from the heat, stir in the sage and rosemary, and set aside.

—Preheat the oven to 425°F (220°C).

—For the roasted chestnuts, take a small sharp knife (pocket knives and utility knives work, too) and cut an X into the flat side of each chestnut, piercing the shell and the skin. Place a medium saucepan of cold water over medium heat and add the chestnuts. Bring the water to a boil and cook for 5 minutes. Drain and pat the chestnuts dry.

—Place a large sheet of foil on a rimmed baking sheet. Arrange the chestnuts on the foil, keeping them in one flat layer toward the center of the foil so you have several inches of space around them. Drizzle them with half the browned butter mixture and top with the rosemary, sage, and thyme sprigs. Fold the extra foil edges over the chestnuts and herbs, touching the edges of the foil together but leaving a little opening at the center for steam to escape.

—Roast until the edges of the scored X start to curl up and the chestnuts are cooked through, 30 to 45 minutes, depending on the size of the chestnuts. Remove and allow to cool for 10 minutes before handling.

—The nuts will still be very hot, but the skin and shell will come off more easily while the nuts are still warm, so you need to work quickly. Use a clean dish towel to pick each one up from the pan, squeeze it slightly to help loosen the skin, then peel off the hard exterior shell and fuzzy underskin. Repeat until all the chestnuts are shelled and skinned. Drizzle with the remaining brown butter mixture (you may need to reheat it to bring it to a liquid state) and sprinkle with the salt. Serve immediately.

BROWN BUTTER–SAGE SAUCE
1 cup (2 sticks/225 g) unsalted butter

5 fresh sage leaves

½ teaspoon chopped fresh rosemary leaves

ROASTED CHESTNUTS
1½ pounds (680 g) chestnuts (about 50 chestnuts)

4 sprigs fresh rosemary

2 sprigs fresh sage

2 sprigs fresh thyme

1 teaspoon flake kosher sea salt

Spanikopita

— Makes about 36 —

My father made spanikopita, *the traditional savory Greek pastry made from spinach, feta cheese, and filo dough, six days a week for more than thirty years at my parents' Greek deli. This is based on his recipe, but with the addition of sautéed onions and a bit of ricotta. I'm slightly obsessed with onions and put them in nearly every single savory dish I make, so if you're not a big onion fan, you can omit them here. (Although they really do add a nice flavor to the filling once they're sautéed. Seriously, onions are the best.) I like using fresh spinach because it has a brighter flavor that holds up better when baked than the frozen pre-shredded stuff; plus, the frozen stuff is really waterlogged, and if you don't squeeze out all the excess water, you'll end up with some sad, soggy spanikopitas. As far as the feta goes, you can read through my generous helping of Greek cheese advice on page 54. Trust me, using good-quality feta cheese will make all the difference in getting the right flavor and texture inside your* spanikopita. *Your stomach and guests will thank you!*

—Preheat the oven to 375°F (190°C).

—In a Dutch oven, heat the oil over low heat. Add the onion and cook, stirring, until softened and transparent, about 5 minutes. Add the spinach and cook, stirring every minute, until very wilted, 4 to 5 minutes. Remove from the heat and allow to cool until just warm.

—In a large bowl, mix together the egg, feta, ricotta, oregano, dill, pepper, and salt until combined. Stir in the spinach mixture until evenly distributed throughout.

—Lay the filo flat on a clean working surface and cover it with a clean dish towel. Each time you grab a sheet of filo from the pile, make sure to cover the pile with the towel; otherwise, it will dry out very quickly, crumble around the edges, and become difficult to work with.

—Lay down a sheet of the filo and use a pastry brush to lightly brush it with the butter. Fold it in half lengthwise and brush the surface sparingly with butter again. Place 1 heaping tablespoon of the filling in the bottom right corner of the strip. Fold the filo over from the bottom right to the left to create a small triangle. Continue folding up the strip, in the same method you'd use to fold a flag, lightly brushing the exposed filo with butter each time you fold it. The filling should now be wrapped in the filo. Seal the bottom by brushing the seam with butter and place it, seam side down, on a 13 by 18-inch (33 by 46-cm) rimmed baking sheet. Brush the top with butter. Repeat this process, filling up the first baking sheet and starting to fill a second one, until you've used all the filling, making sure to leave at least ½ inch (12 mm) of space between the spanikopitas on the baking sheet. Place the sheet in the oven and cook until golden brown, about 15 minutes. Allow to cool for 20 minutes before serving.

—Spanikopita also freezes very well before being baked. Place them on a baking sheet lined with parchment paper and wrapped with plastic wrap and freeze for 6 hours. Remove from the baking sheet and stack them in an airtight resealable container with parchment or waxed paper between each layer. They will keep like this in the freezer for up to 6 months.

—Note: To bake frozen spanikopita, follow the above baking directions but add about 10 minutes to the cooking time.

1 tablespoon extra-virgin olive oil

1 small yellow onion, chopped

8 cups chopped spinach (about 8 ounces/225 g)

1 large egg, beaten

12 ounces (340 g) feta cheese, crumbled

1¼ cups (305 g) whole-milk ricotta cheese

½ teaspoon dried oregano

½ teaspoon dried dill

¼ teaspoon freshly cracked black pepper

¼ teaspoon flake kosher sea salt

12 ounces (340 g) filo dough sheets, thawed if frozen

¾ cup (1½ sticks/170 g) unsalted butter, melted

Roasted Garlic Sourdough with Kopanisti

— Makes 1 loaf of sourdough and about 1 cup (260 g) kopanisti —

I learned to make sourdough from my friends Derek and Sean. Derek is one of the chefs behind Wicked Healthy, and Sean is a deeply talented baker who has worked as the head baker at Bouchon Bakery, Sullivan Street Bakery, and Grand Central Bakery. I'm using his sourdough recipe here, and it is essential that you have an accurate kitchen scale to measure the ingredients for the bread using grams. It's incredibly easy to change the amount of flour you use in a recipe simply by tapping the measuring cup to allow the flour to settle (which you're not supposed to do). It's also very important to roast the garlic before incorporating it into the bread; if you ever try to put raw garlic in sourdough, it won't rise due to the antiseptic qualities of raw garlic, which harm the yeast. I've also included my recipe for kopanisti, *which is a traditional whipped Greek feta spread with garlic, olive oil, lemon, and rosemary. I love pairing it with freshly baked bread, since the flavor of the* kopanisti *is quite strong and goes with the subtle, warm sourdough splendidly. This recipe also calls for the bread to proof in a banneton basket, a woven straw basket that allows the bread to breathe while rising and also imparts a beautiful spiral pattern onto the top of the loaf. If you don't have a banneton, you can use a lightly greased bowl instead.*

ROASTED GARLIC SOURDOUGH

2 heads garlic

2 tablespoons olive oil

12 ounces (360 g) water, ideally 65°F (18°C)

1 cup (209 g) properly fed sourdough starter

3½ cups (420 g) bread flour, plus more for flouring the banneton

3 teaspoons flake kosher sea salt

Extra-virgin olive oil, for greasing the bowl

Rice flour, for flouring the banneton

Wheat bran, for flouring the banneton

KOPANISTI

8 ounces (225 g) feta cheese

⅓ cup (75 ml) extra-virgin olive oil

1 garlic clove, minced

2 teaspoons fresh lemon juice

1½ teaspoons finely chopped fresh rosemary

¼ teaspoon red pepper flakes

—Preheat the oven to 400°F (205°C).

—For the roasted garlic sourdough, cut the top quarter off the heads of garlic and place the heads in the center of a sheet of foil. Drizzle with the oil and wrap them, leaving a small opening at the top for steam to escape. Place the foil packet on a small pan and roast until the garlic is very fragrant and lightly golden, about 35 minutes. Allow to cool to room temperature. Squeeze the roasted garlic cloves from the papery husks into a bowl, discarding the husks.

—Place the water, sourdough starter, and flour in the bowl of a stand mixer and fit the mixer with the dough hook. Beat the mixture on low speed until it just comes together in a shaggy mass, 30 to 60 seconds. Pour the salt on top of the mixture and allow it to rest at room temperature for 20 minutes.

—Beat the mixture on low speed until the dough comes away from the bowl in a solid mass around the hook and makes a slapping sound as it hits the sides of the bowl, 10 to 15 minutes. Add the roasted garlic bits and mix until just incorporated. Transfer the dough to a bowl well-greased with oil.

—Fold the dough by pulling one side of the dough straight up and then over to the opposite side of the dough, pressing down into that side of the dough ball. Turn the bowl a quarter turn and repeat. Repeat this two more times. Cover the bowl with a dish towel and set aside at room temperature out of direct sunlight to rise for 45 minutes. Repeat the dough folding process and allow the dough to rest for 45 minutes more, then repeat the dough folding process again and allow it to rest for a final 45 minutes. The dough

recipe continues

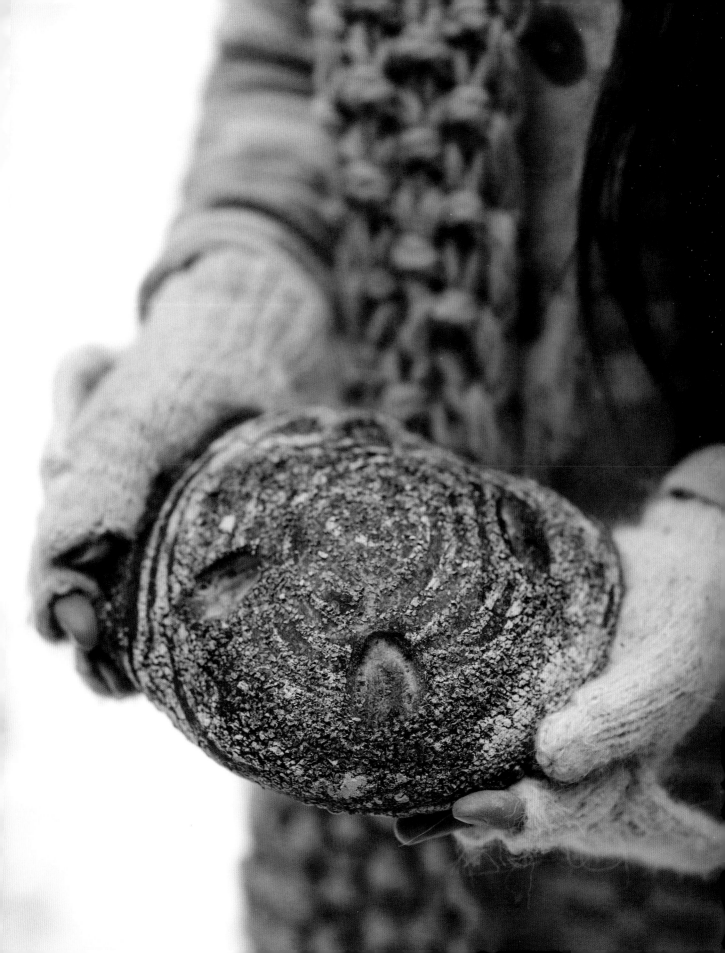

will have rested for a total of 2 hours 15 minutes by the time the turning and resting cycle is complete.

—At this point, you can cover and refrigerate the dough for up to 24 hours if you want to finish making the dough the next day. To continue making the bread the same day, turn the dough out onto a lightly floured surface. Form the dough by using the folding technique, pulling up one side of the dough up and over to the other side. Repeat this until the dough forms a circular ball shape. Next, you will form the dough by creating tension within it. Flip the dough over so that the smooth side is on top. Flatten your hand so that the sides of all your fingers are touching, and then curve your hand into a C or hook shape. Use your hand to cup the dough and pull it toward yourself over the work surface, working in short, quick movements, dragging it across the surface and using your cupped hands to rotate it slightly as it moves. Repeat this cupping movement until the dough is smooth and tight on top and very round in shape.

—Flour a banneton basket with a mixture of equal parts bread flour and rice flour, as well as a dusting of wheat bran. Transfer the dough ball into the banneton, smooth side down. Cover it with a dish towel and set aside at room temperature out of direct sunlight to rise until it is 50 percent larger, about 1 hour, depending on the temperature of the room.

—Meanwhile, preheat the oven to 500°F (260°C). Set a lidded 4-quart (3.8 L) Dutch oven inside to preheat for a minimum of 45 minutes.

—Remove the Dutch oven and lid from the oven, and remove the lid from the Dutch oven with oven mitts. Flip the banneton over onto a well-floured work surface, then quickly nudge it off the surface and into the Dutch oven. You can also do this with well-floured hands, if your hands are large enough to handle the mass of dough. Quickly score the surface of the loaf with a lame, razor, or kitchen shears. Cover the Dutch oven with the lid and place it back in the oven. Bake, covered, for 20 minutes, then remove the lid and bake, uncovered, until the bread is deeply golden and the crust is firm, about 20 minutes more. Remove the bread from the Dutch oven and allow it to cool completely on a wire rack before slicing and serving.

—For the kopanisti, in a blender or food processor, combine the feta, oil, garlic, lemon juice, and rosemary and puree on low speed until smooth and fluffy. Stir in the red pepper flakes and serve with the roasted garlic sourdough.

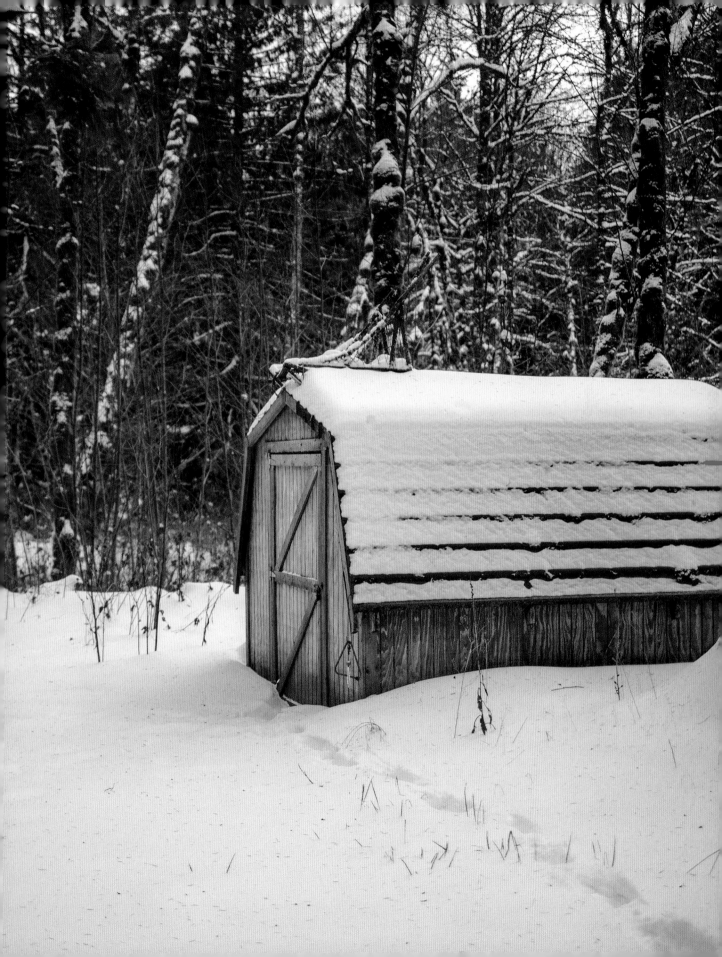

Carrot, Pine Nut, and Parmesan Skillet Pizza with Creamy Roasted Garlic Sauce

— Makes one 12-inch (30.5-cm) pizza —

I love making this pizza in the firepit in our backyard. The fire and ash give it the most appealing smoky flavor, and if you have the dough ready, it's really quick to throw together. I use my roasted garlic sourdough recipe for the crust. You could also substitute your own pizza dough here for simplicity's sake (see page 61 for mine). The key to woodfire cooking is to let the fire burn down a bit. When you first start a fire, the flames are large. After 30 to 45 minutes, though, the flames are very small, and the wood turns into glowing red embers. This is the prime time for woodfire cooking, since the heat is less intense and more consistent—perfect for burying a lidded cast-iron skillet and baking a savory, wintry pizza!

CREAMY ROASTED GARLIC SAUCE

2 heads garlic

¼ cup plus 2 tablespoons (90 ml) extra-virgin olive oil

3 ounces (85 g) Parmesan cheese, grated

3 tablespoons pine nuts

2 tablespoons fresh lemon thyme leaves

1 tablespoon white wine vinegar

¼ teaspoon freshly cracked black pepper

SKILLET PIZZA

2 tablespoons rice flour

2 tablespoons all-purpose flour

½ recipe Roasted Garlic Sourdough dough (page 250), risen and ready to use, or 17 ounces (485 g) ready-made pizza dough

2 medium carrots, peeled and shaved into thin strips using a mandoline or vegetable peeler

1½ ounces (43 g) Parmesan cheese, shaved

2 tablespoons pine nuts

1 tablespoon fresh lemon thyme leaves

—Preheat the oven to 400°F (205°C).

—For the creamy roasted garlic sauce, cut the top quarter off the heads of garlic and place the heads in the center of a sheet of foil. Drizzle with ¼ cup oil and wrap them, leaving a small opening at the top for steam to escape. Place the foil packet on a small pan and roast until the garlic is fragrant and golden, about 35 minutes. Allow to cool to room temperature. Squeeze the roasted cloves from the papery husks into a bowl, discarding the husks.

—Add the Parmesan, pine nuts, remaining oil, lemon thyme, vinegar, and pepper to a blender or food processor and puree until smooth. Set aside.

—For the skillet pizza, bury a lidded 12-inch (30.5-cm) cast-iron skillet in the glowing red embers of a fire that has burned down a bit and has a mix of glowing embers and small flames. Allow the pan to preheat for 30 minutes, adding more wood to the fire, as needed, to maintain a low flame.

—Meanwhile, in a small bowl, mix together the rice flour and all-purpose flour until combined. Lay the garlic sourdough out on a clean work surface lightly dusted with the flour mixture. Use your fingertips to gently press it out into a flat round circle 12 inches (30.5 cm) in diameter. Transfer the crust to a pizza peel well-dusted with the flour mixture. Use heatproof gloves to remove the pan from the fire, remove the lid from the pan, and immediately transfer the garlic sourdough crust off the peel and into the pan. Spread the creamy roasted garlic sauce on the pizza, leaving a 1-inch (2.5-cm) border around the edges, and top with the carrots, Parmesan, and pine nuts. Cover with the lid and bury the pan in the embers. Cook until the dough is puffy and there are some deep gold or charred marks on the carrots, 5 to 20 minutes, depending on the heat intensity of your flame. Keeping the pan in the fire, expose the lid and remove it, allowing the pizza to cook for a few minutes more, uncovered, until the crust is completely cooked through in the center. Remove from the heat, garnish with the lemon thyme leaves, slice, and serve.

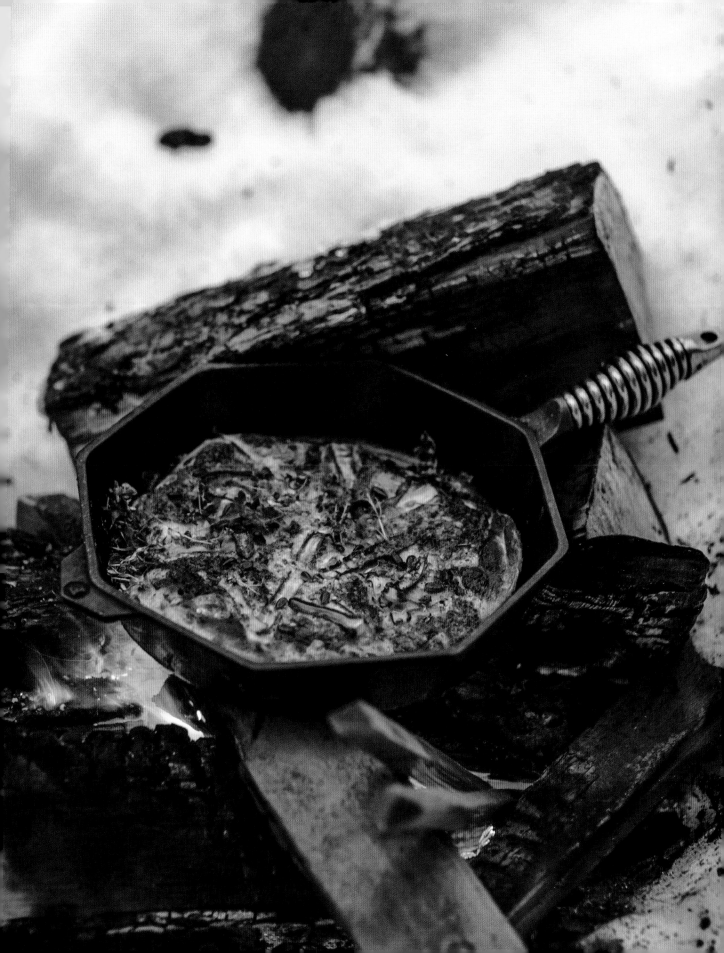

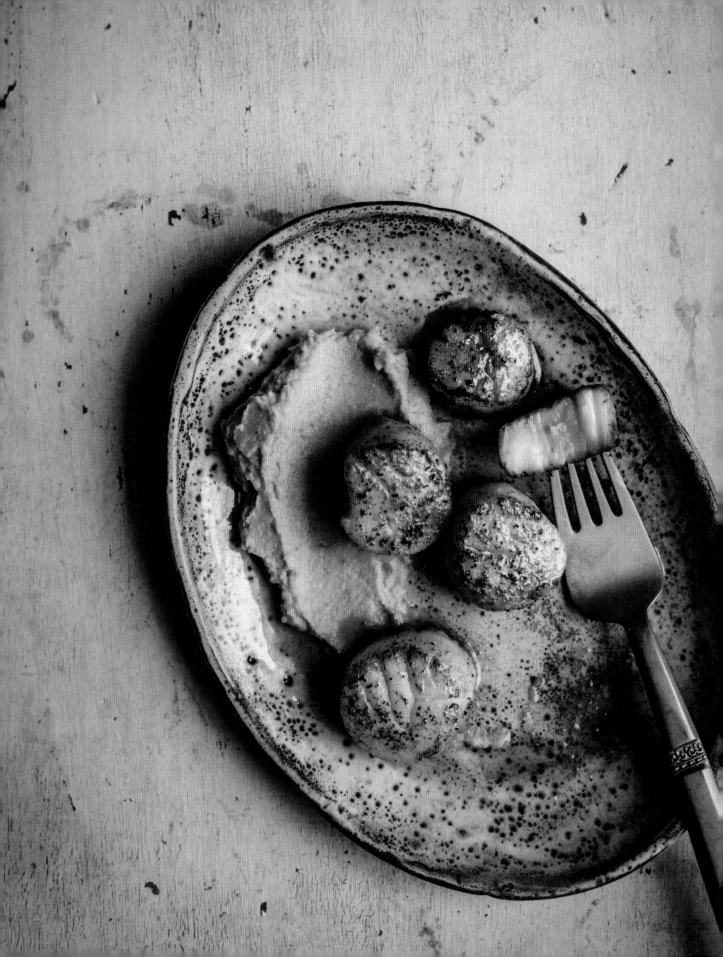

Seared Scallops with Brown Butter–Sage-Roasted Rutabaga Puree

— Serves 2 —

If you want to make something fancy for dinner but want it to require minimal effort and time, then this recipe is for you. Scallops are probably one of the easiest things to cook; all they require is a simple sear in some fat on a pan for a couple minutes per side and voilà! They're ready to go. They have a slightly sweet flavor to them, which pairs really well with the brown butter–sage-roasted rutabaga puree. Even though the name is long, the ingredients and techniques for making the puree are very simple. You just toss some rutabaga in olive oil and salt and roast it for a bit, then puree the roasted bits with some brown butter, sage, and milk. If you're unfamiliar with rutabaga, it is a winter root vegetable that is purplish on top and pale gold on the bottom. They look a bit like turnips but with a gold tint to the whole exterior (and— fun fact—they originated as a cross between turnips and cabbage). I love rutabagas because they aren't quite as spicy as turnips, and they get wonderfully sweet when they're cooked—just think of a caramelized, less-starchy potato, and that's pretty much the flavor of a roasted rutabaga. Whole rutabagas also keep for a really long time in the refrigerator, so you can buy a few pounds at the farmers' market when they're in season and put them to use over the next month or two.

—Preheat the oven to 400°F (205°C).

—For the rutabaga puree, in a large bowl, toss together the rutabagas, oil, and salt until coated. Spread them out on a rimmed baking sheet and roast until the rutabagas are lightly golden and can be easily pierced with a fork, about 30 minutes. Remove and set aside to cool slightly; reduce the oven temperature to 200°F (90°C).

—In a large stainless-steel skillet, melt the butter over medium heat. Swirl the pan around a bit every couple of minutes to help it cook evenly. Over a period of several minutes, the foam at the top of the butter will change from a light yellow to dark tan. Once it reaches the dark tan stage, smell it. It should smell nutty and toasted. Remove the pan from the heat and add the sage. Steep the sage in the brown butter for 5 minutes, then transfer the brown butter mixture, the roasted rutabagas, and the milk to a blender or food processor and blend on medium-high speed until completely smooth, stopping to scrape down the inside of the container with a rubber spatula, as needed. Pour the mixture into a medium casserole dish, cover with foil, and keep warm in the oven until ready to serve.

—For the seared scallops, pat the scallops dry. In a small bowl, mix together the salt, pepper, and sage. Sprinkle the spice mixture all over the outside of the scallops. In a medium skillet, melt the butter over high heat. Add the scallops and cook until lightly golden on each side but still translucent in the center, 1½ to 2 minutes per side. Serve with the brown butter–sage rutabaga puree.

RUTABAGA PUREE

1¾ pounds (800 g) rutabagas, peeled and cut into 1-inch (2.5-cm) cubes

1 tablespoon extra-virgin olive oil

1 teaspoon flake kosher sea salt

4 tablespoons (½ stick/55 g) unsalted butter

4 fresh sage leaves

½ cup (120 ml) whole milk, at room temperature

SEARED SCALLOPS

1 pound (455 g) scallops

½ teaspoon flake kosher sea salt

¼ teaspoon freshly cracked black pepper

Pinch of rubbed sage

3 tablespoons unsalted butter

Sweet Potato and Collard Green Curry

— Serves 6 —

I grew sweet potatoes for the first time last year, which was slightly nerve-racking, since you never really know how the plant produces until months afterward, when you dive into the earth and see what's underneath. Luckily, I had a really strong harvest of the four heirloom purple sweet potatoes I'd planted—Okinawan Purple, Myanmar Purple, Molokai Purple, and Korean Purple. The flavor of purple sweet potatoes is just as sweet as the orange and white varieties but gives you a little extra pop of color. The purple ones can be a little firmer, though, so I've found I need to cook them just a tad longer than their orange counterparts. I used a mix of orange and purple ones for this recipe, so if you go full purple, you'll likely end up with a slightly different-colored curry than this one, but I promise it will be just as tasty!

2 tablespoons extra-virgin olive oil

1 large yellow onion, chopped

2 garlic cloves, minced

1 (1-inch/2.5-cm) piece fresh ginger, peeled and minced

1 teaspoon red Thai curry paste

2¼ pounds (917 g) sweet potatoes, peeled and cut into 1-inch (2.5-cm) cubes

5 cups (1.2 L) full-fat coconut milk

12 ounces (340 g) collard green leaves, chopped

Flake kosher sea salt

—In a large Dutch oven, heat the oil over medium heat. Add the onion, garlic, ginger, and curry paste and stir to combine. Cook until the onion has softened significantly and is translucent, about 5 minutes. Add half the sweet potatoes and cook, stirring every 2 minutes, until softened slightly around the edges, about 10 minutes.

—Add the coconut milk and stir to combine. Bring the mixture to a boil and cook, stirring every 5 to 10 minutes and mashing the sweet potato pieces against the side of the pot with the back of a wooden spoon as they cook, until the sweet potato pieces soften significantly and the coconut milk has thickened, 25 to 30 minutes.

—Add the collard greens and remaining sweet potatoes and cook until the collard greens have wilted and turned dark green and the recently added sweet potatoes are soft when pricked with a fork, about 20 minutes more. Remove from the heat, season with salt, and serve.

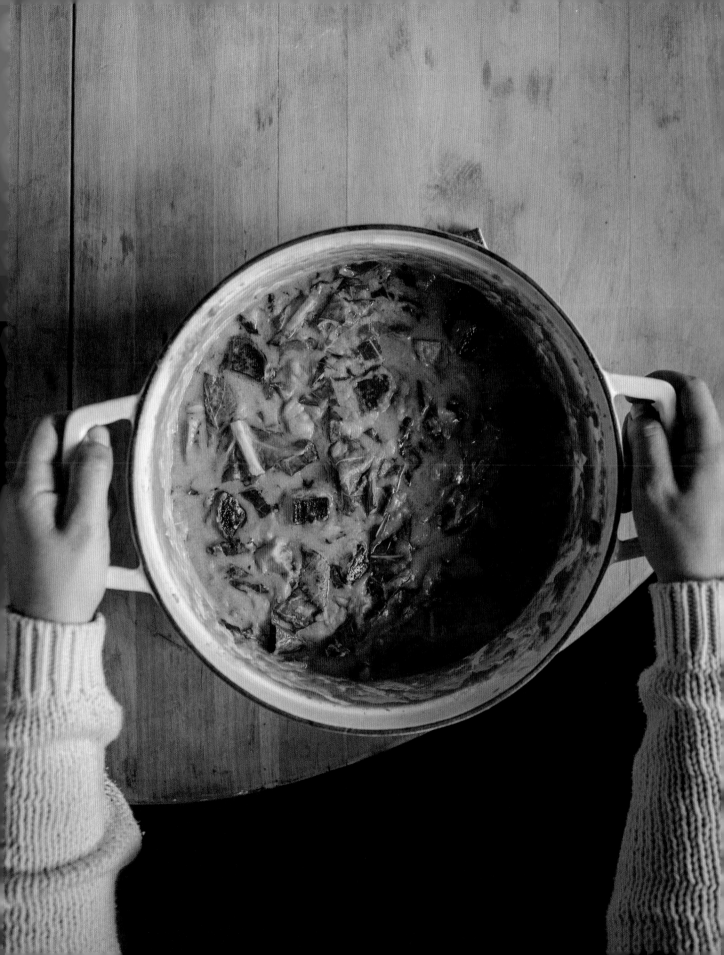

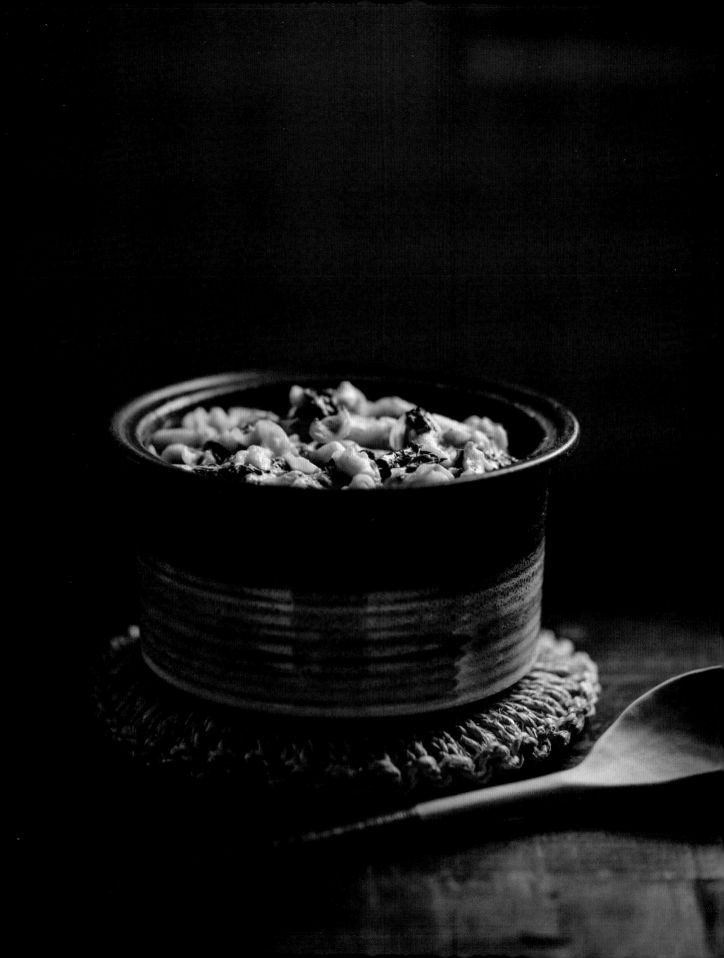

Spinach and Caramelized Leek Mac and Cheese

— Serves 4 to 6 —

I love incorporating caramelized veggies into mac and cheese—there's just something about the way the creamy, salty cheese complements the sweet-yet-slightly-savory vegetables that makes my heart sing and my mouth water. I've caramelized leeks for this recipe and combined them with a bit of wilted spinach, sharp white cheddar, creamy ricotta, and tangy chèvre. To get as many caramelized leek bits out of each leek, I recommend picking leeks with a large white part on the stem and smaller green part, since you'll only use the white and light green parts of the leek (toss the dark greens in the freezer to save for vegetable stock).

—In a large Dutch oven, melt the butter over medium-high heat. Add the leeks and stir to coat with the butter. Reduce the heat to medium-low and cook, stirring every 5 minutes, then more frequently as the leeks darken, until caramelized, 20 to 25 minutes. Add the sherry and stir to scrape up all the browned bits from the bottom of the pan. Remove from the heat and set aside.

—Bring a large pot of lightly salted water to a boil over medium-high heat. Add the pasta and cook until al dente according to the manufacturer's directions. Drain, rinse with cold water, then toss the noodles with 2 tablespoons of the oil. Set aside.

—Meanwhile, in a large skillet, heat the remaining 2 tablespoons oil over medium-low heat. Add the spinach and cook, stirring every minute, until the leaves are wilted and shrunken, 5 to 7 minutes. Remove from the heat and set aside.

—Preheat the oven to 350°F (175°C).

—Place the leek mixture back over low heat and add the flour, stirring until a paste forms. Add the milk, ½ cup (60 ml) at a time, allowing the liquid to smooth out before adding the next ½ cup (60 ml). Add the cream and stir until smooth. Cook, stirring every minute or two, until very warm but not boiling, 5 to 7 minutes. Add the ricotta, cheddar, and chèvre and stir to incorporate. Cook, stirring every 30 seconds, until the cheese has melted completely, about 5 minutes more. Add the vinegar, pepper, garlic powder, and salt and stir until incorporated. Remove from the heat, add the pasta and spinach, and stir gently to combine. Place the pot in the oven and bake, uncovered, until the top of the pasta is golden around the edges, 20 to 25 minutes.

3 tablespoons unsalted butter

2 large leeks, whites and light green parts only, halved lengthwise, washed well, and cut into slices ½-inch (12-mm) thick

¼ cup (60 ml) cream sherry

¼ teaspoon flake kosher sea salt, plus more for water

1 pound (455 g) toscani pasta or other spiral-shaped pasta

4 tablespoons (60 ml) extra-virgin olive oil

10 cups (300 g) chopped fresh spinach

3 tablespoons all-purpose flour

1½ cups (360 ml) whole milk

¼ cup (60 ml) heavy cream

⅔ cup (165 g) full-fat ricotta cheese

6 ounces (170 g) sharp white cheddar, grated

4 ounces (115 g) chèvre, crumbled

1 teaspoon sherry vinegar

½ teaspoon freshly cracked black pepper

½ teaspoon garlic powder

Shaved Beet Salad with Port-and-Balsamic Vinaigrette

— Serves 4 —

Raw beets have an intensely bright and earthy flavor when they're served raw. Because of their incredibly firm texture, they need to be shaved into strips to be eaten raw with ease, and this works out to the visual benefit of the salad because beets just so happen to be absolutely gorgeous inside. I recommend using a variety of Chioggia, golden, and plain red beets for the salad, but tossing the plain red beets separately so that their color doesn't bleed onto the other varieties. If you're unfamiliar with Chioggia beets, they're the ones whose insides are striped with red and white circles like a target. The earthy flavor of the beets pairs perfectly with the creaminess of the chèvre and the sweet acidity of the port-and-balsamic vinaigrette, making for a killer winter salad that's a treat for both the palate and the eyes.

PORT-AND-BALSAMIC VINAIGRETTE

2 tablespoons port wine

2 tablespoons extra-virgin olive oil

1 tablespoon balsamic vinegar

1 teaspoon honey

1 teaspoon flake kosher sea salt

1 teaspoon fresh thyme leaves

¼ teaspoon freshly cracked black pepper

SHAVED BEET SALAD

10 ounces (280 g) beets, shaved

2 ounces (55 g) carrots, peeled and shaved

4 ounces baby greens (about 4 cups)

2 tablespoons micro thyme or 1 tablespoon thyme leaves

4 ounces (115 g) crumbled chèvre

—For the port-and-balsamic vinaigrette, whisk together the port, olive oil, vinegar, honey, salt, thyme, and pepper until completely combined. Set aside.

—For the shaved beet salad, in a large bowl, toss together the beets, carrots, baby greens, thyme, and chèvre until combined. Distribute the salad among four plates and drizzle each with one-quarter of the vinaigrette. Serve immediately.

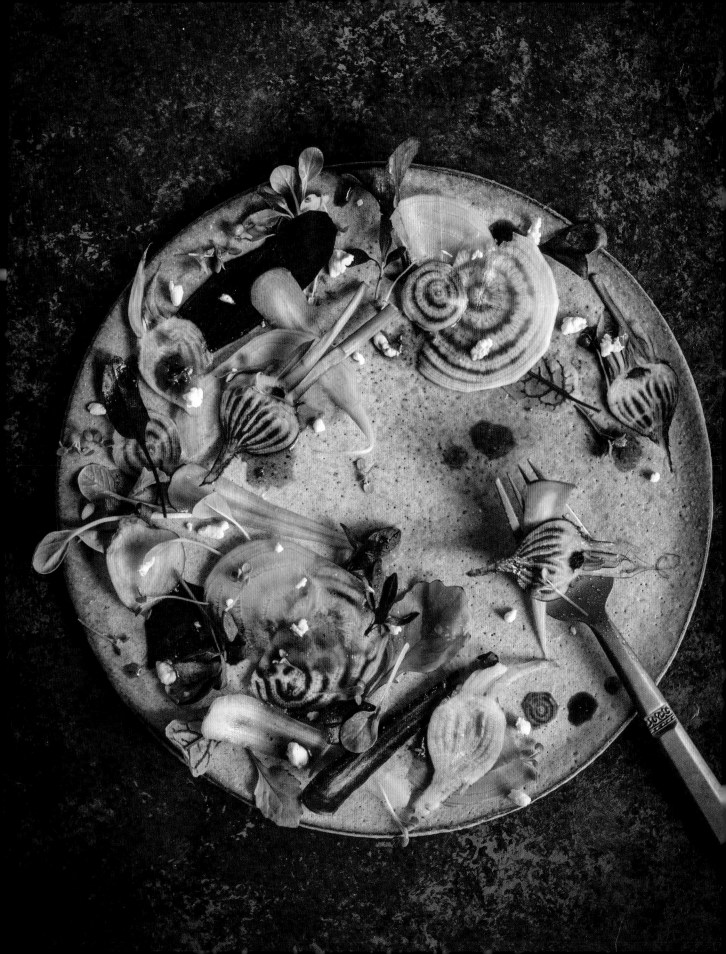

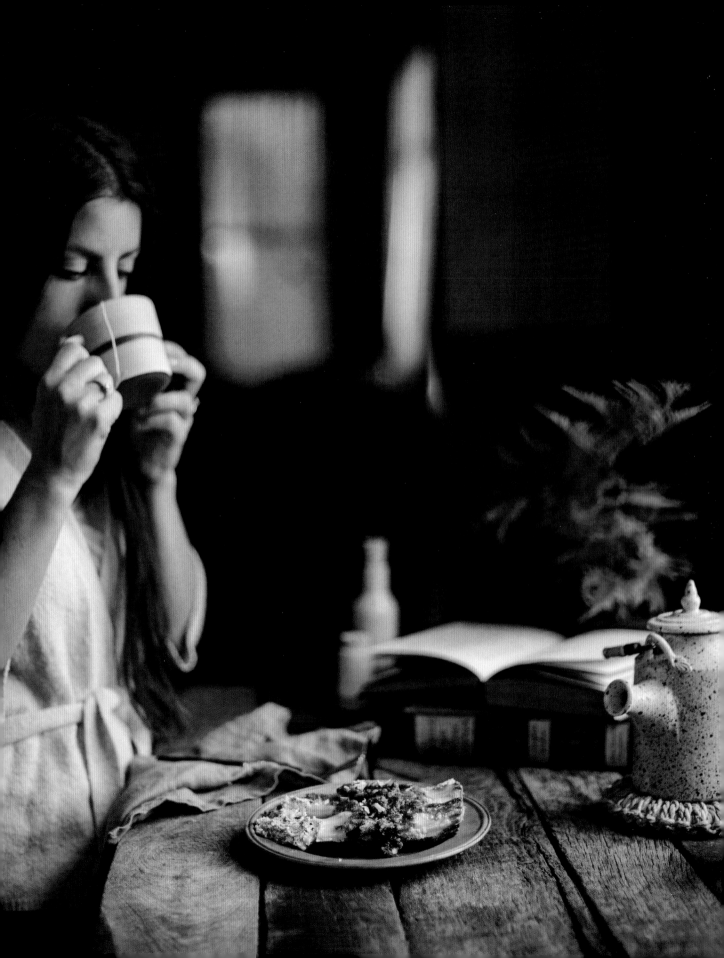

Kale-Pesto Manicotti

— Makes 14 —

Kale is probably one of the hardiest things in my garden. Kale itself has an earthy, almost mushroomy flavor and tastes more like broccoli than any lettuce. This deep flavor lends itself very well to the other ingredients typically found in pesto. Basil, garlic, Parmesan, and olive oil all complement it ridiculously well, rounding out the earthiness of it with fresh, spicy, rich, and salty perfection. The filling itself doesn't use all of the kale pesto you'll make, so I always serve some extra on the side so folks can get as many spoonfuls of this goodness as they want.

—For the kale pesto, combine the kale, Parmesan, pine nuts, basil, and garlic in a food processor and pulse until chopped. Add the oil and puree until smooth. Cover and set aside.

—For the tomato–bay leaf sauce, in a medium saucepan, melt the butter over medium-low heat. Add the onion and garlic and cook, stirring every minute, until the onion is translucent and has softened, about 5 minutes. Add the bay leaf and tomatoes and raise the heat to medium. Cook, stirring every 5 minutes and breaking the tomatoes apart with your spoon as they cook, until the tomatoes have nearly disintegrated, about 30 minutes.

—Remove from the heat, stir in the thyme, oregano, pepper, and salt, and allow to cool for 20 minutes. Transfer to a food processor or blender and puree until smooth. Stir in ½ cup (60 ml) of the kale pesto and set aside.

—For the manicotti and filling, in a medium bowl, stir together ¾ cup (180 ml) of the kale pesto, the ricotta, ½ cup (50 g) of the Parmesan, the milk, egg, pepper, and salt until smooth. Add the kale and chives and stir until combined.

—Preheat the oven to 450°F (230°C).

—To prepare the manicotti, bring a large pot of lightly salted water to a boil. Add the manicotti and cook until al dente according to the package directions, then drain, brush with the oil, and set aside.

—Pour one-third of the tomato sauce into a 10 by 14-inch (25 by 35.5-cm) casserole dish. Stuff each manicotti with about 3 tablespoons of the filling and arrange them all in an even layer in the pan. Pour the remaining tomato sauce over the manicotti and sprinkle with the remaining ¼ cup (25 g) Parmesan. Bake until the sauce is bubbling around the edges, 20 to 25 minutes. Remove from the oven and serve with the remaining kale pesto.

KALE PESTO

3 cups (195 g) coarsely chopped lightly packed kale, leaves and stems

1¼ cups (125 g) freshly grated Parmesan cheese

1 cup (135 g) pine nuts

¾ cup (30 g) fresh basil leaves

5 garlic cloves, crushed

⅓ cup (75 ml) extra-virgin olive oil

TOMATO–BAY LEAF SAUCE

3 tablespoons unsalted butter

1 large yellow onion, coarsely chopped

4 garlic cloves, minced

1 dried bay leaf

10 ounces (280 g) fresh tomatoes, coarsely chopped

½ teaspoon dried thyme leaves

½ teaspoon dried oregano

½ teaspoon freshly cracked black pepper

1½ teaspoons flake kosher sea salt

MANICOTTI AND FILLING

3¾ cups (920 g) full-fat ricotta

¾ cup (70 g) freshly grated Parmesan cheese

¼ cup (60 ml) whole milk

1 egg, beaten

¼ teaspoon freshly cracked black pepper

1 teaspoon flake kosher sea salt, plus more for the water

1¾ cups (115 g) finely chopped kale leaves

2 tablespoons chopped fresh chives

14 manicotti shells

3 tablespoons extra-virgin olive oil

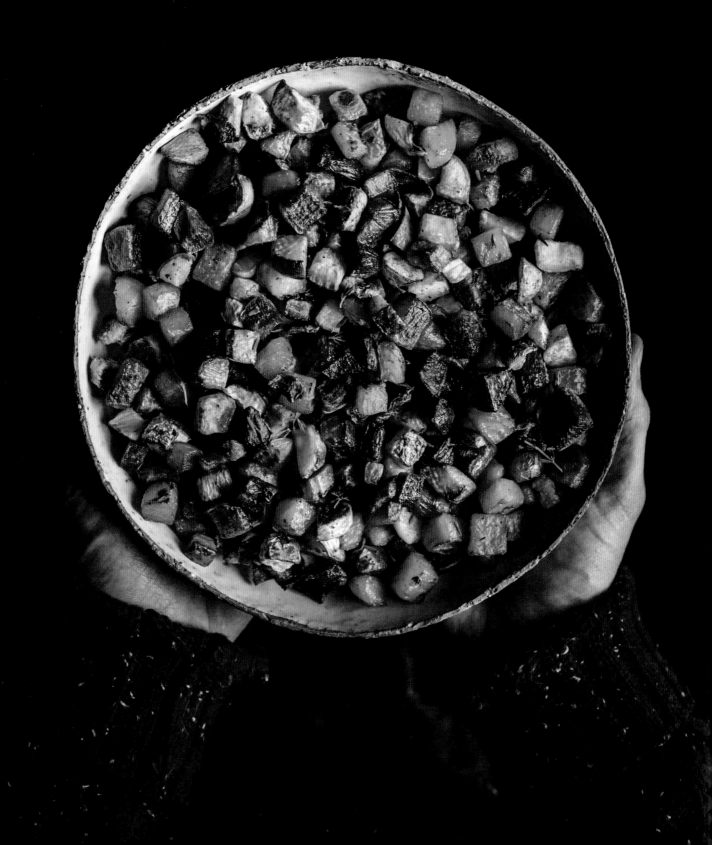

Winter Root Vegetable Hash

— Serves 4 —

I love eating cubed hash for breakfast, but it takes so long to cook on the stovetop and requires such constant monitoring that it's hard to find the motivation to make it right after waking up. I want those savory, sweet, delicious root veggie cubes so badly, but I don't want to spend the first thirty minutes of my morning standing in front of the stove. The struggle is real! To pacify the lazy cook within, I figured out another way to make these guys with much less hands-on time. You just toss the root veggies with some olive oil and seasonings, spread them out on a baking sheet, and roast them. The key to making them cook evenly is to stir up the contents of the pan twice during the cooking time—this will keep the sides of the veggies touching the pan from getting too charred, and mimics the texture and consistency of the stovetop stuff perfectly. As for the rainbow of colors in the hash, I use a wide variety of heirloom turnips and potatoes, including Red Round turnips, Gilfeather turnips, Magenta Love potatoes, and Purple Pelisse potatoes. I stuck with golden beets, though, because the red ones tend to leak a lot of color, and I didn't want to dye the other veggie bits while tossing them together in the oil. I recommend serving these with a tasty fried egg and a thick slice of buttered toast.

—Preheat the oven to 375°F (190°C).

—In a small bowl, mix together the salt, garlic powder, pepper, cumin, and paprika. In a large bowl, toss the vegetables with the oil and half the spice mixture. Spread out the vegetables in an even layer on two large rimmed baking sheets. Roast until the edges of the vegetables are golden, a little wrinkly, and easily pierced with a fork, 45 to 55 minutes, gently tossing the vegetables in the pan every 15 minutes.

—Transfer the vegetables to a serving bowl and toss with the remaining spice mixture and the thyme. Serve immediately.

2 teaspoons flake kosher sea salt

1 teaspoon garlic powder

½ teaspoon freshly cracked black pepper

½ teaspoon ground cumin

½ teaspoon paprika

1¾ pounds (800 g) turnips, peeled and cut into 1-inch cubes

¾ pound (340 g) golden beets, peeled and cut into 1-inch cubes

¾ pound (340 g) potatoes, peeled and cut into 1-inch cubes

2 tablespoons extra-virgin olive oil

2 teaspoons fresh thyme leaves

Beet, Hazelnut, and Black Bean Burgers

— Makes 6 —

For most of my life, the only veggie burgers I'd had were the frozen Gardenburger variety, which are fine, but they're mostly rice and not as rich with savory vegetable flavor as I'd like. Then I was introduced to the magic of beet burgers at a little Portland restaurant called White Owl Social Club, and a serious love affair began. I became obsessed with trying to re-create them at home. After much recipe testing, I was able to create a burger that was more flavorful than any meat-based patty I'd had, held together without issue, and left me feeling full and satisfied—as opposed to some of the less protein-heavy veggie patties that leave you hungry again in an hour or two. The combination of ingredients for the patty might sound strange (black beans, seaweed, beets, eggs, and hazelnuts, to be exact), but I swear to the lord of light that they come together in the most fluid, savory, and complementary way.

¾ cup (100 g) chopped rehydrated wakame seaweed

1 pound (455 g) beets, peeled and grated

1 cup (85 g) crushed hazelnuts

1 can (15 ounces/430 g) black beans, rinsed, drained, and pureed

2 large eggs, beaten

2 teaspoons flake kosher sea salt

½ teaspoon garlic powder

1 teaspoon shiitake mushroom powder (optional)

¼ teaspoon freshly cracked black pepper

12 tablespoons (120 ml) mayonnaise

2 teaspoons vinegar-based hot sauce, such as Tabasco

1 teaspoon smoked paprika

¼ teaspoon garlic powder

6 brioche buns

2 cups (65 g) alfalfa sprouts

3 ounces (85 g) chèvre, crumbled

⅓ cup (54 ml) Quick-Pickled Onions (page 30)

—Preheat the oven to 400°F (205°C). Line a baking sheet with parchment paper.

—Press the seaweed between your hands to squeeze out any excess water. Place it in a food processor and add the beets, hazelnuts, and black beans. Pulse several times until a coarse puree forms. Pour the mixture into a bowl and mix in the eggs, salt, garlic powder, shiitake mushroom powder (if using), and pepper until evenly incorporated.

—Use your hands to form the mixture into 6 patties and place them on the prepared baking sheet. Roast in the oven until they've deepened in color and are crisp around the edges, about 30 minutes. Allow the patties to cool on the pan for 10 minutes before handling.

—Meanwhile, in a small bowl, mix together the mayonnaise, hot sauce, paprika, and garlic powder. To assemble, evenly distribute the mayonnaise sauce between the insides of the buns. Use a spatula to remove each patty and place it on the bottom of each of the buns. Top each patty with ⅓ cup (30 g) of the sprouts, ½ ounce (15 g) of the chèvre, and a generous pinch of the onions, then add the top of the bun and serve.

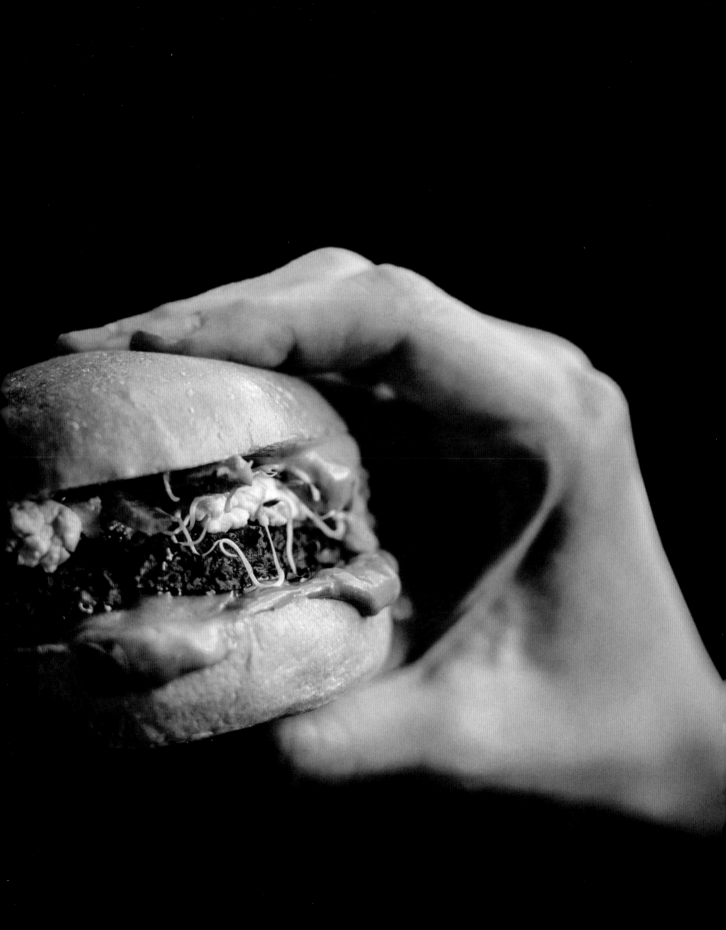

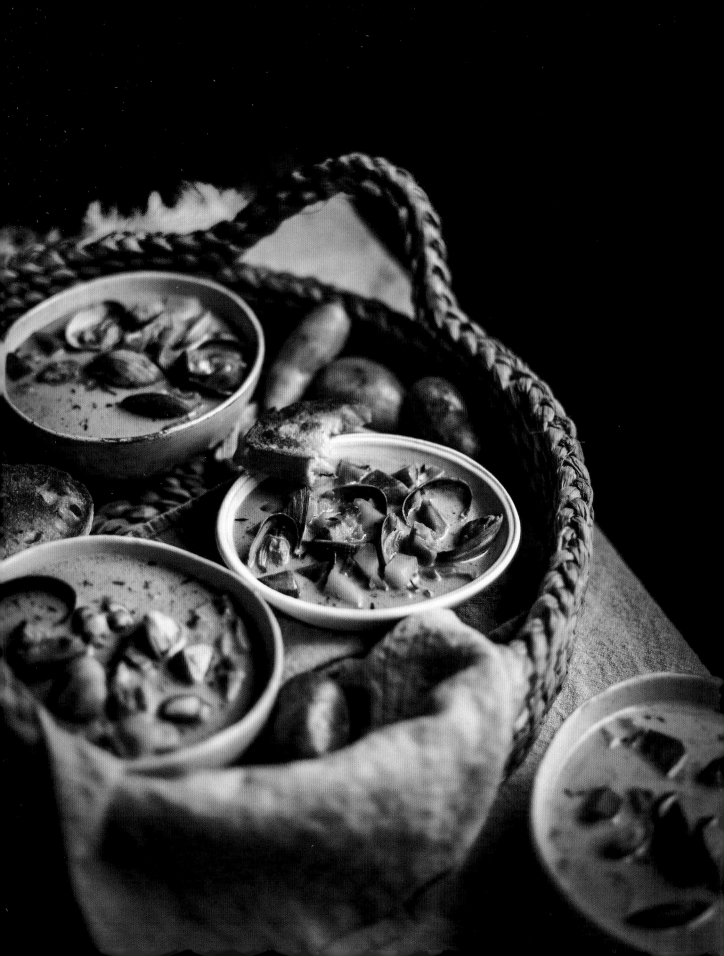

Heirloom Potato Clam Chowder

— Serves 4 to 6 —

Every year, Jeremy and I go to Garibaldi Bay along the Oregon coast and do some good old-fashioned clamming. There are different techniques, depending on the type of clam you're trying to catch, but we just use a clam rake when the tide is out to search for near-surface-dwelling butter clams. It's a really fun and easy activity, and the view of the coast when the tide is completely out is unreal. My favorite clam recipe is this classic clam chowder. I like this version because it's a little lighter—it's heavier on the wine and vegetable stock than the milk—and really lets the flavor of the fresh clams come through. Once you get your hands on some fresh clams, the best way to store them is to line a large shallow dish with a layer of ice, then put a container on top of the ice and transfer the clams into that container, making sure the walls of the container are high enough to keep out any water as the ice melts. Cover the clams with a damp paper towel, place them in the refrigerator, and use them within twenty-four hours.

—In a large Dutch oven, melt the butter over medium heat. Add the onion and sauté until softened and translucent, about 5 minutes. Reduce the heat to medium-low and add the bay leaves, garlic, and pork belly. Cook, stirring every 5 minutes, until the onion turns golden and the edges of the pork belly are crispy, 35 to 45 minutes.

—Add the wine to the pan and stir until all the crusty bits at the bottom have dissolved. Add the stock and milk and stir to combine. Bring the mixture to a boil, then add the potatoes, thyme, garlic powder, pepper, and Old Bay seasoning. Cook until the potatoes are tender when pierced with a fork, about 20 minutes.

—Add the clams and cook, covered, until they're tender, have opened, and are *just* cooked all the way through, 3 to 5 minutes. Discard any clams that do not open along with the bay leaf. Season with salt and serve alongside toasted bread for dipping.

3 tablespoons unsalted butter

1 large yellow onion, chopped

2 bay leaves

2 garlic cloves, minced

6 ounces (170 g) salt pork belly, cut into ½-inch (12-mm) cubes

1 cup (240 ml) dry white wine

3 cups (720 ml) Vegetable Stock (page 34)

2 cups (480 ml) whole milk

3 pounds (1.4 kg) heirloom potatoes, peeled and cut into 1-inch (2.5-cm) cubes

2 teaspoons dried thyme leaves

½ teaspoon garlic powder

½ teaspoon freshly cracked black pepper

1 teaspoon Old Bay seasoning

3 pounds (1.4 kg) clams

Flake kosher sea salt

Roasted Chicken with Persimmon and Port Glaze

— Serves 4 to 6 —

It's hard to find a finer comfort food than a classic roasted chicken. In the wintertime, I tend to make them on the regular, and out of all the cold-weather produce I've tried cooking them with, nothing compares to the persimmon. Persimmons, which grow on trees much like apples, have an interior texture that is very dense, kind of like a tomato, but without all the goopy seedy bits and just the thick meaty part. When eaten raw, they have a very mildly tomato-y flavor with a hint of sweetness that gets stronger the riper they are. There are two types of persimmons you'll find at the market, Fuyu and Hachiya. Fuyu are short, squat, and round and are typically eaten when their skins are fully bright orange, but the fruit is still hard and crisp. Hachiya, on the other hand, are more elongated and oval-shaped and need to be eaten when bright orange, very ripe, and soft. If you try to eat an unripe Hachiya persimmon raw, it will taste straight-up terrible, which is why it's important to purchase them several days before you intend to use them. Leave them in a brown paper bag on your kitchen counter to ripen fully. You can use either variety for this recipe, although a fully ripened Hachiya has a higher sugar content and will make for a slightly sweeter overall flavor.

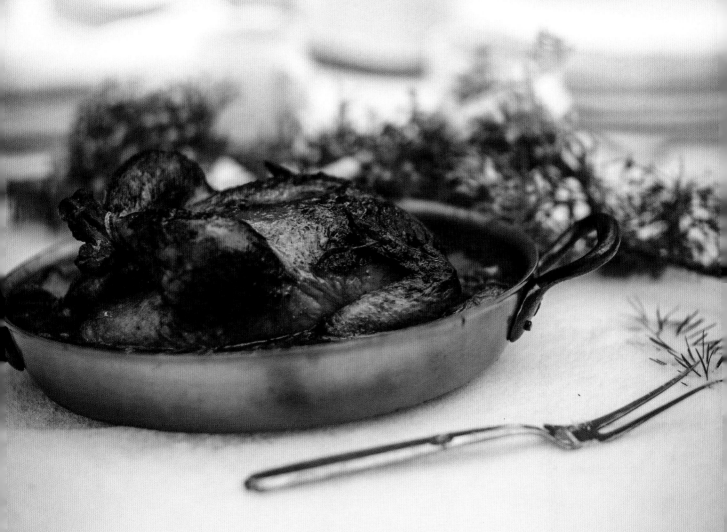

—For the port brine, whisk together the water and salt in a large bowl until the salt has completely dissolved. Whisk in the port, rosemary, thyme, and sage and allow to cool to room temperature. Place the chicken in a resealable plastic bag in a casserole dish (this will make it easier to take it in and out of the refrigerator) and add the brine. Seal the bag and refrigerate for at least 12 hours or up to 48 hours.

—For the persimmon butter sauce, in a medium skillet, melt the butter over medium heat. Add the chicken neck and cook until lightly browned on both sides, 5 to 7 minutes per side. Add the onion and persimmon and stir to coat in the pan juices. Cook, stirring every 3 to 5 minutes, until the persimmon and onion bits are golden around the edges, about 20 minutes.

—Add the port and stir, using your spoon to scrape up any browned bits off the bottom of the pan. Add the rosemary and salt and stir to incorporate. Cook, stirring every 2 to 3 minutes, until thickened slightly and it no longer smells of alcohol, about 5 minutes. Remove from the heat and allow to cool just to warm, then puree with the chicken stock until smooth. Set aside.

—Preheat the oven to 400°F (205°C).

—For the roasted chicken, evenly distribute the chopped onions and chopped persimmon over the bottom of a roasting pan. In a small bowl, whisk together the oil, 2 tablespoons of the persimmon butter sauce, the sage, and thyme until smooth. Set aside. Remove the chicken from the brine, rinse thoroughly, and pat it completely dry with paper towels. Coat it inside and out with the oil mixture, getting underneath the skin of the breast but taking care not to tear the skin while doing so. Toss the persimmon-onion mixture in the roasting pan with the remaining oil mixture.

—Place the chicken on top of the persimmon-onion mixture in the roasting pan and stuff the chicken cavity with two of the rosemary sprigs. Truss the bird and drizzle the remaining persimmon butter sauce into the pan around the bird along with the stock and port. Arrange the persimmon slices around the chicken and place a rosemary sprig on either side of the bird. Roast until the skin is golden and the internal temperature at the thigh joint reaches 165°F (75°C), 1 to 1½ hours, depending on the size of the chicken. Remove the pan from the oven and allow the bird to rest for 20 minutes before carving and serving.

PORT BRINE

2 quarts (7.5 L) warm water

½ cup (134 g) flake kosher sea salt

¼ cup (60 ml) ruby port

1 teaspoon dried rosemary

½ teaspoon dried thyme leaves

½ teaspoon rubbed sage

1 chicken (about 5 pounds/2.3 kg)

PERSIMMON BUTTER SAUCE

2 ounces (½ stick/55 g) unsalted butter

1 chicken neck

½ large yellow onion, chopped

1 persimmon, finely chopped

⅓ cup (75 ml) ruby port

1 teaspoon chopped fresh rosemary

¾ teaspoon flake kosher sea salt

½ cup (60 ml) chicken stock or Poultry Stock (page 34), at room temperature

ROASTED CHICKEN

½ large yellow onion, chopped

1 persimmon, chopped

¼ cup (60 ml) extra-virgin olive oil

¼ teaspoon rubbed sage

¼ teaspoon dried thyme leaves

4 sprigs fresh rosemary

¼ cup (60 ml) chicken stock or Poultry Stock (page 34)

¼ cup (60 ml) ruby port

3 persimmons, cut into ¼-inch (6-mm) thick slices

Braised Pork Spareribs with Figs and Anise

— Serves 4 —

Spareribs come from the lower ribs of the pig, right near the belly, and because of this proximity, they tend to have more fat on them than their backbone-adjacent baby back rib counterparts. Since the large bits of fat aren't great to eat on their own after grilling or roasting, I always braise spareribs in a flavorful broth to disintegrate the fats and add even more flavor and richness to the cooking liquid. This low-and-slow braising technique also softens the tight muscle tissue on the ribs so the meat falls off the bone right as you put it to your mouth. For the broth, I've combined cashew milk, dried figs, soy sauce, ponzu, and star anise for a salty and sweet Asian-inspired stock. I love using cashew milk for braising because, unlike cow's milk, it doesn't curdle when exposed to high temperatures for a long period of time, and it develops a deeper, nuttier flavor as it cooks, almost like it's being slowly toasted.

2½ pounds (1.2 kg) pork spareribs, cut into 3-rib sections

2 teaspoons flake kosher sea salt

2 tablespoons extra-virgin olive oil

1 large yellow onion, chopped

12 ounces (340 g) dried figs

1½ cups (360 ml) plain unsweetened cashew milk

¼ cup (60 ml) soy sauce

2 tablespoons ponzu

1 star anise pod

—Preheat the oven to 325°F (165°C).

—Coat the spareribs with the salt and place them in the bottom of a 9 by 13-inch (23 by 33-cm) roasting pan in an even layer.

—In a medium Dutch oven, heat the oil over medium-low heat. Add the onion and stir to coat in the oil. Cook until softened and translucent, about 5 minutes. Cut half of the figs in half, then add all of the figs to the pan and stir to incorporate. Cook, stirring every minute, until the figs are softened slightly, about 5 minutes.

—Add the cashew milk, soy sauce, ponzu, and star anise and stir. Bring the mixture to a boil and cook for 5 minutes before removing from the heat.

—Pour the contents of the Dutch oven into the roasting pan, then add 2 cups (480 ml) water. Cover the pan with foil and place it in the oven. Roast for 1 hour 30 minutes, then remove the foil and roast for 30 minutes more, uncovered. Discard the star anise and serve.

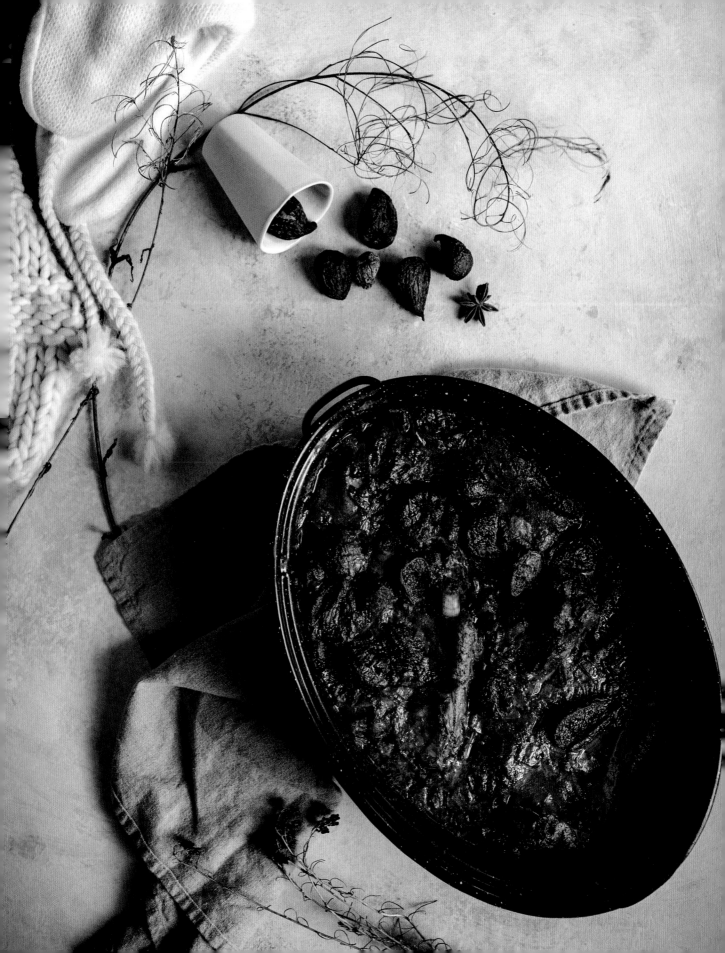

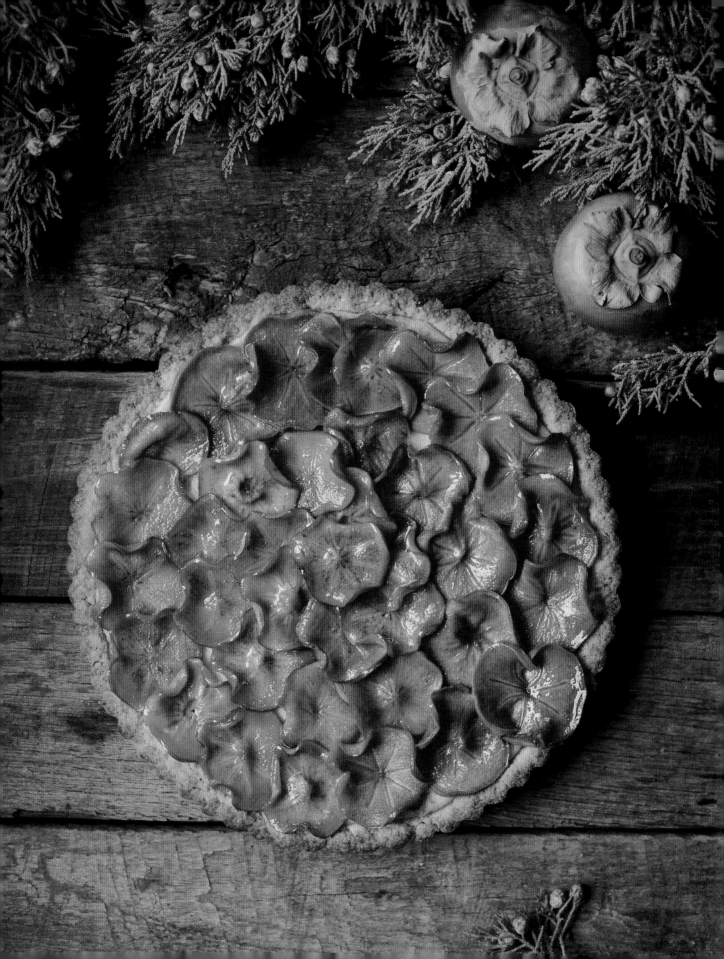

Persimmon-Mascarpone Cheesecake Tart with Almond Crust

— Makes one 8-inch (20-cm) tart —

This is one of the prettiest desserts I've ever made, and it has the perfect balance of sweet, creamy, smooth, nutty, and crunchy. The crust is made from an almond flour and cake flour base and is filled with a mixture of mascarpone, sugar, lemon, vanilla, and cinnamon. But the real star here is the persimmon. I recommend using a mandoline to slice them very thin. The thinner they are, the more they will ruffle around the edges when boiled in the cinnamon-honey syrup. I accidentally discovered this textural transformation while preparing another recipe. I'm not exactly sure what causes it, but the thin layers begin to ruffle in the most graceful and consistent way—a beautiful sight to behold!

—For the candied persimmons, in a medium saucepan, combine the sugar, honey, cinnamon stick, and ¾ cup (180 ml) water and bring to a boil over medium-high heat. Reduce the heat to medium-low and add some of the persimmon slices, keeping them in a single even layer on top of the syrup, and cook them until they begin to ruffle around the edges, 5 to 7 minutes per side, working in batches as necessary. Remove any tan froth from the surface of the syrup with a mesh spoon or small strainer. Remove the persimmons from the syrup and place on a cutting board lined with parchment paper until cool enough to handle. Repeat with the remaining persimmon slices. Transfer to a wire rack to cool completely and allow any excess syrup to drip off.

—For the almond crust, in the bowl of a stand mixer fitted with the paddle attachment, beat together the confectioners' sugar and butter on low speed until smooth. Add the egg yolk and vanilla and mix until combined. In a separate medium bowl, mix together the flour, almond meal, lemon zest, cinnamon, and salt. With the mixer running on low speed, add the flour mixture to the yolk mixture and mix until little sandy crumbs form. Transfer the crumbs to an 8-inch (20-cm) tart pan and press them into the bottom and up the sides of the pan to form the crust. Poke all over with a fork, then cover and freeze for 30 minutes.

—Preheat the oven to 350°F (175°C).

—Parbake the crust for 10 minutes, then remove it from the oven.

—For the mascarpone filling, in the bowl of a stand mixer fitted with the paddle attachment, combine the mascarpone, sugar, eggs, lemon juice, vanilla, cinnamon, and salt and mix on medium-low speed until smooth.

—Pour the filling into the crust and bake until the filling puffs slightly but is still jiggly in the center, 25 to 30 minutes. Remove the tart from the oven and allow to cool to room temperature before topping with the candied persimmon slices and serving.

CANDIED PERSIMMONS

½ cup (100 g) sugar

⅓ cup (75 ml) honey

1 cinnamon stick

4 large persimmons, thinly sliced crosswise

ALMOND CRUST

½ cup (50 g) confectioners' sugar

½ cup (1 stick/115 g) unsalted butter, at room temperature

1 egg yolk

1 teaspoon pure vanilla extract

1¼ cups (165 g) cake flour, sifted

1 cup (95 g) almond meal, sifted

½ teaspoon finely grated lemon zest

¼ teaspoon ground cinnamon

¼ teaspoon flake kosher sea salt

MASCARPONE FILLING

1⅓ cups (305 g) mascarpone cheese, at room temperature

⅓ cup (65 g) sugar

2 large eggs

3 tablespoons fresh lemon juice

1 teaspoon pure vanilla extract

¼ teaspoon ground cinnamon

¼ teaspoon flake kosher sea salt

Buttermilk-Beet Cake
with Cream-Cheese Buttercream

— Makes one 8-inch (20-cm) cake —

You might think the idea of beets in a cake sounds a bit strange, but beets actually have a lot of sugar in them, and they sweeten up significantly when baked. They also have a slightly bitter, earthy flavor, much in the same vein as chocolate. So in this cake, grated beets are mixed with a bit of cocoa powder, buttermilk, sugar, vanilla, and cinnamon to create a moist, dense, and flavorful cake that's very similar in overall flavor to a traditional carrot cake but with a chocolate-like quality. I recommend using plain red beets for this one, since the dark color works well with the chocolate theme, but you can use whatever variety you have handy, since they'll all taste very similar. I ice this with my classic cream-cheese frosting—with only a handful of ingredients, it has the perfect balance of sugar and cream cheese and a delightfully smooth consistency for spreading. I recommend using this icing on carrot cakes, lemon cakes, and strawberry short cakes, too.

—Preheat the oven to 350°F (175°C). Grease three round 8-inch (20-cm) cake pans with butter and line the bottoms with parchment paper cut to fit.

—For the buttermilk-beet cake, in a medium bowl, mix together the flour, cocoa powder, baking soda, cinnamon, and salt. Set aside.

—In the bowl of a stand mixer fitted with the paddle attachment, cream together the butter, sugar, and brown sugar on medium-low speed until smooth. Add the eggs, one at a time, mixing well after each addition. Add the vanilla and mix to combine. Alternate between adding the flour mixture and the buttermilk to the butter mixture, mixing on low speed *just* until smooth. Stir in the beets and evenly distribute the batter among the three cake pans. Bake until the cakes are lightly golden on top and a toothpick inserted into the center comes out clean, 20 to 25 minutes. Allow to cool for 15 minutes before turning the cakes out of the pans onto a wire rack to cool completely.

—For the cream-cheese buttercream, in the bowl of a stand mixer fitted with the paddle attachment, beat together the cream cheese and butter on medium speed until completely smooth. Reduce the speed to low and add the confectioners' sugar and vanilla. Mix until combined, then raise the speed to medium. Beat the mixture until smooth, light, and fluffy, about 5 minutes more. Frost the cake with the buttercream and serve.

BUTTERMILK-BEET CAKE

2½ cups (325 g) cake flour, sifted

¼ cup (25 g) unsweetened cocoa powder, sifted

1 teaspoon baking soda

1 teaspoon ground cinnamon

¾ teaspoon flake kosher sea salt

½ cup (1 stick/115 g) unsalted butter, at room temperature, plus more for greasing the pans

1½ cups (300 g) granulated sugar

¼ cup (55 g) packed dark brown sugar

3 large eggs

1½ teaspoons pure vanilla extract

1 cup (240 ml) full-fat buttermilk

10 ounces (280 g) beets, peeled and grated

CREAM-CHEESE BUTTERCREAM

1 (8-ounce/225-g) package cream cheese, at room temperature

1 cup (2 sticks/225 g) unsalted butter, at room temperature

3 cups (300 g) confectioners' sugar

¼ teaspoon pure vanilla extract

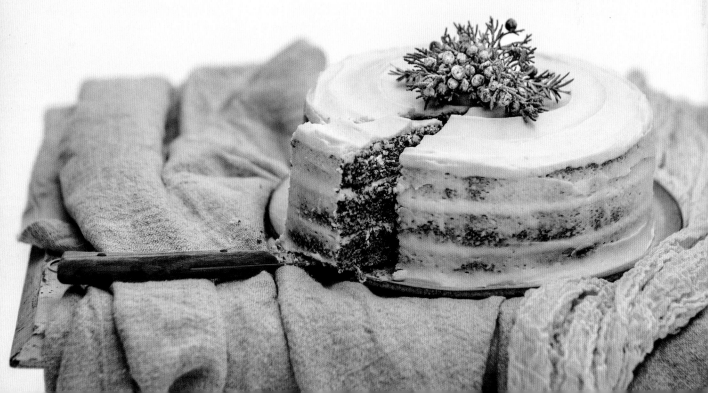

Rosemary-and-Date Roulade
with Brown-Butter Buttercream

— Makes one 9-inch (23-cm) -long rolled cake —

If you haven't noticed yet, there's a whole *lotta brown butter going on in this chapter. There's just something about its warm, toasted, nutty flavor that's so deeply comforting and hearty, making it the ideal ingredient for wintertime foods. When you're browning butter, you're essentially cooking the butter right up until the edge of burning it, so the milk fat inside the butter becomes golden brown and toasted, which is what gives it that remarkable smell and taste. And when you use it to make buttercream, you get a deep, resonating flavor that pairs perfectly with the herbal rosemary and caramelized little date bits in the cake itself. As far as rolling the cake goes, it's imperative that you roll the cake right after you've pulled it from the oven, when it's still hot. It's most flexible at this point—waiting until it cools will mean certain breakage. As for the rolling fabric, I've found linen dusted with confectioners' sugar to be the least sticky and easiest to work with.*

ROSEMARY-AND-DATE ROULADE

1 tablespoon unsalted butter, at room temperature, plus more for greasing the pan

1 cup (130 g) cake flour

½ teaspoon baking powder

½ teaspoon ground cinnamon

3 large eggs

1 egg yolk

1 cup (200 g) granulated sugar

⅓ cup (75 ml) whole milk

1 teaspoon pure vanilla extract

1 tablespoon finely chopped fresh rosemary, plus 3 sprigs fresh rosemary, for garnish

1 cup (145 g) chopped pitted dates

Confectioners' sugar, for dusting

BROWN-BUTTER BUTTERCREAM

1 cup (2 sticks/225 g) unsalted butter

3 cups (300 g) confectioners' sugar

2 tablespoons heavy cream

¼ teaspoon pure vanilla extract

¼ teaspoon flake kosher sea salt

—Preheat the oven to 375°F (190°C). Line a 9 by 13-inch (23 by 33-cm) pan with parchment paper cut to fit and grease the sides with unsalted butter.

—For the cake, in a medium bowl, sift together the flour, baking powder, and cinnamon. Set aside.

—In the bowl of a stand mixer fitted with the whisk attachment, beat together the eggs, egg yolk, and granulated sugar on medium-high speed until pale and fluffy, 2 to 3 minutes. Add the milk and vanilla and mix until combined. Add the flour mixture and rosemary and fold until incorporated. Pour the batter into the prepared pan and evenly distribute the chopped dates over it. Bake until set and lightly golden around the edges, about 13 minutes.

—Remove the cake from the oven and invert it onto a linen dish towel dusted with confectioners' sugar. Carefully remove the parchment paper, then trim the edges of the cake, dust the cake with more confectioners' sugar, and place another linen dish towel on top. Starting at the long side of the cake, tightly roll the cake and allow it to cool to room temperature.

—For the brown-butter buttercream, in a large stainless-steel skillet, melt the butter over medium heat. Swirl the pan around a bit every couple of minutes to help it cook evenly. Over a period of several minutes, the foam at the top of the butter will change from a light yellow to dark tan. Once it reaches the dark tan stage, smell it. It should smell nutty and toasted. Remove from the heat and set aside to cool to room temperature.

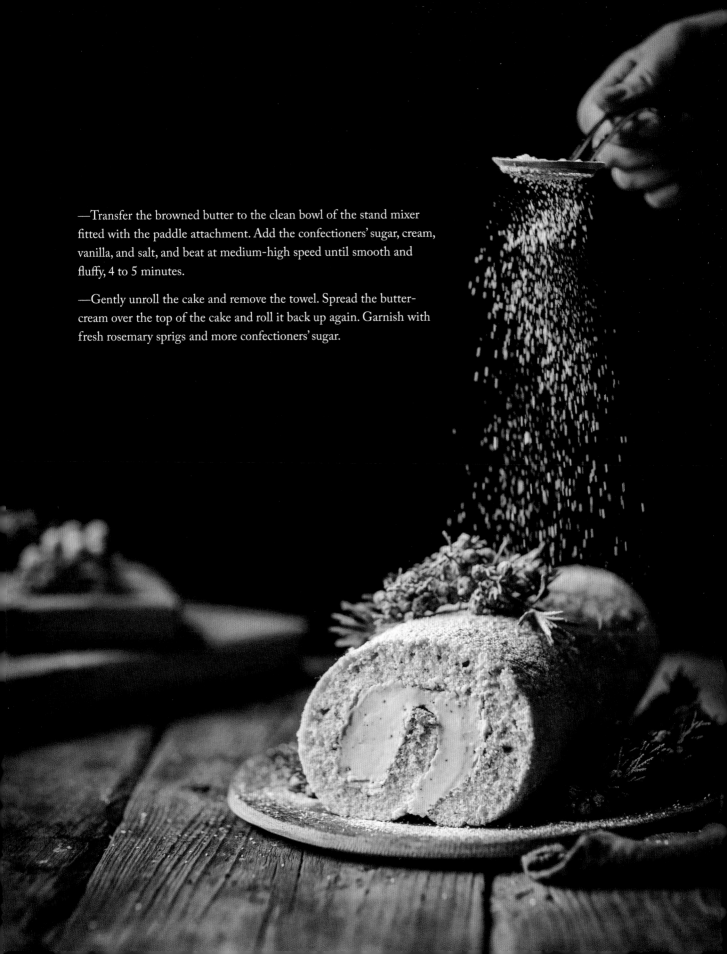

—Transfer the browned butter to the clean bowl of the stand mixer fitted with the paddle attachment. Add the confectioners' sugar, cream, vanilla, and salt, and beat at medium-high speed until smooth and fluffy, 4 to 5 minutes.

—Gently unroll the cake and remove the towel. Spread the buttercream over the top of the cake and roll it back up again. Garnish with fresh rosemary sprigs and more confectioners' sugar.

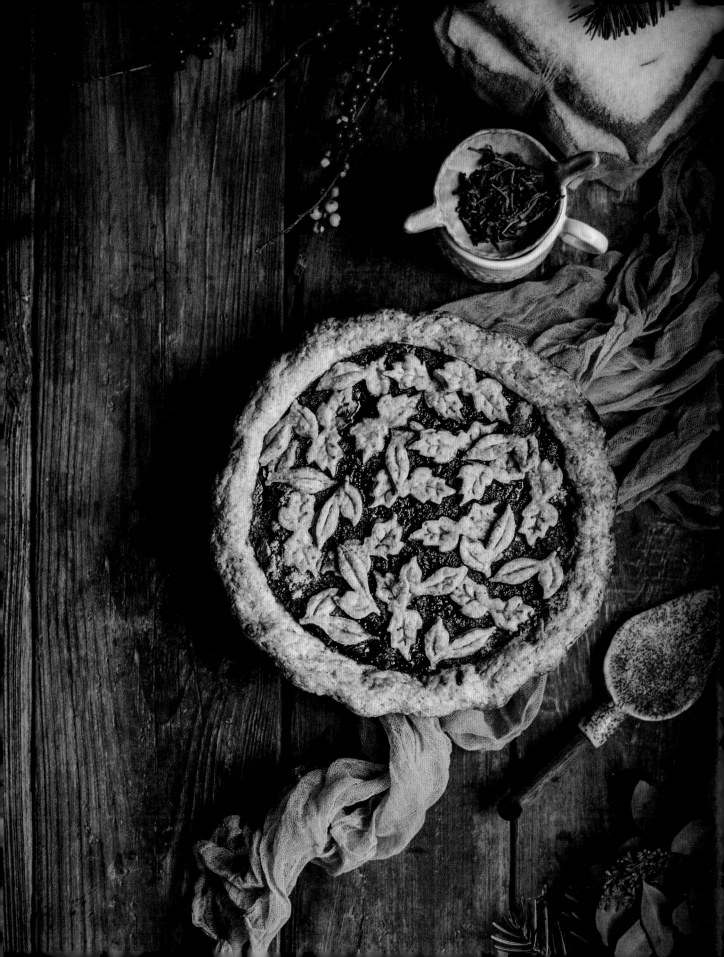

Cranberry-Apple Pie with Graham Cracker Crust

— Makes one 9-inch (23-cm) pie —

The zippy acidity of cranberries is subdued by the sweetness of crisp winter apples in this aromatic and comforting pie. The color is also quite the sight to behold, with bubbling bright red juices flowing up around the patterned crust's edges. The crust itself has a little bit of graham cracker crumbs in it for some extra flavor and texture, and I use little pie stamps to cut out the fun shapes on top of the pie. You can find pie stamps on Amazon.com and at specialty baking stores, but feel free to top it with a lattice pattern instead. I love serving this with a scoop of vanilla ice cream for some melty, creamy contrast to the fruity pie.

—For the cranberry-apple filling, in a medium saucepan, combine the apples, cranberries, sugar, cinnamon stick, and ¼ cup (60 ml) water and bring to a boil over medium-high heat. Reduce the heat to medium-low and cook, uncovered, until the mixture has thickened, the cranberries have burst, and the apples are very soft, about 30 minutes, stirring every 5 to 10 minutes. Remove from the heat and stir in the nutmeg, ground cinnamon, salt, cloves, and vanilla. Set aside to cool to room temperature. Once cooled, remove and discard the cinnamon stick.

—For the graham cracker crust, in a large bowl, mix together the flour, ½ cup (60 g) of the graham cracker crumbs, the sugar, salt, allspice, nutmeg, and ginger until combined. Grate the frozen butter over the bowl, stirring it every 30 seconds to help coat the individual shards of butter in the flour mixture. Add 10 tablespoons (150 ml) of the water in 1-tablespoon increments, stirring, until all the water has been added. Knead the dough for 1 to 2 minutes to help disperse the moisture, then grab a handful of the mixture and squeeze. If it generally sticks together when you let go, it is fine. If it completely crumbles apart, it needs another tablespoon or so of water.

—Once the dough holds its shape, roll it out on a floured work surface until it is ¼ inch (12 mm) thick. Transfer it to a 9-inch (23-cm) pie plate, trim the excess, and form the edge. If you'd like, you can save the excess dough and roll it out again to ¼ inch (12 mm) thick, then use pie stamps or cookie cutters to cut out shapes to place on top of the pie for decoration. Place the crust and any decorative shapes in the freezer for 30 minutes.

—Preheat the oven to 375°F (190°C).

—Pour the filling into the crust and top with the remaining ¼ cup graham cracker crumbs and the decorative crust shapes. Bake until the crust is golden brown around the edges, 45 to 55 minutes. Remove from the oven and allow to cool for 1 hour before slicing and serving.

CRANBERRY-APPLE FILLING

1¼ pounds (570 g) apples, peeled, cored, and chopped

14 ounces (400 g) fresh cranberries

1 cup (200 g) sugar

1 cinnamon stick

1¼ teaspoons ground nutmeg

1 teaspoon ground cinnamon

½ teaspoon flake kosher sea salt

¼ teaspoon ground cloves

1 teaspoon pure vanilla extract

GRAHAM CRACKER CRUST

2 cups (250 g) all-purpose flour, plus more for dusting

¾ cup (90 g) graham cracker crumbs

2 tablespoons sugar

¾ teaspoon flake kosher sea salt

¼ teaspoon ground allspice

¼ teaspoon ground nutmeg

¼ teaspoon ground ginger

1 cup (2 sticks/225 g) unsalted butter, frozen

10 to 13 tablespoons (150 to 195 ml) ice water

Carrot and Cajeta Bread Pudding

— Makes 1 bread pudding Bundt —

Carrots are chock-full of natural sugars, which is why they make such a great addition to sweets. Much like beets, the sugars in carrots caramelize when you cook them, creating a deep and slightly toasty flavor. This bread pudding pulls a lot of ingredients from traditional carrot cake—like cinnamon, vanilla, allspice, and cloves—but it also has a little extra something called cajeta. Cajeta has that wonderfully rich creaminess of dulce de leche but with the slight tang of goat's milk, making for an incredibly complex and deeply addicting caramel sauce. An important word of note: to get the bread pudding to hold the shape of the Bundt pan and unmold properly, you must allow the cake to cool completely to room temperature while still in the pan. This will take several hours, but if you rush it, the bread pudding will not hold the Bundt pan's shape and will instead begin to expand outward. Patience is key when making this recipe.

CAJETA

7 cups (1.7 L) goat's milk
2½ cups (500 g) sugar
1 cinnamon stick
1 vanilla bean, split lengthwise

CARROT BREAD PUDDING

Unsalted butter, for greasing
8 large eggs
8 egg yolks
3 cups (720 ml) whole milk
⅔ cup (165 ml) heavy cream
¼ cup (60 ml) honey
1½ teaspoons pure vanilla extract
1½ teaspoons ground cinnamon
½ teaspoon ground allspice
¼ teaspoon ground cloves
¼ teaspoon flake kosher sea salt
14 cups stale French bread,
 about 12 ounces (340 g),
 cut into 1-inch (2.5-cm) cubes
10 ounces (280 g) carrots, peeled
 and grated

—For the cajeta, in a medium saucepan, combine the goat's milk, sugar, cinnamon stick, and vanilla bean pod and seeds. Cook over low heat, stirring about every 10 minutes, until the mixture turns a light caramel color, 1 hour 15 minutes to 1 hour 30 minutes. Continue to cook, stirring every 5 minutes at first but then stirring every minute once it gets closer to a deep golden color, until the mixture turns a deep golden color and thickens, 30 to 45 minutes more. To see if it is done, place a drop of it in a glass of room-temperature water. If it stays roughly in shape, it is done. If it spreads out and starts partially dissolving in the water, it needs more cooking time. Once done, remove it from the heat, remove and discard the cinnamon stick and vanilla bean husks, and set aside to cool to room temperature.

—Preheat the oven to 350°F (175°C). Set an 8-inch (20-cm) cake pan two-thirds full of water on the lowest rack of the oven. This will fill the oven with steam as it simmers and help keep the bread pudding moist. Generously grease a 10-cup (2.4 L) Bundt pan with unsalted butter.

—In a large bowl, whisk together the eggs, egg yolks, milk, cream, honey, ¼ cup (60 ml) of the cajeta, the vanilla, cinnamon, allspice, cloves, and salt until completely smooth. In a separate large bowl, toss together the bread cubes and carrots. Pour the egg mixture over the bread mixture and toss gently with your hands to coat. Allow the mixture to soak for 15 minutes.

—Pour the bread mixture into the Bundt pan, pressing down on the bread pudding in the pan to compress the bread cubes to allow them all to fit in the pan. Place the Bundt pan on a rack just above the water-filled cake pan and bake until the bread pudding pulls away from the sides of the pan and looks golden on top, 50 to 60 minutes. Remove the pan of water from the oven and discard it.

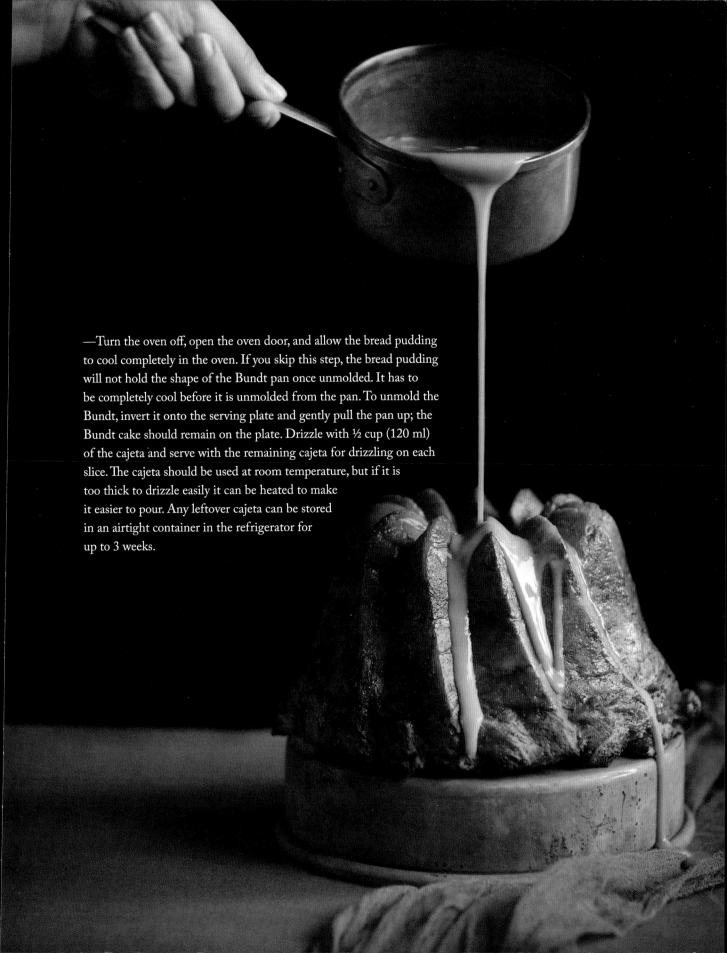

—Turn the oven off, open the oven door, and allow the bread pudding to cool completely in the oven. If you skip this step, the bread pudding will not hold the shape of the Bundt pan once unmolded. It has to be completely cool before it is unmolded from the pan. To unmold the Bundt, invert it onto the serving plate and gently pull the pan up; the Bundt cake should remain on the plate. Drizzle with ½ cup (120 ml) of the cajeta and serve with the remaining cajeta for drizzling on each slice. The cajeta should be used at room temperature, but if it is too thick to drizzle easily it can be heated to make it easier to pour. Any leftover cajeta can be stored in an airtight container in the refrigerator for up to 3 weeks.

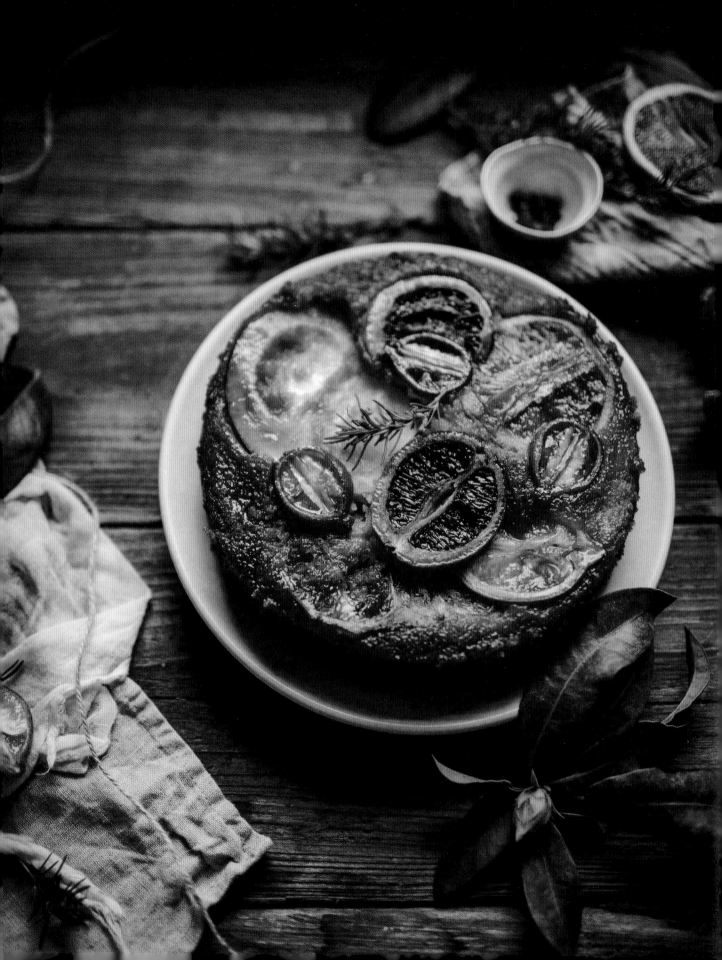

Winter Citrus Cake

— Makes one 8-inch (20-cm) cake —

People use the term winter citrus *pretty regularly nowadays, but the source of its meaning isn't really widely known, and, because I am a giant food nerd, I am going to share it with you. . . . Back in the day, when being able to quickly ship exotic fruits and vegetables wasn't really an option, wealthy English landowners had gardeners whose jobs it was to keep the land of the estate producing and looking robust. Because they needed food sources year-round, the landowners had elaborate and beautiful greenhouses built, and the best of the best gardeners would be able to produce a harvest of fruits, namely citrus, in the dead of winter. And thus "winter citrus" was born. There are so many types of citrus out there, and the best part is that you can use any of them for this cake. It's not limited to orange, lemon, kumquat, tangerine, or grapefruit—the rainbow citrus sky is the limit with this one!*

—Preheat the oven to 375°F (190°C). Grease an 8-inch (20-cm) round cake pan well with unsalted butter and line the bottom with parchment paper cut to fit.

—In a small saucepan, combine the butter, brown sugar, honey, and lemon juice and heat over low heat, whisking, until the sugar has dissolved. Remove from the heat and pour the syrup into the prepared cake pan. Arrange the citrus slices over the bottom of the pan in an even layer, overlapping them to ensure the entire bottom of the pan is covered. Set aside.

—In a medium bowl, stir together the flour, baking powder, salt, cinnamon, and cardamom until blended. Set aside.

—In the bowl of a stand mixer fitted with the paddle attachment, beat the eggs, granulated sugar, and oil on medium-low speed until smooth. Add the orange juice, citrus juice, milk, vanilla, and orange zest and mix until incorporated. Gradually add the flour mixture and mix until just blended.

—Fill the cake pan three-quarters full with batter and bake for 30 to 40 minutes, or until a toothpick inserted into the center of the cake comes out clean. Allow it to cool in the pan for 10 minutes, then invert it onto a wire rack, peel off the parchment paper, and allow to cool completely before slicing and serving.

3 tablespoons unsalted butter, plus more for greasing the pan

½ cup (110 g) packed light brown sugar

1 tablespoon honey

2 teaspoons fresh lemon juice

5 to 8 thin various citrus slices

2 cups (250 g) all-purpose flour

2 teaspoons baking powder

½ teaspoon flake kosher sea salt

½ teaspoon ground cinnamon

½ teaspoon ground cardamom

4 large eggs

1⅓ cups (265 g) granulated sugar

½ cup (120 ml) extra-virgin olive oil

¼ cup (60 ml) fresh orange or blood orange juice

¼ cup (60 ml) fresh citrus juice, such as lemon or lime juice

3 tablespoons whole milk

2 teaspoons pure vanilla extract

1 teaspoon grated orange zest

Douglas fir, spruce, and hemlock tree tips can make for a nourishing herbal tea. The flavor tastes pretty much how the tree smells, making it incredibly bright and refreshing. So, what are fir tips, anyway? Well, they're called tips for a reason, and that's because they're the softer, brighter green, newer growth that's right at the tip of the branch. You can see the color difference pretty clearly. When harvesting, you want to snip off the really bright green part and leave the darker green, older growth in place. You can do this in spring when the whole new growth is soft and pliable, and you can still do it in the fall and winter, when the new growth stem will have become a bit woody. Once you get home from foraging, you'll need to spread out the clippings in an even layer on a wire rack with a large sheet of waxed paper or parchment paper underneath it. Let them dry out for three days at room temperature, then you can pull the needles off the woody stems more easily, saving the needles and discarding the stems.

3 ounces (85 g) freshly dried fir tip needles

4 ounces (115 g) dried lemon verbena leaves

2 ounces (55 g) dried chrysanthemum blossoms

1 ounce dried peppermint leaves

—In a medium bowl, mix together the fir tips, lemon verbena, chrysanthemum, and peppermint until combined. Store in a brown paper bag; best if used within 1 month. For steeping, steep 1 tablespoon of the tea mixture in 1 cup (240 ml) hot water for 5 minutes, strain, and enjoy.

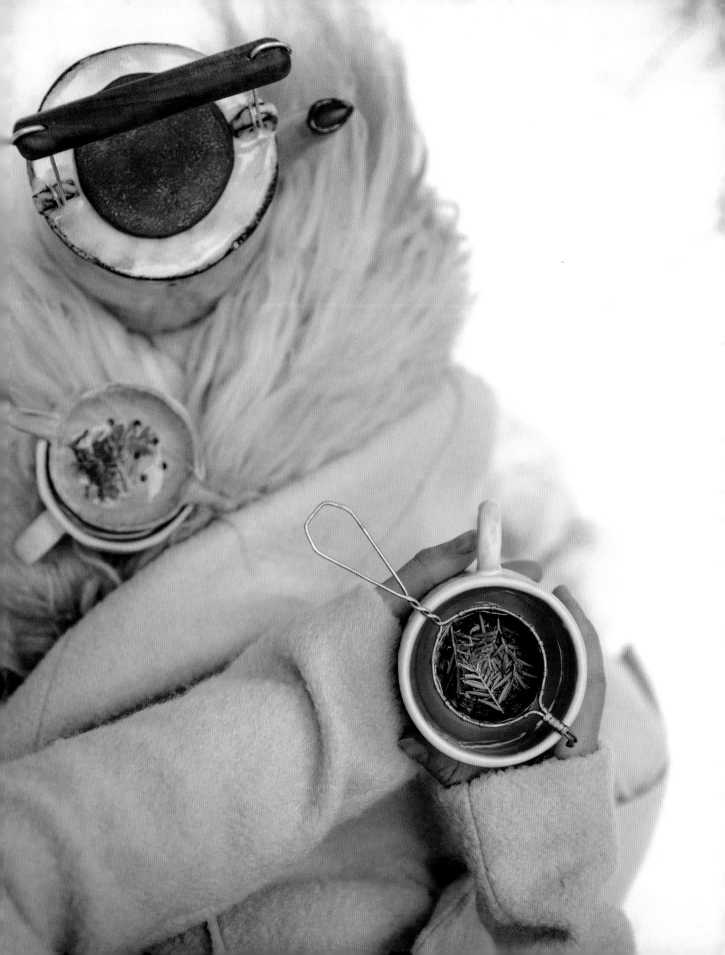

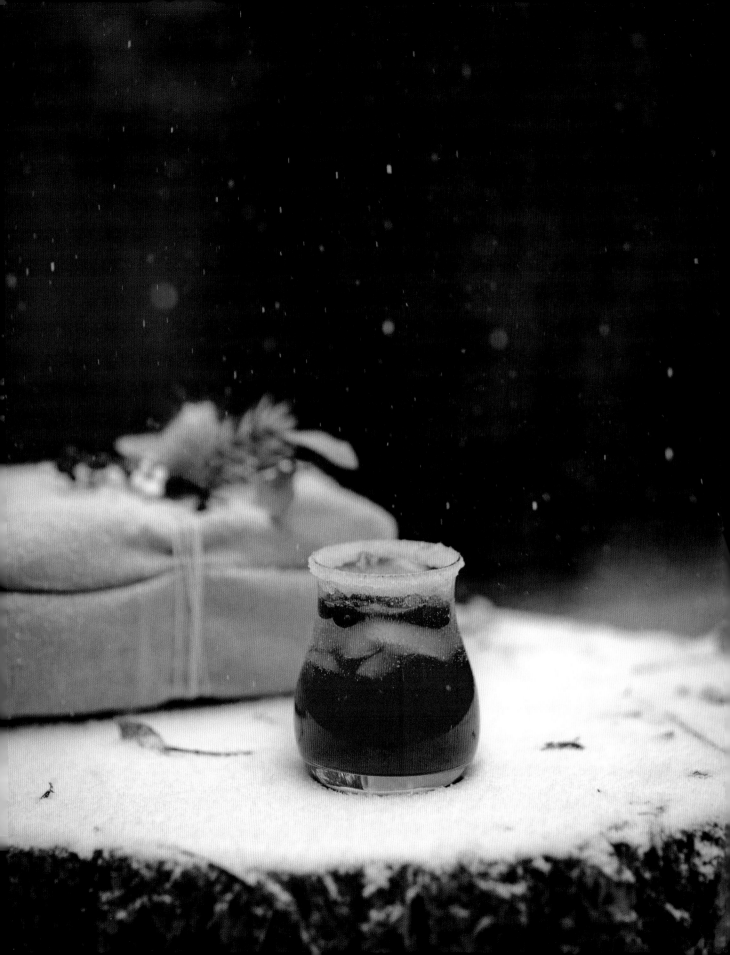

Cranberry Gin Spritzer

— Serves 4 —

Using fresh, ripe cranberries makes all the difference in this drink, which relies on a homemade cranberry syrup to impart a little sweet tanginess. I get my cranberries from a local Pacific Northwest grower called Starvation Alley (highly recommended if you're in the area), but any organic fresh cranberries will be great. You just want to avoid any nonorganic ones, since pesticides can add an unpleasant chemical flavor to the syrup. The gin adds a pleasantly refreshing quality to the drink, while the raspberry liqueur helps balance out the tartness of the cranberry syrup with some extra-fruity sweetness. The sparkling water adds a light and bubbly mouthfeel, giving a celebratory quality to this cocktail that is perfect for holiday gatherings.

—For the cranberry syrup, bring the cranberries, sugar, 1 cup (240 ml) water, and cinnamon stick to a boil in a small saucepan over medium-high heat. Reduce the heat to medium-low and simmer, uncovered, for 10 minutes, breaking the cranberries apart with a wooden spoon as they cook. Remove from the heat and set aside to cool to room temperature.

—Strain the syrup into a bowl, discarding the cranberries and cinnamon stick.

—For the cranberry gin spritzer, in a medium bowl, stir together the gin, cranberry syrup, and the raspberry liqueur. Add the sparkling water, stir gently, and pour into four lowball glasses.

CRANBERRY SYRUP

2 cups (190 g) fresh cranberries

1 cup (200 g) sugar

1 cinnamon stick

CRANBERRY GIN SPRITZER

16 ounces (480 ml) gin

8 ounces (240 ml) Cranberry Syrup

4 ounces (120 ml) raspberry liqueur

24 ounces (720 ml) sparkling water

Eggnog

— Serves 6 —

I didn't try homemade eggnog until I was in my late twenties. This was because every time I had store-bought eggnog, I hated it, and I assumed that all eggnog tasted like rancid bubblegum. As it turns out, I was deeply mistaken, and I learned this at Portland restauranteur Jeffrey Morgenthaler's bar, Clyde Common. I had my first real eggnog there, and a deep and lasting love affair began. I tried many iterations with different alcohols and liqueurs, some with just yolks, some with egg whites and yolks, some with mostly cream, some with mostly milk, some with honey, some with granulated sugar . . . well, you get the idea. After much experimenting, I settled on this recipe. I use both the egg whites and the yolks, because I love the silky mouthfeel the whites give to the drink, but I whisk the yolks with maple syrup first until they ribbon to make the consistency of the drink extra-smooth. I use rum as well as hazelnut liqueur, but you could also sub in brandy and amaretto, depending on your flavor preferences and what you have handy. For me, the most important aspect of good eggnog is the nutmeg. It has to be freshly grated. Fresh nutmeg has a buttery, nutty, toasty quality that the preground stuff loses after sitting on the shelf so long. You can find whole nutmeg at most natural food stores and at Mountain Rose Herbs' website (mountainroseherbs.com). I recommend grating it on the finest setting of your grater, too, to keep the consistency nice and fine so you don't get any strange crunchy bits of nutmeg in the 'nog.

4 large eggs, separated

⅓ cup plus 1 tablespoon (90 ml) maple syrup

16 ounces (480 ml) whole milk

8 ounces (240 ml) heavy cream

4 ounces (120 ml) golden rum

3 ounces (90 ml) hazelnut or amaretto liqueur

½ teaspoon freshly grated nutmeg, plus more for garnishing

½ teaspoon unsweetened cocoa powder, plus more for garnishing

¼ teaspoon ground cinnamon

¼ teaspoon ground cloves

—In the bowl of a stand mixer fitted with the whisk attachment, beat the egg yolks and maple syrup on medium-high speed until very pale, fluffy, and thick and a steady ribbon of the mixture flows down from the whisk when it's lifted from the bowl, 2 to 3 minutes.

—Transfer the egg yolk mixture to a blender and add the egg whites, milk, cream, rum, liqueur, nutmeg, cocoa powder, cinnamon, and cloves. Cover and blend on medium speed for 30 seconds. Stir in any froth on top of the mixture and pour into a pitcher.

—Garnish with a few pinches of nutmeg and cocoa powder. Can be served warm or chilled. Will keep in an airtight container in the refrigerator for up to 2 weeks.

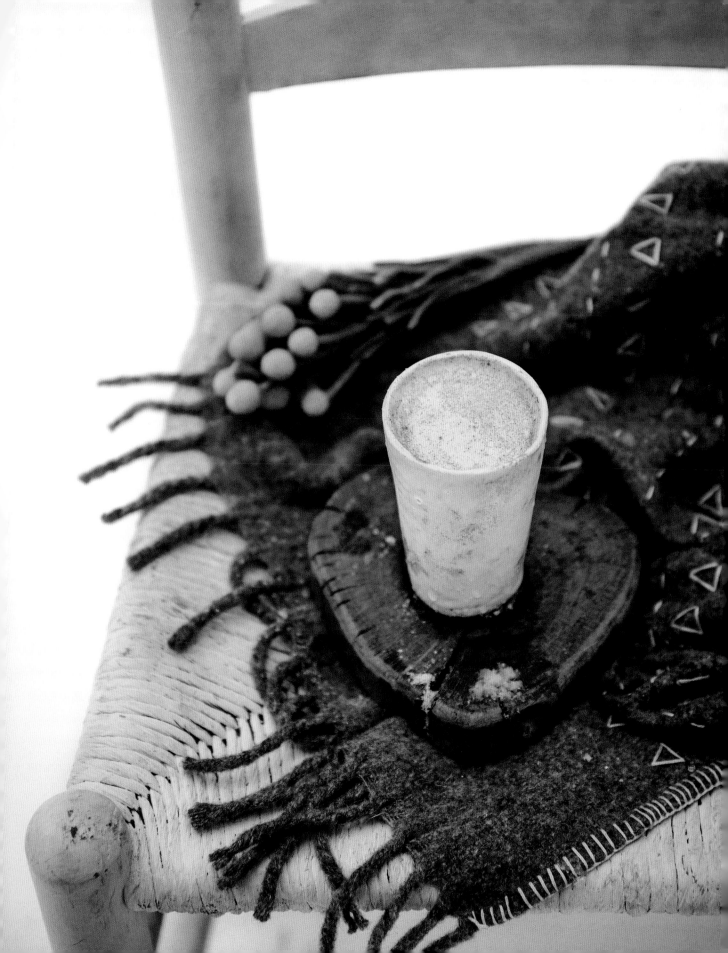

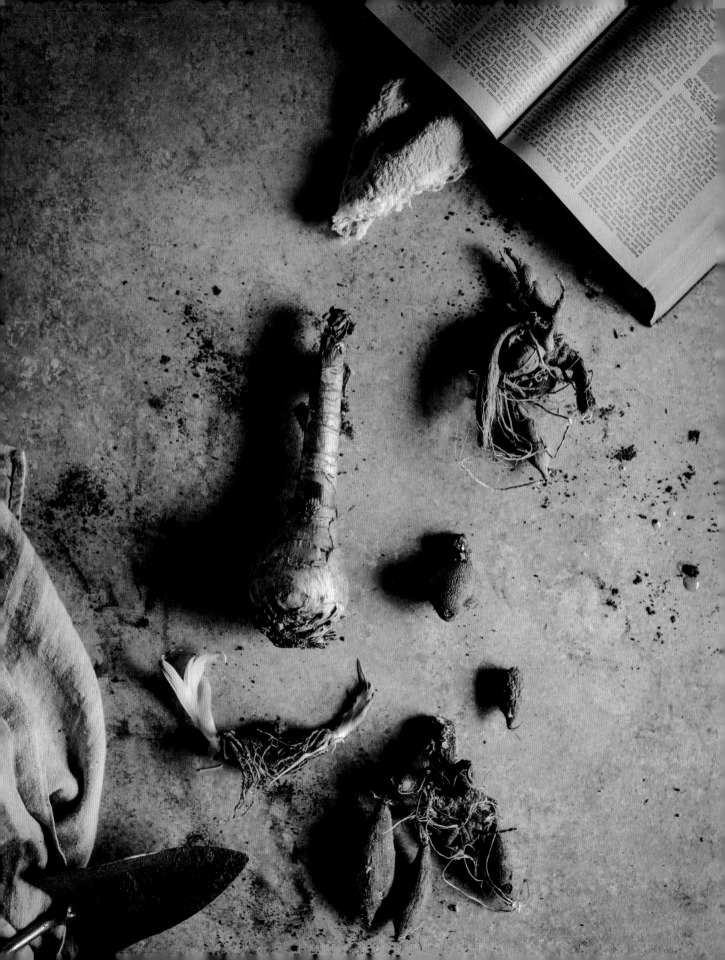

Resources

―

RECOMMENDED READING

The Art of Fermentation by Chelsea Green

Bet the Farm: How Food Stopped Being Food by Frederick Kaufman

Cooked: A Natural History of Transformation by Michael Pollan

The Ethical Meat Handbook: Complete Home Butchery, Charcuterie and Cooking for the Conscious Omnivore by Meredith Leigh

Gaia's Garden: A Guide to Home-Scale Permaculture by Toby Hemenway

The Good Life: Helen and Scott Nearing's Sixty Years of Self-Sufficient Living by Scott and Helen Nearing

Tomatoland: How Modern Industrial Agriculture Destroyed Our Most Alluring Fruit by Barry Estabrook

GARDEN AND KITCHEN SUPPLIES

—**Crème Fraîche**
Vermont Creamery
www.cermontcreamery.com

—**Heirloom bulbs**
Old House Gardens
www.oldhousegardens.com

—**Heirloom roses**
Heirloom Roses
www.heirloomroses.com

—**Locate your nearest CSA**
Local Harvest
www.localharvest.org/csa

—**Locate your nearest sustainable restaurants, shops, and markets**
Eat Well Guide
www.eatwellguide.org

—**Seeds**
Victory Seeds
www.victoryseeds.com

Seed Savers Exchange
www.seedsavers.org

—**Seeds and bare-root plants**
Baker Creek Heirloom Seeds
www.rareseeds.com

—**Seeds, plants, trees, drip irrigation systems**
Grow Organic
www.groworganic.com

—**Sourdough Starter**
Cultures for Health
www.culturesforhealth.com

King Arthur Flour
www.kingarthurflour.com/shop

—**Spices/Dried Herbs**
Mountain Rose Herbs
www.mountainroseherbs.com

Index

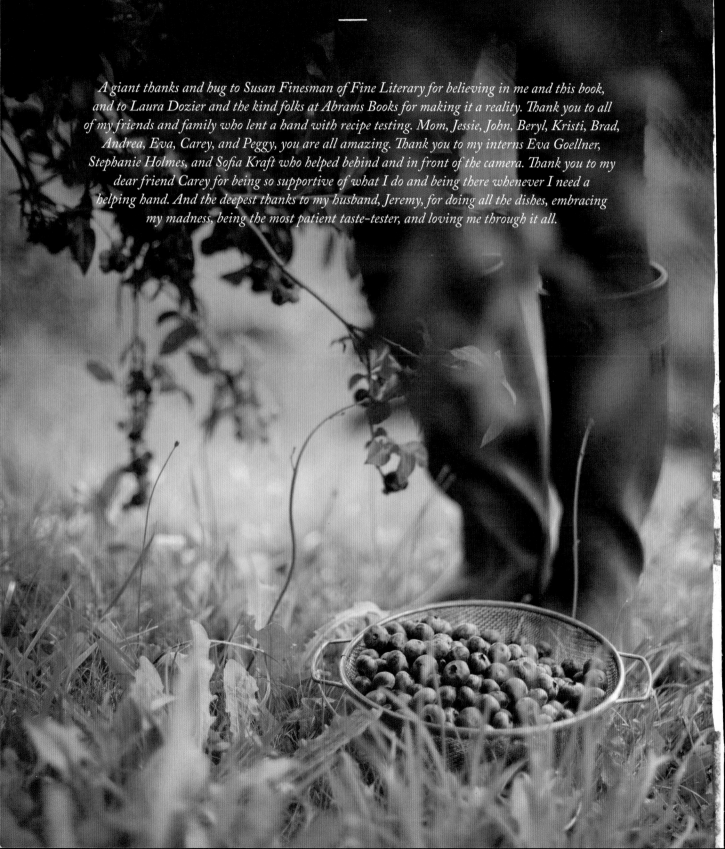

Acknowledgments

—

A giant thanks and hug to Susan Finesman of Fine Literary for believing in me and this book, and to Laura Dozier and the kind folks at Abrams Books for making it a reality. Thank you to all of my friends and family who lent a hand with recipe testing. Mom, Jessie, John, Beryl, Kristi, Brad, Andrea, Eva, Carey, and Peggy, you are all amazing. Thank you to my interns Eva Goellner, Stephanie Holmes, and Sofia Kraft who helped behind and in front of the camera. Thank you to my dear friend Carey for being so supportive of what I do and being there whenever I need a helping hand. And the deepest thanks to my husband, Jeremy, for doing all the dishes, embracing my madness, being the most patient taste-tester, and loving me through it all.